BESTSELLING BOOK SERIES

Digital Photography For Dummies, 4th Edition

P9-CQL-530

Cheat Sheet

Faker's Guide to Digital Photography Lingo

Stuck in a room full of digital photographers? Sprinkle your conversation with these terms to make it sound like you know more about the topic than you really do.

Term	What It Means
CCD, CMOS	Two types of imaging sensors used inside digital cameras; the component responsible for capturing the image
CompactFlash, SmartMedia	Two popular forms of removable memory for digital cameras
compression	A way of shrinking a large image file to a more manageable size
digicam	A hip way to say "digital camera"
dpi	Dots per inch; a measurement of how many dots of color a printer can create per inch
dye-sub	Short for *dye-sublimation*; a type of printer that creates excellent prints of digital images
jpegged	Pronounced *jay-pegged*; slang for an image that has been saved using JPEG compression
megapixel	One million pixels or more; used to describe a high-resolution camera
output resolution	The number of pixels per linear inch (ppi) in a printed photo; higher resolution equals better image quality
pixel	Short for *picture element*. The tiny blocks of color that make up digital images, like tiles in a mosaic
ppi	Pixels per inch; the higher the ppi, the better the image looks when printed
RGB	A color model in which colors are created by mixing red, green, and blue light; digital cameras are RGB images
resample	To add more pixels to an image or throw away existing pixels
sharpening filter	An image-editing tool that creates the appearance of a more sharply focused picture

For Dummies: Bestselling Book Series for Beginners

Digital Photography For Dummies, 4th Edition

Cheat Sheet

File Format Guide

Rely on these popular file formats when saving digital images.

Format	Description
TIFF	Files saved in this format can be opened on both PC and Macintosh computers. The best choice for preserving all image data, but usually results in larger file sizes than other formats. Don't use for images going on a World Wide Web page.
JPEG	JPEG files can be opened on both PC and Macintosh computers. JPEG can compress images so that files are significantly smaller, but too much compression reduces image quality. One of two formats to use for Web images.
GIF	Use for Web images only. Offers a feature that enables you to make part of your image transparent so that the Web page background shows through the image. But all GIF images must be reduced to 256 colors, which can create a blotchy effect. Compatible with both Macintosh and PC computers.
BMP	Use only for images that will be used as Windows system resources, such as a desktop wallpaper.
PICT	Use only for images that will be used as Macintosh system resources, such as a desktop pattern.

Common Keyboard Shortcuts

Press these key combinations to perform basic operations in most image-editing programs, as well as in other computer programs.

Operation	Windows Shortcut	Macintosh Shortcut
Open an existing image	Ctrl+O	⌘+O
Create a new image	Ctrl+N	⌘+N
Save an image	Ctrl+S	⌘+S
Print an image	Ctrl+P	⌘+P
Cut a selection to the Clipboard	Ctrl+X	⌘+X
Copy a selection to the Clipboard	Ctrl+C	⌘+C
Paste the contents of the Clipboard into an image	Ctrl+V	⌘+V
Select the entire image	Ctrl+A	⌘+A
Undo the last thing you did	Ctrl+Z	⌘+Z
Quit the program	Ctrl+Q	⌘+Q

Wiley, the Wiley Publishing logo, For Dummies, the Dummies Man logo, For Dummies, the Dummies Man logo, the For Dummies Bestselling Book Series logo and all related trade dress are trademarks or registered trademarks of Wiley Publishing, Inc. All other trademarks are property of their respective owners.

For Dummies: Bestselling Book Series for Beginners

...FOR DUMMIES™

BESTSELLING BOOK SERIES

References for the Rest of Us!®

Are you intimidated and confused by computers? Do you find that traditional manuals are overloaded with technical details you'll never use? Do your friends and family always call you to fix simple problems on their PCs? Then the For Dummies® computer book series from Wiley Publishing, Inc. is for you.

For Dummies books are written for those frustrated computer users who know they aren't really dumb but find that PC hardware, software, and indeed the unique vocabulary of computing make them feel helpless. For Dummies books use a lighthearted approach, a down-to-earth style, and even cartoons and humorous icons to dispel computer novices' fears and build their confidence. Lighthearted but not lightweight, these books are a perfect survival guide for anyone forced to use a computer.

"I like my copy so much I told friends; now they bought copies."

— *Irene C., Orwell, Ohio*

"Quick, concise, nontechnical, and humorous."

— *Jay A., Elburn, Illinois*

"Thanks, I needed this book. Now I can sleep at night."

— *Robin F., British Columbia, Canada*

Already, millions of satisfied readers agree. They have made For Dummies books the #1 introductory level computer book series and have written asking for more. So, if you're looking for the most fun and easy way to learn about computers, look to For Dummies books to give you a helping hand.

Wiley Publishing, Inc.

5/09

Digital Photography

FOR

DUMMIES®

4TH EDITION

Digital Photography

FOR

DUMMIES®

4TH EDITION

by Julie Adair King

Wiley Publishing, Inc.

Digital Photography For Dummies®, 4th Edition

Published by
Wiley Publishing, Inc.
111 River Street
Hoboken, NJ 07030
www.wiley.com

Copyright @ 2002 by Wiley Publishing, Inc., Indianapolis, Indiana

Published simultaneously in Canada

For general information on our other products and services or to obtain technical support, please contact our Customer Care Department within the U.S. at 800-762-2974, outside the U.S. at 317-572-3993, or fax 317-572-4002.

Wiley also publishes its books in a variety of electronic formats. Some content that appears in print may not be available in electronic books.

Library of Congress Control Number: 2002107898

ISBN: 0-7645-1664-7

Manufactured in the United States of America

10 9 8 7 6

4B/TQ/RS/QT/IN

Ⓦ Wiley Publishing, Inc. is a trademark of Wiley Publishing, Inc.

About the Author

Digital-photography expert **Julie Adair King** is the author of *Photo Retouching & Restoration For Dummies, Adobe PhotoDeluxe For Dummies, Adobe PhotoDeluxe 4.0 For Dummies,* and *Microsoft PhotoDraw 2000 For Dummies.* She has also contributed to many other books on digital imaging and computer graphics and is the author of *WordPerfect Office 2002 For Dummies, WordPerfect Suite 8 For Dummies,* and *WordPerfect Suite 7 For Dummies.*

Dedication

This book is dedicated to my family (you know who you are). Thank you for putting up with me, even on my looniest days. A special thanks to the young 'uns, Kristen, Matt, Adam, Brandon, and Laura, for brightening my world with your smiles and hugs.

Acknowledgments

Many, many thanks to all those people who provided me with the information and support necessary to create this book. I especially want to express my appreciation to the following companies for arranging equipment loans and providing technical guidance:

Canon USA, Inc.
Casio, Inc.
Cloud Dome, Inc.
Eastman Kodak Company
Epson America, Inc.
Fujifilm U.S.A., Inc.
Hewlett-Packard
Kaidan Incorporated.
Lexar Media
Microtech International
Minolta Corporation
Nikon Inc.
Olympus America Inc.
Sony Electronics Inc.
Wacom Technology

I also want to express my appreciation to my astute and extremely helpful technical editor, Alfred DeBat; to project editor Andrea Boucher; to Laura Moss and Megan Decraene for putting together the CD that accompanies this book; and to the entire Wiley Publishing production team. Finally, thanks to Steve Hayes and Diane Steele for presenting me with the opportunity to be involved in this project.

Publisher's Acknowledgments

We're proud of this book; please send us your comments through our online registration form located at www.dummies.com/register/.

Some of the people who helped bring this book to market include the following:

Acquisitions, Editorial, and Media Development

Project Editor: Andrea C. Boucher

Acquisitions Editor: Steven H. Hayes

Technical Editor: Alfred DeBat

Editorial Manager: Carol Sheehan

Permissions Editor: Laura Moss

Media Development Specialist: Megan Decraene

Media Development Manager: Laura VanWinkle

Media Development Supervisor: Richard Graves

Editorial Assistant: Amanda Foxworth

Production

Project Coordinator: Nancee Reeves

Layout and Graphics: Amanda Carter, Melanie DesJardins, Joyce Haughey, LeAndra Johnson, Barry Offringa, Jeremey Unger, Erin Zeltner

Proofreaders: John Greenough, Andy Hollandbeck, Angel Perez, Dwight Ramsey, TECHBOOKS Production Services

Indexer: TECHBOOKS Production Services

Publishing and Editorial for Technology Dummies

Richard Swadley, Vice President and Executive Group Publisher

Mary C. Corder, Editorial Director

Andy Cummings, Vice President and Publisher

Publishing for Consumer Dummies

Diane Graves Steele, Vice President and Publisher

Joyce Pepple, Acquisitions Director

Composition Services

Gerry Fahey, Vice President of Production Services

Debbie Stailey, Director of Composition Services

Contents at a Glance

Introduction ... 1

Part I: Peering through the Digital Viewfinder 9
Chapter 1: Filmless Fun, Facts, and Fiction 11
Chapter 2: Mr. Science Explains It All 23
Chapter 3: In Search of the Perfect Camera 45
Chapter 4: Extra Goodies for Extra Fun 73

Part II: Ready, Set, Shoot! .. 97
Chapter 5: Take Your Best Shot .. 99
Chapter 6: Digicam Dilemmas (And How to Solve Them) 125

Part III: From Camera to Computer and Beyond 145
Chapter 7: Building Your Image Warehouse 147
Chapter 8: Can I Get a Hard Copy, Please? 167
Chapter 9: On-Screen, Mr. Sulu! .. 191

Part IV: Tricks of the Digital Trade 215
Chapter 10: Making Your Image Look Presentable 217
Chapter 11: Cut, Paste, and Cover Up 247
Chapter 12: Amazing Stuff Even You Can Do 273

Part V: The Part of Tens ... 303
Chapter 13: Ten Ways to Improve Your Digital Images 305
Chapter 14: Ten Great Uses for Digital Images 311
Chapter 15: Ten Great Online Resources for Digital Photographers 317

Part VI: Appendixes ... 321
Appendix A: Digital Photography Glossary 323
Appendix B: What's on the CD ... 329

Index .. 339

End-User License Agreement ... 361

Table of Contents

Introduction .. *1*

Why a Book for Dummies? .. 2
What's in This Book? ... 2
 Part I: Peering through the Digital Viewfinder 3
 Part II: Ready, Set, Shoot! 3
 Part III: From Camera to Computer and Beyond 4
 Part IV: Tricks of the Digital Trade 4
 Part V: The Part of Tens 5
 Part VI: Appendixes .. 5
What's on the CD? ... 5
Icons Used in This Book ... 5
Conventions Used in This Book 6
What Do I Read First? .. 7

Part 1: Peering through the Digital Viewfinder *9*

Chapter 1: Filmless Fun, Facts, and Fiction **11**

Film? We Don't Need No Stinkin' Film! 12
Fine, but Why Do I Want Digital Images? 13
But Can't I Do All This with a Scanner? 17
Now Tell Me the Downside 18
Just Tell Me Where to Send the Check. 19
 Cameras .. 19
 Memory cards ... 20
 Image-processing and printing equipment 20

Chapter 2: Mr. Science Explains It All **23**

From Your Eyes to the Camera's Memory 23
The Secret to Living Color 24
Resolution Rules! ... 27
 Pixels: The building blocks of every digital photo 27
 Image resolution and print quality 28
 Image resolution and on-screen picture quality 30
 How many pixels are enough? 31
 More pixels means bigger files 32
 So how do I control pixels and output resolution? ... 32
 More mind-boggling resolution stuff 34
 What all this resolution stuff means to you 36
Lights, Camera, Exposure! 37
 Aperture, f-stops, and shutter speeds: The traditional way 37
 Aperture, shutter speed, and f-stops: The digital way 39

ISO ratings and chip sensitivity ...40
RGB, CMYK, and Other Colorful Acronyms41

Chapter 3: In Search of the Perfect Camera **45**

Mac or Windows — Does It Matter?46
You Say You Want a Resolution ...46
The Great Compression Scheme ..49
Memory Matters ...50
To LCD or Not To LCD ...53
Special Breeds for Special Needs ...54
What? No Flash? ...56
Through a Lens, Clearly ...57
 Fun facts about focal length ...58
 Optical versus digital zoom ...59
 Focusing aids ..60
 Lens gymnastics ...61
 Interchangeable lenses and filters61
Exposure Exposed ...62
Is That Blue? Or Cyan? ..64
Still More Features to Consider ...65
 Now playing, on your big-screen TV65
 Self-timer and remote control65
 There's a computer in that camera!66
 Action-oriented options ...67
 Little things that mean a lot ..68
Sources for More Shopping Guidance70
Try Before You Buy! ...71

Chapter 4: Extra Goodies for Extra Fun **73**

Memory Cards and Other Camera Media74
 Field guide to camera memory74
 Care and feeding of CompactFlash and SmartMedia cards ...76
Download Devices ...77
Long-Term Picture Storage Options82
Software Solutions ...86
 Image-editing software ...87
 Specialty software ..90
Camera Accessories ...93
Mouse Replacement Therapy ...94

Part II: Ready, Set, Shoot!**97**

Chapter 5: Take Your Best Shot **99**

Composition 101 ..99
A Parallax! A Parallax! ..104

Let There Be Light ...105
 Locking in (auto) exposure106
 Choosing a metering mode107
 Adjusting ISO ..107
 Applying exposure compensation109
 Using aperture- or shutter-priority mode110
 Adding a flash of light111
 Switching on additional light sources115
 Lighting shiny objects116
 Compensating for backlighting118
 Excuse me, can you turn down the sun?120
Focus on Focus ..120
 Working with fixed-focus cameras120
 Taking advantage of autofocus121
 Focusing manually ...122
Shifting Depth of Field ...123

Chapter 6: Digicam Dilemmas (And How to Solve Them) 125
Dialing In Your Capture Settings125
 Setting the capture resolution126
 Choosing a compression setting127
 Selecting a file format128
Balancing Your Whites and Colors129
Composing for Compositing131
Zooming In without Losing Out133
 Shooting with an optical (real) zoom133
 Using a digital zoom134
Catching a Moving Target135
Shooting Pieces of a Panoramic Quilt138
Avoiding the Digital Measles141
Dealing with Annoying "Features"142

Part III: From Camera to Computer and Beyond145

Chapter 7: Building Your Image Warehouse 147
Downloading Your Images148
 A trio of downloading options148
 Cable transfer how-tos149
 Take the bullet TWAIN151
 Camera as hard drive152
 Tips for trouble-free downloads152
Now Playing on Channel 3153
File Format Free-for-All ..155
 JPEG ..156
 EXIF ...157

TIFF ...157
RAW ..159
Photo CD ..160
FlashPix ...160
GIF ...161
PNG ...161
BMP ...161
PICT ...162
EPS ..162
Photo Organization Tools ...162

Chapter 8: Can I Get a Hard Copy, Please?**167**

Printer Primer ..167
Inkjet printers ..168
Laser printers ..169
Dye-sub (thermal dye) printers170
Thermo-Autochrome printers170
How Long Will They Last? ...171
So Which Printer Should You Buy?173
Comparison Shopping ...174
Thumbing through Paper Options180
Letting the Pros Do It ..181
Sending Your Image to the Dance182
How to adjust print size and resolution183
These colors don't match! ..187
More words of printing wisdom188

Chapter 9: On-Screen, Mr. Sulu!**191**

Step into the Screening Room ..191
That's About the Size of It ..193
Understanding monitor resolution and picture size193
Sizing images for the screen195
Sizing screen images in inches197
Nothing but Net: Photos on the Web197
Basic rules for Web pictures ..198
Decisions, decisions: JPEG or GIF?199
GIF: 256 colors or bust ...201
JPEG: The photographer's friend208
Drop Me a Picture Sometime, Won't You?211

Part 1V: Tricks of the Digital Trade*215*

Chapter 10: Making Your Image Look Presentable**217**

What Software Do You Need? ..218
How to Open Your Photos ..218

Save Now! Save Often! ..220
Editing Safety Nets ..222
Editing Rules for All Seasons224
Cream of the Crop ..225
Fixing Exposure and Contrast228
 Basic brightness/contrast controls229
 Brightness adjustments at higher Levels231
Give Your Colors More Oomph234
Help for Unbalanced Colors ..235
Focus Adjustments (Sharpen and Blur)237
 Sharpening 101 ..237
 Automatic sharpening filters238
 Manual sharpening adjustments239
 Blur to sharpen? ...242
Out, Out, Darned Spots! ..244

Chapter 11: Cut, Paste, and Cover Up**247**
Why (And When) Do I Select Stuff?248
 What tools should I use?249
 Activating the Elements selection tools250
 Selecting (and deselecting) everything256
 Taking the inverse approach to selections257
 Refining your selection outline258
Selection Moves, Copies, and Pastes260
 Cut, Copy, Paste: The old reliables261
 Adjusting a pasted object262
Deleting Selected Areas ...264
Digital Cover-Ups ...264
 Creating a seamless patch265
 Cloning without DNA ..267
Hey Vincent, Get a Larger Canvas!270

Chapter 12: Amazing Stuff Even You Can Do**273**
Give Your Image a Paint Job273
 What's in your paint box?275
 Pick a color, any color!281
 Pouring color into a selection286
 Using a Fill tool ...288
Spinning Pixels around the Color Wheel289
Uncovering Layers of Possibility290
 Working with Elements layers294
 Building a multilayered collage299
Turning Garbage into Art ..302

Part V: The Part of Tens 303

Chapter 13: Ten Ways to Improve Your Digital Images 305
Remember the Resolution! ..306
Don't Overcompress Your Images306
Look for the Unexpected Angle307
Light 'Er Up! ..307
Use a Tripod ..308
Compose from a Digital Perspective308
Take Advantage of Image-Correction Tools308
Print Your Images on Good Paper309
Practice, Practice, Practice!309
Read the Manual (Gasp!) ..310

Chapter 14: Ten Great Uses for Digital Images 311
Design a More Exciting Web Site312
E-Mail Pictures to Friends and Family312
Create Online Photo Albums313
Add Impact to Sales Materials313
Put Your Mug on a Mug ..314
Print Photo Calendars and Cards314
Include Visual Information in Databases315
Put a Name with the Face ..315
Exchange a Picture for a Thousand Words315
Hang a Masterpiece on Your Wall316

Chapter 15: Ten Great Online Resources for Digital Photographers 317
www.dpreview.com ...318
www.imaging-resource.com ...318
www.megapixel.net ..318
www.pcphotomag.com ..318
www.pcphotoreview.com ...318
www.peimag.com ..319
www.shutterbug.net ...319
rec.photo.digital ...319
comp.periphs.printers ...320
Manufacturer Web Sites ...320

Part VI: Appendixes 321

Appendix A: Digital Photography Glossary 323

Appendix B: What's on the CD 329
System Requirements ..329
How to Use the CD Using Microsoft Windows330

How to Use the CD Using a Mac OS Computer ..331
What You'll Find ...332
 Photo-editing software ..332
 Specialty software ...333
 Catalog/album programs ..334
Images on the CD ...335
 Web links page ..335
 And one last thing.335
If You've Got Problems (Of the CD Kind) ..337

Index...*339*

End-User License Agreement...*361*

Introduction

. .

*I*n the 1840s, William Henry Fox Talbot combined light, paper, a few chemicals, and a wooden box to produce a photographic print, laying the foundation for modern film photography. Over the years, the process that Talbot introduced was refined, and people everywhere discovered the joy of photography. They started trading pictures of horses and babies. They began displaying their handiwork on desks, mantels, and walls. And they finally figured out what to do with those little plastic sleeves inside their wallets.

Today, more than 160 years after Talbot's discovery, we've entered a new photographic age. The era of the digital camera has arrived, and with it comes a new and exciting way of thinking about photography. In fact, the advent of digital photography has spawned an entirely new art form — one so compelling that major museums now host exhibitions featuring the work of digital photographers.

With a digital camera, a computer, and some photo-editing software, you can explore unlimited creative opportunities. Even if you have minimal computer experience, you can easily bend and shape the image that comes out of your camera to suit your personal artistic vision. You can combine several pictures into a photographic collage, for example, and create special effects that are either impossible or difficult to achieve with film. You also can do your own photo retouching, handling tasks that once required a professional studio, such as cropping away excess background or sharpening focus.

More important, digital cameras make taking great pictures easier. Because most cameras have a monitor on which you can instantly review your shots, you can see right away whether you have a keeper or need to try again. No more picking up a packet of prints at the photo lab and discovering that you didn't get a single good picture of that first birthday party, or that incredible ocean sunset, or whatever it was that you wanted to capture.

Digital photography also enables you to share visual information with people around the world instantaneously. Literally minutes after snapping a digital picture, you can put the photo in the hands of friends, colleagues, or strangers across the globe by attaching it to an e-mail message or posting it on the World Wide Web.

Blending the art of photography with the science of the computer age, digital cameras serve as both an outlet for creative expression and a serious communication tool. Just as important, digital cameras are *fun*. When was the last time you could say *that* about a piece of computer equipment?

Why a Book for Dummies?

Digital cameras have been around for several years, but at a price tag that few people could afford. Now, stores like Wal-Mart sell entry-level cameras for less than $100, which moves the technology out of the realm of exotic toy and into the hands of ordinary mortals like you and me. Which brings me to the point of this book (finally, you say).

Like any new technology, digital cameras can be a bit intimidating. Browse the digital camera aisle in your favorite store, and you come face-to-face with a slew of technical terms and acronyms — *CCD, megapixel, JPEG,* and the like. These high-tech buzzwords may make perfect sense to the high-tech folks who have been using digital cameras for a while. However, if you're an average consumer, hearing a camera salesperson utter a phrase like, "This model has a megapixel CCD and can store 60 images on an 8MB CompactFlash card using maximum JPEG compression," is enough to make you run screaming back to the film counter.

Don't. Instead, arm yourself with *Digital Photography For Dummies,* 4th Edition. This book explains everything you need to know to become a successful digital photographer; from choosing a camera to shooting, editing, and printing your pictures. And you don't need to be a computer or photography geek to understand what's going on. *Digital Photography For Dummies* speaks your language — plain English, that is — with a dash of humor thrown in to make things more enjoyable.

What's in This Book?

Digital Photography For Dummies covers all aspects of digital photography; from figuring out which camera you should buy to preparing your images for printing or for publishing on the Web.

Part of the book provides information that will help you select the right digital photography equipment and photo software. Other chapters focus on helping you use your camera to its best advantage. In addition, this book shows you how to perform certain photo-editing tasks, such as adjusting image brightness and contrast and creating photographic collages.

For some photo-editing techniques, I provide specific instructions for doing the job in a popular photo-editing program, Adobe Photoshop Elements. However, if you use another program, don't think that this book isn't for you. The basic editing tools that I discuss function similarly from program to program, and the general approach to editing is the same no matter what

program you use. So you can refer to this book for the solid foundation you need to understand different editing functions and then easily adapt the specific steps to your own photo software.

Although this book is designed for beginning- and intermediate-level digital photographers, I do assume that you have a little bit of computer knowledge. For example, you should understand how to start programs, open and close files, and get around in the Windows or Macintosh environment, depending on which type of system you use. If you're brand-new to computers as well as to digital photography, you may want to get a copy of the appropriate *For Dummies* title for your operating system, as an additional reference.

As a special note to my Macintosh friends, I want to emphasize that although most of the figures in this book were created on a Windows-based computer, this book is for Mac as well as Windows users. Whenever applicable, I provide instructions for both Macintosh and Windows systems.

Now that I've firmly established myself as neutral in the computer platform wars, here's a brief summary of the kind of information you can find in *Digital Photography For Dummies*.

Part I: Peering through the Digital Viewfinder

This part of the book gets you started on your digital photography adventure. The first two chapters help you understand what digital cameras can and can't do and how they perform their photographic magic. Chapter 3 helps you track down the best camera for the type of pictures you want to take, while Chapter 4 introduces you to some of the camera add-ons and other accessories that make digital photography better, easier, or just more fun.

Part II: Ready, Set, Shoot!

Are you photographically challenged? Are your pictures too dark, too light, too blurry, or just plain boring? Before you fling your camera across the room in frustration, check out this part of the book.

Chapter 5 reveals the secret to capturing perfectly exposed, perfectly focused photographs and also presents tips to help you compose more powerful, more exciting images. Chapter 6 explores technical questions that arise on a digital photography shoot, such as what resolution and compression

settings to choose. In addition, you find out how to take pictures that you plan to incorporate into a photo collage, capture a series of photographs that you can stitch together into a panorama, and handle problems such as shooting in fluorescent lighting and taking action shots.

Part III: From Camera to Computer and Beyond

After you fill up your camera with photos, you need to get them off the camera and out into the world. Chapters in this part of the book show you how to do just that.

Chapter 7 explains the process of transferring pictures to your computer and also discusses ways to store and catalog all those images. Chapter 8 gives you a thorough review of your printing options, including information about different types of photo printers. And Chapter 9 looks at ways to display and distribute images electronically — placing them on Web pages and attaching them to e-mail messages, for example.

Part IV: Tricks of the Digital Trade

In this part of the book, you get an introduction to photo editing. Chapter 10 discusses simple fixes for problem pictures. Of course, after reading the shooting tips in Chapters 5 and 6, you shouldn't wind up with many bad photos. But for the occasional stinker, Chapter 10 comes to the rescue by showing you how to adjust exposure and contrast, sharpen focus, and crop away unwanted portions of the image.

Chapter 11 explains how to select a portion of your picture and then copy and paste the selection into another image. You also find out how to cover up flaws and unwanted photo elements. Chapter 12 presents some more-advanced tricks, including painting on your image, building photo collages, and applying special effects.

Keep in mind that coverage of photo editing in this book is intended just to spark your creative appetite and give you a solid background for exploring your photo software. If you want more details about using your software, you can find excellent *For Dummies* books about many photo-editing programs. In addition, one of my other books, *Photo Retouching and Restoration For Dummies,* may be of interest to photographers who want in-depth information about digital photo retouching.

Part V: The Part of Tens

Information in this part of the book is presented in easily digestible, bite-sized nuggets. Chapter 13 contains the top ten ways to improve your digital photographs; Chapter 14 offers ten ideas for using digital images; and Chapter 15 lists ten great online resources for times when you need help sorting out a technical problem or just want some creative inspiration. In other words, Part V is perfect for the reader who wants a quick, yet filling, mental snack.

Part VI: Appendixes

In most cases, the back of a book is reserved for unimportant stuff that wasn't useful enough to earn a position in earlier pages. But the back of *Digital Photography For Dummies* is every bit as helpful as the rest of the book.

Appendix A, for example, contains a glossary of hard-to-remember digital photography terms. And Appendix B provides a guide to all the stuff provided on the CD included with this book. (But if you want a sneak preview, the next section gives you one.)

What's on the CD?

The CD tucked inside the back cover of this book is loaded with goodies. For starters, the CD contains try-before-you-buy versions of some of the best editing, cataloging, and specialty programs available to the digital photographer. You can install these programs on your computer and see which products you like best before you head to the computer store or online shopping mall. I've also provided some sample images so that you can get your feet wet with photo editing if you haven't yet taken your own pictures.

Icons Used in This Book

Like other books in the *For Dummies* series, this book uses icons to flag especially important information. Here's a quick guide to the icons used in *Digital Photography For Dummies*.

This icon lets you know when a product or image that I'm describing is included on the CD at the back of the book. You can try out the program for yourself or open the image and experiment with the technique being discussed.

As mentioned earlier, I sometimes provide steps for accomplishing a photo-editing goal using Adobe Photoshop Elements. The Elements How-To icon marks information specifically related to that program. But if you're using another program, you can adapt the general editing approach to your own software, so don't ignore paragraphs marked with the Elements How-To icon.

Note that although figures feature Elements 1.0, I also provide guidance for Elements 2.0.

This icon marks stuff that you should commit to memory. Doing so will make your life easier and less stressful.

Text marked with this icon breaks technical gobbledygook down into plain English. In many cases, you really don't need to know this stuff, but boy, will you sound impressive if you do.

The Tip icon points you to shortcuts that help you avoid doing more work than necessary. This icon also highlights ideas for creating better pictures and working around common digital photography problems.

When you see this icon, pay attention — danger is on the horizon. Read the text next to a Warning icon to keep yourself out of trouble and to find out how to fix things if you leaped before you looked.

Conventions Used in This Book

In addition to icons, *Digital Photography For Dummies* follows a few other conventions. When I want you to choose a command from a menu, you see the menu name, an arrow, and then the command name. For example, if I want you to choose the Cut command from the Edit menu, I write it this way: "Choose Edit⇨Cut."

Sometimes, you can choose a command more quickly by pressing two or more keys on your keyboard than by clicking your way through menus. I present these keyboard shortcuts like so: "Press Ctrl+A," which simply means to press and hold down the Ctrl key, press the A key, and then let up on both keys. Usually, I provide the PC shortcut first, followed by the Mac shortcut, if it's different.

What Do I Read First?

The answer depends on you. You can start with Chapter 1 and read straight through to the Index, if you like. Or you can flip to whatever section of the book interests you most and start there.

Digital Photography For Dummies is designed so that you can grasp the content in any chapter without having to read all chapters that came before. So if you need information on a particular topic, you can get in and out as quickly as possible.

The one thing this book isn't designed to do, however, is to insert its contents magically into your head. You can't just put the book on your desk or under your pillow and expect to acquire the information inside by osmosis — you have to put eyes to page and do some actual reading.

With our hectic lives, finding the time and energy to read is always easier said than done. But I promise that if you spend just a few minutes a day with this book, you'll increase your digital photography skills tenfold. Heck, maybe even elevenfold or twelvefold. Suffice it to say that you'll discover a whole new way to communicate, whether you're shooting for business, for pleasure, or for both.

The digital camera is the next Big Thing. And with *Digital Photography For Dummies,* you get the information you need in order to take advantage of this powerful new tool — quickly, easily, and with a few laughs along the way.

Part I

Peering through the Digital Viewfinder

In this part . . .

When I was in high school, the science teachers insisted that the only way to learn about different creatures was to cut them open and poke about their innards. In my opinion, dissecting dead things never accomplished anything other than giving the boys a chance to gross out the girls by pretending to swallow formaldehyde-laced body parts.

But even though I'm firmly against dissecting our fellow earthly beings, I am wholly in favor of dissecting new technology. It's my experience that if you want to make a machine work for you, you have to know what makes that machine tick. Only then can you fully exploit its capabilities.

To that end, this part of the book dissects the machine known as the digital camera. Chapter 1 looks at some of the pros and cons of digital photography, while Chapter 2 pries open the lid of a digital camera so that you can get a better understanding of how the thing performs its magic. Chapter 3 puts the magnifying glass to specific camera features, giving you the background you need to select the right camera for your photography needs. Chapter 4 provides the same kind of close inspection of camera accessories and digital imaging software.

All right, put on your goggles and prepare to dissect your digital specimens. And boys, no flinging camera parts around the room or sticking cables up your noses, okay? Hey, that means you, mister!

Chapter 1

Filmless Fun, Facts, and Fiction

In This Chapter

▶ Understanding the differences between digital cameras and regular cameras

▶ Discovering some great uses for digital cameras

▶ Comparing scanners and digital cameras

▶ Assessing the pros and cons of digital photography

▶ Calculating the impact on your wallet

1 love hanging out in computer stores. I'm not a major geek — not that there's anything *wrong* with that — I just enjoy seeing what new gadgets I may be able to justify as tax write-offs.

You can imagine my delight, then, when digital cameras began showing up on the store shelves at a price that even my meager budget could handle. Here was a device that not only offered time and energy savings for my business but, at the same time, was a really cool toy for entertaining friends, family, and any strangers I could corral on the street.

If you, too, have decided that the time is right to join the growing ranks of digital photographers, I'd like to offer a hearty "way to go!" — but also a little word of caution. Before you hand over your money, be sure that you under-stand how this new technology works — and don't rely on the salesperson in your local electronics or computer superstore to fill you in. From what I've observed, many salespeople don't fully understand digital photography. As a result, they may steer you toward a camera that may be perfect for someone else but doesn't meet your needs.

Nothing's worse than a new toy, er, *business investment* that doesn't live up to your expectations. Remember how you felt when the plastic action figure that flew around the room in the TV commercial just stood there doing nothing after you dug it out of the cereal box? To make sure that you don't experience the same letdown with a digital camera, this chapter sorts out the facts from the fiction, explaining the pros and cons of digital imagery in general and digital cameras in particular.

Film? We Don't Need No Stinkin' Film!

As shown in Figure 1-1, digital cameras come in all shapes and sizes. (You can see additional cameras throughout the next several chapters.) But although designs and features differ from model to model, all digital cameras are created to accomplish the same goal: to simplify the process of creating digital images.

When I speak of a *digital image,* I'm referring to a picture that you can view and edit on a computer. Digital images, like anything else you see on your computer screen, are nothing more than bits of electronic data. Your computer analyzes that data and displays the image on-screen. (For a detailed look at how digital images work, see Chapter 2.)

Digital images are nothing new — people have been creating and editing digital pictures using programs such as Adobe Photoshop and Corel PHOTO-PAINT for years. But until the advent of digital cameras, the process of getting a stunning sunset scene or an endearing baby picture into digital form required some time and effort. After shooting the picture with a film camera, you had to get the film developed and then have the photographic print or slide *digitized* (that is, converted to a computer image) using a piece of equipment known as a *scanner.* Assuming that you weren't well-off enough to have a darkroom and a scanner in the east wing of your mansion, all this could take several days and involve several middlemen and associated middleman costs.

Figure 1-1: A sampling of today's digital cameras: the Fujifilm FinePix 601 Zoom, Olympus D-520 Zoom, Sony DSC-F707 Cyber-shot, Nikon Coolpix 2500, and Minolta Dimage X.

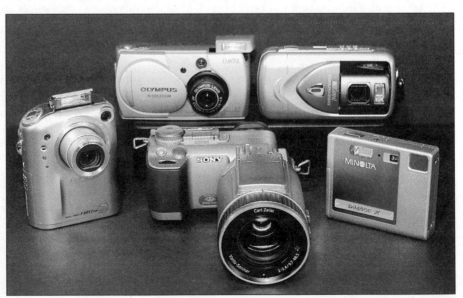

The film-and-scanner approach is still the most common way to create digital photographs. But digital cameras provide an easier, more convenient option. While traditional cameras capture images on film, digital cameras record what they see using computer chips and digital storage devices, creating images that can be immediately accessed by your computer. No film, film processing, or scanning is involved — you press the shutter button, and voilà: You have a digital image. To use the image, you simply transfer it from your camera to the computer, a process that can be accomplished in a variety of ways. With some cameras, you can send your pictures directly to a special photo printer — you don't even need a computer!

Fine, but Why Do I Want Digital Images?

Going digital opens up a world of artistic and practical possibilities that you simply don't enjoy with film. Here are just a few advantages of working with digital images:

✔ You gain added control over your pictures. With traditional photos, you have no input into an image after it leaves your camera. Everything rests in the hands of the photofinisher. But with a digital photo, you can use your computer and photo-editing software to touch up your pictures, if necessary. You can correct contrast and color-balance problems, improve focus, and cut unwanted objects from the scene.

Figures 1-2 and 1-3 illustrate the point: The top image shows an original digital photo. In addition to being overexposed, the picture is poorly framed and contains some distracting background elements. Parts of another swimmer's leg and foot are visible near the top of the frame, and some other unidentified object juts into the picture on the left.

I opened the picture in my photo editor and took care of all of these problems in a few minutes. I removed the intrusive background elements, adjusted the brightness and contrast, and cropped the picture to frame the main subject better. You can see the much-improved picture in Figure 1-3.

Some would say that I could have created the same image with a film camera by paying attention to the background, exposure, and framing before I took the picture. But when you're photographing children and other fast-paced subjects, you have to shoot quickly. Had I taken the time to make sure that everything was perfect before I recorded the image, my opportunity to capture this subject would have been long gone. I'm not saying that you shouldn't strive to shoot the best pictures possible, but if something goes awry, you often can rescue marginal images in the editing stage.

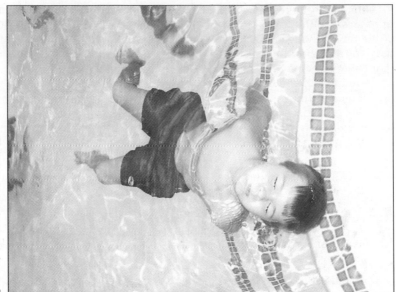

Figure 1-2:
My original photo of this fledgling swimmer is over-exposed and poorly framed.

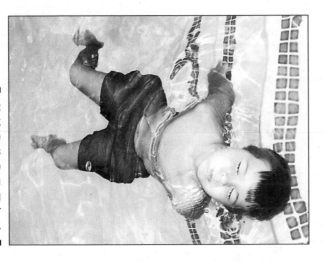

Figure 1-3:
A little work in my photo editor turns a so-so image into a compelling summer memory.

✔ You can send an image to friends, family members, and clients almost instantaneously by attaching it to an e-mail message. This capability is one of the biggest benefits of digital imagery. Journalists covering stories in far-off lands can get pictures to their editors moments after snapping the images. Salespeople can send pictures of products to prospective buyers while the sales lead is still red-hot. Or, to pull an example from my own thrilling life, part-time antiques dealers can share finds with other dealers all over the world without leaving their homes. When I needed help identifying a Danish antique print, for example, I posted a message

to an antiques discussion group on the Internet. A gentleman in Denmark offered to help if I could send him a photograph of the print. No problem. I picked up a digital camera, took a picture of the print, sent the image off via e-mail, and had a response the next day. Is this a great age we live in, or what?

Again, you can achieve the same thing with print photographs and the postal service — and don't think we don't all love receiving the 5 x 7 glossy of your dog wearing the Santa hat every Christmas. But if you had a digital image of Sparky, you could get the picture to all interested parties in a matter of minutes, not days. Not only is electronic distribution of images quicker than regular mail or overnight delivery services, it's also more convenient. You don't have to address an envelope, find a stamp, or truck off to the post office or delivery drop box.

✔ You can include pictures of your products, your office headquarters, or just your pretty face in multimedia presentations and on a Web site. Chapter 9 explains everything you need to do to prepare your images for both types of on-screen use.

✔ You can include digital images in business databases. For example, if your company operates a telemarketing program, you can insert images into a product order database so that when sales reps pull up information about a product, they see a picture of the product and can describe it to customers. Or you may want to insert product shots into inventory spreadsheets, as I did in Figure 1-4.

Figure 1-4: You can insert digital images into spread- sheets to create a visual inventory record.

✔ You can have a lot of fun exploring your artistic side. Using an image-editing program, you can apply wacky special effects, paint mustaches on your evil enemy, and otherwise distort reality. You can also combine several images into a montage, such as the one shown in Color Plate 12-3 and examined in Chapter 12.

✔ You can create your own personalized stationery, business cards, calendars, mugs, T-shirts, postcards, and other goodies, as shown in Figure 1-5. The figure offers a look at Adobe PhotoDeluxe, one of many consumer image-editing programs that provides templates for creating such materials. You just select the design you want to use and insert your own photos into the template. In the figure, I'm placing a picture of a house into a real-estate sales flier.

After you place your photos into the templates, you can print your artwork on a color printer using specialized print media sold by Kodak, Epson, Hewlett-Packard, and other vendors. If you don't have access to a printer with this capability, you can get the job done at a local quick-copy shop or e-mail your image to one of the many vendors offering digital printing services via the Internet.

These are just some of the reasons digital imaging is catching on so quickly. For convenience, quality control, flexibility, and efficiency, digital does a slam-dunk on film.

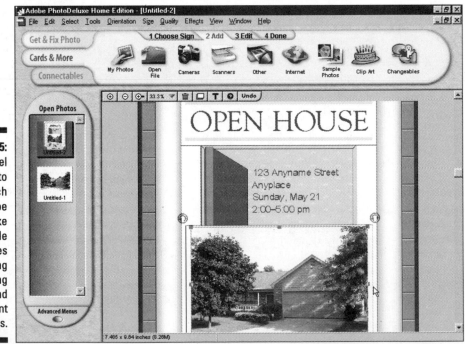

Figure 1-5: Entry-level photo editors such as Adobe PhotoDeluxe provide templates for creating advertising fliers and other print materials.

But Can't I Do All This with a Scanner?

The answer to that question is, yes. You can do everything that I mentioned in the preceding section with any digital image, whether the picture comes from a scanner or a digital camera.

However, digital cameras provide some benefits that you don't enjoy when you work with film prints and a scanner:

- ✔ If you're like most people, only a handful of pictures from every roll of film you have developed fall into the category of "that's a great picture" or even "that's an okay picture." Divide the cost of film and processing by the number of good photos per roll, and you'll discover that you're paying a lot more per picture than you thought.

 With a digital camera, you can review your pictures on your computer and then print only those that are really special. Most cameras even have a built-in monitor that enables you to review your image immediately after you shoot the picture. If the picture isn't any good, you simply delete it from the computer or camera memory.

- ✔ Instant, on-camera review of your pictures also means added peace of mind when you're photographing one-time events such as an anniversary party or important business conference. You know right away whether you snapped a winner or need to try again. No more disappointing moments at the film lab when you discover that your packet of prints doesn't contain a single decent picture of the scene you wanted to capture.

- ✔ If you shoot product pictures on a regular basis, digital cameras offer significant time-savings. You don't have to run off to the lab and wait for your pictures to be processed.

- ✔ With some cameras, you can share your photos with a large group of people by hooking the camera up to a television monitor. You can even connect the camera to a VCR and make a videotape copy of all your images. Some cameras offer a slide-show mode that displays all the pictures in the camera's memory one by one, and a few cameras even enable you to record and play audio clips and text along with your pictures.

- ✔ Finally, digital cameras free up time that you would otherwise spend scanning pictures into your computer. Even the best scanners are painfully slow when compared with the time it takes to transfer pictures from a digital camera to the computer. To scan a single image on a top-of-the-line film scanner, for example, can take several minutes, especially if you want a high-resolution scan. In the same amount of time, you can transfer dozens of pictures from a camera to the computer.

In short, digital cameras save you time and money and, most important, make it easier to produce terrific pictures.

Now Tell Me the Downside

Thanks to design and manufacturing refinements, problems that kept people from moving to digital photography in the early days of the technology — high prices and questionable image quality being the most critical — have been solved. But a couple of downside issues remain, which I should bring up in the interest in fairness:

- Today's digital cameras can produce the same high quality prints as you've come to expect from your film camera. However, to enjoy that kind of picture quality, you need to start with a camera that offers moderate-to-high image resolution, which costs a minimum of $150. Images from lower-priced models just don't contain enough picture information to produce decent prints. Low-resolution cameras are fine for pictures that you want to use on a Web page or in a multimedia presentation, however. (See Chapter 2 for a complete explanation of resolution.)

- After you press the shutter button on a digital camera, the camera requires a few seconds to record the image to memory. During that time, you can't shoot another picture. With some cameras, you also experience a slight delay between the time you press the shutter button and the time the camera captures the image. These lag times can be a problem when you're trying to capture action-oriented events.

 Generally speaking, the more expensive the camera, the less lag time you encounter. With some of the new, top-flight models, lag time isn't much more than you experience with a film camera using an automatic film advance.

 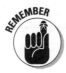

 Many digital cameras also offer a burst or continuous-capture mode that enables you to take a series of pictures with one press of the shutter button. This mode is helpful in some scenarios, although you're typically restricted to capturing images at a low resolution or without a flash. Chapter 6 provides more information.

- Becoming a digital photographer involves learning some new concepts and skills. If you're familiar with a computer, you shouldn't have much trouble getting up to speed with digital images. If you're a novice to both computers and digital cameras, expect to spend a fair amount of time making friends with your new machines. A digital camera may look and feel like your old film camera, but underneath the surface, it's a far cry from your father's Kodak Brownie. This book guides you through the process of becoming a digital photographer as painlessly as possible, but you need to invest the time to read the information it contains.

As manufacturers continue to refine digital-imaging technology, you can expect continued improvements in price and image-capture speed. I'm less hopeful that anything involving a computer will become easier to learn in the near

future; my computer still forces me to "learn" something new every day — usually, the hard way. Of course, becoming proficient with film cameras requires some effort as well.

Whether or not digital will completely replace film as the foremost photographic medium remains to be seen. In all likelihood, the two mediums will each secure their niche in the image world. So make a place for your new digital camera in your camera bag, but don't stick your film camera in the back of the closet just yet. Digital photography and film photography each offer unique advantages and disadvantages, and choosing one option to the exclusion of the other limits your creative flexibility.

Just Tell Me Where to Send the Check. . . .

If you've been intrigued by the idea of digital photography but have so far been put off by the costs involved, I have great news to report. Prices for cameras, printers, and other necessary equipment have fallen dramatically over the past few years. Camera features that would have cost you $900 two years ago can now be had for under $200. (Don't you wish *everything* would keep coming down in price the way computer technology does?)

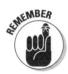

The following sections outline the various costs of going digital. As you read this information, keep in mind that digital photography offers some money-saving benefits to offset the expenses. As I mentioned earlier in this chapter, you can experiment without worrying about the cost of film and processing. If you don't like a picture, you simply delete it. No harm, no foul. If you're a prolific photographer, this capability alone can add up to significant savings over time. So even though the initial outlay for a digital camera may be more than you'd pay for a film camera, digital will likely be cheaper over the long run.

Cameras

Today's digital cameras range from inexpensive point-and-shoot models for casual users to $2,000 *pro-sumer* models that offer the high-end photography controls demanded by advanced amateurs and professional photographers.

You can get a bare-bones camera for less than $50. But models in this price range produce very low-resolution images, suitable for Web pictures and other on-screen uses only. They usually also lack some important convenience features, such as removable image storage and a monitor for reviewing pictures.

Expect to spend $150 and up for a camera that can generate quality prints and includes a flash, a good lens, LCD monitor, removable storage, and other features that you'll want if you plan to use your camera on a regular basis. As you move up the price spectrum, you get higher resolution, which means that you can print larger pictures; you also typically get a zoom lens and other advanced features such as manual shutter speed and aperture control. Chapter 3 helps you figure out just how much camera you need.

Memory cards

Most digital cameras record pictures on removable memory cards, which work just like the floppy disks that you may use with your computer. When you fill up the card with pictures, you have to delete some pictures or transfer them to your computer before you can continue shooting.

Memory cards used to be terribly expensive. In the first years of digital photography, you could spend as much as $6 for a memory card capable of storing just a few pictures. Thankfully, memory card prices have plummeted recently, and you now can buy a 64MB memory card for about $30.

How many pictures you can fit into that 64MB depends on camera resolution and image compression, two subjects that you can explore in the next two chapters. If you're shooting with a 2-megapixel camera and set the camera to its highest resolution and moderate compression — which enables you to produce quality 8 x 10-inch prints — you can fit approximately 100 pictures on a 64MB memory card. When shooting at a lower resolution or higher compression setting, you can pack even more pictures in each megabyte of memory.

Don't get too bogged down in all the numbers — the important point is, you can strike the cost of memory cards from your list of concerns. You won't spend any more than you would on film and processing to produce an equivalent number of traditional prints. And you can reuse memory cards as many times as you want, making them an even bigger bargain when compared to film.

Image-processing and printing equipment

In addition to the camera itself, digital photography involves some peripheral hardware and software, not the least of which is a fairly powerful computer for viewing, storing, editing, and printing your images. You need a machine with a robust processor, at least 64MB of RAM, and a big hard drive with lots of empty storage space. The least you can expect to spend on such a system is about $600.

Getting your images from computer to paper requires an additional invest-ment. Photo printers range in price from about $100 to $700, but you don't need to buy at the high end of that spectrum to get good print quality. Most manufacturers use the same print engine in their low-priced photo printers as they do in their top-of-the-line products, so you can get really great results at a reasonable price. However, the less costly models usually can print only snapshot-size photos and tend to be slower than more expensive models. Higher-priced models offer faster output and additional features such as networking capabilities, the option to print directly from a camera memory card, and the ability to output very large prints.

In addition, you need to factor in the cost of image-editing software, image storage and transfer devices, special paper for printing your photos, camera batteries, and other peripherals. If you're a real photography buff, you may also want to buy special lenses, lights, a tripod, and some other accessories.

Nope, a digital darkroom isn't cheap. Then again, neither is traditional film photography, if you're a serious photographer. And when you consider all the benefits of digital imagery, especially if you do business nationally or internationally, justifying the expense isn't all that difficult. But just in case you're getting queasy, look in Chapters 3, 4, and 8 for more details on the various components involved in digital photography — plus some tips on how to cut budgetary corners.

Chapter 2

Mr. Science Explains It All

In This Chapter

▶ Understanding how digital cameras record images

▶ Visualizing how your eyes — and digital cameras — see color

▶ Perusing a perfectly painless primer on pixels

▶ Exploring the murky waters of resolution

▶ Analyzing the undying relationship between resolution and image size

▶ Looking at f-stops, shutter speeds, and other aspects of image exposure

▶ Exposing color models

▶ Diving into bit depth

*I*f discussions of a technical nature make you nauseated, keep a stomach-soothing potion handy while you read this chapter. The following pages are full of the kind of technical babble that makes science teachers drool but leaves us ordinary mortals feeling motion sick.

Unfortunately, you can't be a successful digital photographer without getting acquainted with the science behind the art. But never fear: This chapter provides you with the ideal lab partner as you explore such important concepts as pixels, resolution, f-stops, bit depth, and more. Sorry, you don't dissect pond creatures or analyze the cell structure of your fingernails in this science class, but you do get to peel back the skin of a digital camera and examine the guts of a digital image. Neither exercise is for the faint of heart, but both are critical for understanding how to turn out quality images.

From Your Eyes to the Camera's Memory

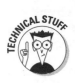

A traditional camera creates an image by allowing light to pass through a lens onto film. The film is coated with light-sensitive chemicals, and wherever light hits the coating, a chemical reaction takes place, recording a latent image. During the film development stage, more chemicals transform the latent image into a printed photograph.

Digital cameras also use light to create images, but instead of film, digital cameras capture pictures using an *imaging array,* which is a fancy way of saying "light-sensitive computer chips." Currently, these chips come in two flavors: CCD, which stands for *charge-coupled device,* and CMOS, which is short for *complementary metal-oxide semiconductor.* (No, Billy, that information won't be on the test.)

Although CCD and CMOS chips differ in some important ways, which you can read about in Chapter 3, both chips do essentially the same thing. When struck by light, they emit an electrical charge, which is analyzed and translated into digital image data by a processor inside the camera. The more light, the stronger the charge.

After the electrical impulses are converted to image data, the data is saved to the camera's memory, which may come in the form of an in-camera chip or a removable memory card or disk. To access the images that your camera records, you just transfer them from the camera memory to your computer. With some cameras, you can transfer pictures directly to a television monitor or printer, enabling you to view and print your photographs without ever turning on your computer.

Keep in mind that what you've just read is only a basic explanation of how digital cameras record images. I could write an entire chapter on CCD designs, for example, but you would only wind up with a big headache. Besides, the only time you need to think about this stuff is when deciding which camera to buy. To that end, Chapters 3, 4, and 7 explain the important aspects of imaging chips, memory, and image transfer so that you can make a sensible purchase decision.

The Secret to Living Color

Like film cameras, digital cameras create images by reading the light in a scene. But how does the camera translate that brightness information into the colors you see in the final photograph? As it turns out, a digital camera does the job pretty much the same way as the human eye.

To understand how digital cameras — and your eyes — perceive color, you first need to know that light can be broken down into three main colors: red, green, and blue. Inside your eyeball, you have three receptors corresponding to those colors. Each receptor measures the brightness of the light for its particular color. The red receptor senses the amount of red light, the green receptor senses the amount of green light, and the blue receptor senses the amount of blue light. Your brain combines the information from the three receptors into one multicolored image in your head.

Because most of us didn't grow up thinking about mixing red, green, and blue light to create color, this concept can be a little hard to grasp. Here's an analogy that may help. Imagine that you're standing in a darkened room and have one flashlight that emits red light, one that emits green light, and one that emits blue light. If you point all the flashlights at one spot, you end up with white light. Remove all the lights, and you get black. And by turning the beam of each light up or down so that you produce a higher- or lower-intensity beam, you can create just about every color of the rainbow.

Just like your eyes, a digital camera analyzes the intensity — sometimes referred to as the *brightness value* — of the red, green, and blue light. Then it records the brightness values for each color in separate portions of the image file. Digital-imaging professionals refer to these vats of brightness information as *color channels.* After recording the brightness values, the camera mixes them together to create the full-color image.

Pictures created using these three main colors of light are known as *RGB images* — for red, green, and blue. Computer monitors, television sets, and scanners also create images by combining red, green, and blue light.

In sophisticated photo-editing programs such as Adobe Photoshop, you can view and edit the individual color channels in a digital image. Figure 2-1 and Color Plate 2-1 show a color image broken down into its red, green, and blue color channels. Notice that each channel contains nothing more than a grayscale image, even when printed in full color, as in the color plate. That's because the camera records only light — or the absence of it — for each channel.

In any of the channel images, light areas indicate heavy amounts of that channel's color. For example, in Color Plate 2-1, the red areas of the boy's shirt appear as nearly white in the red channel image, but nearly black in the green and blue channel images. That tells you that the shirt color is close to a pure red. Likewise, the eyes in the red channel image are very dark because the eyes contain little red.

At the risk of confusing the issue, I should point out that not all digital images contain three channels. If you convert an RGB image to a grayscale image inside a photo-editing program, for example, the brightness values for all three color channels are merged into one channel. And if you convert the image to the *CMYK color model* in preparation for professional printing, you end up with four color channels, one corresponding to each of the four primary colors of ink (cyan, magenta, yellow, and black). For more on this topic, see "RGB, CMYK, and Other Colorful Acronyms," later in this chapter.

Don't let this color channel stuff intimidate you — until you become a seasoned photo editor, you probably will never need to think about channels. I bring them up only so that when you see the term *RGB*, you have some idea about what it means.

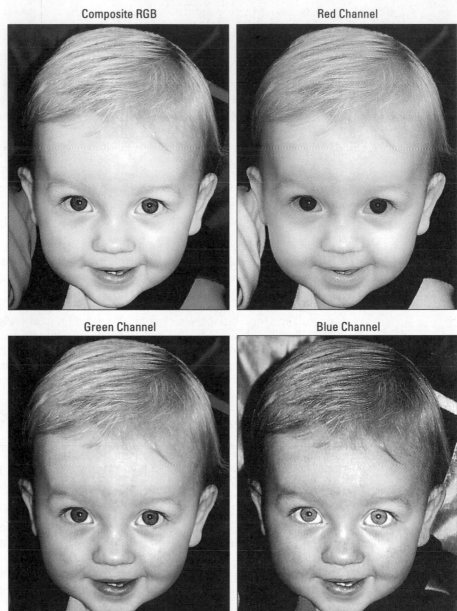

Composite RGB Red Channel

Green Channel Blue Channel

Figure 2-1:
An RGB image (top left) has three color channels, one each for storing the red, green, and blue light values that make up the picture. Color Plate 2-1 shows the composite image in full color.

Resolution Rules!

Without a doubt, the number one thing you can do to improve your digital photos is to understand the concept of *resolution*. Unless you make the right choices about resolution, your pictures will be a disappointment, no matter how captivating the subject.

In other words, don't skip this section!

Pixels: The building blocks of every digital photo

Have you ever seen the painting "A Sunday Afternoon on the Island of La Grande Jatte," by the French artist Georges Seurat? Seurat was a master of a technique known as *pointillism,* in which scenes are composed of millions of tiny dots of paint, created by dabbing the canvas with the tip of a paint-brush. When you stand across the room from a pointillist painting, the dots blend together, forming a seamless image. Only when you get up close to the canvas can you distinguish the individual dots.

Digital images work something like pointillist paintings. Rather than being made up of dots of paint, however, digital images are composed of tiny squares of color known as *pixels.* The term *pixel* is short for *picture element.* Don't you wish you could get a job thinking up these clever computer words?

If you magnify an image on-screen, you can make out the individual pixels, as shown in Figure 2-2. Zoom out on the image, and the pixels seem to blend together, just as when you step back from a pointillist painting.

Every digital photograph is born with a set number of pixels, which you control by using the capture settings on your digital camera. Low-end digital cameras typically create images that are 640 pixels wide and 480 pixels tall. More expensive models can produce images with many more pixels and also enable you to record images at a variety of capture settings, each of which results in a different pixel count. (See Chapter 6 for details on this step in the picture-taking process.)

Some people use the term *pixel dimensions* to refer to the number of pixels in an image — number of pixels wide by number of pixels high. Others use the term *image size,* which can lead to confusion because that term is also used to refer to the physical dimensions of the picture when printed (inches wide by inches tall, for example). For the record, I use *pixel dimensions* to refer specifically to the pixel count and *image size* or *print size* to mean the print dimensions.

Figure 2-2:
Zooming in
on a digital
photo
enables you
to see the
individual
pixels.

Image resolution and print quality

Before you print an image, you use a control in your photo editor to specify an *output resolution,* which determines the number of pixels per inch (ppi). This value, which many people refer to as simply *resolution,* has a major effect on the quality of your printed digital photos. (See Chapter 8 to find out how to adjust the output resolution.)

The more pixels per inch, the crisper the picture, as illustrated by Figures 2-3, 2-4, and 2-5. The first image has an output resolution of 300 ppi; the second, 150 ppi; and the third, 75 ppi. For living-color examples of these three images, see Color Plate 2-2.

Note that output resolution is measured in terms of pixels per *linear* inch, not square inch. So a resolution of 75 ppi means that you have 75 pixels horizontally and 75 pixels vertically, or 5625 pixels for each square inch of image.

Why does the 75-ppi image in Figure 2-5 look so much worse than its higher-resolution counterparts? Because at 75 ppi, the pixels are bigger. After all, if you divide an inch into 75 squares, the squares are significantly larger than if

you divide the inch into 150 squares or 300 squares. And the bigger the pixel, the easier it is for your eye to figure out that it's really just looking at a bunch of squares. Areas that contain diagonal and curved lines, such as the edges of the coins and the handwritten lettering in the example image, take on a stair-stepped appearance.

If you look closely at the black borders that surround Figures 2-3 through 2-5, you can get a clearer idea of how resolution affects pixel size. Each image sports a 2-pixel border. But the border in Figure 2-5 is twice as thick as the one in Figure 2-4 because a pixel at 75 ppi is twice as large as a pixel at 150 ppi. Similarly, the border around the 150-ppi image in Figure 2-4 is twice as wide as the border around the 300-ppi image in Figure 2-3.

Figure 2-3: A digital photo with an output resolution of 300 ppi looks crisp and terrific.

Figure 2-4: When the output resolution of the image in Figure 2-3 is reduced to 150 ppi, the picture loses some sharpness and detail.

Figure 2-5:
Reducing the output resolution to 75 ppi results in significant image degradation.

Image resolution and on-screen picture quality

Although output resolution — pixels per inch — has a dramatic effect on the quality of printed photos, it's a moot point for pictures displayed on-screen. A computer monitor (or other screen device) cares only about the pixel dimensions, not pixels per inch, despite what you may have been told by some folks. The number of pixels does control the *size* at which the picture appears on the monitor, however.

Like digital cameras, computer monitors create everything you see on-screen out of pixels. You typically can choose from several monitor settings, each of which results in a different number of screen pixels. Standard settings include 640 x 480 pixels, 800 x 600 pixels, and 1024 x 768 pixels.

When you display a digital photo on your computer monitor, the monitor completely ignores output resolution (ppi) and simply devotes one screen pixel to every image pixel. So if you set your digital camera to record a 640 x 480-pixel image, that picture consumes the whole screen on a monitor that's set to the 640 x 480 display setting.

This fact is great news for digital photographers with low budgets, because even the most inexpensive digital camera captures enough pixels to cover a large expanse of on-screen real estate. (Read "More mind-boggling resolution stuff," later in this chapter, for more information about screen display; also, refer to Chapter 9 for specifics on how to size your images for the screen.)

How many pixels are enough?

Because printers and screen devices think about pixels differently, your pixel needs vary depending on how you plan to use your picture.

- ✔ If you want to use your picture on a Web page or for some other on-screen use, you need very few pixels. As explained in the preceding section, you just need to match the pixel dimensions of the picture to the amount of the screen you want the image to fill. In most cases, 640 x 480 pixels is more than enough, and for many projects, half that many pixels or even fewer will do.

- ✔ If you plan to print your photo and want the best picture quality, you need enough pixels to enable you to set the output resolution in the neighborhood of 200 to 300 ppi. This number varies depending on the printer; sometimes you can get by with fewer pixels. Check your printer manual for precise resolution guidelines, and see Chapter 8 for additional printing information.

To determine the maximum size at which you can print a picture at a particular resolution, just divide the total number of horizontal image pixels by the desired resolution. Or divide the total number of vertical pixels by the desired resolution. Say that your camera captures 1280 pixels horizontally and 960 pixels vertically. If your target resolution is 300 ppi, divide 1280 by 300 to get the maximum image width — in this case, about 4.25 inches. Or to find out the maximum height, divide 960 by 300, which equals about 3.25 inches. So you can print a 4.25 x 3.25-inch image at 300 ppi.

Because I've hammered home the point that more pixels means better print quality, you may think that if 300 ppi delivers good print quality, higher resolutions produce even better quality. But this isn't the case. In fact, exceeding that 300-ppi ceiling can degrade image quality. Printers are engineered to work with images set to a particular resolution, and when presented with an image file at a higher resolution, most printers simply eliminate the extra pixels. Printers don't always do a great job of slimming down the pixel population, and the result can be muddy or jagged photos. You get better results if you do the job yourself in your photo software.

If you're not sure how you're going to be using your digital photos, set your camera to the setting that's appropriate for print pictures. If you later want to use a picture on a Web page or for some other on-screen use, you can delete extra pixels as necessary. But you can't rely on being able to add pixels after the fact with any degree of success. For more about this subject, see the upcoming section "So how do I control pixels and output resolution?"

More pixels means bigger files

Each pixel in a digital photo adds to the size of the image file. For a point of comparison, the top image in Color Plate 2-2 measures 1110 pixels wide and 725 pixels tall, for a total pixel count of 804,750. This file consumes roughly 2.3MB (megabytes) of storage space. Some of that file space is dedicated to color data, however. The grayscale version of the picture contains the same number of pixels as its full-color cousin but has a file size of about 790KB (kilobytes).

By contrast, the 75-ppi image measures 278 pixels wide by 181 pixels tall, for a total of 50,318 pixels. The full-color version of this image has a file size of just 153K; the grayscale version, 55K.

In addition to eating up storage space, large image files make big demands on your computer's memory (RAM) when you edit them. Typically, the RAM requirement is roughly three times the file size. And when placed on a Web page, huge image files are a major annoyance. Every kilobyte increases the time required to download the file.

To avoid straining your computer — and the patience of Web site visitors — keep your images lean and mean. You want the appropriate number of pixels to suit your final output device (screen or printer), but no more. You can find details on preparing images for print in Chapter 8 and read about designing pictures for screen use in Chapter 9.

So how do I control pixels and output resolution?

As I mentioned earlier in this chapter, every digital photo starts out with a set number of pixels, which is determined by the capture setting you use when you shoot the picture. When you open a picture in your photo editor, the software assigns a default output resolution, which is typically either 72 ppi or 300 ppi. To prepare your picture for printing or on-screen use, you may need to adjust the output resolution or the pixel dimensions. The next two sections introduce you to different approaches to this task.

Adding and deleting pixels (resampling)

One way to increase or decrease output resolution — in other words, to change the number of pixels per inch — is to have your image-editing software add or delete pixels, a process known as *resampling*. Image-editing gurus refer to the process of adding pixels as *upsampling,* and deleting pixels as *downsampling.* When you add or delete pixels, of course, you are changing the pixel dimensions of the image.

Upsampling sounds like a good idea — if you don't have enough pixels, you just go to the Pixel Mart and fill your basket, right? The problem is that when you add pixels, the image-editing software simply makes its best guess as to what color and brightness to make the new pixels. And even high-end image-editing programs don't do a very good job of pulling pixels out of thin air, as illustrated by Figure 2-6.

Figure 2-6: Here you see the result of upsampling the 75-ppi image in Figure 2-5 to 300 ppi.

To create this figure, I started with the 75-ppi image shown in Figure 2-5 and resampled the image to 300 ppi in Adobe Photoshop, one of the best photo-editing programs available. Compare this new image with the 300-ppi version in Figure 2-3, and you can see just how poorly the computer does at adding pixels.

With some images, you can get away with minimal upsampling — say, 10 to 15 percent — but with other images, you notice a quality loss with even slight pixel infusions. Images with large, flat areas of color tend to survive upsampling better than pictures with lots of intricate details.

If your image contains too many pixels, which is often the case for pictures that you want to use on the Web, you can safely delete pixels (downsample). But keep in mind that every pixel you throw away contains image information, so too much pixel-dumping can degrade image quality. Try not to downsample by more than 25 percent, and always make a backup copy of your image in case you ever want those original pixels back.

For step-by-step instructions on how to alter your pixel count, see the section related to sizing images for on-screen display in Chapter 9.

Resizing: The better way to adjust output resolution

A much better way to change the output resolution is to resize the image *while maintaining the original pixel count.* If you reduce the print size of the image, the pixels shrink and move closer together in order to fit into their new boundaries. If you enlarge the print size, the pixels puff themselves up and spread out to fill in the expanded image area.

Say that you have a 4 x 3-inch image set to an output resolution of 150 ppi. If you double the image size to 8 x 6 inches, the resolution is cut in half to 75 ppi. Naturally, the lower output resolution reduces your print quality, for reasons explained earlier in this chapter (see "Image resolution and print quality"). Conversely, if you reduce the image size by half, to 2 x 1.5 inches, the output resolution is doubled, to 300 ppi, and your print quality should improve.

For specific steps involved in adjusting output resolution in this manner, see the Chapter 8 section on sizing photos for print.

Not all image-editing programs enable you to maintain your original pixel count when resizing images. Programs that don't provide this option typically automatically resample your image whenever you resize your photo, so be careful. Check your program's help system or manual to get details on your resizing and resolution controls. If you don't find any specific information, you can test the program by making a copy of a picture and then enlarging the copy. If the file size of the enlarged picture is bigger than the file size of the original, the program added pixels to your image.

More mind-boggling resolution stuff

As if sorting out all the pixel, resampling, and resolution stuff discussed in the preceding sections isn't challenging enough, you also need to be aware that *resolution* doesn't always refer to output resolution as just described. The term is also used to describe the capabilities of digital cameras, monitors, scanners, and printers. So when you hear the word *resolution,* keep the following distinctions in mind:

- ✔ **Camera resolution:** Digital camera manufacturers often use the term *resolution* to describe the number of pixels in the pictures produced by their cameras. A camera's stated resolution might be 640 x 480 pixels or 1.3 million pixels, for example. But those values refer to the pixel dimensions or total pixels a camera can produce, not the number of pixels per inch in the final image. *You* determine that value in your photo-editing software. Of course, you can use the camera's pixel count to figure out the final resolution you can achieve from your images, as described earlier in "How many pixels are enough?"

Some vendors use the term *VGA resolution* to indicate a 640 x 480-pixel image, *XGA resolution* to indicate a 1024 x 768-pixel image, and *megapixel resolution* to indicate a total pixel count of 1 million or more.

✔ **Monitor resolution:** Manufacturers of computer monitors also use the word *resolution* to describe the number of pixels a monitor can display. As I mentioned a few sections ago, most monitors enable you to choose from display settings of 640 x 480 pixels (again, often referred to as VGA resolution), 800 x 600 pixels, or 1024 x 768 pixels (XGA). Some monitors can display even more pixels.

See Chapter 9 to get more details about how screen resolution relates to image resolution.

✔ **Scanner resolution:** Scanner resolution is usually stated in the same terms as image resolution, thankfully. A low-end scanner typically captures a maximum of 600 pixels per inch.

By the way, if you're scanner shopping, pay attention to *optical resolution,* which is a scanner's "real" resolution. Many scanner models make a big deal about offering a high *interpolated* or *enhanced* resolution, but that higher resolution is the result of upsampling from the model's optical (true) resolution. If the importance of that fact is lost on you, read the earlier section, "Adding and deleting pixels (resampling)," earlier in this chapter. Or just remember this: The optical resolution is the important measure of a scanner's capabilities.

✔ **Printer resolution:** Printer resolution is measured in *dots per inch,* or *dpi,* rather than pixels per inch. But the concept is similar: Printed images are made up of tiny dots of color, and dpi is a measurement of how many dots per inch the printer can produce. In general, the higher the dpi, the smaller the dots, and the better the printed image. But as discussed in Chapter 8, gauging a printer solely by dpi can be misleading. Different printers use different printing technologies, some of which result in better images than others. Some 300-dpi printers deliver better results than some 600-dpi printers.

Some people (including some printer manufacturers and software designers) mistakenly interchange dpi and ppi, which leads many users to think that they should set their image resolution to match their printer resolution. *But a printer dot is not the same thing as an image pixel.* Most printers use multiple printer dots to reproduce one image pixel. Every printer is geared to handle a specific image resolution, so you need to check your computer manual for the right image resolution for your model. See Chapter 8 for more information on printing and different types of printers.

What all this resolution stuff means to you

Head starting to hurt? Mine, too. So to help you sort out all the information you accumulated by reading the preceding sections, here's a brief summary of resolution matters that matter most:

- **Number of pixels across (or down) ÷ printed image width (or height) = output resolution (ppi).** For example, 600 pixels divided by 2 inches equals 300 ppi.

- **For good-quality prints, you typically need an output resolution of 200 to 300 ppi.** Chapter 8 provides in-depth information on this topic.

- **For on-screen display, think in terms of pixel dimensions, not output resolution.** See Chapter 9 for specifics.

- **Enlarging a print can reduce image quality.** When you enlarge an image, one of two things has to happen. Either the existing pixels expand to fit the new image boundaries, or the pixels stay the same size and the image-editing software adds pixels to fill in the gaps. Either way, your image quality can suffer.

- **To safely raise the output resolution of an existing image, reduce the print size.** Again, adding pixels to raise the output resolution rarely delivers good results. Instead, retain the existing number of pixels and reduce the print dimensions of the picture. Chapter 8 provides the complete scoop on resizing images in this manner.

- **Set your camera to capture a pixel count at or above what you need for your final picture output.** Most cameras enable you to capture images at several different pixel dimensions. Remember, you can safely toss away pixels if you want a lower image resolution later, but you can't add pixels without risking damage to your image. Also, you may need a low-resolution image today — for example, if you want to display a picture on the Web — but you may decide later that you want to print the image at a larger size, in which case you're going to need those extra pixels. For more on this issue, see Chapter 6.

- **More pixels means a bigger image file.** And even if you have tons of file-storage space to hold all those huge images, bigger isn't always better. Large images require a ton of RAM to edit and increase the time your photo software needs to process your edits. On a Web page, large image files mean long download times. Finally, sending more pixels to the printer than are needed often produces worse, not better, prints. If your image has a higher resolution than required by the output device (printer or monitor), see Chapter 9 for information on how to dump the excess pixels.

Lights, Camera, Exposure!

Whether you're working with a digital camera or a traditional film camera, the brightness or darkness of the image is dependent on *exposure* — the amount of light that hits the film or image-sensor array. The more light, the brighter the image. Too much light results in a washed-out, or *overexposed,* image; too little light, and the image is dark, or *underexposed.*

Most low-to-medium priced digital cameras, like point-and-shoot film cameras, don't give you much control over exposure; everything is handled automatically for you. But some cameras offer a choice of automatic exposure settings, and higher-end cameras provide manual exposure control.

Regardless of whether you're shooting with an automatic model or one that offers manual controls, you should be aware of the different factors that affect exposure — including shutter speed, aperture, and ISO rating — so that you can understand the limitations and possibilities of your camera.

Aperture, f-stops, and shutter speeds: The traditional way

Before taking a look at how digital cameras control exposure, it helps to understand how a film camera does the job. Even though digital cameras don't function in quite the same way as a film camera, manufacturers describe their exposure control mechanisms using traditional film terms, hoping to make the transition from film to digital easier for experienced photographers.

Figure 2-7 shows a simplified illustration of a film camera. Although the specific component design varies depending on the type of camera, all film cameras include some sort of shutter, which is placed between the film and the lens. When the camera isn't in use, the shutter is closed, preventing light from reaching the film. When you take a picture, the shutter opens, and light hits the film. (Now you know why the little button you press to take a picture is called the *shutter button* and why people who take lots of pictures are called *shutterbugs.*)

You can control the amount of light that reaches the film in two ways: by adjusting the amount of time the shutter stays open (referred to as the *shutter speed*) and by changing the *aperture.* The aperture, labeled in Figure 2-7, is a hole in an adjustable diaphragm set between the lens and the shutter. Light coming through the lens is funneled through this hole to the shutter and then onto the film. So if you want more light to strike the film, you make the aperture bigger; if you want less light, you make the aperture smaller.

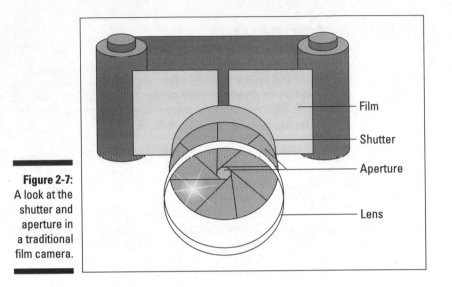

Film

Shutter

Aperture

Lens

Figure 2-7:
A look at the
shutter and
aperture in
a traditional
film camera.

The size of the aperture opening is measured in f-numbers, more commonly referred to as *f-stops*. Standard aperture settings are f/1.4, f/2, f/2.8, f/4, f/5.6, f/8, f/11, f/16, and f/22.

Contrary to what you may expect, the larger the f-stop number, the smaller the aperture and the less light that enters the camera. Each f-stop setting lets in half as much light as the next smaller f-stop number. For example, the camera gets twice as much light at f/11 as it does at f/16. (And here you were complaining that computers were confusing!) See Figure 2-8 for an illustration that may help you get a grip on f-stops.

Shutter speeds are measured in more obvious terms: fractions of a second. A shutter speed of 1/8, for example, means that the shutter opens for one-eighth of a second. That may not sound like much time, but in camera years, it's in fact a very long period. Try to capture a moving object at that speed and you wind up with a big blur. You need a shutter speed of about 1/500 to capture action clearly.

On cameras that offer aperture and shutter speed control, you manipulate the two settings in tandem to capture just the right amount of light. For example, if you are capturing fast action on a bright, sunny day, you can combine a fast shutter speed with a small aperture (high f-stop number). To shoot the same picture at twilight, you need a wide-open aperture (small f-stop number) in order to use the same fast shutter speed.

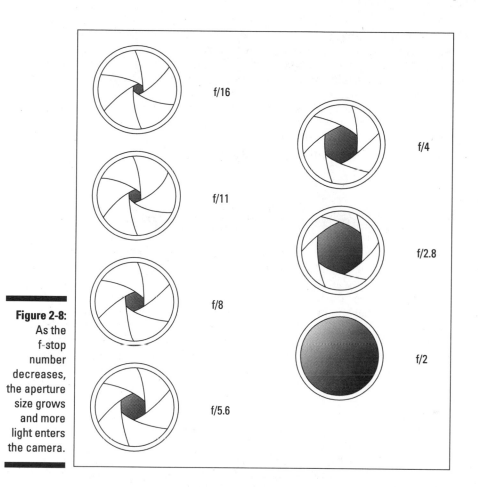

Figure 2-8:
As the f-stop number decreases, the aperture size grows and more light enters the camera.

f/16

f/11

f/8

f/5.6

f/4

f/2.8

f/2

Aperture, shutter speed, and f-stops: The digital way

As with a film camera, the exposure of a picture shot with a digital camera depends on the amount of light that the camera captures. But some digital cameras don't use a traditional shutter/aperture arrangement to control exposure. Instead, the chips in the image-sensor array simply turn on and off for different periods of time, thereby capturing more or less light. In some cameras, exposure is also varied — either automatically or by some control the user sets — by boosting or reducing the strength of the electrical charge that a chip emits in response to a certain amount of light.

Even on cameras that use this alternative approach to exposure control, the camera's capabilities are usually stated in traditional film-camera terms. For example, you may have a choice of two exposure settings, which may be labeled with icons that look like the aperture openings shown in Figure 2-8. The settings are engineered to deliver the *equivalent* exposure that you would get with a film camera using the same f-stop.

Aperture and shutter speeds aren't the only factors involved in image exposure, however. The sensitivity of the image-sensor array also plays a role, as explained next.

ISO ratings and chip sensitivity

Pick up a box of film, and you should see an *ISO number*. This number tells you how sensitive the film is to light and is also referred to as the *film speed*.

Film geared to the consumer market typically offers ratings of ISO 100, 200, or 400. The higher the number, the more sensitive the film, or, if you prefer photography lingo, the *faster* the film. And the faster the film, the less light you need to capture a decent image. The advantage of using a faster film is that you can use a faster shutter speed and shoot in dimmer lighting than you can with a low-speed film. On the downside, photos shot with fast film sometimes exhibit noticeable *grain* — that is, they have a slightly speckled appearance.

Most digital camera manufacturers also provide an ISO rating for their cameras. This number tells you the *equivalent* sensitivity of the chips on the image-sensor array. In other words, the value reflects the speed of film you'd be using if you were using a traditional camera rather than a digital camera. Typically, consumer-model digital cameras have an equivalency of about ISO 100.

I bring all this up because it explains why digital cameras need so much light to produce a decent image. If you were really shooting with ISO 100 film, you would need a wide-open aperture or a slow shutter speed to capture an image in low lighting — assuming that you weren't aiming for the ghostly-shapes-in-a-dimly-lit-cave effect on purpose. The same is true of digital cameras.

Some digital cameras enable you to choose from a few different ISO settings. Unfortunately, raising the ISO setting simply boosts the electronic signal that's produced when you snap a picture. Although this does permit a faster shutter speed, the extra signal power results in electronic "noise" that leads

to grainy pictures, just as you get with fast film. With digital cameras, though, you'll notice even more grain than with the equivalent film ISO. Most camera manuals suggest using the lowest ISO setting for best quality — as do I.

Chapter 5 discusses this and other exposure issues in more detail.

RGB, CMYK, and Other Colorful Acronyms

If you read "The Secret to Living Color" earlier in this chapter, you already know that cameras, scanners, monitors, and television sets are called RGB devices because they create images by mixing red, green, and blue light. When you edit digital photographs, you also mix red, green, and blue light to create the colors that you apply with your software's painting tools.

But RGB is just one of many color-related acronyms and terms you may encounter on your digital photography adventures. So that you aren't confused when you encounter these buzzwords, the following list offers a brief explanation:

- **RGB:** Just to refresh your memory, RGB stands for red, green, and blue. RGB is the *color model* — that is, method for defining colors — used by digital images, as well as any device that transmits or filters light.

 Image-editing gurus also use the term *color space* when discussing a color model, something they do with surprising frequency.

- **sRGB:** A variation of the RGB color model, sRGB offers a smaller *gamut,* or range of colors, than RGB. One reason this color model was designed was to improve color matching between on-screen and printed images. Because RGB devices can produce more colors than printer inks can reproduce, limiting the range of available RGB colors helps increase the possibility that what you see on-screen is what you get on paper. The sRGB color model also aims to define standards for on-screen colors so that images on a Web page look the same on one viewer's monitor as they do on another.

 The sRGB color model is a topic of much debate right now. Many image-editing purists hate sRGB; others see it as a necessary solution to the color-matching problem. For practical purposes, though, most users don't need to worry about the distinction between RGB and sRGB. If you're a high-end user working in Photoshop or some other professional image editor, you can specify whether you want to edit your images in RGB or sRGB, but otherwise, the image-editing software makes the decision for you, behind the scenes.

✔ **CMYK:** While light-based devices mix red, green, and blue light to create images, printers mix primary colors of ink to emblazon a page with color. Instead of red, green, and blue, however, commercial printers use cyan, magenta, yellow, and black ink. Images created in this way are called CMYK images (the *K* is used to represent black because everyone figured B could be mistaken for blue, and commercial printers refer to the black printing plate as the Key plate). Four-color images printed at a commercial printer need to be converted to the CMYK color mode before printing. (See Chapter 8 for more information on CMYK printing.)

✔ **Bit depth:** You sometimes hear people discussing images in terms of bits, as in *24-bit images.* The number of bits in an image — also called the *bit depth* — indicates how much color information each image pixel can contain. A higher bit depth allows more image colors.

Bit is short for *binary digit,* which is a fancy way of saying a value that can equal either 1 or 0. On a computer, each bit can represent two different colors. The more bits, the more colors you can have:

- An 8-bit image can contain as many as 256 colors (2^8=256)

- A 16-bit image can contain about 32,000 colors

- A 24-bit image can contain about 16.7 million colors

If you want the most vibrant, full-bodied images, naturally, you want the highest bit depth you can get. But the higher the bit depth, the larger the image file.

✔ **Indexed color:** Indexed color refers to images that have had some of their colors stripped away in order to reduce the image bit depth and, therefore, the file size (see the preceding item). Many people reduce images to 8-bit (256 color) images before posting them on a Web page; in fact, a popular file format for Web images, GIF, doesn't permit you to use any more than 256 colors.

Where does the term *indexed* come from? Well, when you ask your image editor to reduce the number of colors in an image, the program consults a color table, called an *index,* to figure out how to change the colors of the image pixels. For more on this topic, see Chapter 9 and also take a look at Color Plate 9-1, which illustrates the difference between a 24-bit image and an 8-bit image.

✔ **Grayscale:** A grayscale image is comprised solely of shades of black and white. All the images on the regular pages of this book — that is, not on the color pages — are grayscale images. Some people (and some image-editing programs) refer to grayscale images as black-and-white images, but a true black-and-white image contains only black and white pixels, with no shades of gray in between. Graphics professionals often refer to black-and-white images as *line art.*

As photographers such as Ansel Adams have illustrated, grayscale images can be every bit as powerful as full-color images. Almost every image-editing program can convert color pictures into grayscale images. Check out Chapter 12 for the how-to's on creating a grayscale image and then adding a sepia tone to create the appearance of a hundred-year-old photograph, as I did in Color Plate 12-4.

Some digital cameras offer an option that converts your image to grayscale or sepia as the image is stored in the computer's memory. In a pinch, these options can come in handy, but you get more control over the look of your image if you do the job yourself in your image-editing program.

✔ **CIE Lab, HSB, and HSL:** These acronyms refer to three other color models for digital images. Until you become an advanced digital-imaging guru, you don't need to worry about them. But just for the record, CIE Lab defines colors using three color channels. One channel stores luminosity (brightness) values, and the other two channels each store a separate range of colors. (The a and b are arbitrary names assigned to these two color channels.) HSB and HSL define colors based on hue (color), saturation (purity or intensity of color), and brightness (in the case of HSB) or lightness (in HSL).

About the only time you're likely to run into these color options is when mixing paint colors in an image-editing program. Even then, the on-screen display in the color-mixing dialog boxes makes it easy to figure out how to create the color you want. Some programs also give you the option of opening images from certain Photo CD collections in the CIE Lab color mode. But you can safely ignore that option for now.

Chapter 3

In Search of the Perfect Camera

In This Chapter

▶ Deciding whether to go with Macintosh or Windows

▶ Figuring out how much resolution you need

▶ Understanding compression and other camera specs

▶ Determining which features you really need

▶ Considering image storage options

▶ Looking at lens options

▶ Evaluating high-end functions

▶ Asking other important questions before you hand over your cash

As soon as manufacturers figured out how to create digital cameras at prices the mass market could swallow, the rush was on to jump on the digital bandwagon. Today, everyone from icons of the photography world, such as Kodak, Olympus, Nikon, and Fujifilm, to powerhouse players in the computer and electronics market, such as Hewlett-Packard, Sony, and Casio, offers some sort of digital photography product.

Having so many fingers in the digicam pie is both good and bad. More competition means better products, a wider array of choices, and lower prices. On the downside, you need to do a lot more research to figure out which camera is right for you. Different manufacturers take different approaches to winning the consumer's heart, and sorting through the options takes some time and energy.

If you hate to make decisions, you may be hoping that I can tell you which camera to pick. Unfortunately, I can't. Buying a camera is a very personal decision, and no one camera suits every need. The camera that fits snugly into one person's hand may feel awkward in another's. You may enjoy a camera that has advanced photographic controls, while the guy next door prefers a simple, entry-level model.

But even though I can't guide you to a specific camera, I can help you determine which features you really need and which ones you can do without. I can

also provide you with a list of questions to ask as you're evaluating different models. As you're about to find out, you need to consider a wide variety of factors before you plunk down your money.

Mac or Windows — Does It Matter?

Here's a relatively easy one. Most — not all, but most — digital cameras work on both Macintosh and Windows-based computers. The only differences lie in the cabling that hooks the camera to your computer and the software that you use to download and edit your pictures. Most cameras come with the appropriate cabling and software for both platforms, although you should verify this before making your final selection. Of course, if the camera stores pictures on removable memory cards, you can always buy a memory card reader and eliminate the need to connect camera and computer altogether. (See the upcoming section "Memory Matters" for more about this option.)

Nor do you need to worry that your Mac friends won't be able to open and view your digital photos if you work on a PC, or vice versa. Several image file formats work on both platforms, and you can buy good image-editing programs for both, too, although the choices for Macintosh software are more limited than on the Windows side. Pay a visit to Chapter 7 if you want more details about file formats, and spend a minute or two with Chapter 4 for tips on choosing software.

A few cameras that operate on the Windows platform require computers with a Pentium II or MMX processor or better. And Windows 95 usually doesn't cooperate with cameras that connect to the computer via a USB (Universal Serial Bus) cable, even if you use the version of Windows 95 that's supposed to enable USB. So before buying a camera, check to see whether your computer matches the camera's system requirements. See Chapter 7 for more information about USB devices.

You Say You Want a Resolution

Chapter 2 explores image resolution in detail, but here's the short story: More pixels mean better-looking prints. Different cameras can capture different numbers of pixels; generally, the more you pay, the more pixels you get.

Today, entry-level cameras are limited to VGA resolution (640 x 480 pixels), while high-end models offer resolution in the 4- to 6-megapixel range.

Megapixel means one million pixels. A 2-megapixel camera offers 2 million pixels, a 3-megapixel camera offers 3 million pixels, and so on.

How many pixels do you need? As I explain in Chapter 2, the answer depends on how you want to use your pictures. The following list will help you figure out your resolution requirements:

- **VGA resolution (640 x 480 pixels):** If all you want to do with your digital photos is share them via e-mail, post them on a Web page, or use them in a multimedia presentation, you can get by with a VGA-resolution camera, which can be had for under $50. But as for print quality, you're going to be disappointed. Again, see Chapter 2 if you're not sure how resolution affects print quality.

- **One megapixel:** With a one-megapixel model, which can be had for as little as $100, you get enough pixels to print good snapshot-size pictures. You also have plenty of pixels for any on-screen picture use.

- **Two megapixels:** As you move up the resolution ladder, you increase the size at which you can output quality prints. With 2 megapixels, you can produce very good 5 x 7-inch prints and acceptable 8 x 10s. Cameras offering this resolution start at about $150.

- **Three megapixels:** Photographers who need to produce quality 8 x 10-inch or larger prints should look at 3-megapixel models, which currently start at $250.

 However, if you like to take action shots, understand that the image capture time on a higher resolution camera can be longer than on a lower-resolution model because the camera needs more time to capture all those added pixels. Test the camera you're considering to be sure that it's fast enough for your needs.

- **Four megapixels and up:** At the very top of the consumer market are a few models that offer resolutions of 4 megapixels or greater. With prices starting at around $400, these models are geared toward the serious digital photography enthusiast. In addition to a bounty of pixels, these cameras typically offer high-end photography features like those found on expensive SLR (single-lens reflex) film cameras.

Keep in mind that more pixels increase not only the camera cost but also the amount of storage space you need to hold your picture files. (Check out Chapter 4 for a better understanding of storage issues.) Unless you're interested in making very large prints, you're better off sticking with a 1- to 3-megapixel camera and putting your savings into a few photography accessories or a good photo printer.

As you compare cameras, also be aware that different models deliver the specified pixel count in different ways. And the route the camera takes to create image pixels can have an impact on your images. For this reason, you can't simply look at the pixel values on the camera box and make a wholesale judgment about image quality.

Say that a camera offers you a choice of two capture settings: 640 x 480 or 1024 x 768 pixels. On some cameras, the camera actually captures the number of pixels you select. But other cameras capture the image at the smaller size and *interpolate* — make up — the rest of the pixels. The camera's brain analyzes the color and brightness information of the existing pixels and adds additional pixels based on that information. But because interpolation is an imperfect science, images captured in this way usually don't look as good as those captured without interpolation. Then again, cameras that work this way are typically cheaper than those that don't.

Now add this information to the mix: Most cameras compress image files in order to store them in the camera's memory. As discussed in the next section, to *compress* an image file means to squish all the data together to make the image file smaller so that it takes up less room in the camera's memory. Being able to store more images in less space is an advantage, obviously. But the kind of compression applied to digital camera files eliminates some image data. So a highly compressed, high-resolution image may come out of the camera looking worse than an uncompressed image at a lower resolution.

The moral of the story is this: Match pixel population to your imaging needs and pay attention to *actual* (not interpolated) pixels. But because image quality is affected by many other factors, such as compression, the quality of the lens, and how sensitive the image sensor is to light, don't rely totally on these numbers. Instead, use your head — more specifically, use your eyes. If possible, shoot test images on several different cameras and judge for yourself which unit offers the best image quality.

The war between CCD and CMOS

Image-sensor chips — the chips that capture the image in digital cameras — fall into two main camps: *CCD,* or charge-coupled device, and *CMOS* (pronounced *see-moss*), which stands for complementary metal-oxide semiconductor.

The main argument in favor of CCD chips is that they're more sensitive than CMOS chips, so you can get better images in dim lighting. CCD chips also tend to deliver cleaner images than CMOS chips, which sometimes have a problem with *noise* — small defects in the image.

On the other hand, CMOS chips are less expensive to manufacture, and that cost savings translates into lower camera prices. In addition,

CMOS chips are less power-hungry than CCD chips, so you can shoot for longer periods of time before replacing the camera's batteries.

CMOS chips also perform better than CCD chips when capturing highlights, such as the sparkle of jewelry or the glint of sunlight reflecting across a lake. CCD chips suffer from *blooming,* which means creating unwanted halos around very bright highlights, while CMOS sensors do not.

Currently, an overwhelming number of cameras use CCD technology. But camera manufacturers are working to refine CMOS technology, and when they do, you can expect to hear more about this type of camera.

The Great Compression Scheme

As I said earlier in this chapter, most digital cameras *compress* image files when saving them in the camera memory. To compress a file means to eliminate some data in order to reduce the size of the picture file. Several forms of compression are available, but most cameras use a type known as JPEG (*jay-peg*) compression.

JPEG is a file format that was designed expressly for storing digital image data. The letters stand for Joint Photographic Experts Group, the imaging-industry committee that developed the format.

When you save a file in the JPEG format, you can select from different quality settings, each of which compresses an image to varying degrees. The more compression you apply, the more pictures you can fit in your camera's memory. Unfortunately, JPEG compression often sacrifices vital image data, which can degrade picture quality. For this reason, JPEG compression is known as *lossy compression*. The more compression you apply, the more damage you do to the picture.

To see the impact of JPEG compression, compare the uncompressed, 300-ppi money photo at the top of Color Plate 2-2 with the compressed versions in Color Plate 3-1. All the images in Color Plate 3-1 also have an output resolution of 300 ppi; the only difference lies in the amount of JPEG compression. Figure 3-1 shows the grayscale versions of the inset areas in Color Plate 3-1.

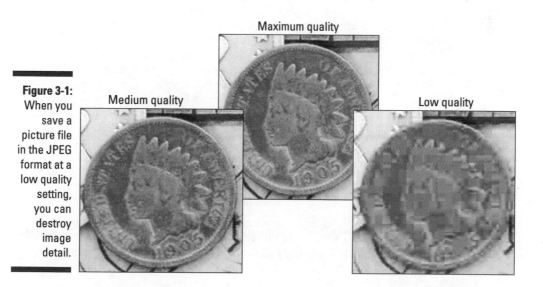

Figure 3-1: When you save a picture file in the JPEG format at a low quality setting, you can destroy image detail.

Maximum quality

Medium quality

Low quality

For the top compression example in the color plate, I saved the file using the maximum quality setting, which applies the smallest possible amount of compression. The file size is reduced from 2.4MB to 900K, and you have to look hard to see any loss of image detail — not a bad tradeoff. I saved the middle compression example using a medium quality setting, which results in a significantly smaller file size. You can start to see some image degradation, but the picture is still in the acceptable category.

In the bottom image in the color plate, I used the lowest quality setting, which applies the maximum compression. The file size shrinks to a mere 47K, but this time there are serious consequences to the photo. Not only are fine details almost totally gone, but random bits of color noise appear throughout the image, a phenomena known as *color artifacting*. Notice the pinkish tinge around the top left edge of the penny in the inset area in the Color Plate? That's color artifacting. The color artifacts aren't noticeable in the grayscale versions of the pennies, but the loss of detail is equally significant.

Does this mean that you should steer away from cameras that compress images? Absolutely not. First of all, a little bit of compression doesn't do unacceptable damage to most images, as illustrated in Color Plate 3-1. Second, for some projects, such as creating a household insurance inventory or sharing a picture over the Web, most people are happy to sacrifice a little image quality in exchange for smaller file sizes.

For the most flexibility, choose a camera that enables you to select from two or three different compression amounts so you can compress a little or a lot, depending on what quality you need for a particular picture. If your photographic projects require the highest possible image quality, look for a camera that offers a low-compression setting. Some cameras enable you to save your files in file formats that apply no compression at all.

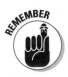

Typically, compression options are given vague names such as "Good," "Better," or "Best." On some cameras, though, these same types of names are given to settings that control the number of image pixels, so be sure that you know what option you're evaluating. Check the camera manual for this information.

Memory Matters

Another specification to examine when you shop for digital cameras is what kind of memory the camera uses to store images. A few cameras have built-in memory (if you want to be hip, call it *on-board memory*). After you fill up the on-board memory, you can't take any more pictures until you transfer the images to your computer.

On-board storage used to be the norm. But the majority of cameras now rely on removable media for image storage. You put a memory card or disk into a slot on the camera, just as you put a floppy disk into your computer. The camera writes the image data to the removable media as you shoot. Figure 3-2 shows me in the process of inserting a memory card into a camera.

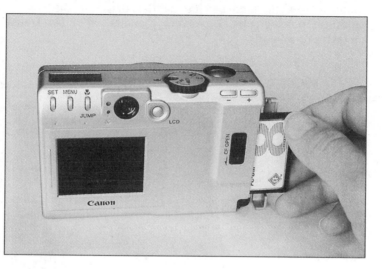

Figure 3-2: Most cameras store images on miniature memory cards such as the Compact Flash card shown here.

For a look at the most common types of removable camera memory, see Figure 3-3. The options in the top row, a mini-CD and standard floppy disk, are used by some Sony digital cameras, as is the Memory Stick shown in the bottom row. Most other manufacturers design their cameras around either SmartMedia or CompactFlash cards, also shown in the bottom row. A few new cameras, especially those that feature tiny camera bodies, store pictures on the diminutive Secure Digital (SD) cards.

Cameras that don't accept removable media are less expensive than those that do. But I think that the benefits of removable media outweigh the cost, for two reasons:

- After you fill up one memory card, you can pop it out of the camera and insert another card. With on-board storage, you have to stop shooting and download pictures before you can take more pictures.

- When you do download images to your computer, the transfer process is slow and inconvenient if your camera offers only on-board storage. You have to cable together the camera and the computer, which often means crawling around the back of the computer looking for the right place to plug in the cable. More important, images take a long time to funnel through the cable.

With removable media, downloading images is painless. If your camera stores images on a floppy disk, you just take the disk out of the camera and slip it into your computer's floppy drive. You then drag and drop the image files to your computer as you would any other files on a floppy disk. Similarly, you can drag-and-drop files from other types of removable media with the help of adapters and readers that enable your computer to "see" the media as just another drive on your computer. In addition to being more convenient, this method of data transfer results in faster downloads.

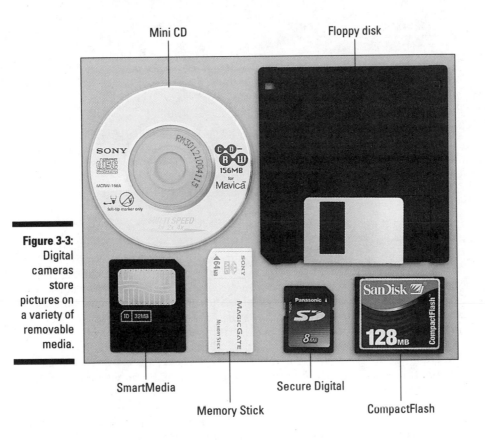

Mini CD

Floppy disk

Figure 3-3:
Digital cameras store pictures on a variety of removable media.

SmartMedia

Memory Stick

Secure Digital

CompactFlash

If you opt for a camera that accepts removable memory, the following additional nuggets of information may be of use:

✔ Each type of memory card offers different storage capacities. Floppy disks, as you may know, hold less than 1.5MB of data, which means that they're not suitable for storing high-resolution, uncompressed images. By contrast, other types of removable camera memory offer capacities of greater than 100MB. Chapter 4 provides details on the storage limits for various removable media, along with cost information.

✔ Although I wouldn't advise you to buy a camera solely on the basis of what type of removable memory it uses, you may find one form of memory more convenient than another for your specific photographic and computing needs. The difference has nothing to do with memory cost or performance, but with the devices that you can use to download images. Some devices may fit your existing computing setup better than others. So before you make the final memory decision, check out the section in Chapter 4 that discusses card readers and adapters to be sure that you understand all your options. In addition, if you have another device that accepts removable media, such as an MP3 player, you may want to find a camera that works with the same media as that device.

One last word of wisdom about memory, whether on-board or removable: When you're comparing cameras, look closely at the manufacturer's "maximum storage capacity" claims — the maximum number of images you can store in the available memory. The figure you see reflects the number of images you can store if you set the camera to capture the fewest number of pixels or apply the highest level or compression, or both. So if Camera A can store more pictures than Camera B, and both cameras offer the same amount of memory, Camera A's images must either contain fewer pixels or be more highly compressed than Camera B's images. (See "The Great Compression Scheme," earlier in this chapter, for more information.)

To LCD or Not To LCD

Most cameras have an LCD *(liquid-crystal display)* screen. The LCD screen is like a miniature computer monitor, capable of displaying images stored in the camera. The LCD is also used to display menus that enable you to change the camera settings and delete images from the camera's memory. Figure 3-4 gives you a look at the LCD screen on a Minolta digital camera.

The ability to review and delete images right on the camera is very helpful because you avoid the time and hassle of downloading unwanted images. If an image doesn't come out the way you wanted, you delete it and try again. And of course, you enjoy the advantage of knowing that you captured the picture before you leave the scene or put away your camera, which is one of the primary benefits of digital over film.

On most cameras, the LCD can also provide a preview of your shot. So if your camera has a traditional viewfinder and an LCD, you can frame your pictures using the LCD or the viewfinder. In fact, most cameras force you to use the LCD when shooting close-up pictures to avoid parallax errors, a phenomenon explained in Chapter 5.

A few cameras with LCDs lack traditional viewfinders — often referred to as *optical viewfinders* — and you must compose all your pictures using the LCD. Manufacturers omit the optical viewfinder either to lower the cost of the

camera or to allow a non-traditional camera design. I find it difficult to shoot pictures using only the LCD because you have to hold the camera a few inches away in order to see what you're shooting. If your hands aren't that steady, taking a picture without moving the camera can be tricky. Additionally, when you're shooting in bright light, the LCD display tends to wash out, making it hard to see what you're shooting.

Figure 3-4: Found on most digital cameras, the LCD monitor enables you to review images and select capture settings and other camera options.

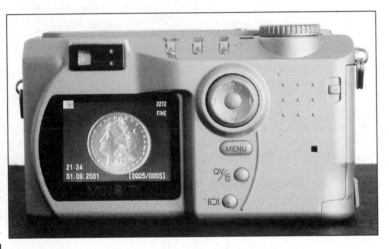

Clearly, many buyers must be happy with having an LCD alone, or the camera makers wouldn't keep making this style of camera. But I personally couldn't do without both monitor and optical viewfinder. Without the monitor, you can't review and delete your pictures on the camera. Without the viewfinder, picture taking is sometimes awkward — and on a bright, sunny day, downright difficult.

A few new cameras offer an electronic viewfinder. A twist on a traditional optical viewfinder, the electronic viewfinder is actually a tiny microdisplay, much like the larger LCD monitor in the back of most cameras. The electronic viewfinder displays the same image that the camera lens sees, so you can shoot without worrying about parallax errors — you get exactly what you see even in close-ups.

Special Breeds for Special Needs

Digital cameras come in all shapes and sizes. Some are styled to look and feel like a 35mm point-and-shoot camera, while others look more like a video camera or a 35mm SLR camera. There's no right or wrong here — all other things being equal, buy the camera that feels the most comfortable to you.

A few cameras, however, are designed to meet specific needs:

- **Webcams:** Sold for as little as $30, so-called "Webcams" are simple video cameras designed for video conferencing and Internet telephony (making phone calls over the Internet). You sit in front of the camera, and the camera sends your image to your adoring online audience.

 Although these cameras can capture still photos, they produce low-resolution images that aren't suitable for anything but casual Web use — posting pictures of items you're selling in an online auction, for example. With most of these cameras, you can take pictures only while the camera is tethered to the computer, which further limits your photographic options.

 A few Webcams, such as the Kodak EZ200, shown in Figure 3-5, can be undocked from the computer and used as a stand-alone camera. This design gives you much more shooting flexibility, but again, don't expect the same picture quality that you get from a dedicated still digital camera. You also typically don't get an LCD monitor for reviewing your pictures or the option of using removable memory. This type of dual-purpose camera runs about $120.

- **Digital video cameras:** Show up with one of these hot new devices and you'll be the envy of all the parents lugging traditional, analog camcorders. However, when it comes to still images, these cameras don't match the quality that you get from a still-image camera, although the two technologies are starting to converge. The latest digital video cameras offer higher still-picture resolution than in the past, and I expect that within a few years, you'll be able to enjoy the best of both worlds in one device. For now, however, stick with a dedicated still digital camera for the best photo quality.

 A good portion of this book applies to still pictures taken with a digital video camera, but for help with the video side of things, you may want to pick up a copy of *Digital Video For Dummies,* 2nd Edition, by Martin Doucette (published by Wiley Publishing, Inc.).

- **Multifunction devices:** The latest fad in digital camera design is to incorporate a camera into a device that serves other media or communication needs. For example, the Olympus camera shown in Figure 3-6 is a 2-megapixel model with a built-in printer that outputs photos on standard Polaroid film. You also can find digital cameras that attach to handheld organizers, can record and play MP3 music files, and connect to the Web using either wireless Web technology or a standard modem connection.

When you're evaluating these hybrid products, consider your primary use for the camera and determine whether the other functions will hinder or enhance that use. The printer in the Olympus model, for example, means a larger than normal camera, which may be problematic if you like traveling light. Then again, if you're using the camera for business, you may be happy to accept the added bulk in exchange for the ability to output instant prints without carting along a standalone printer.

Figure 3-5: The Kodak EZ200 is among a new breed of Webcams that you can detach from the computer for remote picture-taking.

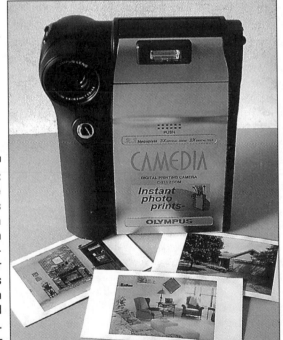

Figure 3-6: The Olympus Camedia C-211 Zoom has a built-in printer that outputs images on Polaroid film.

What? No Flash?

When you take pictures using film, a flash is a must for indoor photography and for shooting outdoors in dim lighting or shadows. You may be surprised to learn that the same isn't always true for digital cameras.

Some cameras take reasonably good indoor pictures without a flash. But not all cameras have the same capability, so before you consider a model that doesn't have a flash, snap some sample pictures in a variety of low-light situations. Also, remember that just as with film cameras, a flash can be very useful even when shooting outdoors, as examined in Chapter 5. You may want a flash to compensate for backlighting, for example, or to light up a subject standing in the shade or shadows.

Here are a few other flash facts to consider when you're shopping:

- For cameras that do offer a flash, find out how many flash settings you get. Usually, cameras with a built-in flash give you at least three settings: *automatic* (the flash fires only when the camera thinks the light is too low); *fill flash* (the flash fires no matter what); and *no flash*. If the camera has an automatic flash, you definitely want the other two modes as well so that you, and not the camera, ultimately control whether the flash fires.

- Many cameras also offer a *red-eye reduction mode,* which is designed to reduce the problem of a flash-induced red glint to subjects' eyes. I'm not too worried about this option because it usually doesn't work that well and you can always cover up red-eye problems in the image-editing stage. See Chapter 11 for details.

- Higher-end cameras usually offer two additional flash modes: a *slow sync mode,* for shooting in very low lighting, and an *external flash mode,* which enables you to attach a separate flash unit to the camera. These options are extremely attractive to professional photographers and advanced hobbyists, but everyday users can get by without them.

- Some cameras also enable you to raise or lower the intensity of the flash slightly, which can be helpful in tricky lighting situations. Give extra points to cameras offering this option.

You can read more about using flash options to improve your pictures and solve lighting problems in Chapter 5.

Through a Lens, Clearly

When shopping for a digital camera, many people get so caught up in the details of resolution, compression, and other digital options that they forget to think about some of the more basic, but just as essential, camera features. The lens is one of those components that is often overlooked — and shouldn't be.

Serving as your camera's "eye," the lens determines what your camera can see — and how well that view is transmitted to the CCD or CMOS chip for recording. The following sections explain some of the lens details that you should consider as you evaluate different cameras.

Fun facts about focal length

Different lenses have different *focal lengths*. On film cameras, focal length is a measurement of the distance between the center of the lens and the film. On a digital camera, focal length measures the distance between the lens and the image sensor (CCD or CMOS array). For both types of cameras, focal length is measured in millimeters.

Don't get bogged down in all the scientific gobbledygook, though. Just focus — yuk, yuk — on the following focal length facts:

✔ Focal length determines the lens's angle of view and the size at which your subject appears in the frame.

 • Lenses with short focal lengths are known as *wide-angle* lenses. A short focal length has the visual effect of "pushing" the subject away from you and making it appear smaller. As a result, you can fit more of the scene into the frame without moving back.

 • Lenses with long focal lengths are called *telephoto* lenses. A long focal length seems to bring the subject closer to you and increases the subject's size in the frame.

✔ On most point-and-shoot cameras, a focal length in the neighborhood of 35mm is considered a "normal" lens — that is, somewhere between a wide-angle and a telephoto. This focal length is appropriate for the kinds of snapshots most people take.

✔ Cameras that offer a zoom lens enable you to vary focal length. As you zoom in, the focal length increases; as you zoom out, it decreases.

✔ A few cameras offer dual lenses, which usually provide a standard, snapshot-oriented focal length plus a telephoto focal length. In addition, some cameras have *macro* modes, which permit close-up photography. Dual-lens cameras are different from zoom lens cameras, which offer the ability to shoot at any focal length along the zoom range. For example, a 38–110mm zoom can be placed at any focal length between its maximum and minimum settings: 38mm, 50mm, 70mm, and so on. A dual lens 38mm/70mm camera has only the two focal-length settings.

✔ To get a visual perspective on focal length, turn to Color Plate 3-2. Here, you see the same scene captured by four different lenses. I shot the top-left picture using a Nikon digital camera that offers a 38–115mm zoom lens; I zoomed all the way out to 38mm for this photo. I took the top-right image with an Olympus model that has a 36–100mm zoom; I zoomed to the shortest focal length to shoot this picture as well. For the bottom-left shot, I picked up a Casio camera with a fixed focal length of 35mm. And for the bottom-right image, I used the Nikon again, but this time with an optional 24mm wide-angle adapter attached.

✔ Note that the focal lengths I mentioned here aren't the true numbers for these cameras. Rather, they indicate the *equivalent* focal length provided by a lens on a 35mm-format film camera. Because of the way digital cameras are designed, the actual focal lengths don't really provide any useful information for the photographer. So manufacturers indicate the capabilities of a lens by providing a "lens equivalency" number. Advertisements and spec sheets for cameras include lens statements such as "5mm lens, equivalent to 35mm lens on a 35mm camera."

This book takes the equivalency approach as well. So if I mention a lens focal length, I'm using the equivalent value.

Now that you understand what those little lens numbers mean on the digital camera boxes, you can choose a camera that offers a lens appropriate for the kind of shooting you plan to do. As mentioned earlier, a standard, 35mm (equivalent) lens is good for taking ordinary snapshots. If you want to do a lot of landscape shooting, you may want to look for a slightly shorter focal length because that will enable you to capture a larger field of view. A wide-angle lens is also helpful for shooting in small rooms; with a standard 35mm, you may not be able to get far enough away from your subject to fit it in the frame. If you want the greatest flexibility with regard to lenses, look for a model that can accept accessory wide-angle and telephoto lenses.

Some wide-angle lenses cause a problem known as *convergence,* a distortion that makes vertical structures appear to lean toward the center of the frame. If you plan to do a lot of wide-angle shooting, be sure to take some test pictures to check for this issue before buying a camera.

Optical versus digital zoom

As explained in the preceding section, zoom lenses give you a closer view of far-away subjects. A zoom lens is especially great for travel photography and is also good for portraits or still-life shots in which you want to shoot a subject without including a large amount of background. (Chapter 6 illustrates this compositional technique.)

If a zoom lens is important to you, be sure that the camera you buy has an *optical zoom.* An optical zoom is a true zoom lens. Some cameras instead offer a *digital zoom,* which is nothing more than some in-camera image processing. When you use a digital zoom, the camera enlarges the image area at the center of the frame and trims away the outside edges of the picture. The result is the same as when you open an image in your photo-editing program, crop away the edges of the picture, and then enlarge the remaining portion of the photo. Enlarging the "zoomed" area reduces the image resolution and the image quality.

For a better understanding of resolution, see Chapter 2; for more information about digital and optical zooms, see Chapter 6.

Focusing aids

Some cameras have *fixed-focus* lenses, which means that the point of focus is unchangeable. Usually, this type of lens is engineered so that images appear in sharp focus from a few feet in front of the camera to infinity.

Many cameras enable you to adjust the focus point for three different distances. Among the settings are *macro mode* for extreme close-ups, *portrait mode* for subjects a dozen feet from the camera, and *landscape mode* for distant subjects.

 Different cameras offer different focus ranges, which is probably most important in the area of close-up photography. Some cameras enable you to get very near your subject, but other cameras are a bit limiting in this regard. If you want to do lots of close-up work, check the minimum subject-to-camera distance of a camera before you buy. Also note that because of the short focal lengths of their lenses, digital cameras typically offer extreme *depth of field,* which means that the zones of sharp focus are far greater than with a film camera.

Cameras with *autofocus* automatically adjust the focus depending on the distance of the subject from the lens. Most cameras with autofocus abilities offer a very useful feature called *focus lock.* You can use this feature to specify exactly which object you want the camera to focus on, regardless of the object's position in the frame. Usually, you center the subject in the viewfinder, press the shutter button halfway down to lock the focus, and then reframe and snap the picture.

A few high-end cameras offer the option to switch from automatic to manual focusing, giving you complete control over the focus range. In many cases, you set the focus point a specific distance from the camera — 12 inches, 3 feet, and so on — via a menu that's displayed on the LCD monitor. But with a few models, such as the Olympus E-20, you adjust focus by twisting a manual focus ring on the lens barrel, just as with a regular SLR lens.

However you implement it, manual focus is a desirable option even for those whose photographic interests aren't advanced enough to demand it. Sometimes autofocusing mechanisms have trouble getting the focus right when you're shooting a complex scene. If you're taking a picture of a tiger in a cage, for example, the autofocus may lock onto the cage instead of the tiger. Setting the focus yourself may be the only way to make sure that the subject is in sharp focus.

For more insights about focus, including how to use autofocus properly, see Chapter 5.

Lens gymnastics

Because of the way that digital cameras work, the lens doesn't have to remain in the standard front-and-center position. Taking advantage of this fact, a few digital cameras offer a rotating lens. Figure 3-7 gives you a look at one such camera from Nikon, which offers several models with this feature.

Figure 3-7: Some cameras in the Nikon Coolpix line offer a rotating lens to provide added shooting flexibility.

Being able to rotate the lens provides you with some useful shooting options. Suppose that you want to photograph an object that's sitting on the floor. You can place the camera on the floor, rotate the lens upward, and get a bug's-eye view that would be impossible or, at the least, awkward with an immovable lens.

Interchangeable lenses and filters

If you're a serious photography buff, you may want to buy a camera that accepts lens adapters and filters. Many cameras now sport lens designs that enable you to screw on wide-angle, fish-eye, or close-up lens adapters.

You also can attach polarizing filters, color-warming filters, star filters, and the like to some lenses. However, depending on your camera model, such filters may be unnecessary because you can create the effects that they produce by using options built into the camera. For example, changing a digital camera's *white balance* setting, explained in Chapter 6, can create results similar to adding a warming or cooling filter to a film camera, as shown in Color Plate 6-1. You also can mimic the look of many traditional filters by applying special effects in a photo editor.

Bear in mind that if you already own filters and adapters for your 35mm film camera, you probably won't be able to use them on your digital camera due to the differences in lens designs. Fortunately, several vendors now make reasonably priced lens accessories for digital cameras. And your loved ones are always happy to get suggestions about what to buy you for your next birthday, right?

Exposure Exposed

As Chapter 2 explains, image exposure is affected by shutter speed and aperture setting. Like point-and-shoot film cameras, digital cameras offer *programmed autoexposure,* which means that the camera selects the proper aperture and shutter speed for you.

In addition to this basic autoexposure feature, you may want to choose a camera that offers some or all of the following exposure tools:

- *Aperture-priority autoexposure* means that you select the aperture and the camera sets the appropriate shutter speed to produce a good exposure. On low-priced cameras, you typically get only two aperture settings: one for low-light shooting and another for bright light. Higher-end cameras enable you to select from a larger range of apertures when you shoot in aperture-priority mode.

 If you're an experienced film photographer who works with an SLR camera, you may be aware that you can vary aperture to affect depth of field. You can use the same technique with digital cameras, too, but digital cameras typically don't offer as wide a range of aperture settings as their film counterparts, so the possible variations in depth of field are more limited. Chapter 5 discusses this issue in more detail.

- *Shutter-priority autoexposure* enables you to tackle the exposure issue from a different angle. You select the shutter speed, and the camera chooses the aperture. This feature is helpful when you're trying to capture moving subjects that require a fast shutter speed; the speed selected by the programmed autoexposure may not be quick enough to "stop the action." Chapter 6 gives you more tips on snapping action shots.

- *Manual exposure*, available on mid- to high-priced models, enables you to set both shutter speed and aperture, a feature that advanced photography enthusiasts appreciate.

- *EV compensation* enables you to increase or decrease the exposure setting chosen by the automatic exposure mechanism. EV compensation comes in handy when the camera's autoexposure system doesn't produce a lighting effect that you like. For example, if you're shooting a bright subject against a dark background, the autoexposure mechanism

may underexpose the subject because it "sees" the dark background and factors the brightness of that area into the exposure settings. See Chapter 5 for more information on this subject; see Color Plate 5-3 to see an example of how EV compensation affects exposure.

✔ *Automatic bracketing* enables you to snap a series of shots, each at a different exposure, with one press of the shutter button. Many photographers routinely shoot the same scene at different exposures — called *bracketing the shot* — to make sure that they get a least one image with an exposure that's correct. Some people also combine the darkest exposure and lightest exposure in a photo editor to achieve an image that has better detail in both the shadows and highlights than you can get from a single exposure.

Of course, bracketing is less vital with a digital camera because you can review the picture on the camera's monitor to check exposure. And if your camera doesn't offer automatic bracketing, you can simply change the exposure settings on your own before each shot. But automatic bracketing ensures that you capture exactly the same image area with each exposure, which makes combining dark and light exposures in the image-editing stage easier. If you have to fiddle with camera settings between each shot, the images likely will vary from picture to picture because you have to move the camera from its original shooting position to make the changes and then reframe the scene.

✔ *Metering modes* determines how the camera evaluates the available light when determining the correct exposure. Three basic metering modes exist:

 • *Spot metering* sets the exposure based on the light at the center of the frame only.

 • *Center-weighted metering* reads the light in the entire frame but gives more importance to the light in the center quarter of the frame.

 • *Matrix* or *multizone metering* reads the light throughout the entire frame and chooses an exposure that does the best job of capturing both the brightest and darkest regions of the picture.

Lower-priced cameras typically provide only the last metering mode, which works well for everyday pictures. More advanced cameras enable you to choose from all three metering modes. Center-weighted and spot metering are helpful for shooting very dark subjects against a bright background, and vice versa. For examples of how metering mode affects exposure, see Chapter 5.

Newer digital cameras also may offer a choice of ISO settings. This feature is modeled after film ISO ratings, which reflect the film speed, which in turn affect how much light is needed to produce a good exposure. The higher the ISO, the "faster" the film and the less light required. Unfortunately, shifting to a higher ISO on a digital camera usually results in a grainy or "noisy" image, as illustrated in Color Plate 5-2. For this reason, I wouldn't pay extra for ISO flexibility.

Is That Blue? Or Cyan?

Just as different types of film see colors a little differently, different digital cameras have different interpretations of color. One camera may emphasize the blue tones in an image, whereas another may slightly overstate the red hues, for example. Color Plate 3-2 illustrates the color perspectives of cameras from three different manufacturers.

Note that the colors generated by a particular camera are not always a reflection of the camera's ability to record color accurately but rather an indication of the manufacturer's decision about what types of colors will please the majority of its customers. If a manufacturer finds that the target audience for a camera prefers highly saturated colors and deep blues, for example, the camera is geared to boost the saturation and the blues.

Bear in mind, too, that the colors in the Color Plate aren't exactly what came out of these cameras. For reasons discussed in Chapters 2 and 8, colors usually shift during the printing process. So consider the images in the Color Plate as simply a reminder that different cameras perceive colors differently.

In order to compare cameras on the basis of color output, you need to actually shoot and download some images — you can't really rely on a camera's LCD to give you an accurate impression of the colors in your images. Keep in mind, too, that your monitor throws its own color prejudices into the mix. If this kind of pre-purchase testing isn't possible, read the equipment reviews in digital camera magazines, which gauge color accuracy based on standardized technical specifications.

Discount-store bargains — really a good buy?

You're cruising through the aisles of your neighborhood discount store. Just past the table of slightly imperfect waterbed sheets and the rack of 24-roll, megasaver toilet-paper packages, you spot a display of digital cameras. Wow! Digital cameras at deep discounts? Is this your lucky day? Or are you looking at a deal that's too good to be true? Maybe . . . maybe not.

Although you *can* get a good buy at deep-discount stores, you need to shop armed with plenty of data to be sure that you get a real bargain. Off-price stores and even major electronics chains often feature last year's cameras.

Although these cameras may be just fine from a quality and performance standpoint, they don't usually represent the best price/feature ratio, even when they're sold at a huge discount to the original retail prices.

Each year, manufacturers refine production processes to develop better, cheaper digital cameras. Most vendors also manufacture digital cameras in greater quantities now than in past years, which has lowered the per-unit cost even further. As a result, you may get more features for the same or less money if you opt for the manufacturer's newest model.

Accurately calibrating camera, monitor, and printer output isn't easy, and even with sophisticated color-management software, the best you can hope for is pretty close color matching. So don't expect your interior decorator to be able to use a digital photo to find a chair that perfectly matches the colors in your couch. If you need super-accurate color matching, you need a professional digital photographer with a professional color-calibration system.

Still More Features to Consider

The preceding sections cover the major features to evaluate when you're camera shopping. Options discussed in the following sections, presented in no particular order, may also be important to you, depending upon the kind of photography you want to do.

Now playing, on your big-screen TV

Many cameras offer *video-out* capabilities. Translated into plain English, this means that you can connect your camera to your television and display your pictures on the TV screen or record the images on your VCR.

When might you use such a feature? One scenario is when you want to show your pictures to a group of people — such as at a seminar or family gathering. Let's face it, most people aren't going to put up with crowding around your 15-inch computer monitor for very long, no matter how terrific your images are.

Fortunately, video-out is one option that doesn't cost big bucks. Even a few low-priced cameras offer this feature.

You may sometimes hear video-out called *NTSC output*. NTSC, which stands for National Television Standards Committee, refers to the standard format used to generate TV pictures in North America. Europe and some other parts of the world go by a different standard, known as *PAL*, an acronym for *phase alteration line-rate*. You can't display NTSC images on a PAL system.

In addition to video input/output options, some cameras enable you to record audio clips along with your images. So when you play back your image, you can actually hear your subjects shouting "Cheese!" as their happy mugs appear on-screen.

Self-timer and remote control

Many cameras offer a *self-timer* mechanism. Just in case you've never been to a large family gathering and haven't had experience with this particular

option, a self-timer enables the photographer to be part of the picture. You press the shutter button, run into the camera's field of view, and after a few seconds, the picture is snapped automatically.

A few cameras take the self-timer concept one step further and provide a remote control unit that you can use to trigger the shutter button while standing a few feet away from the camera. Figure 3-8 shows the Olympus E-20, a high-end camera, with its remote control.

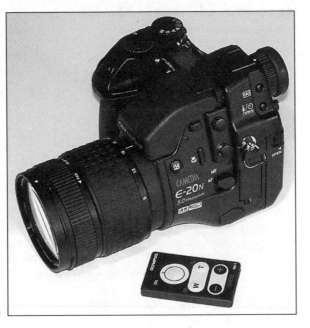

Figure 3-8: This Olympus model comes with a remote control that allows you to snap pictures without having your finger on the shutter button.

A remote control or self-timer function also offers a great way to avoid the camera shake that sometimes occurs when clumsy or anxious fingers jab at the shutter button with too much force. You put the camera on a tripod or other steady surface, frame the picture, and then use the remote or the self-timer to take a hands-free shot.

There's a computer in that camera!

All digital cameras include some computer-like components — chips that enable them to capture and store images, for example. But some of the newer models have bigger "brains" that enable them to perform some interesting functions that otherwise require a full-fledged computer. Here are some of the features you can find on such cameras, which some pundits have described as *camputers:*

✔ **Digita scripting:** Some cameras can run *Digita scripts,* which are mini-programs developed by FlashPoint Technology to simplify some imaging chores, such as file management, and to add creative options to your picture-taking. For example, a Digita script may enable you to add a custom logo to all your images. Scripts are either "built in" to cameras or are downloadable from the camera manufacturer's Web site.

✔ **Time-lapse photography:** Some cameras provide a time-lapse shooting option that tells the camera to take a picture automatically at specified intervals. If you need to take pictures of events that occur over a long period of time — a flower opening and closing its blooms, for example — look for this feature.

✔ **On-board image correction:** Many cameras enable you to perform basic image correction without ever downloading pictures to your computer. You can apply sharpening and color correction, for example. Usually, you select the correction options before you snap the picture, and the corrections are applied as the image is saved to memory.

I'm not a big fan of this feature because you don't get the same kind of control over the correction as you do when fixing images yourself using even a basic image editor. But on-board editing can come in handy if you use a printer that can print directly from your camera or removable memory card. The on-board processing can improve print quality in this scenario.

✔ **Direct printing:** Several cameras enable you to output images directly to a printer. Cameras that offer this function typically also provide options for setting up the print job. For example, you can choose to print several copies of the same image on one sheet of paper and even add decorative backgrounds to your pictures. You don't get the same flexibility as when you manipulate pictures using your computer and photo-editing software, but then again, you don't have to mess with manipulating your pictures using your computer and photo-editing software.

Of course, you'll also have to buy a printer that can connect to your camera. Alternatively, you can buy printers that can print from memory cards, which takes the camera out of the equation. Chapter 8 discusses printing options in more detail.

Action-oriented options

Shooting action with digital cameras can be difficult because most cameras need a few seconds between shots to process an image and store it in memory. Some newer cameras have been engineered to enable more rapid shooting, however. If action photography is important to you, I recommend visiting the manufacturer Web sites to find out which models in a particular company's digital lineup are geared to fast shooting.

Some cameras also offer a *continuous-capture mode*, often referred to as *burst* mode. With this feature, you can record a series of images with one press of the shutter button. The camera waits until after you release the shutter button to perform most of the image-processing and storage functions, so lag time is reduced.

Note that I said *reduced,* not *eliminated.* You can usually shoot a maximum of two or three frames per second. That's a fast capture rate, but it's still not quick enough to catch every moving target. See Chapter 6 (especially Figure 6-4) for examples of the pros and cons of continuous-capture shooting.

You should also know that most cameras default to a lower resolution — usually 640 x 480 — in continuous-capture mode. The flash is sometimes also disabled because the camera can't recycle the flash quickly enough to keep up with the image capture rate.

As an alternative action-shot feature, some cameras enable you to record a "mini movie" in a digital video format, such as MPEG. You can capture images and sounds for a short period of time and then play the moving images back on your TV or on any computer that has software for opening and playing the movie files.

Little things that mean a lot

When you're shopping for digital cameras, you can sometimes focus so much on the big picture (no pun intended) that you overlook the details. The following list presents some of the minor features that may not seem like a big deal in the store, but can really frustrate you after you get the camera home.

 ✔ **Batteries:** Thinking about batteries may seem like a trivial matter, but trust me, this issue becomes more and more important as you shoot more and more pictures. On some cameras, you can suck the life out of a set of batteries in less than an hour of shooting, even quicker if you keep the LCD monitor turned on.

 Some cameras can accept AA lithium batteries, which have about three times the life of a standard AA alkaline battery — and cost twice as much. Other cameras use rechargeable NiCad or NiMH batteries or 3-volt lithium batteries, and others can accept only regular AA alkaline batteries. A few low-priced cameras run on a standard 9-volt battery.

 Be sure to ask which types of batteries the camera can use and how many pictures you can expect to shoot on a set of batteries. Then factor that battery cost into the overall cost of camera ownership. Some cameras come with a battery charger and rechargeable batteries, which adds up to major savings over time.

✔ **AC adapters:** Many cameras offer an AC adapter that enables you to run the camera off AC power instead of batteries. Some manufacturers include the adapter as part of the standard camera package, whereas others charge extra for it.

✔ **Ease of use:** When you're looking at cameras, have the salesperson demonstrate how you operate the various controls, and then try working those controls yourself. How easy or how complicated is it to delete a picture, for example, or change the resolution or compression settings? Are the controls clearly labeled and easy to manipulate? After you take a picture or turn the camera off, do all the settings return to the default settings, or does the camera remember your last instructions? If the controls aren't easy to use, the camera may ultimately frustrate you.

✔ **Tripod mount:** As with a film camera, if you move a digital camera during the time the camera is capturing the image, you get a blurry picture. And holding a digital camera steady for the length of time the camera needs to capture the exposure can be difficult, especially when you're using the LCD as a viewfinder or when you're shooting in low light (the lower the light, the longer the exposure time). For that reason, using a tripod can greatly improve your pictures. Unless you have very steady hands, be sure to find out whether the camera you're considering can be screwed onto a tripod — not all cameras can.

✔ **Physical fit:** Don't forget to evaluate the personal side of the camera: Does it fit into your hands well? Can you reach the shutter button easily? Can you hold the camera steady as you press the shutter button? Do you find your fingers getting in the way of the lens, or does your nose bump up against the LCD when you look through the viewfinder? Is the viewfinder large enough that you can see through it easily? Don't just run out and buy whatever camera a friend or magazine reviewer recommends — make sure that the model you select is a good fit for you.

✔ **Durability:** Does the camera seem well built, or is it a little flimsy? For example, when you open the battery compartment, does the little door or cover seem durable enough to withstand lots of opening and closing, or does it look like it might fall off after 50 or 60 uses?

✔ **Computer and printer hookups:** How does the camera connect to your computer? Some cameras connect via serial port, others via a USB port (Universal Serial Bus), and some via wireless infrared connection technology known as IrDA.

Some novice-oriented cameras offer a "one-button transfer" feature. After connecting the camera to the computer, you press a button to automatically launch the camera's image-transfer software and move your pictures from camera to computer. You can even send images to friends and family via the Web through a similar automated process.

Whether you need such handholding or not, make sure that the connection provided by the camera works with your system — or that you can buy whatever adapters may be needed to bring the two devices together. Some cameras require that you buy an accessory "docking station" in order to enjoy the automatic transfer function.

If you're buying a camera that records pictures on removable media, of course, you can always transfer images through a card reader instead of hooking the camera directly to the computer. But just as a backup, you should be able to connect your camera "the old-fashioned way" if necessary.

Remember that USB devices often don't work well with Windows 95. Just for the record, IrDA transfer can be problematic as well. Although an IrDA device from one manufacturer is supposed to work well with IrDA devices from every other manufacturer, things don't always go that smoothly. In fact, I recently sat in a meeting of digital imaging experts, and even with our collective experience, we couldn't get a camera-to-laptop transfer to work. The technology seems to work best when you transfer files between two devices from the same manufacturer — for example, from a Hewlett-Packard camera to a Hewlett-Packard printer.

✔ **Software:** Every camera comes with software for downloading images. But many also come with basic photo-editing software. Because the programs included with cameras typically retail for under $50, having an image editor included with the camera isn't a huge deal. Then again, 50 bucks is 50 bucks, so if all other things are equal, software is something to consider.

✔ **Warranty, restocking fee, exchange policy:** As you would with any major investment, find out about the camera's warranty and the return policy of the store. Be aware that some major electronics stores and mail-order companies charge a *restocking fee,* which means that unless the camera is defective, you're charged a fee for the privilege of returning or exchanging the camera. Some sellers charge restocking fees of 10 to 20 percent of the camera's price.

Sources for More Shopping Guidance

If you read this chapter, you should have a solid understanding of the features you do and don't want in your digital camera. But I urge you to do some more in-depth research so that you can find out the details on specific makes and models.

First, look in digital photography magazines as well as in traditional photography magazines such as *Shutterbug* for reviews on individual digital cameras and peripherals. Some of the reviews may be too high-tech for your taste or complete understanding, but if you first digest the information in this chapter as well as Chapter 2, you should be able to get the gist of things.

If you have Internet access, you can also find good information on several Web sites dedicated to digital photography. See Chapter 15 for suggestions on a few Web sites worth visiting.

Computer magazines and Web sites routinely review digital cameras, too, but I find their commentary less helpful than what's available from sources whose main concern is photography. For example, I've seen reviews in a leading computer magazine that award the publication's highest rating to a camera even though the reviewer calls the image quality only "fair." Call me crazy (many do), but I think that a camera isn't deserving of a good rating, let alone the highest possible marks, if it can't produce excellent images!

Try Before You Buy!

Some camera stores offer digital camera rentals. If you can find a place to rent the model you want to buy, I *strongly* recommend that you do so before you make a purchase commitment. For about $30, you can spend a day testing out all the camera's bells and whistles. If you decide that the camera isn't right for you, you're out 30 bucks, but that's a heck of a lot better than spending several hundred dollars to buy the camera and finding out too late that you made a mistake.

To find a place that rents cameras, call your local camera, computer, and electronics stores. As digital cameras become more and more popular, more and more outlets may begin offering short-term camera rentals.

Chapter 4

Extra Goodies for Extra Fun

● ●

In This Chapter

▶ Buying and using removable storage media

▶ Transferring images to your computer the easy way

▶ Choosing a digital closet (storage solutions)

▶ Seeking out the best imaging software

▶ Stabilizing and lighting your shots

▶ Protecting your camera from death and destruction

▶ Pushing the cursor around with a pen

● ●

Do you remember your first Barbie doll or — if you're a guy who refuses to admit playing with a girl's toy — your first G.I. Joe? In and of themselves, the dolls were entertaining enough, especially if the adult who ruled your household didn't get too upset when you tried stuff like shaving Barbie's head and seeing whether G.I. Joe was tough enough to withstand a spin in the garbage disposal. But Barbie and Joe were even more fun if you could talk some doting adult into buying you some of the many doll accessories on the toy-store shelves. With a few changes of clothing, a plastic convertible or tank, and loyal doll friends like Midge and Ken, Dollworld was a much more interesting place.

Similarly, you can enhance your digital photography experience by adding a few hardware and software accessories. Digital camera accessories don't bring quite the same rush as a Barbie penthouse or a G.I. Joe surface-to-air missile, but they greatly expand your creative options and make some aspects of digital photography easier.

This chapter introduces you to some of the best camera accessories, from adapters that speed the process of downloading images, to software that enables you to retouch and otherwise manipulate your photographs. If you begin buttering up your loved ones now, I just know that one of them will cave and buy you one of these goodies soon.

Memory Cards and Other Camera Media

If your camera stores pictures on removable storage media, you may have received one memory card or disc with your camera. At minimum, cameras that include removable media in the box typically provide at least 8MB of storage capacity.

In the days when digital cameras produced only low-resolution images, 8MB was more storage space than most people needed on a regular basis. But because today's models can capture many more pixels than cameras even a few years old, 8MB now represents just a starting point for most digital photographers.

How much storage space do you need? That depends on how many pictures you want to take at a time and what resolution and compression settings you use when you shoot those images. (See Chapter 3 for an explanation of image compression.) Your camera manual should provide a table that lists the file sizes of pictures taken at each of the resolution and compression settings the camera offers. Use these numbers as a guide to how many megabytes of storage will serve your needs.

In my case, there is no such thing as too much storage space. But I use high-resolution cameras and typically capture images using the lowest possible amount of image compression, which adds up to large image files. On top of that, I'm often shooting away from my office, and I don't like lugging around a laptop computer just for the purpose of downloading pictures. So the more removable media I can tuck in my camera bag, the better.

If you can get by with fewer pixels or you don't mind applying a high degree of compression to your photos, your memory needs are much smaller because the image files are smaller. And of course, if you usually have a computer close by, enabling you to download images when you fill up your existing memory, you may not need any additional memory at all.

After you decide on how many megabytes you need, look to the following sections for everything you need to know about buying and caring for your storage media.

Field guide to camera memory

Removable media for digital cameras comes in several flavors. Most digital cameras can use only one type, however, so check your manual to find out which of the following options works with your model. (For a look at the most popular types of removable camera media, refer to Figure 3-3, in Chapter 3.)

Note that in the descriptions here, prices are what you can expect to pay in retail or online stores — what the trade refers to as "street prices." Fortunately, prices have fallen recently, while storage capacities seem to be ever increasing. So by the time you read this, you may be able to get even more for your money.

- **Floppy disks:** Some Digital Mavica cameras from Sony store images on regular old floppy disks. If you own one of these models, purchasing additional memory is a no-brainer; floppy disks are pennies apiece, so stock up. Remember that each floppy can hold less than 1.5MB of image data.

- **PC Cards:** Some professional-level digital cameras, as well as a few older models of consumer cameras, accept PC Cards, formally known as PCMCIA Cards. About the size of a credit card, these memory cards are the same type used by most laptop computers. If your camera uses PC Cards, be sure to find out whether it uses Type I, II, or III before going shopping. Prices for PC Card memory range from about $2 to $4 per megabyte, depending on the type and capacity of the card.

- **CompactFlash:** Smaller versions of PC Cards, CompactFlash cards sport a hard-shell outer case and pin connectors at one end. These cards come in two flavors: Type I and the slightly thicker Type II. Cameras that accept Type II cards typically can also read Type I cards, but the reverse isn't true unless you use an adapter. Currently, you can buy cards in capacities ranging from 8MB to 1G (gigabyte). Both Type I and Type II cards range from $.50 to $1 per megabyte; you pay less per megabyte when you buy a large capacity card.

- **SmartMedia:** These cards are smaller, thinner, and more flexible than CompactFlash cards; they feel sort of like the old 5.25-inch floppy disks that we used in the dark ages of computing.

You sometimes see the initials *SSFDC* in conjunction with the SmartMedia moniker. SSFDC stands for Solid State Floppy Disk Card and refers to the technology used in the cards. But if you go into a store and ask for an SSFDC card, you're likely to be greeted by blank stares, so stick with SmartMedia instead.

Like CompactFlash cards, SmartMedia cards come in several different capacities, but the biggest-capacity SmartMedia card you can buy at present is 128MB. You'll pay about $.50 to $1 per megabyte, and, as with most memory cards, you get a better per-megabyte price if you buy the larger-capacity cards.

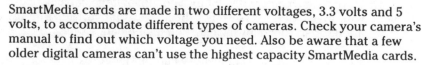

SmartMedia cards are made in two different voltages, 3.3 volts and 5 volts, to accommodate different types of cameras. Check your camera's manual to find out which voltage you need. Also be aware that a few older digital cameras can't use the highest capacity SmartMedia cards.

- **Sony Memory Stick:** This type of memory card works only with certain Sony digital cameras and other devices. The largest capacity Memory Stick card holds 128MB of data. Cost per megabyte is about the same as for CompactFlash and SmartMedia cards.

- **And the rest:** I lumped these last storage options together because only a handful of cameras use them:

 - **Secure Digital (SD):** Some of the newest digital cameras store pictures on SD cards, a relatively new type of memory card that's about the size of a postage stamp. These cards come in capacities up to 128MB and cost about $1 to $2 per megabyte.

 - **IBM Microdrive:** Some high-resolution cameras can store images on an IBM Microdrive as well as CompactFlash Type I and Type II cards. The Microdrive, which is about the same physical size as a CompactFlash card, comes in capacities from 340MB to 1GB. The smallest option sets you back about $200; the 1GB model runs about $400.

 - **Mini CD-R:** Sony offers high-resolution Mavica models that store images on miniature CDs. About three inches in diameter, these discs can store 156MB of data. Some of the cameras feature CD-R technology, while others offer both CD-R and CD-RW. (With CD-R, you can't erase images once they're on the CD. See the sidebar "CD-R or CD-RW?" for information.) The CD-R discs cost about $2 to $5, depending on the quantity you buy; the CD-RW versions sell for twice that amount.

Prices for all types of removable media vary quite a bit depending on where you buy and what brand you buy. So shop around — you likely can get even better prices than mentioned here if you watch the sale ads. Also, many stores offer extra memory as a bonus when you buy a particular camera, so keep an eye out for these promotions if you're camera shopping.

Care and feeding of CompactFlash and SmartMedia cards

CompactFlash and SmartMedia cards are the most widely used types of removable camera memory. Although the cost of both products has dropped dramatically over the past year, you can easily spend as much on them as you do for a camera if you buy a couple of large capacity cards. To protect your investment — as well as the images that you store on the cards — pay attention to the following care and maintenance tips:

- When you insert a memory card into your camera for the first time, you may need to format the card so that it's prepared to accept your digital images. Your camera should have a format procedure, so check your manual.

✔ Never remove the card while the camera is still recording or accessing the data on the card. (Most cameras display a little light or indicator to let you know when the card is in use.)

✔ Don't turn off the power to your camera while the camera is accessing the card, either.

✔ Avoid touching the contact areas of the card.

• On a SmartMedia card, the gold region at the top of the card is the no-touch zone.

• On a CompactFlash card, keep your mitts off the connector on the bottom of the card.

✔ Don't bend a SmartMedia card. SmartMedia cards are flexible, so if you decide to carry them in your hip pocket, don't sit down.

✔ If your card gets dirty, wipe it clean with a soft, dry cloth. Dirt and grime can affect the performance of memory cards.

✔ Try not to expose memory cards to heat, humidity, static electricity, and strong electrical noise. You don't need to be overly paranoid, but use some common sense in this area.

✔ Ignore those rumors you hear about airport security scanners destroying data on memory cards. This rumor has become a hot one again with the installation of newer, stronger scanners in some airports. But according to manufacturers of storage cards, security scanners do no harm to the cards. So instead of worrying about your data being damaged when you put your camera bag through the scanner, keep an eye out for airport thieves who would like nothing more than to lift your camera off the scanner belt while you're not paying attention.

Download Devices

In years past, most digital cameras came with a serial cable for connecting the camera to the computer. To download images, you plugged the cable into both devices and used special image-transfer software to move the pictures from camera to computer. This method of file transfer was excruciatingly slow — transferring a dozen pictures could easily take 20 minutes or more.

Thankfully, most manufacturers have now switched over to USB technology for image transfer. In case you're wondering, USB stands for *Universal Serial Bus* and is the geeky name assigned to a type of connection between two digital devices — in this case, camera and computer. Most cameras ship with a USB cable that works on both Windows-based and Macintosh computers that have USB ports.

With USB, images flow from camera to computer much more quickly than via serial cable. But as you're aware if you've explored Chapter 3, USB presents

two problems: First, if your computer's a few years old, you may not be able to take advantage of USB connections because your machine may not have a USB port. And if you use Windows 95 as your computer's operating system, expect a hassle getting USB connections to work, even if you install the updated version of Windows 95 that supposedly corrects USB hang-ups.

The difficulties presented by direct camera-to-computer connections helped the Sony Digital Mavica cameras that store images on floppy disk become huge sellers. With these models, you don't have to mess with getting camera and computer to shake hands through a cable. You just eject the floppy disk from the camera and push it into your computer's floppy disk drive to download images.

Similarly, CD Mavica cameras store pictures on miniature CD-R and CD-RW disks that you slip into your computer's CD-ROM drive to transfer images. With some computers, a supplied adapter is necessary in order to make the CDs work in the CD drive. Figure 4-1 shows a CD Mavica model along with the adapter.

Figure 4-1:
An adapter supplied with Sony CD Mavica cameras makes image data readable by CD-ROM drives that can't normally open files stored on miniature CDs.

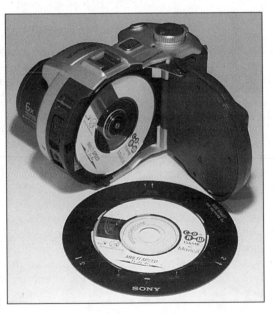

In the past few years, manufacturers have developed devices that enable photographers whose cameras use other types of removable storage media to enjoy the same download speed and convenience offered by the Mavica's floppy-disk setup. If you shoot digitally on a regular basis, you definitely

should get one of these gadgets — you'll never regret the investment. Not only can you transfer images to your computer in a flash, you save yourself the annoyance of having to fiddle with cable connections between your computer and your camera every time you want to download some images.

Here's a look at your options:

- ✔ **Floppy disk adapter:** For about $60, you can buy an adapter that makes SmartMedia and Memory Stick cards readable by your floppy disk drive. Figure 4-2 shows an adapter that works with SmartMedia cards. With either type of card, you just slip the card into the adapter and then put the adapter into your floppy drive. You can then drag and drop image files from the floppy drive to your hard drive as you would any file on a floppy disk.

- ✔ **PC Card adapter:** These adapters enable CompactFlash, SmartMedia, Secure Digital, and Memory Stick cards to masquerade as standard PC Cards. You can also buy an adapter for the IBM Microdrive.

 Figure 4-3 offers a glimpse of an adapter for a CompactFlash card. After putting the memory card in the adapter, you insert the whole shebang into your laptop computer's PC Card slot or into a PC Card reader (see the next bullet point). The PC Card shows up as a drive on your computer desktop, and you drag and drop image files from the PC Card to your hard drive.

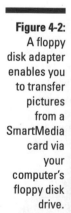

Figure 4-2:
A floppy disk adapter enables you to transfer pictures from a SmartMedia card via your computer's floppy disk drive.

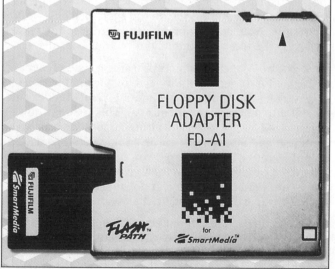

Figure 4-3:
This adapter makes Compact Flash cards readable in PC Card slots, which are found on many laptop computers.

Some CompactFlash manufacturers provide a free PC Card adapter when you buy a memory card, but the adapters are also available independently for about $10. (Some CompactFlash adapters also work with the IBM Microdrive.) PC Card adapters for SmartMedia, Memory Stick, and Secure Digital cards cost about $40.

✔ **Card reader:** Another download alternative for easy image transfer is to buy a memory-card reader. You can buy an internal card reader that installs into an empty expansion slot on your computer or an external reader that cables to the computer, usually via a parallel port or USB port.

After you install the reader's driver software, your computer "sees" the card reader as just another drive on the system, like your floppy drive or your hard drive. You insert your memory card into the reader and then drag and drop the files from the reader to your hard drive.

You can buy card readers that accept a single type of memory card for about $25, but for added flexibility and long-term functionality, you may want to invest a little more and get a multi-format reader such as the Microtech USB CameraMate (about $40). This reader, shown on the right side of Figure 4-4, can transfer files from an IBM Microdrive as well as CompactFlash and SmartMedia cards. (Some versions of this product also accept Memory Stick cards.) If you buy a camera down the road and the camera uses different media than your old one, you won't need to buy a new card reader. You also can download images taken by visitors whose cameras use different media than yours.

If you buy a card reader that connects via the parallel port, look for a model that offers a *pass-through connection* for your printer. In plain English, that means that you connect the reader to the parallel port and then connect the printer to the reader. That way, the two devices can

share the same parallel port, which is important because many computers have only one parallel port. But be advised that some printers aren't happy with this arrangement and may spit out garbage pages every now and then to voice their displeasure. Before buying a card reader (or any other device, for that matter) that provides a pass-through connection, pay a visit to the manufacturer's Web site and check for any potential hardware conflicts.

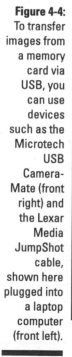

Another USB option, the Lexar Media JumpShot cable, shown on the left side of Figure 4-4, enables you to transfer images from USB-enabled CompactFlash cards, also from Lexar Media. Technically, the JumpShot cable (about $20) isn't a card reader — functions normally handled by the reader are built into the card itself, and the cable just serves to connect the card to the computer. But together, the card and cable work like a card reader, so don't worry about the specifics. The USB-enabled cards fall into the same price range as ordinary CompactFlash cards and work in any device that accepts CompactFlash media. You can't use regular CompactFlash cards with the JumpShot cable, however.

Figure 4-4:
To transfer images from a memory card via USB, you can use devices such as the Microtech USB Camera-Mate (front right) and the Lexar Media JumpShot cable, shown here plugged into a laptop computer (front left).

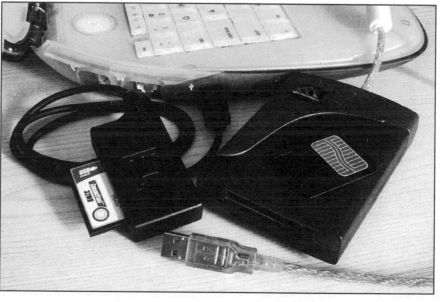

✔ **Docking stations:** Because so many new users have trouble with the process of downloading images from camera to computer — no, you're *not* the only one! — a few manufacturers have developed so-called *camera docks* that are designed to simplify things. A dock is a small base unit that you leave permanently connected to your computer, usually via a USB cable. When you're ready to download pictures from your camera, you place the camera into the dock, press a button or two, and the dock and camera work together to automatically start the transfer process.

Figure 4-5 shows a Kodak version of the camera-and-dock setup, which the company refers to as its EasyShare system. In addition to assisting you with image transfers, the Kodak dock serves as the camera's battery charger. It also provides features that facilitate printing and e-mailing pictures. The dock sells as a separate accessory for about $80.

✔ **Photo printer with memory card slots:** If you have a photo printer that can print directly from your camera's memory card, you may be able to transfer images to the computer by way of the printer instead of investing in a separate card reader. This option may not work well — or at all — with some printers, especially those that connect via a parallel port, which doesn't offer very fast data-transfer speeds. But if you already own a printer that has memory card slots, check your owner's manual to find out whether this transfer option is available to you.

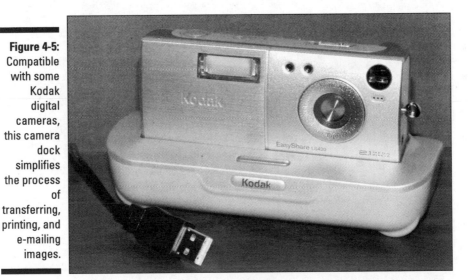

Figure 4-5:
Compatible
with some
Kodak
digital
cameras,
this camera
dock
simplifies
the process
of
transferring,
printing, and
e-mailing
images.

Long-Term Picture Storage Options

In the professional digital imaging world, the hot new topic is *digital asset management*. Digital asset management — which, incredibly, is often referred

to by its initials — simply refers to the storing and cataloging of image files. Professional graphic artists and digital photographers accumulate huge collections of images and are always striving for better ways to save and inventory their assets.

Your image collection may not be as large as that of a professional photographer's, but at some point, you, too, need to think about where to keep all those photos you take. You may be at that point now if you shoot high-resolution pictures and your computer's hard drive — the thing that stores all of your data files — is already cramped for space.

Additional storage options are plentiful — provided you have the cash, you can add as many digital closets and shoe boxes to your system as you want. For starters, you can add an additional hard drive to your computer. Several companies, including Maxtor, offer external hard drives geared specifically to people who need to store large picture and media files. You can buy a 40GB external Maxtor drive for about $200.

Although adding a second hard drive may temporarily solve your picture storage concerns, you may also want to invest in a storage device that copies data to removable media. Because hard drives do fail on occasion, making backup copies on removable media is a good idea for special pictures. In addition, this option enables you to give copies of your picture files to other people, something you can't do if you have only a hard drive for image storage. If you do purchase a removable media storage device, you may be able to do without additional hard drive space.

The following list looks at a few of the most popular removable media devices for home and small-office users. Chapter 7 introduces you to some cataloging programs that can help you keep track of all your images after you stow them away.

- The most common removable storage option is the floppy disk. Almost every computer today, with the exception of the iMac and iBook from Apple, has a floppy disk drive. The disks themselves are incredibly cheap: You can get a floppy for less than $1 if you watch the sale ads. The problem is that a floppy disk can hold less than 1.5MB of data, which means that it's suitable for storing small, low-resolution, or highly compressed images, but not large, high-resolution, uncompressed pictures.

- Several companies offer removable storage devices commonly known as *super floppies*. These drives save data on disks that are just a little larger than a floppy but that can hold much more data. The most popular option in this category is the Iomega Zip drive, available in 100MB and 250MB versions. Many vendors now include Zip drives as standard equipment on desktop and even laptop computers. If you want to add a Zip drive to your system, save up about $80 for the smaller-capacity drive and $150 for the 250MB drive. A 100MB disk costs around $10; a 250MB disk sets you back about $15.

✔ Perhaps the most affordable and convenient option for long-term storage is a CD recorder, which tech-heads refer to as a *CD burner*. Several manufacturers now make CD recorders aimed at the consumer and small-business market. Figure 4-6 shows an external Hewlett-Packard CD model. You can pick up a CD recorder for under $100, and the CDs themselves, which can store as much as 650MB of data, cost from $.50 to $3, depending on which type you buy. (See the upcoming sidebar "CD-R or CD-RW?" for more on different types of CDs and CD recorders.)

Just a few years ago, I would have told you to avoid this storage option because the recorders were a little too finicky and the recording software too complicated for anyone who didn't care to spend hours learning a slew of new technical languages and sorting out hardware conflicts. But many of the problems previously associated with this technology have been resolved, making the process of burning your own CDs much easier and much more reliable. Most recorders ship with wizards that walk you through the process of copying your images to a CD, so you no longer have to be a technical guru to make things work. In fact, many new computers now ship with CD recorders already installed in place of a standard read-only CD drive.

That said, recording your own CDs is by no means as carefree a prospect as copying files to a floppy disk or Zip disk. First, some compatibility issues exist that make it impossible for some types of homemade CDs to be read by some older computers. Second, even with the software wizards to guide you, you still must deal with plenty of new and confusing technical terminology when choosing recording options. So if techno-babble intimidates you and the occasional unexplained glitch tempts you to put your fist through your computer monitor, you may want to hold off on a CD recorder. Or at the very least, ask your neighborhood computer guru to help you install and set up the recorder.

Figure 4-6:
Burning
your own
CDs offers
an
inexpensive
means of
storing and
sharing
digital
photos.

If you decide that you're not ready to burn your own CDs, you can have your images transferred to a CD at a digital-imaging lab (check your Yellow Pages for a lab in your area that offers this service). Cost per image varies. In my neck of the woods, transferring 1–150MB worth of images costs about $40.

 A close cousin to the CD burner, DVD-R and DVD-RW writers enable you to record your photos onto a DVD (digital video disc). What's the difference between CDs and DVDs? Capacity, mostly. A single DVD stores 4.7GB of data, while a CD holds about 650MB.

Although DVD is poised to overtake the CD as the most popular archival storage option in the next few years, it's too expensive and new for me to recommend it as a solution for the average photographer just yet. Stand-alone DVD burners cost about $500-600, although some computer makers do offer built-in DVD recorders as standard equipment on high-end models. More important, the industry doesn't seem to have settled firmly on a DVD format, which means that DVDs that you burn today may not be readable by tomorrow's DVD players. And of course, you can't share a DVD with people whose computers have only the more common CD-ROM drive.

 As with any computer data, digital-image data will degrade over time. How soon you begin to lose data depends on the storage media you choose. With devices that use magnetic media, which includes hard drives, Zip disks and floppies, image deterioration starts to become noticeable after about ten years. In other words, don't rely on magnetic media for long-term archiving of images.

To give your images the longest possible life, opt for CD-ROM storage, which gives you about 100 years before data loss becomes noticeable. However, to get this storage life, you need to select the right type of CD media. If you're having your images transferred to CD at a professional lab, request archival-quality CDs; if you're burning your own CDs, use CD-R, not CD-RW, discs in your CD recorder. CD-RW discs have an estimated life of just 30 years. (See the sidebar "CD-R or CD-RW?" for information on the difference between CD-R and CD-RW discs.)

When choosing a storage option, also remember that the various types of disks aren't interchangeable. Floppy disks, for example, don't fit in a Zip drive. So if you want to be able to swap images regularly with friends, relatives, or coworkers, you need a storage option that's in widespread use. You probably know many people who have a CD-ROM drive, for example, but you may not find anybody in your circle of acquaintances using a Zip drive. Also, if you're going to send images to a service bureau or commercial printer on a regular basis, find out what types of media it can accept before making your purchase.

CD-R or CD-RW?

CD recorders enable you to *burn* your own CDs — that is, copy image files or other data onto a compact disc (CD). Two types of CD recording exist: CD-R and CD-RW. The *R* stands for *recordable; RW* stands for *rewriteable.*

With CD-R, you can record data until the disc is full. But you can't delete files to make room for new ones — after you fill the disc once, you're done. On the plus side, your images can never be accidentally erased. Additionally, CD-R discs have a life expectancy of approximately 100 years, making them ideal for long-term archiving of important images. CD-R discs are cheap, too, selling for about $.50 each or even less if you happen upon a special store promotion. (However, because quality can vary from brand to brand, I recommend that you stay away from no-name, ultra-cheap CD-R discs and stick with high-quality discs from a respected manufacturer for your important image archives.)

With CD-RW, your CD works just like any other storage medium. You can get rid of files you no longer want and store new files in their place. Although CD-RW discs cost more than CD-R discs — about $2 each — they can be less expensive over the long run because you can reuse them as you do a floppy disk or Zip disk. However, you shouldn't rely on CD-RW discs for archiving purposes. For one thing, you can accidentally overwrite or erase an important image file. For another, data on CD-RW discs starts to degrade after about 30 years.

One other important factor distinguishes CD-R from CD-RW: compatibility with existing CD-ROM drives. If you're creating CDs to share images with other people, you should know that those people need *multiread* CD drives to access files on a CD-RW disc. This type of CD drive is being implemented in many new computer systems, but most older systems do not have multiread drives. Older computers can usually read CD-R discs without problems, however. (Depending on the recording software you use, you may need to format and record the disc using special options that ensure compatibility with older CD drives.)

Industry experts predict that CD-RW devices will be standard equipment in all new computer systems within two years, so more people will be able to access CD-RW discs. For now, if you're shopping for a CD recorder, be aware that some recorders can write to CD-R discs only, while other recorders can write to both CD-R and CD-RW discs. The best bet is a machine that gives you the option of creating either CD-R or CD-RW discs. You can use the cheaper and more widely supported CD-R discs for archiving images and distributing your photos to others and use CD-RW discs for routine storage.

Software Solutions

Flashy and sleek, digital cameras are the natural stars of the digital-imaging world. But without the software that enables you to access and manipulate your images, your digital camera would be nothing more than an overpriced

paperweight. Because I know that you have plenty of other had-to-have-it, never-use-it devices that can serve as paperweights, the following sections introduce you to some software products that help you get the most from your digital camera.

Be sure to investigate the CD at the back of this book, too. The CD includes demo versions of many popular digital-imaging programs so that you can test them out before you buy.

Image-editing software

Image-editing software enables you to alter your digital photos in just about any way you see fit. You can correct problems with brightness, contrast, color balance, and the like. You can crop out excess background and get rid of unwanted image elements. You can also apply special effects, combine pictures into a collage, and explore countless other artistic notions. Part IV of this book provides you with a brief introduction to photo editing to get you started on your creative journey.

Today's computer stores, mail-order catalogs, and online shopping sites are stocked with an enormous array of photo-editing products. But all these programs can be loosely grouped into two categories: entry-level and advanced. The following sections help you determine which type of software fits your needs best.

Entry-level photo-editing programs

Several companies offer programs geared to the photo-editing novice; popular choices include Adobe PhotoDeluxe, Ulead PhotoExpress, Jasc AfterShot, and Microsoft Picture It!, all available for about $50.

All of these programs provide a basic set of image-correction tools plus plenty of on-screen hand-holding. *Wizards* (step-by-step on-screen guides) walk you through different editing tasks, and project templates simplify the process of adding your photo to a business card, calendar, e-mail postcard, or greeting card. In Figure 4-7, I'm using PhotoDeluxe to put a picture on a baby-shower invitation.

Within this category, the range of editing and effects tools provided varies widely, so you should read product reviews before buying to make sure that the program you get will enable you to do the photographic projects you have in mind. See Chapter 15 for the names of some Web sites where you can find this kind of information.

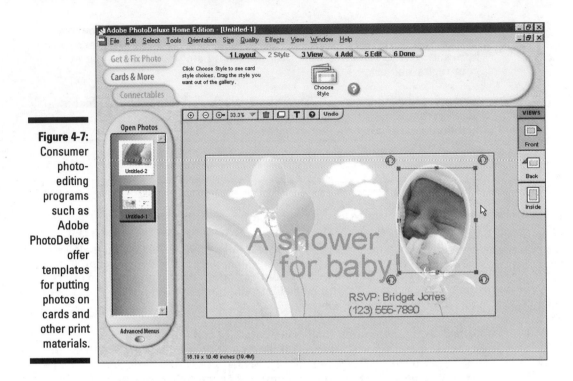

Figure 4-7:
Consumer
photo-
editing
programs
such as
Adobe
PhotoDeluxe
offer
templates
for putting
photos on
cards and
other print
materials.

Advanced photo-editing programs

Although the entry-level programs discussed in the preceding section provide enough tools to keep most casual users happy, people who edit pictures on a daily basis or just want a little more control over their images may want to move up the software ladder a notch. Ranging in price from $100 to $700, advanced photo-editing programs provide you with more flexible, more powerful, and, often, more convenient image-editing tools than entry-level offerings.

What kind of additional features do you get for your money? Here's just one example to illustrate the differences between beginner and advanced programs. Say that you want to retouch an image that's overexposed. In an entry-level program, you typically are limited to adjusting the exposure for all colors in the image by the same degree. But in an advanced program, you can adjust the highlights, shadows, and midtones (areas of medium brightness) independently — so that you can make a businessman's white shirt even whiter without also giving his dark brown hair and beige suit a bleach job.

Additionally, using tools known as *dodge* and *burn tools*, you can "brush on" lightness and darkness as if you were painting with a paintbrush. In some programs, you can even apply exposure adjustments in a way that preserves all the original image data in case you decide later that you don't like the results of your changes. And that's but a sampling of your many options — all just for adjusting exposure.

Advanced programs also include tools that enable power-users to accomplish complicated tasks more quickly. Some programs enable you to record a series of editing steps and then play the editing routine back to apply those same edits to a batch of images, for example.

The downside to advanced programs is that they can be intimidating to new users and also require a high learning curve. You usually don't get much on-screen assistance or any of the templates and wizards provided in beginner-level programs. Expect to spend plenty of time with the program manual or a third-party book to become proficient at using the software tools.

Price is also a drawback, especially if you opt for either of the two premium players in the advanced category, Adobe Photoshop (about $600) or Corel PHOTO-PAINT ($480), both of which are geared to the professional photographer and digital artist. Fortunately, several good, less-expensive alternatives exist for users who don't need every possible bell and whistle. Jasc Paint Shop Pro ($109) and Ulead PhotoImpact ($100) are two to consider. Another good choice in the same price range — and the software featured in Part IV of this book — is Adobe Photoshop Elements, which includes Photoshop's basic power tools but also provides some of the same types of help features provided in consumer-level programs. Figure 4-8 gives you a look at the Photoshop Elements program window.

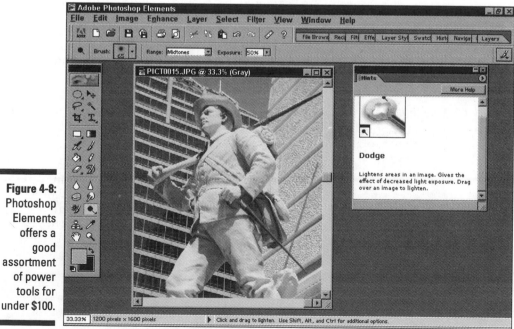

Figure 4-8:
Photoshop Elements offers a good assortment of power tools for under $100.

Before you invest in any imaging program, no matter how expensive, you're smart to give the program a whirl on your computer, using your images. The CD at the back of this book includes demo and trial versions of several image-editing programs, and you can find others at the Web sites of the software vendors.

Specialty software

In addition to programs designed specifically for photo editing, you can find some great niche programs geared to special digital photography needs and interests. The following list discusses some of the best programs I've found. (If you see the *On the CD* icon next to a paragraph, the CD at the back of this book includes a try-out version of the software mentioned.)

✔ Programs such as PicMeta's Print Station ($20), shown in Figure 4-9, fall into a category that I call *photo-utility* software. These programs are designed for digital photographers who simply need a quick way to print their images or send them with an e-mail message. Print Station, for example, simplifies the process of printing multiple images on the same sheet of paper.

✔ Image-cataloging programs assist you in keeping track of all your images. As mentioned earlier in this chapter, some industry gurus refer to these programs as digital asset management (DAM) tools. But you can just call them cataloging programs and get along fine with me. I don't think you want to walk into a computer store and ask to see all the DAM programs, anyway. At any rate, Chapter 7 provides more information about this kind of software, and the CD includes several cataloging programs for you to try.

✔ Image-stitching programs enable you to combine a series of images into a panoramic photo — similar to the kind you can take with some point-and-shoot film cameras. Chapter 6 offers more information on the concept.

✔ Finally, you can find several programs that fall into the "pure fun" category, such as BrainsBreaker, shown in Figure 4-10. With this $20 program, you can turn any photo into a digital jigsaw puzzle. You put the puzzle together by dragging pieces into place with your mouse — an endeavor that I find enormously addictive, I should add.

Figure 4-9:
Print
Station,
from
PicMeta,
gives you an
easy way to
print
multiple
images on
the same
sheet of
paper.

Figure 4-10:
Brains
Breaker
turns any
digital photo
into a virtual
jigsaw
puzzle.

I never metadata I didn't like

Many digital cameras, especially those at the mid- to high end of the consumer price range, store *metadata* along with picture data when recording an image to memory. Metadata is a fancy name for information that gets stored in a special area of the image file. Digital cameras record such information as the aperture, shutter speed, exposure compensation, and other camera settings as metadata.

To capture and retain metadata, digital cameras typically store images using a variation of the JPEG file format known as EXIF, which stands for *exchangeable image file format*. This flavor of JPEG is often stated in camera literature as JPEG (EXIF).

If your camera captures metadata using the EXIF format, you can view the metadata using an *extractor* program such as PicMeta Picture Information Extractor, shown here. (A demo copy of the program is provided on the CD accompanying this book.)

By reviewing the metadata for each image, you can get a better grasp on how the various settings on your camera affect your images. It's like having a personal assistant trailing around after you, making a record of your photographic choices each time you press the shutter button — only you don't have to feed this assistant lunch or provide health insurance.

Camera Accessories

So far, this chapter has focused on accessories to make your life easier and more fun after you shoot your digital pictures. But the three items in the following list are even more essential because they help you capture great pictures in the first place:

- **Special lens adapter and lenses:** If your camera can accept other lenses, you can expand your range of creativity by investing in a wide-angle, close-up, or telephoto lens (telephoto lenses are designed for making faraway objects appear closer). With some cameras, you can add supplementary wide-angle and telephoto elements that slip over the normal camera lens. The price range of these accessories varies depending on the quality and type and whether or not you need a separate adapter to fit the lens to your camera.

- **Tripod:** If your pictures continually suffer from soft focus, camera shake is one possible cause — and using a tripod is a good cure. You can spend a little or a lot on a tripod, with models available for anywhere from $20 to several hundred dollars. I can tell you that I've been quite happy with my $20 model, though. And at that price, I don't worry about tossing the thing into the trunk when I travel. Just be sure that the tripod you buy is sturdy enough to handle the weight of your camera. You may want to take your camera with you when you shop so that you can see how well the tripod works with your camera.

 Alfred DeBat, technical editor for this book, suggests this method for testing a tripod's sturdiness: Set the tripod at its maximum height, push down on the top camera platform, and try turning the tripod head as though it were a doorknob. If the tripod twists easily, look for a different model.

 If you enjoy making panorama images that involve stitching together a series of shots, you may want to invest in a panoramic head attachment for your tripod. The panoramic head assists you in correctly lining up your shots so they'll stitch together seamlessly. Chapter 6 explores this topic and type of product further.

- **LCD hoods:** If you have difficulty viewing images on your camera's LCD monitor in bright light, you may want to invest in an LCD hood. Hoods wrap around the monitor to create a four-sided awning that reduces glare on the screen. Several companies, including Hoodman (www. hoodmanusa.com) make custom-tailored hoods for a variety of digital cameras.

- **Light dome or box:** If you use your digital camera to take product shots of shiny or sparkly objects, such as glass or jewelry, you may find it almost impossible to avoid getting reflections or glare from your flash or

other light source. You can solve this problem by using a light dome or tent, which serves as a diffusion screen between the objects and the light source. Chapter 5 offers a look at one such product that's designed expressly for use with a digital camera.

✔ **Camera case:** Digital cameras are sensitive pieces of electronic equipment, and if you want them to perform well, you need to protect them from hazards of daily life. No camera is likely to take great pictures after being dropped on the sidewalk, being banged around inside a briefcase, or suffering other physical abuse on a regular basis. So whenever you're not using the camera, you should stow it in a well-padded camera case.

You can pick up a decent, padded case for about $10 at a discount store. Or if you want to spend a little more, head for a camera store, where you can buy a full-fledged digital camera bag that has room for all your batteries and other gear. Some digital cameras do come with their own cases, but most of these cases are pretty flimsy and not up to the job of keeping your camera safe from harm. You're spending several hundred dollars on a camera, so do yourself a favor and invest a little more on a proper protective case.

Mouse Replacement Therapy

To wrap up this chapter, I want to introduce you to one more accessory that doesn't seem to fit nicely into any of the other categories discussed so far: a digital drawing tablet.

A drawing tablet enables you to do your photo editing using a pen stylus instead of a mouse. If you do a good deal of intricate touch-up work on your pictures or you enjoy digital painting or drawing, you'll wonder what you ever did without a tablet after you try one.

To give yourself the most flexibility, look for a tablet that either ships with a cordless mouse in addition to a stylus or provides a connection that enables you to keep both the tablet and your regular, corded mouse operational. For example, I use a Wacom tablet, shown in Figure 4-11, that plugs into my PC's serial port. My mouse goes into a PS/2 mouse port, so I can switch back and forth between mouse and pen whenever I want. Typically, I use the mouse for performing actions that call for large cursor movements — things like choosing menu commands and selecting words in my word processor. I pick up the pen stylus for doing detailed image-editing tasks, such as drawing a selection outline or cloning (see Part IV for more about image editing).

Figure 4-11:
Intricate
photo-
editing tasks
become
easier when
you set
aside the
mouse in
favor of a
drawing
tablet and
stylus like
this Intuos
model from
Wacom.

Professional drawing tablets run as high as $700, but you don't need to spend anywhere near that much to enjoy the benefits of a decent tablet. You can buy a 4 x 5-inch tablet (the size shown in Figure 4-10) in Wacom's Intuos 2 line for about $200. These models, geared toward imaging professionals, offer some advanced features such as buttons that you can program to easily access commands in certain photo-editing programs.

Frankly, though, unless you're doing serious photo editing on a regular basis, you'll probably be happy without the programmable buttons and other features that come with professional-grade tablets. For people who just want the added control offered by a drawing tablet, Wacom (www.wacom.com) and other manufacturers offer basic-feature tablets selling for about $80. Most come with both a stylus and cordless mouse and connect to your computer via a USB port.

Part II
Ready, Set, Shoot!

The 5th Wave By Rich Tennant

THE GLACIER MOVEMENT PROJECT UPDATE THEIR WEBSITE

Camera ready? Wait a minute, hold it. Ready? Wait for the action... steady... steady... not yet... eeeasy. Hold it. Okay, stay focused. Ready? Not yet... steeeady... eeeasy...

In this part . . .

Digital cameras for the consumer market are categorized as "point-and-shoot" cameras. That is, you're supposed to be able to simply point the camera at your subject and shoot the picture.

But as is the case with point-and-shoot film cameras, picture-taking with a digital camera isn't quite as automatic as the camera manufacturers would like you to believe. Before you aim that lens and press the shutter button, you need to consider quite a few factors if you want to come away with a good picture, as this part of the book reveals.

Chapter 5 tells you everything you need to know about composition, lighting, and focus — three primary components of a great photograph. Chapter 6 covers issues specific to digital photography, such as choosing the right capture resolution and shooting pictures that you want to place in a photo collage or stitch together into a panorama.

By abandoning the point-and-shoot approach and adopting the think-point-and-shoot strategies outlined in this part, you, too, can turn out impressive digital photographs. At the very least, you will no longer wind up with pictures in which the top of your subject's head is cut off or the focus is so far gone that people ask why you took pictures on such a foggy day.

Chapter 5

Take Your Best Shot

In This Chapter

▶ Composing your image for maximum impact

▶ Shooting with and without a flash

▶ Adjusting exposure

▶ Compensating for backlighting

▶ Shooting reflective objects

▶ Bringing your subject into focus

▶ Using aperture controls to change depth of field

*A*fter you figure out the mechanics of your camera — how to load the batteries, how to turn on the LCD, and so on — taking a picture is a simple process. Just aim the camera and press the shutter button. Taking a *good* picture, however, isn't so easy. Sure, you can record an okay image of your subject without much effort. But if you want a crisp, well-exposed, dynamic image, you need to consider a few factors before you point and shoot.

This chapter explores three basic elements that go into a superior image: composition, lighting, and focus. By mulling over the concepts presented in this chapter, you can begin to evolve from so-so picture taker to creative, knock-their-socks-off photographer. Chapter 6 takes you one step further in your photographic development — sorry, bad pun — by exploring some issues specifically related to shooting with digital cameras.

Composition 101

Consider the image in Figure 5-1. As pictures go, it's not bad. The subject, a statue at the base of the Soldiers and Sailors Monument in Indianapolis, is interesting enough. But overall, the picture is . . . well, boring.

Figure 5-1:
This image falls flat because of its uninspired framing and angle of view.

Now look at Figure 5-2, which shows two additional images of the same subject, but with more powerful results. What makes the difference? In a word, *composition*. Simply framing the statue differently, zooming in for a closer view, and changing the camera angle create more captivating images.

Figure 5-2:
Getting closer to the subject and shooting from less-obvious angles results in more interesting pictures.

Not everyone agrees on the "best" ways to compose an image — art being in the eye of the beholder and all that. For every composition rule, you can find an incredible image that proves the exception. That said, the following list offers some suggestions that can help you create images that rise above the ho-hum mark on the visual interest meter:

- Remember the rule of thirds. For maximum impact, don't place your subject smack in the center of the frame, as was done in Figure 5-1. Instead, mentally divide the image area into thirds, as illustrated in Figure 5-3. Then position the main subject elements at spots where the dividing lines intersect.

- To add life to your images, compose the scene so that the viewer's eye is naturally drawn from one edge of the frame to the other, as in Figure 5-4. The figure in the image, also part of the Soldiers and Sailors Monument, appears ready to fly off into the big, blue yonder. You can almost feel the breeze blowing the torch's flame and the figure's cape.

- Avoid the plant-on-the-head syndrome. In other words, watch out for distracting background elements such as the flower and computer monitor in Figure 5-5.

- Shoot your subject from unexpected angles. Again, refer to Figure 5-1. This image accurately represents the statue. But the picture is hardly as captivating as the images in Figure 5-2, which show the same subject from more unusual angles.

Figure 5-3: One rule of composition is to divide the frame into thirds and position the main subject at one of the intersection points.

Figure 5-4:
To add life
to your
pictures,
frame the
scene so
that the eye
is naturally
drawn from
one edge of
the image to
the other.

Figure 5-5:
This photo
provides a
classic
example of
a beautiful
subject set
against a
horrendous
background.

✔ Here's a trick for shooting children: Photograph them while they're lying down on the floor and looking up at the camera, as in Figure 5-6. Maybe the children you photograph live in pristine surroundings, but in my family, rooms full of children are also full of toys, sippy cups, and other kid paraphernalia, which can make getting an uncluttered shot difficult. So I simply shove everything off to a small area of carpet and have the kids get down on the floor and pose.

✔ Another good approach for shooting the wee ones is to hunker down so that you can shoot at eye level, as I did in Figure 5-7. If your knees are as bad as mine, this tactic isn't as easy as it sounds — the getting-down-to-eye-level part is easy enough, but the getting-back-up isn't! But the results are worth the effort and resulting ice pack.

✔ Get close to your subject. Often, the most interesting shot is the one that reveals the small details, such as the laugh lines in a grandfather's face or the raindrop on the rose petal. Don't be afraid to fill the frame with your subject, either. The old rule about "head room" — providing a nice margin of space above and to the sides of a subject's head — is a rule meant to be broken on occasion.

✔ Try to capture the subject's personality. The most boring people shots are those in which the subjects stand in front of the camera and say "cheese" on the photographer's cue. If you really want to reveal something about your subjects, catch them in the act of enjoying a favorite hobby or using the tools of their trade. This tactic is especially helpful with subjects who are camera-shy; focusing their attention on a familiar activity helps put them at ease and replace that stiff, I'd-rather-be-anywhere-but-here look with a more natural expression.

Figure 5-6: If you can't photograph kids without getting playroom clutter in the scene, have them lie down on an empty swatch of carpet.

Figure 5-7: Getting down to eye level is another good tactic for shooting kid pics.

A Parallax! A Parallax!

You compose your photo perfectly. The light is fine, the focus is fine, and all other photographic planets appear to be in alignment. But after you snap your picture and view the image on the camera monitor, the framing is off, as though your subject repositioned itself while you weren't looking.

You're not the victim of some cruel digital hoax — just a photographic phenomenon known as a *parallax error*.

On most digital cameras, as on most point-and-shoot film cameras, the viewfinder looks out on the world through a separate window from the camera lens. Because the viewfinder is located an inch or so above or to the side of the lens, it sees your subject from a slightly different angle than the lens. But the image is captured from the point of view of the lens, not the viewfinder.

When you look through your viewfinder, you should see some lines near the corners of the frame. The lines indicate the boundaries of the frame as seen by the camera lens. Pay attention to these framing cues, or you may wind up with pictures that appear to have been lopped off along one edge, as in Figure 5-8.

The closer you are to your subject, the bigger the parallax problem becomes, whether you use a zoom lens or simply position the camera lens nearer to your subject. Some cameras provide a second set of framing marks in the viewfinder to indicate the framing boundaries that apply when you're shooting close-up shots. Check your camera manual to determine which framing marks mean what. (Some markings have to do with focusing, not framing.)

Figure 5-8:
My pal
Bernie loses
his ears as
the result of
a parallax
error.

If your camera has an LCD monitor, you have an additional aid for avoiding parallax problems. Because the monitor reflects the image as seen by the lens, you can simply use the monitor instead of the viewfinder to frame your image. On some cameras, the LCD monitor turns on automatically when you switch to macro mode for close-up shooting.

Let There Be Light

Digital cameras are extremely demanding when it comes to light. A typical digital camera has a light sensitivity equivalent to that of ISO 100 film. (ISO film ratings and their implications are discussed in Chapter 2.) As a result, image detail tends to get lost when objects are in the shadows. Too much light can also create problems. A ray of sunshine bouncing off a highly reflective surface can cause *blown highlights* — areas where all image detail is lost, resulting in a big white blob in your picture.

Color Plate 5-1 illustrates the problems that too much and too little light can create. In the lower-right corner of the image, where shadow falls over the scene, the detail and contrast suffer. On the other side of the scene, too much light in the upper-middle portion of the image causes blown highlights in the lemon. (The inset area provides a close-up view to give you a better look at this phenomenon.) In the upper-left corner of the image, where the light is neither too low nor too strong, the detail and contrast are excellent.

Capturing just the right amount of light involves not only deciding whether to use a flash or external photographic lights, but also figuring out the right exposure settings. The following sections address everything you need to know to capture a well-lit, properly exposed image.

Keep in mind that you can correct minor lighting and exposure problems in the image-editing stage. Generally speaking, making a too-dark image brighter is easier than correcting an overexposed (too bright) image. So if you can't seem to get the exposure just right, opt for a slightly underexposed image rather than an overexposed one.

Locking in (auto) exposure

Exposure refers to the amount of light captured by the camera. (Read Chapter 2 for a complete discussion of exposure.) Most consumer-level digital cameras feature *autoexposure,* sometimes known as *programmed autoexposure,* in which the camera reads the amount of light in the scene and then sets the exposure automatically for you.

In order for your camera's autoexposure mechanism to work correctly, you need to take this three-step approach to shooting your pictures:

1. **Frame your subject.**

2. **Press the shutter button halfway down and hold it there.**

 The camera analyzes the scene and sets the focus and exposure. (Upcoming sections discuss the focus side of the equation.) After the camera makes its decisions, it signals you in some fashion — usually with a blinking light near the viewfinder or with a beeping noise.

 If you don't want your subject to appear in the middle of the frame, you can recompose the image after locking in the exposure and focus. Just keep holding the shutter button halfway down as you reframe the image in your viewfinder. Don't move or reposition the subject before you shoot, or the exposure and focus may be out of whack.

3. **Press the shutter button the rest of the way down to take the picture.**

On lower-end cameras, you typically get a choice of two autoexposure settings — one appropriate for shooting in very bright light and another for average lighting. Many cameras display a warning light or refuse to capture the image if you've chosen an autoexposure setting that will result in a badly overexposed or underexposed picture. Higher-priced cameras give you more control over autoexposure, as discussed in the next few sections.

Choosing a metering mode

Some higher-priced digital cameras enable you to choose from several *metering modes.* (Check your manual to find out what buttons or menu commands to use to access the different modes.) In plain English, *metering mode* refers to the way in which the camera's autoexposure mechanism meters — measures — the light in the scene while calculating the proper exposure for your photograph. The typical options are as follows:

- **Matrix metering:** Sometimes known as *multizone metering,* this mode divides the frame into a grid (matrix) and analyzes the light at many different points on the grid. The camera then chooses an exposure that best captures both shadowed and brightly lit portions of the scene. This mode is typically the default setting and works well in most situations.

- **Center-weighted metering:** When set to this mode, the camera measures the light in the entire frame but assigns a greater importance — weight — to the center quarter of the frame. Use this mode when you're more concerned about how stuff in the center of your picture looks than stuff around the edges. (How's that for technical advice?)

- **Spot metering:** In this mode, the camera measures the light only at the center of the frame. Spot metering is helpful when the background is much brighter than the subject — for example, when you're shooting backlit scenes (subjects that are in front of the sun or another light source). In matrix or center-weighted metering mode, your subject may be underexposed because the camera reduces the exposure to account for the brightness of the background, as illustrated by the top two examples in Figure 5-9. For the top-left shot, I used matrix metering; for the top-right image, I used center-weighted metering.

When using spot-metering mode, compose your image so that your main subject is in the center of the frame and lock in the exposure and focus as explained in "Locking in (auto) exposure," earlier in this chapter. In the bottom example of Figure 5-9, I used this technique to properly expose the subject's face. See the section "Compensating for backlighting," later in this chapter, for other tricks for dealing with this shooting scenario.

Adjusting ISO

As you know if you explored Chapter 2, film is assigned an ISO number to indicate light sensitivity. The higher the number, the "faster" the film — meaning that it reacts more quickly to light, enabling you to shoot in dim lighting without a flash or to use a faster shutter speed or smaller aperture.

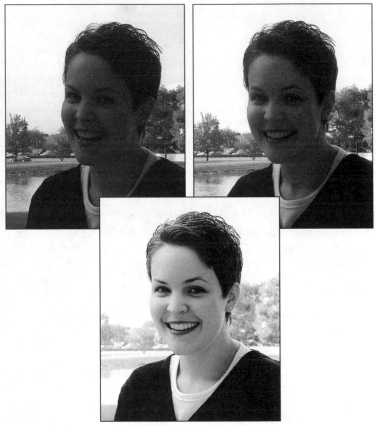

Figure 5-9:
Matrix
metering
(top left) and
center-
weighted
metering
(top right)
under-
exposed the
subject due
to the bright
background
light. Spot
metering
(bottom)
exposes the
image
based on
the light on
the subject's
face.

Some digital cameras also offer a choice of ISO settings, which theoretically gives you the same flexibility as working with different speeds of film. I say "theoretically" because raising the ISO has a downside that usually outweighs the potential advantage.

Pictures shot at a higher ISO tend to suffer from *noise,* which is a fancy way of referring to a speckled, grainy texture. Faster film also produces grainier pictures than slower film, but the quality difference seems to be greater when you shoot digitally. When you print pictures at a small size, the texture produced by the excess grain may not be apparent to the eye; instead, the image may have a slightly blurry look.

The twilight photos in Color Plate 5-2 illustrate the impact of ISO on quality. I took all four images in programmed autoexposure mode but used different ISO settings for each shot: 200, 400, 800, and 1600. As I doubled the ISO, the camera increased the shutter speed or reduced the aperture — or both — to produce the same exposure as at the lower ISO. But each shift up in ISO meant a step down in image quality.

For some shooting scenarios, you may be forced to use a higher ISO if you want to get the picture. Had I waited for the sun to recede a little further when taking my twilight shots, for example, the camera wouldn't have been able to produce a properly exposed photo at all at the lower ISO settings. And if you're trying to capture a moving subject, you may need to raise the ISO in order to use the fast shutter speed necessary to freeze the action.

The bottom line is this: Experiment with ISO settings if your camera offers them, and by all means, go with a higher ISO if the alternative is not getting the shot at all. But for best picture quality, keep the ISO at its lowest or next-to-lowest setting. (How far up you can go depends on the camera, so take some test shots to evaluate quality at each setting.)

Applying exposure compensation

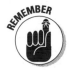

Exposure compensation, also referred to as EV *(exposure value)* adjustment, bumps the exposure up or down a few notches from what the camera delivers at the autoexposure setting.

How you get to the exposure compensation settings varies from camera to camera. But you typically choose from settings such as +0.7, +0.3, 0.0, –0.3, –0.7, and so on, with the 0.0 representing the default autoexposure setting.

A positive EV value increases the exposure, resulting in a brighter image. To decrease the exposure, choose a negative EV value.

Different cameras provide you with different ranges of exposure options, and the extent to which an increase or decrease in the exposure value affects your image also varies from camera to camera. Color Plate 5-3 shows you how a few exposure settings available on a Nikon digital camera affected a picture that I shot indoors, without a flash.

The top image in the color plate shows the exposure that the camera created when I set the EV value to 0.0. The middle row shows the same shot when I reduced the exposure by using a negative EV value; the bottom row shows what happened when I increased the exposure by using a positive EV value. Figure 5-10 offers a grayscale version of the EV 0.0 exposure along with the +1.0 and –1.0 settings.

This photo points up the benefits of exposure compensation. I wanted an exposure that was dark enough to allow the candle flame to create a soft glow and capture the contrast between the shadowed background areas and the bands of strong afternoon sunshine, which were coming in through the slats of a wooden blind. The non-adjusted exposure (labeled 0.0) was just a bit brighter than I had in mind. So I just played with the EV values until I came up with a mix of shadows and highlights that suited the subject. For my purposes, I liked the result I obtained with an EV setting of –0.3.

EV -1.0 EV 0.0 EV +1.0

Figure 5-10: By raising or lowering the EV value, you can adjust the auto-exposure mechanism to produce a lighter or darker image.

Don't forget that if your camera offers a choice of metering modes, you may want to experiment with changing the metering mode as well as using EV adjustment. Adjusting the metering mode changes the area of the frame that the camera considers when making its exposure decision. In the candle image, I used matrix metering mode.

Using aperture- or shutter-priority mode

Cameras at the higher end of the consumer-model price tier enable you to switch from regular autoexposure mode, where the camera sets both aperture and shutter speed, to *aperture-priority* autoexposure or *shutter-priority* autoexposure. These options work as follows:

✔ **Aperture-priority autoexposure:** This mode gives you control over the aperture. After setting the aperture, you frame your shot and then press the shutter button halfway down to set the focus and exposure, as you do when using programmed autoexposure mode. But this time, the camera checks to see what aperture you chose and then selects the shutter speed necessary to correctly expose the image at that aperture.

By altering the aperture, you can control depth of field — the range of sharp focus. The last section in this chapter explores this technique.

✔ **Shutter-priority autoexposure:** If you work in shutter-priority mode, you choose the shutter speed, and the camera selects the correct aperture. (If you're not sure what the terms *shutter speed* and *aperture* mean, check out Chapter 2.)

Theoretically, you should wind up with the same exposure no matter what aperture or shutter speed you choose, because as you adjust one value, the camera makes a corresponding change to the other value, right? Well, yes, sort of. Keep in mind that you're working with a limited range of shutter speeds and apertures (your camera manual provides information on available settings). So depending on the lighting conditions, the camera may not be able to properly compensate for the shutter speed or aperture that you choose.

Suppose that you're shooting outside on a bright, sunny day. You shoot your first picture at an aperture of f/11, and the picture looks great. Then you shoot a second picture, this time choosing an aperture of f/4. The camera may not be able to set the shutter speed high enough to accommodate the larger aperture, which means an overexposed picture.

Here's another example of how things can go wrong: Say that you're trying to catch a tennis player in the act of smashing a ball over the net on a gray, overcast day. You know that you need a high shutter speed to capture action, so you switch to shutter-priority mode and set the shutter speed to 1/300 second. But given the dim lighting, the camera can't capture enough light even at the largest aperture setting. So your picture turns out too dark.

As long as you keep the camera's shutter speed and aperture range in mind, however, switching to shutter-priority or aperture-priority mode can come in handy in the following scenarios:

- You can't get the camera to produce the exposure you want in programmed autoexposure mode or by playing with EV compensation adjustment (see the preceding section) or metering mode.

- You're trying to capture an action scene, and the shutter speed the camera selects in programmed autoexposure mode is too slow.

- You purposefully want to use a too-slow shutter speed so that your picture looks a little blurry, creating a sense of motion.

- You want to alter depth of field. Again, see the last section in this chapter for details on this possibility.

Adding a flash of light

If the techniques discussed in preceding sections don't deliver a bright enough exposure, you simply have to find a way to bring more light onto your subject. The obvious choice, of course, is to use a flash.

Most digital cameras, like point-and-shoot film cameras, have a built-in flash that operates in several modes. You typically can choose from these options:

- ✔ **Auto flash:** In this mode, which is usually the default setting, the camera gauges the available light and fires the flash if needed.

- ✔ **Fill flash:** This mode triggers the flash regardless of the light in the scene. Fill-flash mode is especially helpful for outdoor shots, such as the one in Figure 5-11. I shot the image on the left using the auto-flash mode. Because this picture was taken on a bright, sunny day, the camera didn't see the need for a flash. But I did because the shadow from the hat obscured the subject's eyes. Turning on the fill-flash mode threw some additional light on her face, bringing her eyes into visible range.

- ✔ **No flash:** Choose this setting when you don't want to use the flash, no way, no how. With digital photography, you may find yourself using this mode more than you may expect. Especially when you're shooting highly reflective objects, such as glass, a flash can cause blown high-lights. You usually get better results if you turn off the flash and use alternate light sources (as explained in the next section) or boost the exposure using your camera's exposure adjustments, if available. The upcoming section "Lighting shiny objects" offers more help with this problem.

 You may also want to turn off the flash simply because the quality of the existing light is part of what makes the scene compelling, as is the case in Figure 5-12. The interplay of shadows and light is the interesting aspect of the scene. You can almost feel the plant leaves straining to reach the late afternoon sun. Turn on the flash, and you have nothing more than a boring shot of your average plant on a stand.

 When you turn off the flash, remember that the camera may reduce the shutter speed to compensate for the dim lighting. That means that you need to hold the camera steady for a longer period of time to avoid blurry images. Use a tripod or otherwise brace the camera for best results.

- ✔ **Flash with red-eye reduction:** Anyone who's taken people pictures with a point-and-shoot camera — digital or film — is familiar with the so-called red-eye problem. The flash reflects in the subject's eyes, and the result is a demonic red glint in the eye. Red-eye reduction mode aims to thwart this phenomenon by firing a low-power flash before the "real" flash goes off or by lighting a little lamp for a second or two prior to capturing the image. The idea is that the prelight, if you will, causes the iris of the eye to shut down a little, thereby lessening the chances of a reflection when the final flash goes off.

Unfortunately, red-eye reduction on digital cameras doesn't work much better than it does on film cameras. Often, you still wind up with fire in the eyes — hey, the manufacturer only promised to *reduce* red eye, not eliminate it, right? Worse, your subjects sometimes think the preflash or light is the real flash and start walking away just when the picture is actually being captured. So if you shoot with red-eye mode turned on, be sure to explain to your subjects what's going to happen.

Figure 5-11: An outdoor image shot without a flash (left) and with a flash (right).

Figure 5-12: Turn off the flash to capture an interesting interplay of shadows and light.

The good news is that, because you're shooting digitally, you can edit out those red eyes in your image-editing software. Use the cloning or painting techniques that I discuss in Chapters 11 and 12 to make your red eyes blue (or black, gray, green, or brown, as the case may be).

✔ **Slow-sync flash:** A few higher-end cameras offer this variation on the auto-flash mode. Slow-sync flash increases the exposure time beyond what the camera normally sets for flash pictures. With a normal flash, your main subject may be illuminated by the flash, but background elements beyond the reach of the flash may be obscured by darkness. With slow-sync flash, the longer exposure time helps make those background elements brighter.

✔ **External flash:** Another high-end option enables you to use a separate flash unit with your digital camera, just as you can with a 35mm SLR and other high-end film cameras. In this mode, the camera's on-board flash is disabled, and you must set the correct exposure to work with your flash. This option is a great one for professional photographers and advanced photo hobbyists who have the expertise and equipment to use it; check your camera manual to find out what type of external flash works with your camera and how to connect the flash.

If your camera has a built-in flash but doesn't offer an accessory off-camera flash connection, you can get the benefits of an external flash by using so-called "slave" flash units. These small, self-contained, battery-operated flash units have built-in photo eyes that trigger the supplemental flash when the camera's flash goes off. If you're trying to photograph an event in a room that's dimly lit, you can put several slave units in different places. All the units will fire when you take a picture anywhere in the room.

But it looked good in the LCD!

If your camera has an LCD monitor, you can get a good idea of whether your image is properly exposed by reviewing it in the monitor. But don't rely entirely on the monitor, because it doesn't provide an absolutely accurate rendition of your image. Your actual image may be brighter or darker than it appears on the monitor, especially if your camera enables you to adjust the brightness of the monitor display.

To make sure that you get at least one correctly exposed image, *bracket* your shots if your camera offers exposure-adjustment controls. Bracketing means to record the same scene at several different exposure settings. Some cameras even offer an automatic bracketing feature that records multiple images, each at a different exposure, with one press of the shutter button.

Switching on additional light sources

Although your camera's flash offers one alternative for lighting your scene, flash photography isn't problem-free. When you're shooting your subject at close range, a flash can cause blown highlights or leave some portions of the image looking overexposed. A flash can also lead to red-eyed people, as discussed in the preceding section.

Some digital cameras can accept an auxiliary flash unit, which helps reduce blown highlights and red eye because you can move the flash farther away from the subject. But if your camera doesn't offer this option, you usually get better results if you turn off the flash and use another light source to illuminate the scene.

If you're a well-equipped film photographer and you have studio lights, go dig them up. Or you may want to invest in some inexpensive photoflood lights — these are the same kind of lights used with video camcorders and are sometimes called "hot" lights because they "burn" continuously.

But you really don't need to go out and spend a fortune on lighting equipment. If you get creative, you can probably figure out a lighting solution using stuff you already have around the house. For example, when shooting small objects, I sometimes clear off a shelf on the white bookcase in my office. A nearby window offers a perfect natural light source.

For shots where I need a little more space, I sometimes use the setup shown in Figure 5-13. The white background is nothing more than a cardboard presentation easel purchased at an art and education supply store — teachers use these things to create classroom displays. I placed another white board on the table surface.

The easel and board brighten up the subject because they reflect light onto it. If I need still more light, I switch on a regular old desk lamp or a small clip-on shop light (the kind you buy in hardware stores). And if I want a colored background instead of a white one, I clip a piece of colored tissue paper, also bought at that education supply store, onto the easel. A solid-colored tablecloth or even a bed sheet works just as well as a background drape.

Okay, so professional photographers and serious amateurs will no doubt have a good laugh at these cheap little setups. But I say, whatever works, works. Besides, you've already spent a good sum of money on your camera, so why not save a few bucks where you can?

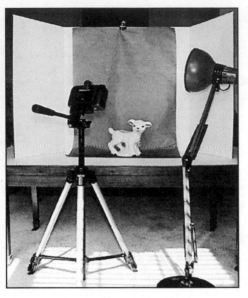

Figure 5-13:
You can create a makeshift studio using nothing more than a sunny window, a white presentation easel, a tripod, and a household lamp.

When using an artificial light source, whether it is a true-blue photography light or a makeshift solution like a desk lamp, you get better results if you don't aim the light directly at the object you're photographing. Instead, aim the light at the background and let the light bounce off that surface onto your subject. For example, when using a setup like the one in Figure 5-13, you might aim the light at one of the side panels. This kind of lighting is called *bounce lighting,* in case you're curious.

Because different light sources have different *color temperatures* (contain different amounts of red, green, and blue light), lighting a subject both with sunlight and an artificial light source, as shown in Figure 5-13, can confuse your camera. If your pictures exhibit an unwanted color cast, try changing your camera's white-balance setting to fix the problem. Alternatively, you can buy some daylight photo flood bulbs to get the color temperature of your artificial lights more in sync with the daylight shining through the window. For more details about white balance, check out Chapter 6.

Lighting shiny objects

When you shoot shiny objects such as jewelry, glass, chrome, and porcelain, lighting presents a real dilemma. Any light source that shines directly on the object can bounce off the surface and cause blown highlights, as shown in the left image in Figure 5-14. In addition, the light source or other objects in the room may be reflected in the surface of the object you want to shoot.

Figure 5-14:
Shooting
with a built-
in flash
creates
blown
highlights
(left);
abandoning
the flash
and working
with a
diffused
light source
solves the
problem
(right).

Professional photographers invest in expensive lighting setups and studio backdrops to avoid these problems when shooting product shots like the one in Figure 5-14. If you're not in the professional category — or just don't have a huge budget for outfitting a studio — try these tricks to get a decent pictures of shiny stuff:

- First, turn off your camera's built-in flash and find another way to light the object. The built-in flash will create a strong, focused light source that's bound to create problems. See earlier sections in this chapter to find out how various digital camera features may enable you to get a good exposure without using a flash.

- Find a way to diffuse the lighting. Placing a white curtain or sheet between the light source and the object can not only soften the light and help prevent blown highlights, but also prevent unwanted reflections.

- If you regularly need to photograph small to medium-sized shiny objects, you may want to invest in a product like the Cloud Dome, shown in Figure 5-15. You put the objects you want to shoot under the dome and then attach your camera to a special mount, centering the camera lens over a hole in the top of the dome. The dome diffuses the light sources and eliminates reflections. In addition, the mount stabilizes the camera, eliminating camera shake that can cause a blurred image.

The Cloud Dome shown here sells for $275 (visit www.clouddome.com); less expensive models are available, as are extenders that allow for shooting taller or wider objects. The price may seem a little steep at first, but if you do a lot of this type of photography, the amount of time and frustration it can save may be well worth your investment.

Figure 5-15:
Devices like the Cloud Dome make shooting glass, jewelry, and other reflective objects easier.

Compensating for backlighting

A *backlit* picture is one in which the sun or light source is behind the subject. With autoexposure cameras, strong backlighting often results in too-dark subjects because the camera sets the exposure based on the light in the overall scene, not just on the light falling on the subject. The left image in Figure 5-16 is a classic example of a backlighting problem.

To remedy the situation, you have several options:

✔ Reposition the subject so that the sun is behind the camera instead of behind the subject.

✔ Reposition yourself so that you're shooting from a different angle.

✔ Use a flash. Adding the flash can light up your subjects and bring them out of the shadows. However, because the working range of the flash on most consumer digital cameras is relatively small, your subject must be fairly close to the camera for the flash to do any good.

✔ If the backlighting isn't terribly strong and your camera offers exposure compensation, try raising the EV value, as explained in "Applying exposure compensation," earlier in this chapter. Check your camera's manual for information on using exposure compensation controls and other exposure options described elsewhere in this chapter.

Keep in mind that while increasing the exposure may brighten up your subjects, it may also cause the already bright portions of the scene to appear overexposed.

✔ If your camera offers a choice of metering modes, switch to spot-metering or center-weighted metering. Check out "Choosing a metering mode," earlier in this chapter, for information about metering modes.

✔ On cameras that don't offer spot- or center-weighted metering, meaning that the camera considers the light throughout the frame when setting the exposure, you can try to "fool" the autoexposure meter. Fill the frame with a dark object, press the shutter button halfway down to lock in the exposure, reframe the subject, and press the shutter button the rest of the way down to take the picture.

Because the focus is also set when you press the shutter button halfway, be sure that the dark object you're using to set the exposure is the same distance from the camera as your real subject. Otherwise, the focus of the picture will be off.

Figure 5-16: Backlighting can cause your subjects to appear lost in the shadows (left). Adjusting the exposure or using a flash can compensate for backlighting (right).

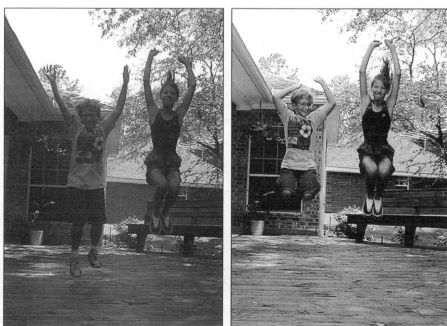

In the image on the right in Figure 5-16, I increased the exposure slightly and also used a flash. The image still isn't ideal — the subjects are still too dimly lit for my taste, and some regions border on being overexposed — but it's a vast improvement over the original. A little bit of additional brightness adjustment in a photo-editing program could improve things even more. To fix this image, I would raise the brightness level of the foreground subjects only, leaving the sky untouched. For information on this kind of image correction, see Chapters 10 and 11.

Excuse me, can you turn down the sun?

Adding more light to a scene is considerably easier than reducing the light. If you're shooting outdoors, you can't exactly hit the dimmer switch on the sun. If the light is too strong, you really have only a few options. You can move the subject into the shade (in which case you can use a fill flash to light the subject), or, on some cameras, reduce the exposure by lowering the EV value.

If you can't find a suitable shady backdrop, you can create one with a piece of cardboard. Just have a friend hold the cardboard between the sun and the subject. Voilà — instant shade. By moving the cardboard around, you can vary the amount of light that hits the subject.

Focus on Focus

Like point-and-shoot film cameras, digital cameras for the consumer market provide focusing aids to help you capture sharp images with ease. The following sections describe the different types of focusing schemes available and explain how to make the most of them.

Working with fixed-focus cameras

Fixed-focus cameras are just that — the focus is set at the factory and can't be changed. The camera is designed to capture sharply any subject within a certain distance from the lens. Subjects outside that range appear blurry.

Fixed-focus cameras sometimes are called *focus-free* cameras because you're free of the chore of setting the focus before you shoot. But this term is a misnomer, because even though you can't adjust the focus, you have to remember to keep the subject within the camera's focusing range. There is no such thing as a (focus) free lunch.

Be sure to check your camera manual to find out how much distance to put between your camera and your subject. With fixed-focus cameras, blurry images usually result from having your subject too close to the camera. (Most fixed-focus cameras are engineered to focus sharply from a few feet away from the camera to infinity.)

Taking advantage of autofocus

Most digital cameras offer autofocus, which means that the camera automatically adjusts the focus after measuring the distance between lens and subject. But "autofocusing" isn't totally automatic. For autofocus to work, you need to "lock in" the focus before you shoot the picture, as follows:

1. **Frame the picture.**

2. **Press the shutter button halfway down and hold it there.**

 Your camera analyzes the picture and sets the focus. If your camera offers autoexposure — as most do — the exposure is set at the same time. After the exposure and focus are locked in, the camera lets you know that you can proceed with the picture. Usually, a little light blinks near the viewfinder or the camera makes a beeping noise.

3. **Press the shutter button the rest of the way down to take the picture.**

Although autofocus is a great photography tool, you need to understand a few things about how your camera goes about its focusing work in order to take full advantage of this feature. Here's the condensed version of the autofocusing manual:

✔ Autofocus mechanisms fall into one of two main categories:

- **Single-spot focus:** With this type of autofocus, the camera reads the distance of the element that's at the center of the frame in order to set the focus.

- **Multi-spot focus:** The camera measures the distance at several spots around the frame and sets focus relative to the nearest object.

You need to know how your camera adjusts focus so that when you lock in the focus (using the press-and-hold method just described), you place the subject within the area that the autofocus mechanism will read. If the camera uses single-spot focusing, for example, you should place your subject in the center of the frame when locking the focus. Some cameras enable you to choose which type of focusing you want to use for a particular shot; check your camera manual for details.

✔ If your camera offers single-spot focus, you may see little framing marks in the viewfinder that indicate the focus point. Check your camera manual to see what the different viewfinder marks mean. On some cameras, the marks are provided to help you frame the picture rather than as a focusing indicator. (See the section "A Parallax! A Parallax!" earlier in this chapter for more information.)

✔ After you lock in the focus, you can reframe your picture if you want. As long as you keep the shutter button halfway down, the focus remains locked. Be careful that the distance between the camera and the subject doesn't change, or your focus will be off.

✔ Some cameras that offer autofocus also provide you with one or two manual-focus adjustments. Your camera may offer a *macro mode* for close-up shooting and an *infinity lock* or *landscape mode* for shooting subjects at a distance, for example. When you switch to these modes, autofocusing may be turned off, so you need to make sure that your subject falls within the focusing range of the selected mode. Check your camera's manual to find out the proper camera-to-subject distance.

Focusing manually

On most consumer digital cameras, you get either no manual-focusing options or just one or two options in addition to autofocus. You may be able to choose a special focus setting for close-up shooting and one for faraway subjects.

But a few high-end cameras offer more extensive manual focusing controls. Although some models offer a traditional focusing mechanism where you twist the lens barrel to set the focus, most cameras require you to use menu controls to select the distance at which you want the camera to focus.

The ability to set the focus at a specific distance from the camera comes in handy when you want to shoot several pictures of one, nonmoving subject. By setting the focus manually, you don't have to go to the trouble of locking in the autofocus for each shot. Just be sure that you've accurately gauged the distance between camera and subject when setting the manual-focus distance.

If you're using manual focus for close-up shooting, get out a ruler and make sure that you have the correct camera-to-subject distance. You can't get a good idea of whether the focus is dead-on from the viewfinder or LCD, and being just an inch off in your focus judgment can mean a blurry picture.

Hold that thing still!

A blurry image isn't always the result of poor focusing; you can also get fuzzy shots if you move the camera during the time the image is being captured.

Holding the camera still is essential in any shooting situation, but it becomes especially important when the light is dim because a longer exposure time is needed. That means that you have to keep the camera steady longer than you do when shooting in bright light.

To help keep the camera still, try these tricks:

✔ Press your elbows against your sides as you snap the picture.

✔ Squeeze, don't jab, the shutter button. Use a soft touch to minimize the chance of moving the camera when you press the shutter button.

✔ Place the camera on a countertop, table or other still surface. Better yet, use a tripod. You can pick up an inexpensive tripod for about $20.

✔ If your camera offers a self-timer feature, you can opt for hands-free shooting to eliminate any possibility of camera shake. Place the camera on a tripod (or other still surface), set the camera to self-timer mode, and then press the shutter button (or do whatever your manual says to activate the self-timer mechanism). Then move away from the camera. After a few seconds, the camera snaps the picture for you automatically.

Of course, if you're lucky enough to own a camera that offers remote-control shooting, you can take advantage of that feature instead of the self-timer mode.

Shifting Depth of Field

If you're an experienced photographer, you probably know that one aspect of focusing — depth of field — is controlled in part by the aperture setting you use when shooting the picture. Depth of field refers to how much of an image is in sharp focus. The larger the depth of field, the greater the zone of sharp focus.

Figure 5-17 shows an example of how aperture affects depth of field. For both pictures, I used the camera's macro focusing mode. But I shot the left image with an aperture setting of f/3.4 and the right image with an aperture of f/11.

In the left image, only objects very close to the front tulip are sharply focused — in other words, the picture has a short depth of field. Reducing the aperture increased the depth of field, bringing more surrounding flowers into focus. (Remember, a higher f-stop number means a smaller aperture.)

f/3.4 f/11

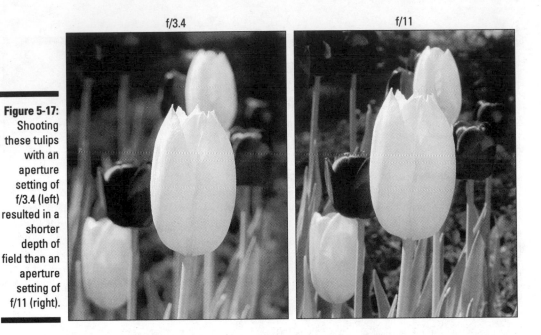

Figure 5-17:
Shooting
these tulips
with an
aperture
setting of
f/3.4 (left)
resulted in a
shorter
depth of
field than an
aperture
setting of
f/11 (right).

Because digital cameras typically don't have as wide a range of aperture settings as film cameras, you may not be able to alter depth of field to the same degree as you can with an SLR film camera. But as you can see from Figure 5-17, you still can produce a pronounced shift in depth of field. Note that zooming in on a subject also changes the depth of field; for more about this issue, see Chapter 6.

If your digital camera doesn't offer aperture control or a zoom lens, you can use your photo editor's blur filters, discussed in Chapter 10, to create the effect of a short depth of field in an existing picture.

Chapter 6

Digicam Dilemmas (And How to Solve Them)

. .

In This Chapter

▶ Choosing the right resolution and compression settings

▶ Getting your whites to be white

▶ Composing for digital creativity

▶ Devoting more pixels to your subject

▶ Working with optical and digital zoom

▶ Capturing action

▶ Shooting panoramas

▶ Avoiding grainy images

▶ Dealing with other digital quirks

. .

Most of the tips and techniques in Chapter 5 apply not just to digital photography, but to film photography as well. This chapter is different.

Here, you find out how to tackle some of the challenges that are unique to digital photography. You also discover how to alter your shooting strategy to take advantage of the many new possibilities that are open to you now that you've gone digital.

In other words, it's time to look at photography from a pixel perspective.

Dialing In Your Capture Settings

Before you press the shutter button or even compose your image, you need to make a few decisions about how you want the camera to capture and store

your images. Most digital cameras offer you a choice of image resolution and compression settings, and some cameras also enable you to store the image in one or two different file formats.

The following sections help you come to the right conclusions about your camera's resolution, compression, and file-format options.

Setting the capture resolution

Depending on your camera, you may be able to select from two or more image resolution settings. These settings determine how many horizontal and vertical pixels the image will contain, not pixels per inch (ppi). You set this second value in your photo editor before you print one of your digital pictures. (See Chapter 2 for the complete story on all this resolution stuff.)

On some cameras, resolution values are specified in pixels — 640 x 480, for example — with the horizontal pixel count always given first. But on other cameras, the different resolution settings go by such vague names as Basic, Fine, Superfine, and so on.

Your camera manual should spell out exactly how you go about changing the image resolution and how many pixels you get with each setting. You should also find information on how many images you can store per megabyte of camera memory at each setting.

When setting the camera resolution, consider the final output of the image. For Web or on-screen pictures, you can get by with 640 x 480 pixels or even 320 x 240 pixels. But if you want to print your picture, choose the capture setting that comes closest to giving you the output resolution — pixels per inch, or ppi — that your printer manual recommends.

For example, suppose that you camera offers the following resolution options: 640 x 480, 1024 x 768, and 1600 x 1200. Your printer manual tells you that the optimum output resolution for quality prints is 300 pixels per inch. If you capture the image at the lowest resolution, the print size at 300 ppi is around 2 inches wide by 1.6 inches tall. At 1024 x 768, you get a print size of about 3.4 x 2.5 inches; at 1600 x 1200, about 5 x 4. (These are just loose guidelines; you may be able to get good prints with fewer pixels per inch.)

Of course, the more pixels, the bigger the picture file and the more memory your image consumes. So if your camera has limited memory and you're shooting at a location where you won't be able to download images, you may want to choose a lower resolution setting so that you can fit more pictures into the available memory. Alternatively, you can select a higher degree of image compression (discussed in the next section) to reduce file size.

On some cameras, capture resolution is lowered automatically when you use certain features. For example, many cameras provide a burst mode that enables you to record a series of images with one press of the shutter button (see "Catching a Moving Target," later in this chapter). When you use this mode, most cameras reduce the capture resolution to 640 x 480 pixels or lower. Cameras that offer a choice of ISO settings also typically limit resolution at the highest settings. (Chapter 2 explains ISO.)

Choosing a compression setting

Your camera probably provides a control for choosing the amount of *compression* that is applied to your images. You can read more about compression in Chapter 3, but in short, compression trims some data out of an image file so that its file size is reduced.

Lossless compression removes only redundant image data so that any change in image quality is virtually undetectable. But because lossless compression often doesn't result in a significant shrinking of file size, most digital cameras use *lossy compression,* which is less discriminating when dumping data. Lossy compression is great at reducing file size, but you pay the price in reduced image quality. The more compression you apply, the more your image suffers. Color Plate 3-1 provides an example of how different compression amounts affect image quality.

Typically, compression settings are given the same vague monikers as resolution settings: Good/Better/Best or High/Normal/Basic, for example. Remember that these names refer not to the type or amount of compression being applied, but to the resulting image quality. If you set your camera to the Best setting, for example, the image is less compressed than if you choose the Good setting. Of course, the less you compress the image, the larger its file size, and the fewer images you can fit in the available camera memory.

Because all cameras provide different compression options, you need to consult your manual to find out what the options on your particular model do. Typically, you find a chart in the manual that indicates how many images you can fit into a certain amount of memory at different compression settings. But you need to experiment to find out exactly how each setting affects picture quality. Shoot the same image at several different compression settings to get an idea of how much damage you do to your pictures if you opt for a higher degree of compression. If your camera offers several capture resolution settings, do the compression test for each resolution setting.

As you choose your capture settings, remember that pixel count and compression work in tandem to determine file size and image quality. Tons of pixels and minimum compression mean big files and maximum quality. Fewer pixels and maximum compression mean smaller files and lesser quality.

Selecting a file format

Some cameras enable you to select from a few different file formats — JPEG, TIFF, and so on. (Chapter 7 explains these and other file formats in detail.) Some cameras also provide a proprietary format — that is, a format unique to the camera — along with the more standard formats.

When deciding on a file format, consider these factoids:

✔ Some file formats result in larger image files than others because of the structure of the data in the file or the amount of compression that's applied.

If that sounds sort of vague, well, it is. I suggest that you shoot the same image using the different file formats available on your camera. Then transfer the pictures to your computer and compare the file size of each image. Now you know what format to use when you want to stuff the maximum number of images in your camera's available memory.

✔ The format you select may affect image quality. So give each of your test images a close-up inspection. Does one picture look sharper than the other? Is one a little jaggedy in areas where the other looks fine? When picture quality is a priority, choose the file format that gives you the best-looking images.

Keep in mind, though, that you pay for better picture quality with larger file sizes. For example, some cameras enable you to store images as TIFF files with no compression or as JPEG files with some compression. Although you undoubtedly get better image quality from the TIFF option, the number of pictures you can take before you fill up your available camera memory will be much lower than if you select JPEG.

✔ All other things being equal, choose a standard file format, such as JPEG or TIFF, over a camera's proprietary image format. Why? Because most proprietary formats aren't supported by image-editing and image-cataloging programs. So before you can edit or catalog your pictures, you have to take the extra step of converting them to a standard file format using the software that came with your camera.

If you're transferring your images to your computer using a cable connection, you can often perform the format conversion at the same time you download (check your camera's software manual for format information and see Chapter 7 for more information on this process). But if you're transferring pictures via a floppy disk, floppy-disk adapter, or memory-card reader, storing your images in a standard format rather than the proprietary format means that you can open the files on your disk or memory card immediately, without doing any conversion.

> ✔ A few cameras provide you with the option of storing images in the FlashPix file format. Developed a few years ago, FlashPix was once touted as the ideal solution for digital images. Although the concept behind FlashPix was intriguing, the format never took hold and appears now to be dead in its tracks. As a result, few cataloging and image-editing programs can work with FlashPix files. So stay away from this format unless your software welcomes FlashPix files with open arms.

Balancing Your Whites and Colors

Different light sources have varying *color temperatures,* which is a fancy way of saying that they contain different amounts of red, green, and blue light.

Color temperature is measured on the Kelvin scale, a fact that you don't really need to remember unless you want to dish with experienced film or video photographers, who sometimes toss the term into their conversations.

Anyway, the color temperature of the light source affects how a camera — video, digital, or film — perceives the colors of the objects being photographed. If you've taken pictures in fluorescent lighting, you may have noticed a slight green tint to your photographs. The tint comes from the color of fluorescent light.

Film photographers use special films or lens filters designed to compensate for different light sources. But digital cameras, like video cameras, get around the color-temperature problem using a process known as *white balancing.* White balancing simply tells the camera what combination of red, green, and blue light it should perceive as pure white, given the current lighting conditions. With that information as a baseline, the camera can then accurately reproduce all the other colors in the scene.

On most digital cameras, white balancing is handled automatically. But many higher-end models provide manual white-balance controls as well. Why would you want to make manual white-balance adjustments? Because sometimes automatic white balancing doesn't go quite far enough in removing unwanted color casts. If you notice that your whites aren't really white or that the image has an unnatural tint, you can sometimes correct the problem by choosing a different white-balance setting.

Typically, you can choose from the following manual settings:

- ✔ Daylight or Sunny, for shooting outdoors in bright light
- ✔ Cloudy, for shooting outdoors in overcast skies
- ✔ Fluorescent, for taking pictures in fluorescent lights, such as those found in office buildings
- ✔ Tungsten, for shooting under incandescent lights (standard household lights)
- ✔ Flash, for shooting with the camera's on-board flash

Color Plate 6-1 gives you an idea of how image colors are affected by white-balance settings. I took these pictures with a Nikon digital camera. Normally, the automatic white-balance feature on this camera, as on other cameras, works pretty well. But this shooting location threw the camera a curve because the subject is lit by three different light sources. Like most office buildings, the one in which this picture was taken has fluorescent lights, which light the subject from above. To the subject's left (the right side of the picture), bright daylight was shining through a large picture window. And just to make things even more complicated, I switched on the camera's flash.

The image has a slightly yellowish cast at the Automatic setting. That's because in the Automatic mode, the camera I was using selects the Flash white-balance setting when the flash is turned on (which is why the results of the Flash mode and the Automatic mode are the same in the Color Plate). But the Flash mode balances colors for the temperature of the flash only and doesn't account for the two other light sources hitting the subject. In my shooting scenario, the Fluorescent setting achieved the most accurate color balance, with the Sunny option coming in a close second.

 Although white-balance controls are designed to improve color accuracy, some digital photographers use them to mimic the effects produced by traditional color filters, such as a warming filter. As illustrated by Color Plate 6-1, you can get a variety of takes on the same scene simply by varying the white-balance setting. How each setting affects your image colors depends on the lighting conditions in your scene.

If your camera doesn't offer white-balance adjustment or you just forget to think about this issue when you're shooting, you can remove unwanted color casts or give your picture a warmer or cooler tone in the photo-editing stage. Chapter 10 gives you information on color adjustments.

Composing for Compositing

For the most part, the rules of digital image composition are the same rules that film photographers have followed for years. But when you're creating digital images, you need to consider an additional factor: how the image will be used. If you want to be able to lift part of your picture out of its background — for example, in order to paste the subject into another image — pay special attention to the background and framing of the image.

Digital-imaging gurus refer to the process of combining two images as *compositing,* by the way.

Suppose that you're creating a product brochure and you want to create a photo montage that combines images of four products. To make life easier in the photo-editing stage, shoot each product against a plain background. That way, you can easily separate the product from the background when you're ready to cut and paste the product image into your montage.

As explained in Chapter 11, you must *select* an element before you can lift it out of its background and paste it into another picture. Selecting simply draws an outline around the element so that the computer knows which pixels to cut and paste. So why does shooting your subject against a plain background make the job easier? Because most photo editors offer a tool that enables you to click a color in your image to automatically select surrounding areas that are similarly colored. If you shoot your subject against a red backdrop, for example, you can select the background by clicking on a red background pixel. You then can invert (reverse) the selection to easily select the subject.

If you shoot the object against a complex background, like the one in Figure 6-1, you lose this option. You have to draw your selection outline manually by tracing around it with your mouse. Selecting an image "by hand" is a fairly difficult proposition for most folks, especially when working with a mouse.

All of this selection stuff is explained more thoroughly in Chapter 11, but for now, just remember that if you want to separate an object from its background in the editing stage, shoot the object against a plain background, as in Figure 6-2. Make sure that the background color is distinct from the colors around the *perimeter* of the subject, not the interior, if you have a multicolor subject such as the camera in Figure 6-2. I shot the camera against a dark background to provide the greatest contrast to the silver edges of the camera.

See Color Plate 12-2 for another look at this concept. I knew that I wanted to cut and paste each of the objects into a montage, so I chose contrasting backgrounds when shooting the pictures. (In some cases, a white background would work better than the colors I chose, but I didn't want to bore you with a page full of white backgrounds when you're paying for living color.)

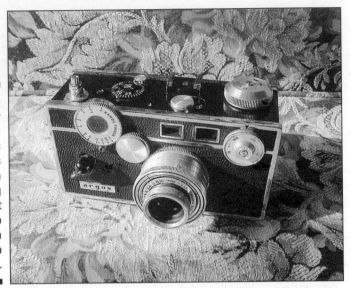

Figure 6-1:
Avoid busy back-grounds such as this one when shooting objects that you plan to use in a photo collage.

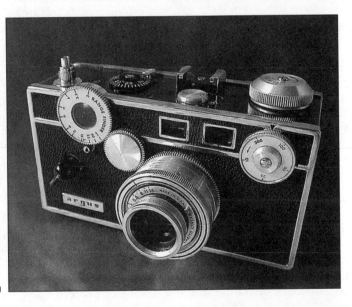

Figure 6-2:
Shoot collage elements against a plain, contrasting background and fill as much of the frame as possible with the object.

Another important rule of shooting images for compositing is to fill as much of the frame as possible with your subject, as I did in Figure 6-2. That way, you devote the maximum number of pixels to your subject, rather than wasting them on a background that you're going to trim away. The more pixels you have, the better the print quality you can achieve. (See Chapter 2 for more information on this law of digital imaging.)

While we're on the subject of creating photographic collages, make it a point on your next photographic expedition to look for surfaces that you can use as backgrounds in your composite images. For example, a close-up of a nicely colored marble tile or a section of weathered barn siding can serve as an interesting background in a montage, as illustrated by Color Plate 11-2.

Zooming In without Losing Out

Many digital cameras offer zoom lenses that enable you to get a close-up perspective on your subject without going to the bother of actually moving toward the subject.

Some cameras provide an *optical zoom,* which is a true zoom lens, just like the one you may have on your film camera. Other cameras offer a *digital zoom,* which isn't a zoom lens at all but a bit of pixel sleight of hand. The next two sections offer some guidelines for working with both types of zooms.

Shooting with an optical (real) zoom

If your camera has an optical zoom, keep these tips in mind before you trigger that zoom button or switch:

✔ The closer you get to your subject, the greater the chance of a parallax error. Chapter 5 explains this phenomenon fully, but in a nutshell, parallax errors cause the image you see in your viewfinder to be different from what your camera's lens sees and records. To make sure that you wind up with the picture you have in mind, frame your picture using the LCD monitor instead of the viewfinder. You can alternatively frame your subject using the framing marks in your viewfinder; check your camera's manual to find out which marks apply for zoom shooting.

✔ When you zoom in on a subject, you can fit less of the background into the frame than if you zoom out and get your close-up shot by moving nearer to the subject, as illustrated by Figure 6-3. In the case of this shot, zooming enabled me to fill the frame without including the less-than-attractive porch area behind the flowers.

✔ Zooming to a telephoto setting also tends to make the background blurrier than if you shoot close to the subject. This happens because the *depth of field* changes when you zoom. Depth of field simply refers to the zone of sharp focus in your photo. With a short depth of field — which is what you get when you're zoomed in — elements that are close to the camera are sharply focused, but distant background elements are not. When you zoom to a wide-angle lens setting, you have a greater depth of field, so faraway objects may be as sharply focused as your main

subject. Notice that the bricks in the left portion of Figure 6-3 — the zoomed image — are less sharply focused than those in the right image. This effect would be even more pronounced if the flowers were situated farther from the bricks.

Keep in mind that varying the camera's aperture setting also affects depth of field. See the last section in Chapter 5 for details.

Using a digital zoom

Some cameras put a new twist on zooming, providing a *digital zoom* rather than an optical zoom. With digital zoom, the camera enlarges the elements at the center of the frame to create the *appearance* that you've zoomed in.

Say that you want to take a picture of a boat that's bobbing in the middle of a lake. You decide to zoom in on the boat and lose the watery surroundings. The camera crops out the lake pixels and then enlarges and resamples the boat area to fill the frame. The end result is no different than if you had captured both boat and lake, cropped the lake away in your photo software, and then enlarged and resampled the remaining boat image. In addition, a digital zoom doesn't produce the same change in depth of field as an optical zoom. (See the preceding section for details on this issue.)

Figure 6-3:
Zooming in on a subject (left) means less background in the frame than zooming out and moving closer to the subject (right).

Given that a digital zoom doesn't provide anything you couldn't achieve in your photo software, why use it? Well, if you aren't going to have the opportunity to edit the picture in your photo software before you need to print or e-mail it, you can rely on digital zoom to achieve the framing and image size you want. Otherwise, ignore the feature and do your cropping and enlarging in your photo software. You'll likely find that your photo software does a better job of retaining image quality than your camera (although you need to test that theory with your camera and software).

Catching a Moving Target

Capturing action with most digital cameras isn't an easy proposition. As you may recall if you read Chapter 2, digital cameras need plenty of light to produce good images. Unless you're shooting in a very brightly lit setting, the shutter speed required to properly expose the image may be too slow to "stop" action — that is, to record a non-blurry image of a moving target.

Compounding the problem, the camera needs a few seconds to establish the autofocus and autoexposure settings before you shoot, plus a few seconds after you shoot to process and store the image in memory. If you're shooting with a flash, you also must give the flash a few seconds to recycle between pictures.

Some cameras offer a rapid-fire option, usually known as *burst mode* or *continuous capture mode,* that enables you to shoot a series of images with one press of the shutter button. The camera takes pictures at timed intervals as long as you keep the shutter button pressed. This feature eliminates some of the lag time that occurs from the moment you press the shutter button until the time you can take another picture. I used the burst mode on a Kodak digital camera to record the series of images in Figure 6-4.

If your camera offers burst-mode shooting, check to find out whether you can adjust the settings to capture more or fewer images within a set period of time. To capture the images in Figure 6-4, for example, I set the camera to its fastest burst mode, three frames per second.

Keep in mind that most cameras can shoot only low- or medium-resolution pictures in burst mode (high-resolution pictures would require a longer storage time). And the flash is typically disabled for this capture mode. More importantly, though, timing the shots so that you catch the height of the action is difficult. Notice that in Figure 6-4, I didn't capture the most important moment in the swing — the point at which the club makes contact with the ball! If you're interested in recording just one particular moment, you may be better off using a regular shooting mode so that you have better control over when each picture is taken.

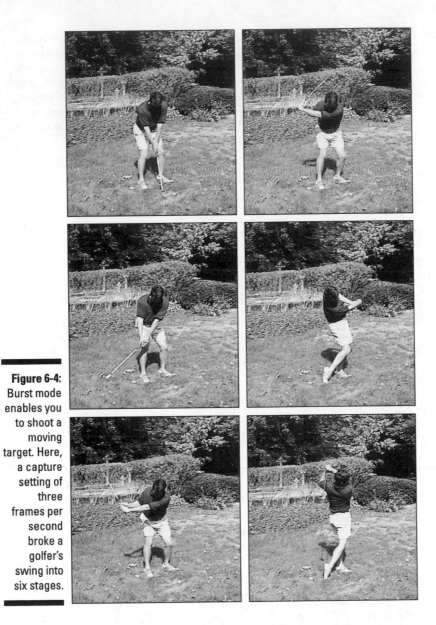

Figure 6-4:
Burst mode
enables you
to shoot a
moving
target. Here,
a capture
setting of
three
frames per
second
broke a
golfer's
swing into
six stages.

When you're shooting action shots "the normal way" — that is, without the help of burst mode — use these tricks to do a better job of stopping a moving subject in its tracks:

TIP

- Lock in focus and exposure in advance. Press the shutter button halfway down to initiate the autofocus and autoexposure process (if your camera offers these features) well ahead of the time when you want to capture the image. That way, when the action happens, you don't have to wait for the focus and exposure to be set. When locking in the focus and exposure, aim the camera at an object or person approximately the same distance away and in the same lighting conditions as your final subject will be. See Chapter 5 for more information about locking in focus and exposure.

- Anticipate the shot. With just about any camera, there's a slight delay between the time you press the shutter button and the time the camera actually records the image. So the trick to catching action is to press the shutter button just a split second *before* the action occurs. Practice shooting with your camera until you have a feel for how far in advance you need to press that shutter button.

- Turn on the flash. Even if it's daylight, turning on the flash sometimes causes the camera to select a higher shutter speed, thereby freezing action better. To make sure that the flash is activated, use the fill-flash mode, discussed in Chapter 5, rather than auto-flash mode. Remember, though, that the flash may need time to recycle between shots. So for taking a series of action shots, you may want to turn the flash off.

- Switch to shutter-priority autoexposure mode (if available). Then select the highest shutter speed the camera provides and take a test shot. If the picture is too dark, lower the shutter speed a notch and retest. Remember, in shutter-priority mode, the camera reads the light in the scene and then sets the aperture as needed to properly expose the image at the shutter speed you select. So if the lighting isn't great, you may not be able to set the shutter speed high enough to stop action. For more about this issue, see Chapter 5.

- Use a lower capture resolution. The lower the capture resolution, the smaller the image file, and the less time the camera needs to record the image to memory. That means that you can take a second shot sooner than if you captured a high-resolution image.

- If your camera offers an "instant review" feature that automatically displays a picture on the LCD monitor for a few seconds after you shoot the image, turn off the feature. When it's on, the camera likely won't let you take another picture during the review period.

- Make sure that your camera batteries are fresh. Weak batteries can sometimes make your camera behave sluggishly.

- Keep the camera turned on. Because digital cameras suck up battery juice like nobody's business, the natural tendency is to turn off your camera between shots. But digital cameras take a few seconds to warm up after you turn them on — during which time, whatever it was that you were trying to record may have come and gone. Do turn the LCD monitor off, though, to conserve battery power.

Shooting Pieces of a Panoramic Quilt

You're standing at the edge of the Grand Canyon, awestruck by the colors, light, and majestic rock formations. "If only I could capture all this in a photograph!" you think. But when you view the scene through your camera's viewfinder, you quickly realize that you can't possibly do justice to such a magnificent landscape with one ordinary picture.

Wait — don't put down that camera and head for the souvenir shack just yet. When you're shooting digitally, you don't have to try to squeeze the entire canyon — or whatever other subject inspires you — into one frame. You can shoot several frames, each featuring a different part of the scene, and then stitch them together just as you would sew together pieces of a patchwork quilt. Figure 6-5 shows two images of a historic farmhouse that I stitched together into the panorama shown in Figure 6-6.

Figure 6-5: I stitched together these two images to create the panorama in Figure 6-6.

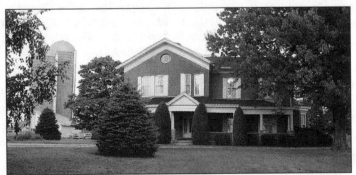

Figure 6-6: The resulting panorama provides a larger perspective on the farmhouse scene.

Although you could conceivably combine photos into a panorama using your image-editor's regular cut-and-paste editing tools, a dedicated stitching tool makes the job easier. You simply pull up the images you want to join, and the program assists you in stitching the digital "seam."

Some camera manufacturers provide proprietary stitching tools as part of the camera's software bundle. In addition, many photo-editing programs offer a stitching tool; Figure 6-7 shows the version provided in Photoshop Elements. You also can buy stand-alone stitching programs such as ArcSoft Panorama Maker ($30, www.arcsoft.com) and Photovista Panorama, from MGI Software ($50, www.mgisoft.com).

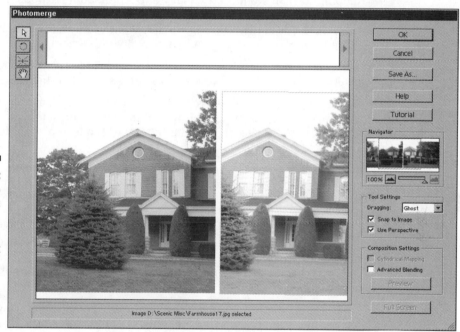

Figure 6-7: Photoshop Elements offers a panorama tool that helps you stitch images together.

The stitching process is easy if you shoot the original images correctly. If you don't, you wind up with something that looks more like a crazy quilt than a seamless photographic panorama. Here's what you need to know:

✔ You must capture each picture using the same camera-to-subject distance and camera height. If you're shooting a wide building, don't get closer to the building at one end than you do at another, for example, or raise the camera for one shot in the series.

✔ Each shot should overlap the previous shot by at least 30 percent. Say that you're shooting a line of ten cars. If image one includes the first three cars in the line, image two should include the third car as well as

cars four and five. Some cameras provide a panorama mode that displays a portion of the previous shot in the monitor so that you can see where to align the next shot in the series. If your camera doesn't offer this feature, you need to make a mental note of where each picture ends so that you know where the next picture should begin.

✔ As you pan the camera to capture the different shots in the panorama, imagine that the camera is perched atop a short flagpole, with the camera's lens aligned with the pole. Be sure to use that same alignment as you take each shot. If you don't keep the same axis of rotation throughout your shots, you can't successfully join the images later. For best results, use a tripod.

✔ Keeping the camera level is equally important. Some tripods include little bubble levels that help you keep the camera on an even keel. If you don't have this kind of tripod, you may want to buy a little stick-on level at the hardware store and put it on top of your camera.

✔ Use a consistent focusing approach. If you lock the focus on the foreground in one shot, don't focus on the background in the next shot.

✔ Check your camera manual to find out whether your camera offers an exposure lock function. This feature retains a consistent exposure throughout the series of panorama shots, which is important for seamless image stitching.

If your camera doesn't provide a way to override autoexposure, you may need to fool the camera into using a consistent exposure. Say that one half of a scene is in the shadows and the other is in the sunlight. With autoexposure enabled, the camera increases the exposure for the shadowed area and decreases the exposure for the sunny area. That sounds like a good thing, but what it really does is create a noticeable color shift between the two halves of the picture. To prevent this problem, lock in the focus and exposure on the same point for each shot. Choose a point of medium brightness for best results.

✔ Be aware of people, cars, and other objects that may be moving in the background, and try to avoid including them in your shots. If a person is walking across the landscape you're trying to shoot, you wind up with the same strolling figure in each frame of the panorama!

If you really enjoy creating panorama images or need to do so regularly for business purposes, you can make your life a little easier by investing in a product such as the Kaidan KiWi+ Panoramic Tripod Head, shown in Figure 6-8. This tripod attachment helps you make sure that each shot is perfectly set up to create a seamless panorama. The KiWi+ sells for about $300 (www.kaidan.com).

Figure 6-8:
Specialized
tripod
attachments
such as the
Kaidan
KiWi+ make
shooting
seamless
panoramic
images
easier.

Photographers with even bigger budgets may want to consider so-called *one-shot panorama tools,* which capture all the pictures needed to create a 360-degree panoramic image with one press of the shutter button. Expect to pay about $1,000 for such tools, offered by Kaidan and a few other manufacturers.

Avoiding the Digital Measles

Are your images coming out of your camera looking a little blotchy or dotted with colored speckles? Do some parts of the image have a jagged appearance? If so, the following remedies can cure your pictures:

- ✔ Use a lower compression setting. Jaggedy or blotchy images are often the result of too much compression. Check your camera manual to find out how to choose a lower compression setting.

- ✔ Raise the resolution. Too few pixels can mean blocky-looking — or *pixelated* — images. The larger you print the photo, the worse the problem becomes. (See Chapter 2 for information on why low resolution translates to poor print quality.)

- ✔ Increase the lighting. Photos shot in very low light often take on a grainy appearance, like the one in Figure 6-9.

- ✔ Lower the camera's ISO setting (if possible). Typically, the higher the ISO, the grainier the image. For more on this issue, check out Chapter 5.

Figure 6-9:
Low lighting
can result in
grainy
images.

Dealing with Annoying "Features"

You know that saying, "One man's trash is another man's treasure"? Well, with digital cameras, what one person considers a helpful feature may drive another person nuts. I haven't found ways around every annoying camera feature, but I can offer a few tips for dealing with some of them.

- ✔ **On-board image processing:** Some cameras automatically apply certain image-correction functions, such as *sharpening* (boosting contrast to create the illusion of sharper focus). Personally, I prefer to make all my image corrections in my photo software, where I can control the extent of the corrections. Thankfully, most cameras provide a menu that enables you to turn off automatic processing; check your manual for information. You may want to leave the processing options turned on, however, if you plan on printing directly from the camera or memory card.

- ✔ **Automatic defaults at power up:** Many cameras that enable you to make adjustments to exposure, compression, and so forth, revert to the default settings when you turn off the camera. So if you shoot a picture using a certain combination of settings and then turn the camera off for a few minutes, you have to start from square one to reset all the controls when you turn the camera back on.

I don't have a workaround to solve this annoyance, unfortunately. Check your camera manual to find out which settings, if any, are retained when you power down the camera so that you know which options you have to reset and which ones are still in force the next time you take a picture.

✔ **Auto shutdown (power saver):** Because digital cameras drain batteries so rapidly, most cameras shut off automatically if you don't take a picture or perform some other function within a certain period of time. Usually, that allowable downtime is very short — 30 seconds or so.

Auto shutdown can be a major pain when you're trying to carefully compose a picture. Just as you're rearranging the subject to your liking or working on other compositional details, the camera powers down. And when you turn the camera back on, you may have to go through the process of resetting all the manual controls! Aaaghh!

A few cameras enable you to disable the automatic-shutoff feature or at least to set the function to a longer wait time. If your camera doesn't, you have to remember to do something to make the camera think that it's in use to prevent the automatic shutdown. If your camera has a zoom, you can just zoom in and out a bit. Or press the shutter button halfway to activate the autofocus/autoexposure mechanism.

✔ **Washed-out LCD monitors:** The first time you take a picture in a bright, sunny setting using your LCD monitor to frame the image, you discover the drawback to an otherwise very cool feature. Bright light washes out the image on the LCD so much that you can't see what you're shooting.

If you're using a tripod, you can shade the LCD with your free hand (the other hand needs to be free to press the shutter button). But for a hands-free solution, you may want to invest in a lens hood, which is a simple strap-on "awning" designed to throw some shade onto the monitor.

Newer digital cameras often offer a control for adjusting the brightness of the monitor. Although raising the brightness can make images easier to see in the LCD, it can also give you a false impression of your image exposure. So before you leave your shooting location, be sure to review your pictures in a setting where you can return the monitor to its default brightness level. See Chapter 5 for more tips about exposure.

Part III
From Camera to Computer and Beyond

The 5th Wave By Rich Tennant

"Ooo-wait! That's perfect for the clinic's home page. Just stretch it out a little further... little more..."

In this part . . .

One major advantage of digital photography is how quickly you can go from camera to final output. In minutes, you can print or electronically distribute your images, while your film-based friends are cooling their heels, waiting for their pictures to be developed at the one-hour photo lab.

The chapters in this part of the book contain everything you need to know to get your pictures out of your camera and into the hands of friends, relatives, clients, or anyone else. Chapter 7 explains the process of transferring images to your computer and also discusses various ways to store image files. Chapter 8 describes all your printing options and provides suggestions for which types of printers work best for different printing needs. And Chapter 9 explores electronic distribution of images — placing them on the World Wide Web, sharing them via e-mail, and the like — and offers ideas for additional on-screen uses for your images.

In other words, you find out how to coax all the pretty pixels inside your camera to come out of hiding and reveal your photographic genius to the world.

Chapter 7

Building Your Image Warehouse

In This Chapter

▶ Downloading photos from the camera to your computer

▶ Importing pictures directly into a photo-editing or catalog program

▶ Viewing photos on a TV and recording pictures on videotape

▶ Choosing an image file format to use

▶ Organizing your picture files

Maybe you're a highly organized photographer. As soon as you bring home prints from the photofinisher, you sort them according to date or subject matter, slip them into a photo album, and neatly record the date the picture was shot, the negative number, and the place where the negative is stored.

Then again, maybe you're like the rest of us — full of good intentions about organizing your life, but never quite finding the time to do it. I, for one, currently have no fewer than ten packets of pictures strewn about my house, all waiting patiently for their turn to make it into an album. Were you to ask me for a reprint of one of those pictures, you'd no doubt go to your grave waiting for me to deliver, because the odds that I'd be able to find the matching negative are absolutely zilch.

If you and I are soul mates on this issue, I have unfortunate news for you: Digital photography demands that you devote some time to organizing and cataloging images after you download them to your computer. If you don't, you'll have a tough time finding specific photos when you need them. With digital photos, you can't flip through a stack of prints to find a particular shot — you have to use a photo editor or viewer to look at each picture. Unless you set up some sort of orderly cataloging system, you waste a *lot* of time opening and closing image files before you find the picture you want.

Before you can catalog your photos, of course, you have to move them from the camera to the computer. This chapter gives you a look at the picture-downloading process, explains the file formats you can use when saving your images, and introduces you to image-cataloging software. By the end of this chapter, you'll be so organized that you may even be motivated to tackle that disaster of a closet in your bedroom.

Downloading Your Images

You've got a camera full of pictures. Now what? You transfer them to your computer, that's what. The following sections introduce you to several methods of doing so.

Some digital photography aficionados refer to the process of moving photos from the camera to the computer as *downloading,* by the way.

A trio of downloading options

Digital camera manufacturers have developed several ways for users to transfer pictures from camera to computer. You may or may not be able to use all these options, depending on your camera. The following list outlines the various transfer methods, beginning with the fastest and easiest choice:

- **Memory card transfer:** If your camera stores images on a floppy disk, just pop the disk out of your camera and insert it into the floppy drive on your computer. Then copy the images to your hard drive as you do regular data files on a floppy disk.

 If your camera uses CompactFlash, SmartMedia, Memory Stick, or some other type of removable storage media, you can also enjoy the convenience of transferring images directly from that media, provided you have a matching card reader or adapter. See Chapter 4 for more information on these gadgets.

- **Cable transfer:** If you don't have the luxury of using the preceding transfer option, you're stuck with the "old-fashioned" method, which is to connect your computer and camera using the cable that came in your camera box.

 In some cases, the connection is via a serial cable, which transfers data at a speed roughly equivalent to a turtle pulling a 2-ton pickup. Okay, so maybe the speed isn't quite that slow — it just seems that way. Fortunately, most newer cameras connect to the computer via a USB port, which makes the transfer process faster.

 The steps in the next section explain the transfer process, whether you use serial or USB cabling.

- **Infrared transfer:** A few cameras have an IrDA port that enables you to transfer files via infrared light beams, similar to the way your TV remote control transfers your channel-surfing commands to your TV set. In order to use this feature, your computer must have an IrDA port.

In case you're curious, IrDA stands for Infrared Data Association, an organization of electronics manufacturers that sets technical standards for devices that use infrared transfer. These standards ensure that the IrDA port on one vendor's equipment can talk to the IrDA port on another vendor's equipment.

Having tried IrDA transfer, I can tell you that getting the communication settings just right can be a challenge. I had the help of two tech support people (one for my laptop and one for the camera I was using), and between the three of us, getting the system working took well over an hour — basically, we just kept playing with different options until we stumbled across the right combinations. Maybe you'll have better luck.

If you do manage to get your camera and computer to communicate via IrDA, you simply place your camera close to your computer and start the camera's transfer program. Your image-transfer speed depends on the capabilities of your computer's IrDA port. With my laptop, the transfer rate was no faster than using a serial-cable connection (see the preceding bullet point).

Different IrDA devices work differently, so consult your camera and computer manuals to find out how to take advantage of this option.

If all you want to do is print your images, you may not need to download the picture files to your computer at all. Several new photo printers can print directly from removable media; see Chapter 8 for more information.

Regardless of which transfer method you use, don't forget to install the image-transfer software that came with your camera. If you're using direct memory card-to-computer transfer and your camera saves images in a standard file format (such as TIFF or JPEG), you may not need the software; you can open your images directly from the card (or other removable media) in your photo-editing program. But some cameras store images in a proprietary format that can be read only by the camera's transfer software. Before you can open the pictures in a photo-editing program, you have to convert them to a standard format using the camera transfer software. (See "File Format Free-for-All," later in this chapter, for an explanation of file formats.)

Cable transfer how-tos

Transferring photos via a camera-to-computer connection works pretty much the same way from model to model. Because transfer software differs substantially from camera to camera, I can't give you specific commands for accessing your photos; check your camera's manual for that information. But in general, the process works as outlined in the following steps. (I'm assuming that you're not working with one of the new camera docks that stays connected to your computer while you're off shooting pictures. For more on these devices, see Chapter 4.)

Also note that the first time you connect your camera and computer, you may need to do so in a special way and install some software that came with the camera. Again, dig out that camera manual for specifics.

With the proper software installed, the transfer process works like so:

1. **If you're connecting via serial cable, turn off your computer and camera.**

 This step is *essential;* most cameras don't support *hot swapping* — connecting via serial cable while the devices are turned on. If you connect the camera to the computer while either machine is powered up, you risk damaging the camera.

2. **If you're connecting via USB, check your camera manual.**

 You probably do not have to shut down your computer before hooking up the camera. But please, check your camera and computer manuals to be certain. You may or may not need to turn the camera off.

3. **Connect the camera to your computer.**

 Plug one end of the connection cable into your camera and the other into your computer. If you're going the serial-cable route and you use a Macintosh computer, you typically plug the camera cable into the printer or modem port, as shown in the top half of Figure 7-1. On a PC, the serial cable usually connects to a COM port (often used for connecting external modems to the computer), as shown in the bottom half of Figure 7-1.

 The setup is the same for cameras that come with a USB cable. Plug one end of the cable into the camera and the other into your computer's USB port.

 Note that if you use Windows 95, your computer may refuse to recognize the presence of the camera, even if you install the Windows 95 update that is supposed to enable USB. So if you want to avoid hassles, either upgrade to a later version of Windows or use some method of image transfer other than USB.

4. **Turn the computer and camera back on, if you turned them off before connecting.**

5. **Set the camera to the appropriate mode for image transfer.**

 On some cameras, you put the camera in playback mode; other cameras have a PC setting. Check your manual to find out the right setting for your model.

6. **Start the image-transfer software.**

7. **Download away.**

 From here on out, the commands and steps needed to get those pictures from your camera onto your computer vary, depending on the camera and transfer software.

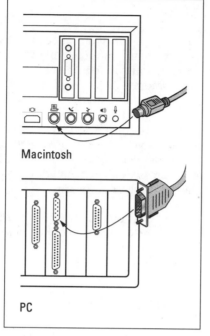

Figure 7-1:
If
connecting
a camera
via serial
cable, you
usually plug
the cable
into the
printer or
modem port
on a Mac
and into a
COM port
on a PC.

Macintosh

PC

Take the bullet TWAIN

Chances are good that your camera comes with a CD that enables you to install something called a *TWAIN driver* on your computer. TWAIN is a special *protocol* (language) than enables your photo-editing or catalog program to communicate directly with a digital camera or scanner. Rumor has it that TWAIN stands for Technology Without An Interesting Name. Those wacky computer people!

After you install the TWAIN driver, you can access picture files that are still on the camera through your photo-editing or cataloging program. Of course, your camera still needs to be cabled to the computer. And your photo-editing or cataloging program must be *TWAIN compliant,* meaning that it understands the TWAIN language.

The command you use to open camera images varies from program to program. Typically, the command is found in the File menu and is named something like Acquire or Import. (In some programs, you first have to select the *TWAIN source* — that is, specify which piece of hardware you want to access. This command is also usually found in the File menu.)

Camera as hard drive

With some digital cameras, the manufacturer provides special software that, when installed on your computer, makes your computer think that the camera is just another hard drive. When you connect the camera to a Windows-based PC, for example, the camera gets its own little drive icon in Windows Explorer. On a Macintosh, the Finder displays the camera icon.

Whatever the operating system, you can double-click the camera icon to display a list of files in the camera, just as you would to review files on your other drives. Then you can drag and drop files from the camera to a location on your hard drive, an option that's typically quicker than downloading the individual images through the camera's transfer software.

How this feature works — if at all — depends on what version of Windows or the Macintosh operating system you use as well as on your camera. Check your camera's manual for details.

Tips for trouble-free downloads

For whatever reason, the download process is one of the more complicated aspects of digital photography. The introduction of direct memory-card-to-computer transfer has made things much easier, but not all users have access to this method. If you're transferring images via a serial cable, USB, or IrDA, don't feel badly if you run into problems — I do this stuff on a daily basis, and I still sometimes have trouble getting the download process to run smoothly when I work with a new camera. The problem isn't helped by camera manuals that provide little, if any, assistance on how to get your camera to talk to your computer.

Here are some troubleshooting tips I've picked up during my struggles with image transfer:

✔ If you get a message saying that the software can't communicate with the camera, check to make sure that the camera is turned on and set to the right mode (playback, PC mode, and so on).

✔ On a Macintosh, you may need to turn off AppleTalk, Express Modem, and/or GlobalFax, which can conflict with the transfer software. Check the camera manual for possible problem areas.

✔ On a PC, check the COM port setting in the transfer software if you have trouble getting the camera and computer to talk to each other via a serial cable connection. Make sure that the port selected in the download program is the one into which you plugged the camera.

✔ If you're connecting via a USB port, make sure that the USB port is enabled in your system. Some manufacturers ship their computers with the port disabled. To find out how to turn the thing on, check your computer manual. Also see my earlier comments about USB and Windows 95 in the section "Cable transfer how-tos."

✔ Check your camera manufacturer's Web site for troubleshooting information. Manufacturers often post updated software drivers on their Web sites to address downloading problems. Log on to the Web sites for your brand of computer and image software, too, because problems may be related to that end of the download process rather than to your camera.

✔ Some transfer programs give you the option of choosing an image file format and compression setting for your transferred images. Unless you want to lose some image data — which results in lower image quality — choose the no-compression setting or use a lossless-compression scheme, such as LZW for TIFF images. (If that last sentence sounded like complete gibberish, you can find a translation in the section "File Format Free-for-All," later in this chapter. Also check out the section on file compression in Chapter 3.)

✔ Digital cameras typically assign your picture files meaningless names such as DCS008.jpg and DCS009.jpg (for PC files) or Image 1, Image 2, and the like (for Mac files). If you previously downloaded images and haven't renamed them, files by the same names as the ones you're downloading may already exist on your hard drive.

When you attempt to transfer files, the computer should alert you to this fact and ask whether you want to replace the existing images with the new images. But just in case, you may want to create a new folder to hold the new batch of images before you download. That way, there's no chance that any existing images will be overwritten.

✔ If your camera has an AC adapter, use it when downloading images via a serial cable. The process can take quite a while, and you need to conserve all the battery power you can for your photography outings.

✔ When you initiate the transfer process, you may be able to select an option that automatically deletes all images from the camera's memory after downloading. At the risk of sounding paranoid, I *never* select this option. After you transfer images, always review them on your computer monitor *before* you delete any images from your camera. Glitches can happen, so make sure that you really have that image on your computer before you wipe it off your camera. As an extra precaution, make a backup copy of the image on removable media (CD, Zip, or the like).

Now Playing on Channel 3

If you've shopped for a DVD player recently, you may have spotted an interesting new feature on a few models: A slot that accepts some types of digital

camera media. You can pop a memory card out of your camera, into the DVD player, and view all the pictures on the card on your television set.

For those without the latest in home electronics technology, many cameras come with a *video-out* port and video connection cable. Translated into English, that means that you can connect the camera itself to a DVD player or regular old TV to display your digital photos. You can even connect the camera to a VCR and record your images on videotape.

Why would you want to display your images on a TV? For one thing, you can show your pictures to a group of people in your living room or office conference room instead of having them huddle around your computer monitor. Viewing your images on TV also enables you to review your images more closely than you can on your camera's LCD monitor. Small defects that may not be noticeable on the camera monitor become readily apparent when viewed on a 27-inch television screen.

As with connecting the camera to a computer, consult your camera's manual for specific instructions on how to hook your camera to the DVD player, TV, or VCR. Typically, you plug one end of an AV cable (supplied with the camera) into the camera's video- or AV-out port and then plug the other end into the video-in port on your TV, DVD player, or VCR, as shown in Figure 7-2. If your camera has audio-recording capabilities, as does the camera shown in the figure, the cable has a separate AV plug for the audio signal. That plug goes into the audio-in port, as in the figure. If your playback device supports stereo sound, you typically plug the camera's audio plug into the mono-input port.

Figure 7-2:
Cameras such as this model from Kodak enable you to send video and audio signals from the camera to your TV, VCR, or DVD player for playback.

Video in

Audio in

To display your pictures on the TV, you generally use the same procedure as when reviewing your pictures on the camera's LCD monitor, but again, check your manual. To record the images on videotape, just put the VCR in record mode, turn on the camera, and display each image for the length of time you want to record it. You may need to select a different input source for the VCR or TV — for example, to switch the VCR from its standard antenna or cable input setting to its auxiliary input setting.

Most digital cameras sold in North America output video in NTSC format, which is the format used by televisions in North America. You can't display NTSC images on televisions in Europe and other countries that use the PAL format instead of NTSC. So if you're an international business mogul needing to display your images abroad, you may not be able to do it using your camera's video-out feature. Some newer cameras do provide you with the choice of NTSC or PAL formats.

File Format Free-for-All

You may be asked to choose a file format when you transfer images from your camera to your computer or when you set up the camera itself — many new cameras can store images in two or more different file formats. You also need to specify a file format in order to save your image after editing it in your image-editing software. (See Chapter 10 for more information on editing and saving files.)

The term *file format* simply refers to a way of storing computer data. Many different image formats exist, and each one takes a unique approach to data storage. Some formats are *proprietary,* which means that they're used only by the camera you're using. (Proprietary formats are sometimes also referred to as *native* formats.)

If you want to edit photos stored in a proprietary format, you must use the software provided with the camera. Typically, you can use that software to convert the photo files to a format that can be opened by other programs.

Many photo-editing programs also have a proprietary format. Adobe Photoshop and Photoshop Elements, for example, use the PSD format, which is geared to support all the editing features available in those programs and to speed editing inside the program. If you want to open the picture file in some other program that doesn't support the PSD format, you can *export* the file to another format — that is, save a copy in that other format.

Some formats are used only on the Mac, and some formats are for PCs only. A few formats are so obscure that almost no one uses them anymore, while others have become so popular that almost every program on both platforms supports them. The following sections detail the most common file formats for storing images, along with the pros and cons of each format.

JPEG

Say it *jay-peg.* The acronym stands for Joint Photographic Experts Group, which was the organization that developed this format.

JPEG is one of the most widely used formats today, and almost every program, on both Macintosh and Windows systems, can save and open JPEG images. JPEG is also one of the two main file formats used for photos on the World Wide Web. Most digital cameras also store photos in this format.

One of the biggest advantages of JPEG is that it can compress image data, which results in smaller picture files. Smaller files consume less space on disk and take less time to download on the Web.

The catch is that JPEG uses a *lossy compression scheme,* which means that some image data is sacrificed during the compression process. For initial storage of pictures in camera memory, you don't lose too much data if you select a capture option that applies minimal or even a medium amount of compression. But each time you open, edit, and resave your photo in your photo editor, the image is recompressed, and more damage is done.

When you save a file in the JPEG format, you can specify how much compression you want to apply. For example, if you use the Save As command in Adobe Photoshop Elements to save the file, you see the dialog box shown in Figure 7-3. In this dialog box, as in most programs, you control the amount of compression by using the Quality options — which makes sense because compression directly affects photo quality.

Figure 7-3: When you save a picture in the JPEG format, you can specify the amount of file compression.

To keep data loss to a minimum and ensure the best images, choose the highest-quality setting (which results in the least amount of compression). For Web images, you can get away with a medium-quality, medium-compression setting. See Color Plate 3-1 for a look at how a large amount of JPEG compression affects an image, and read Chapter 3 for more on this subject.

The other options shown in Figure 7-3 are related to saving photos for use on the Web. For details, see Chapter 9. That same chapter also discusses the Photoshop Elements Save for Web feature, which enables you to preview your image at different compression settings before saving.

While you're working on a picture, save it in your photo-editing program's native format or the TIFF format (explained shortly), which retains all critical image data. Save to JPEG only when you're completely finished editing the image. That way, you keep data loss to a minimum.

EXIF

EXIF, which stands for *exchangeable image file format,* is one of many variants of the JPEG format. Many digital cameras store images using EXIF, sometimes referred to as JPEG (EXIF), to take advantage of the opportunity to store *metadata* — extra data — with the image file. In the case of digital cameras, information such as the shutter speed, aperture, and other capture settings gets recorded as metadata.

If your camera records metadata, you don't need to do anything different while capturing images, but you do need to use a special EXIF *extractor* program if you want to view the metadata after you download the pictures. Some cameras ship with proprietary software for viewing the metadata; you can also buy inexpensive programs to take a look. Two examples are Picture Information Extractor, shown in Chapter 4, in the sidebar "I never metadata I didn't like," and ThumbsPlus, featured in the last section of this chapter. (The CD at the back of the book includes tryout versions of both programs.)

One caveat regarding EXIF data: If you open your original picture file and resave it inside a photo-editing program, the metadata may be stripped from the file. If you're concerned with retaining metadata, always work on a copy of the original picture file.

TIFF

TIFF stands for *Tagged Image File Format,* in case you care, which you really shouldn't. TIFF — say it *tiff,* as in a little spat — ranks right up there with JPEG on the popularity scale except for use on the World Wide Web.

Like JPEG images, TIFF images can be opened by most Macintosh and Windows programs. If you need to bring a digital photo into a publishing program (such as Microsoft Publisher) or into a word processing program, TIFF is a good choice.

When you save an image to the TIFF format inside a photo editor, you're usually presented with a dialog box containing a few options. Figure 7-4 shows the Photoshop Elements version of the dialog box.

Figure 7-4:
Photoshop
Elements
offers a few
advanced
options
when you
save a
picture in
the TIFF
format.

The most common TIFF option is *byte order.* If you want to use the image on a Mac, choose Macintosh; otherwise, select IBM PC. You also usually get the choice of applying LZW compression. LZW is a *lossless compression scheme,* which means that only redundant image data is abandoned when the image is compressed so that there is no loss in image quality.

Unfortunately, compressing an image in this way doesn't reduce the image file size as much as using JPEG compression, which is why TIFF isn't used on the Web and isn't supported by most Web browsers. (Most e-mail programs can't display TIFF images, either.)

Most, but not all, photo-editing and publishing programs support LZW-compressed TIFF images. If you have trouble opening a TIFF image, compression may be the problem. Try opening and resaving the image in another program, this time turning compression off.

Some programs, including Photoshop and Elements, offer a few additional TIFF options, including the ability to apply JPEG compression. Unless you know what you're doing, leave these options at their default settings because they can cause the same file-opening problems as LZW compression. (And after all, if you're going to apply JPEG compression, what's the point of saving in the TIFF format in the first place?)

JPEG 2000: the holy grail of file formats?

You say you want the small file sizes of JPEG *and* the image quality of TIFF? You're in good company.

As of yet, this holy grail of photo file formats doesn't exist, but a group of experts is working toward that end by developing a new flavor of JPEG known as JPEG 2000. The first draft of the format was produced in the year 2000 — hence the name — but JPEG 2000 isn't yet ready for prime time.

Although a few photo-editing programs can open and save JPEG 2000 files, I don't recommend the format because all the kinks aren't worked out. In addition, not all Web browsers can display JPEG 2000 files, which is kind of a problem for a format that's geared toward online use.

If you want to know more about JPEG 2000 and you're game for an incredibly technical read, point your Web browser to www.jpeg.org.

In addition to saving your picture as a TIFF file inside a photo editor, you may be able to set your camera to record TIFF images instead of JPEG files. Choose TIFF when picture quality is more important than file size — you can always make a copy of the picture in the JPEG format later if you want to use it on the Web.

RAW

High-resolution digital cameras aimed at serious photo enthusiasts often enable the user to capture pictures in the RAW file format as well as in JPEG and, sometimes, TIFF.

Unlike most computer terms, RAW isn't an acronym for anything — it simply means *raw,* as in *unprocessed* or *untouched.* Of course, when writing about the format, you have to capitalize it just for good technical measure.

When you capture a digital photo as a RAW file, any in-camera processing that's normally done to the picture files isn't applied. That includes sharpening, white balance, and other corrections that your camera may do automatically.

Some purists like RAW because it theoretically provides a truer version of the scene in front of the camera lens. However, RAW has some significant drawbacks. First off, RAW files are substantially larger than JPEG files, although usually not as large as TIFF files. Second, many photo-editing and image-browsing programs can't open RAW files without a special plug-in (software add-on). Web browsers can't display RAW images, period, and you can't import RAW files into many other programs, including word processing programs, either.

If your digital camera offers the RAW format option, the manufacturer proba-
bly provides special software for viewing the picture files and converting
them to a more common file format. Each manufacturer's version of RAW is
slightly different, so you're likely locked into using your camera's software for
these tasks.

Photo CD

Developed by Eastman Kodak, Photo CD is a format used expressly for trans-
ferring slides and film negatives onto a CD-ROM. Image-editing and cataloging
programs can open Photo CD images. But no consumer software enables you
to save to this format; if you want to store pictures as Photo CD images, you
must enlist the help of a commercial imaging lab.

The Photo CD format stores the same image at five different sizes, from 128 x
192 pixels all the way up to 2048 x 3072 pixels. The Pro Photo CD format,
geared to those professionals who need ultra-high-resolution images, saves
one additional size: 4096 x 6144 pixels.

When you open a Photo CD image, you can select which image size you want
to use. Choose the size that corresponds to the number of pixels you need
for your final output. For images that you plan to print, you generally want to
select the largest size available. Remember that the more pixels in the image,
the higher the image resolution and the better your printed output. If your
computer complains that it doesn't have enough memory to open the image,
try the next smaller size. For Web images, you can go with one of the smaller
image sizes. (To read more about resolution, see Chapter 2.)

Many people confuse Photo CD with Picture CD, which isn't a file format at
all, but a Kodak photofinishing offering. When you get your film developed at
some photofinishers and request the Picture CD option, you receive regular
prints plus a CD-ROM that contains scanned copies of your pictures. The pic-
tures are stored on the CD in the JPEG format, and you open them as you do
any JPEG image file.

FlashPix

The FlashPix format was introduced a few years ago to much fanfare. Among
other things, it was supposed to enable us to edit large images on computers
that don't have gargantuan amounts of RAM or the most powerful processors.

Somewhere along the way, though, the FlashPix train derailed. It was never
fully supported by some mainstream image-editing and cataloging programs,
and some hardware and software makers who formerly provided FlashPix
support in their products have stopped doing so. For that reason, I don't

recommend using this format unless you want to work expressly in an image-editing program that supports FlashPix, and you don't plan on sharing your images with anyone who uses a different program.

GIF

Some people pronounce this format *gif,* with a hard *g,* while other folks say *jif,* like the peanut butter. I prefer the former, but you do what makes you happy. Either way you say it, GIF was developed to facilitate transmission of images on CompuServe bulletin-board services.

Today, GIF *(Graphics Interchange Format)* and JPEG are the two most widely accepted formats for World Wide Web use. One variety of GIF, thoughtfully named GIF89a, enables you to make areas of your image transparent, so that your Web page background is visible through the image. You can also produce animated Web graphics using a series of GIF images.

GIF is similar to TIFF in that it uses LZW compression, which creates smaller file sizes without dumping any important image data. The drawback is that GIF is limited to saving 8-bit images (256 colors or less). To see the difference this limitation can mean to your image, look at Color Plate 9-1. The top image is a 24-bit image, while the bottom image is an 8-bit image. The 8-bit image has a rough, blotchy appearance because there aren't enough different colors available to express all the original shades in the fruit. One shade of yellow must be used to represent several different yellow tones, for example. For information on converting your image to 256 colors and creating a transparent GIF image, see Chapter 9.

PNG

PNG, which stands for *Portable Network Graphics* format and is pronounced *ping,* is a relatively new format designed for Web graphics. Unlike GIF, PNG isn't limited to 256 colors, and unlike JPEG, PNG doesn't use lossy compression. The upside is that you get better image quality; the downside is that your file sizes are larger, which means longer download times for Web surfers wanting to view your images. More problematic than that drawback, though, is the fact that people viewing your Web pages with older browsers may not be able to display PNG images. For now, GIF and JPEG are better options for Web use.

BMP

Some people pronounce this one by saying the letters (B-M-P), while other folks use *bimp* or *bump,* and still others avoid the whole issue by using the official name of the format, *Windows Bitmap.* A popular format in the past,

BMP is used today primarily for images that will be used as wallpaper on PCs running Windows. Programmers sometimes also use BMP for images that will appear in Help systems.

BMP offers a lossless compression scheme known as RLE (Run-Length Encoding), which is a fine option except when you're creating a wallpaper image file. Windows sometimes has trouble recognizing files saved with RLE when searching for wallpaper images, so you may need to turn RLE off for this use.

PICT

When talking about this format, say *pict,* as in *Peter Piper PICT a peck of pixels.* PICT is based on the Apple QuickDraw screen language and is the native graphics format for Macintosh computers.

If QuickTime is installed on your Mac, you can apply JPEG compression to PICT images. But be aware that QuickTime's version of JPEG compression does slightly more damage to your image than what you get when you save an image as a regular JPEG file. Because of this, saving your file to JPEG is a better option than PICT in most cases. About the only reason to use PICT is to enable someone who doesn't have image-editing software to see your images. You can open PICT files inside SimpleText, Microsoft Word, and other word processors.

EPS

EPS (*Encapsulated PostScript,* pronounced *E-P-S*) is a format used mostly for high-end desktop publishing and graphics production work. If your desktop publishing program or commercial service bureau requires EPS, go ahead and use it. Otherwise, choose TIFF or JPEG. EPS files take up much more room on disk than TIFF and JPEG files.

Photo Organization Tools

After you move all those picture files from your camera to your hard drive, a CD, or other image warehouse, you need to organize them so that you can easily find a particular photo.

If you're a no-frills type of person, you can simply organize your picture files into folders, as you do your word-processing files, spreadsheets, and other documents. You may keep all pictures shot during a particular year or month in one folder, with images segregated into subfolders by subject. For example, your main folder may be named Photos, and your subfolders may be named Family, Sunsets, Holidays, Work, and so on.

Many photo-editing programs include a utility that enables you to browse through your image files and view thumbnails of each photo. Figure 7-5 shows the file browser utility included with Version 1.0 of Photoshop Elements, for example. Such utilities make it easy to track down a particular image if you can't quite remember what you named the thing.

Figure 7-5:
Photoshop
Elements
offers a
simple
photo-file
browser.

Depending on your computer's operating system, it also may offer tools for browsing through thumbnails of your digital photo files. Recent versions of Windows, for example, enable you to view thumbnails in Windows Explorer. If you work on a Macintosh computer running OS X 10.1.2 or later, you can download a free copy of a photo browser called iPhoto at the Apple Web site.

You may find that your operating system or photo editing program together offer all the image-file viewing and management tools that you need. But in many cases, these tools are very limited, slow, or both. If you have a large photo collection, the job of managing your picture files becomes much easier with stand-alone image-management programs such as ThumbsPlus ($80, www.thumbsplus.com), shown in Figure 7-6.

You can browse and manage your images in several different layouts, including one that mimics the Windows Explorer format, as shown in Figure 7-6. In the latest version of this program, you also can inspect all the EXIF metadata that your camera may store in the image file.

Figure 7-6:
ThumbsPlus
is a popular
tool for
viewing and
organizing
digital photo
files.

But the real power of programs such as ThumbsPlus lies in their database features, which you can use to assign keywords to images and then search for files using those keywords. For example, if you have an image of a Labrador retriever, you might assign the keywords "dog," "retriever," and "pet" to the picture's catalog information. When you later run a search, entering any of those keywords as search criteria brings up the image. ThumbsPlus also enables you to perform some limited image editing and create a Web page that features your pictures. (If you want to try this program out, install the evaluation version on the CD-ROM included with this book.)

Geared to more casual use, programs such as FlipAlbum Suite ($80, www.flipalbum.com) feature a traditional photo-album motif. Figure 7-7 offers a look at this program, and the CD at the back of the book includes a trial version. You drag images from a browser onto album pages, where you can then label the images and record information, such as the date and place the image was shot.

Photo-album programs are great for those times when you want to leisurely review your images or show them to others, much as you would enjoy a traditional photo album. And creating a digital photo album can be a fun project to enjoy with your kids — they'll love picking out frames for images and adding other special effects. In addition, some album programs, including FlipAlbum Suite, offer tools to help you create and share CDs containing your digital photo albums.

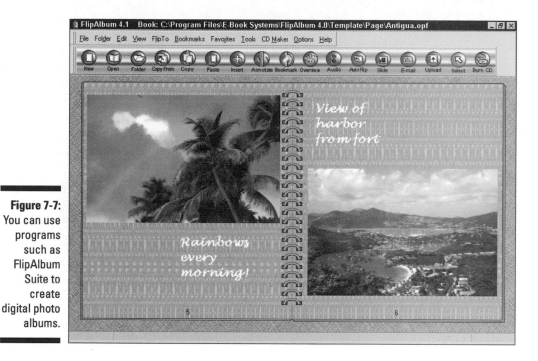

Figure 7-7:
You can use
programs
such as
FlipAlbum
Suite to
create
digital photo
albums.

For simply tracking down a specific image or organizing images into folders, however, I prefer the folder-type approach like the one used by ThumbsPlus. I find that design quicker and easier to use than flipping through the pages of a digital photo album.

Chapter 8

Can I Get a Hard Copy, Please?

In This Chapter

▶ Sorting through the maze of printer options

▶ Making your digital prints last

▶ Understanding CMYK

▶ Choosing the right paper for the job

▶ Letting the pros print your images

▶ Setting the output size and resolution before printing

*T*aking your digital photos from camera or computer to paper involves several decisions, not the least of which is choosing the right printer for the job. You also need to think about things like output resolution, color matching, and paper stock.

This chapter helps you sort through the various issues involved in printing your pictures, whether you want to handle the job yourself or have a commercial printer do the honors. In addition to discussing the pros and cons of different types of printers, the pages to come offer tips and techniques to help you get the best possible output from any printer.

Printer Primer

When they aren't in high-level conferences thinking up acronyms like CMOS and PCMCIA, engineers in the world's computer labs are busy trying to devise the perfect technology for printing digital photos. In the commercial printing arena, the technology for delivering superb prints is already in place. (See "Letting the Pros Do It," later in this chapter, for more information about commercial printing.)

On the consumer front, several vendors, including Hewlett-Packard, Epson, Olympus, and Canon, sell printers that are specially designed for printing digital photos at home or in the office. Whereas the first photo printers, released a few years ago, couldn't deliver the quality you got from a professional imaging lab or even your neighborhood photofinisher, some of the newest models

deliver prints that are indistinguishable from the best traditional film prints. With a model such as the $500 Epson Stylus Photo 1280, shown in Figure 8-1, you can even output borderless prints as wide as 13 inches.

Figure 8-1: With the Epson Stylus Photo 1280, you can output borderless inkjet prints up to 13 inches wide.

This Epson printer uses inkjet printing technology, which is just one of the options you'll encounter when you go printer shopping. Each type of printer offers advantages and disadvantages, and the technology you choose depends on your budget, your printing needs, and your print-quality expectations. To help you make sense of things, the following sections discuss the main categories of consumer and small-office printers.

Inkjet printers

Inkjet printers work by forcing little drops of ink through nozzles onto the paper. Inkjet printers designed for the home office or small business cost anywhere from $50 to $900. Typically, print quality peaks as you reach the $200 price range, though. Higher-priced inkjets offer speedier printing and extra features, such as the ability to output on wider paper, produce borderless prints, hook up to an office network, or print directly from a camera memory card.

Most inkjet printers enable you to print on plain paper or thicker (and more expensive) photographic stock, either with a glossy or matte finish. That flexibility is great because you can print rough drafts and everyday work on plain paper and save the more costly photographic stock for final prints and important projects.

Inkjets fall into two basic categories:

- ✔ General-purpose models, which are engineered to do a decent job on both text and pictures

- ✔ Photo printers, sometimes referred to as *photocentric* printers, which are geared solely toward printing images. Photocentric printers produce better-quality photographic output than all-purpose printers, but they're typically not well suited to everyday text printing because the print speed is slower than on a general-purpose machine.

That's not to say that you should expect lightning-fast prints from a general-purpose inkjet, though. Even on the fastest inkjet, outputting a color image can take several minutes if you use the highest-quality print settings. And with some printers, you can't perform any other functions on your printer until the print job is complete (see the section "Comparison shopping," later in this chapter).

In addition, the wet ink can cause the paper to warp slightly, and the ink can smear easily until the print dries. (Remember when you were a kid and painted with watercolors in a coloring book? The effect is similar with inkjets, although not as pronounced.) You can lessen both of these effects by using specially coated inkjet paper (see "Thumbing through Paper Options," later in this chapter).

Despite these flaws, inkjets remain a good, economical solution for many users. Newer inkjet models incorporate refined technology that produces much higher image quality, less color bleeding, and less page warping than models in years past. Images printed on glossy photo stock from the latest photocentric inkjets rival those from a professional imaging lab. For the record, I've been especially impressed with output from Epson, Hewlett-Packard, and Canon photocentric models.

Laser printers

Laser printers use a technology similar to that used in photocopiers. I doubt that you want to know the details, so let me just say that the process involves a laser beam, which produces electric charges on a drum, which rolls toner — the ink, if you will — onto the paper. Heat is applied to the page to permanently affix the toner to the page (which is why pages come out of a laser printer warm).

Color lasers can produce near-photographic quality images as well as excellent text. They're faster than inkjets, and you don't need to use any special paper (although you get better results if you use a high-grade laser paper as opposed to cheap copier paper).

The downside to color lasers? Price. Although they've become much more affordable over the past two years, color lasers still run $700 and up. And these printers tend to be big in stature as well as price — this isn't a machine that you want to use in a small home office that's tucked into a corner of your kitchen.

However, if you have the need for high-volume color output, a color laser printer can make sense. Although you pay more up front than you do for an inkjet, you should save money over time because the price of *consumables* (toner or ink, plus paper) is usually lower for laser printing than inkjet printing. Many color lasers also offer networked printing, making them attractive to offices where several people share the same printer.

Dye-sub (thermal dye) printers

Dye-sub is short for *dye-sublimation,* which is worth remembering only for the purpose of one-upping the former science-fair winner who lives down the street. Dye-sub printers transfer images to paper using a plastic film or ribbon that's coated with colored dyes. During the printing process, heating elements move across the film, causing the dye to fuse to the paper.

Dye-sub printers are also called *thermal-dye* printers — heated (thermal) dye . . . get it?

Like the newest photocentric inkjet printers, dye-sub printers deliver very good photo quality. Dye-sub printers manufactured for the consumer market fall within the same price range as quality photocentric inkjets, but they present a few disadvantages that may make them less appropriate for your home or office than an inkjet.

First, most dye-sub printers can output only snapshot size prints, although a few new models, such as the $500 Olympus P-400 shown in Figure 8-2, can produce 7.5 x 10-inch prints. More important, you have to use special stock designed to work expressly with dye-sub printers. That means that dye-sub printing isn't appropriate for general-purpose documents; these machines are purely photographic tools. The cost per print depends on the size of the paper, as with any printer. Olympus estimates that the cost of a 7.5 x 10-inch print from its P-400 model is just under $2.

Thermo-Autochrome printers

A handful of printers use Thermo-Autochrome technology. With these printers, you don't have any ink cartridges, sticks of wax, or ribbons of dye. Instead, the image is created using light-sensitive paper — the technology is similar to that found in fax machines that print on thermal paper.

Composite RGB

Red Channel

Green Channel

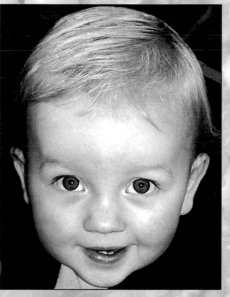

Blue Channel

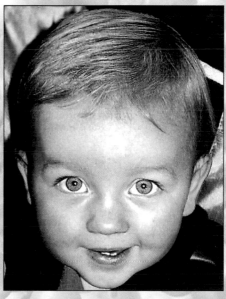

Color Plate 2-1:
An RGB image is created by mixing red, green, and blue light. In the picture file, the brightness
values for the three light components are stored in separate vats known as *channels*. Some
advanced photo-editing programs enable you to view the individual channels, as shown here.
The software combines the three channels to create the composite RGB image (top left).

300 ppi, 2.4MB

Color Plate 2-2:
Output resolution plays a major role in the appearance of printed images. The top photo has an output resolution of 300 ppi (pixels per inch); the middle photo, 150 ppi; and the bottom photo, a meager 75 ppi. Lower resolution means bigger pixels, a fact you can spot easily by looking at the black border around each picture. I applied a 2-pixel border to all three photos, but at 75 ppi, the border is twice the size it is at 150 ppi, and the 150 ppi border is twice the size of the 300 ppi border.

150 ppi, 595K

75 ppi, 153K

Color Plate 3-1:

When you apply JPEG compression, you sacrifice some picture data in the name of smaller file sizes. Here, I saved the top photo from Color Plate 2-2 at three levels of JPEG compression. Saving the picture at the maximum quality setting does little damage (top). But at lower quality settings, which apply more compression, details get lost and odd color halos can occur (middle, bottom). The quality difference becomes more noticeable as you enlarge the photo.

Maximum Quality, 900K

Medium Quality, 150K

Low Quality, 47K

Nikon, 38mm

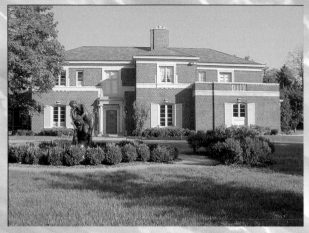

Olympus, 36mm

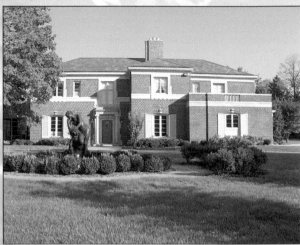

Casio, 35mm

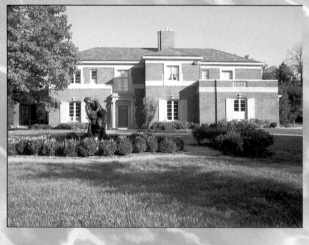

Nikon, 24mm adapter

Color Plate 3-2:
The same scene as captured by four different digital cameras, each of which has a slightly differ-
ent take on color. Each camera also captures a slightly different image area due to different lens
focal lengths. The Olympus and Nikon models have zoom lenses; for the top two images, I set each
camera to its shortest focal length. For the bottom-right image, I attached a wide-angle adapter to
the Nikon lens.

Color Plate 5-1:
This classic fruit-in-a-bowl scene illustrates the problems of too much and too little light. On the top of the lemon, too much light created a hot spot where all image detail was lost (see the inset area for a closer view). In the bottom portion of the image, the light is too low, reducing contrast and clarity. Compare the amount of detail you can see in this area with that in the upper-left corner of the image, where the light is just about perfect.

ISO 200, f/4, 1/160

ISO 400, f/4, 1/320

ISO 800, f/5.6, 1/320

ISO 1600, f/8, 1/300

Color Plate 5-2:
Raising the camera's ISO setting enables you to produce the same exposure using a faster shutter speed, a smaller aperture, or both. However, a higher ISO also reduces picture quality, as illustrated by these four twilight shots, taken with ISO settings ranging from 200 to 1600.

EV 0.0

Color Plate 5-3:
Many digital cameras offer exposure compensation controls that boost or reduce the exposure chosen by the camera's autoexposure mechanism. When exposure compensation is set to 0.0, the camera makes no adjustment to the exposure (top). A negative exposure value (EV) darkens the scene (middle row); a positive value creates brighter pictures (bottom row).

EV -0.3

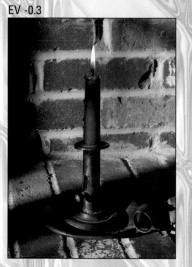

EV -0.7

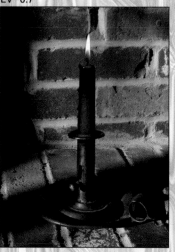

EV -1.0

EV +0.3

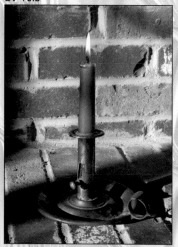

EV +0.7

EV +1.0

Auto

Sunny

Incandescent

Fluorescent

Flash

Cloudy

Color Plate 6-1:
To compensate for the varying color temperatures of different light sources, many cameras provide both automatic and manual white balance controls. This picture, taken with a Nikon digital camera, presented a special challenge because the subject was lit using a combination of fluorescent lighting (from above), bright daylight (from a window to the left of the subject, out of the frame), and the on-board flash. The Auto and Flash white-balance options on this particular camera deliver the same results because in Auto mode, the camera switches to Flash mode when the flash is turned on. The Fluorescent and Sunny white-balance options resulted in the most accurate skin tones.

Color Plate 9-1:
Zooming in on a bowl of fruit reveals what can happen when you convert a 24-bit image (top) to an 8-bit (256 color) GIF image (bottom). Without a broad variety of shades to represent the fruit, the bananas, lime, and apple look blotchy.

Color Plate 10-1:
Colors in my original butterfly picture (left) seemed a little drab; boosting the saturation value slightly produced deeper hues that more closely matched what I saw through the camera viewfinder.

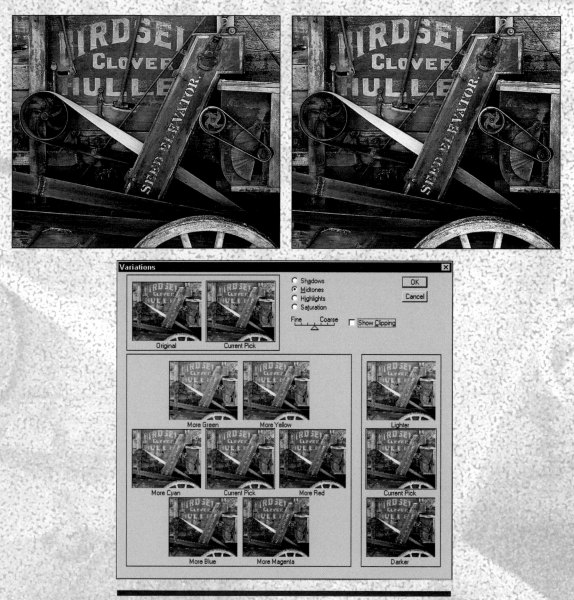

Color Plate 10-2:
I shot this photo, which provides a close-up view of the mechanics of an old clover huller, using a digital camera that tends to emphasize blue tones. The original image (upper left) had a blue cast that wasn't terribly bothersome from an artistic standpoint, but didn't reflect the real colors of the huller. To fix the problem, I went into the Photoshop Elements Variations dialog box, shown here. Adding a little yellow and red removed the blue cast and brought out the warm, faded hues of the old paint.

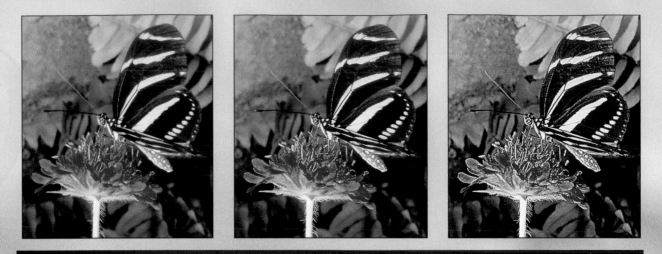

Color Plate 10-3:
A slightly soft image (left) benefits from a conservative application of a sharpening filter (middle). Too much sharpening, however, gives the picture a grainy look and creates weird, glowing halos along color boundaries (right).

Unsharpened

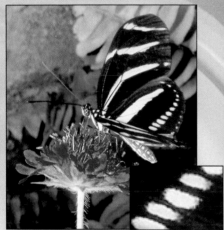

Amount, 50

Amount, 100

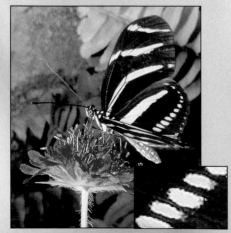

Amount, 200

Color Plate 10-4:
When applying the Unsharp Mask filter, raise the Amount value to increase the sharpening effect. Here, I applied the filter using three different Amount values. I set the Radius value to 1.0 and the Threshold value to 0 for all three sharpened examples.

Radius, .5; Threshold, 0

Radius, 2.0; Threshold, 0

Radius, .5; Threshold, 5

Radius, 2.0; Threshold, 5

Radius, .5; Threshold, 10

Radius, 2.0; Threshold, 10

Color Plate 11-1:
Most photo-editing programs include a tool similar to the Photoshop Elements Magic Wand, which selects areas based on color. In this example, I clicked at the spot marked by the X with the Magic Wand set to four different Tolerance values. The yellow tinted areas and dotted lines indicate the scope of the resulting selection outline. (See the left image in Color Plate 11-2 to see the rose without the selection markings.) As you can see, low Tolerance values select only pixels that are very similar in color to the pixel that you click. Higher values make the tool less discriminating.

Tolerance, 10

Tolerance, 32

Tolerance, 64

Tolerance, 100

Color Plate 11-2:
After selecting the rose in the left image, I copied it and pasted it into the middle image, which is simply a close-up of some weathered wood siding. Then I lowered the opacity of the rose to 50 percent to create the image on the right.

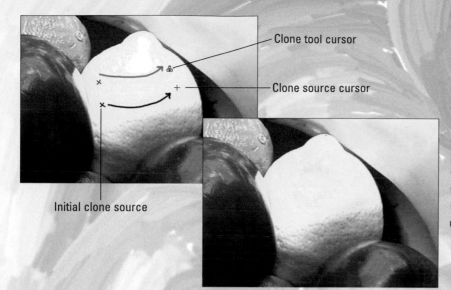

Clone tool cursor

Clone source cursor

Initial clone source

Original

Fill, Normal mode

Fill, Color mode

Hue, -83

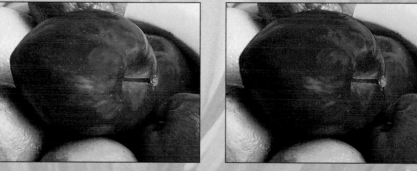

Color Plate 12-1:
To create a new species of apple, I first selected the apple but not the stem. Filling the selected area using the Photoshop Elements Fill command with the blending mode set to Normal resulted in a solid blob of color (top right). Using the Color blending mode turned the apple purple while retaining the original shadows and highlights (lower left). In the lower right example, I didn't fill the selected area at all. Instead, I used the Hue/Saturation filter. Lowering the Hue value to -83 turned the reddish parts of the apple purple and made the yellowish areas pink.

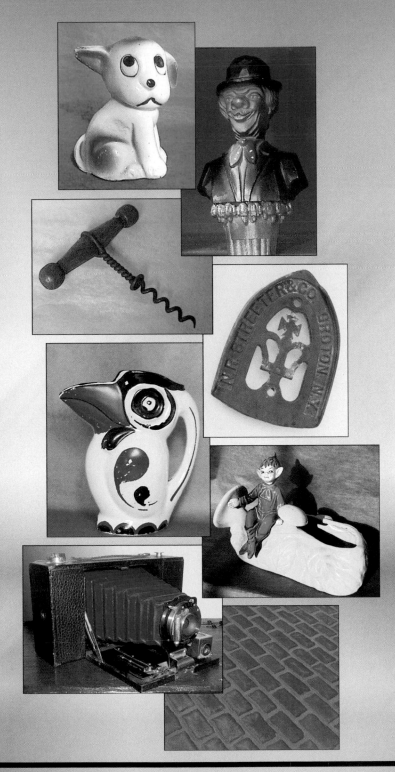

Color Plate 12-2:
These eight images served as the basis for the collage in Color Plate 12-3. I selected the subject of each of the top seven images and then copied and pasted them on top of the brick image, using the stacking order shown here.

Color Plate 12-3:
By placing each of the images in Color Plate 12-2 on a separate layer, I created this collage of objects from yesteryear.

Color Plate 12-4:
To create this antique photograph effect, I converted the color version of Color Plate 12-3 to grayscale. Then I created a new layer, filled the layer with dark gold, set the layer blend mode to Color, and set the layer opacity to 50 percent.

Original

Watercolor

Find Edges

Crystallize

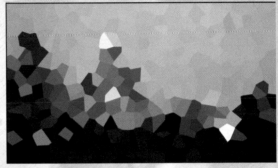

Colored Pencil

Glowing Edges

Color Plate 12-5:
With the help of special-effects filters, you can sometimes create art out of a crummy picture. Here, I applied five filters found in Photoshop Elements to a dark, grainy skyline scene, creating a variety of interesting color compositions.

Figure 8-2:
The Olympus P-400 can output 7.5 x 10-inch dye-sub prints.

You can find Thermo-Autochrome printers within the same general price range as consumer dye-sub printers. But as with dye-sub machines, most consumer Thermo-Autochrome printers can output snapshot-size prints only and can't print on plain paper. More important, examples that I've seen from consumer printers that employ this technology don't match dye-sub or good inkjet output, although I will say that the latest crop of Thermo-Autochrome printers does a much better job than earlier models.

How Long Will They Last?

In addition to the issues presented in the preceding discussion of printer types, another important factor to consider when deciding on a printer is print stability — that is, how long can you expect the prints to last?

All photographs are subject to fading and color shifts over time. Researchers say that a standard film print has a life expectancy of anywhere from 10 to 60 years, depending on the photographic paper, the printing process, and exposure to ultraviolet light and airborne pollutants, such as ozone. Those same criteria affect the stability of photos that you output on your home or office printer.

Unfortunately, the two technologies capable of delivering image quality equal to a traditional photograph — dye-sub and inkjet printing — produce prints that can degrade rapidly, especially when displayed in very bright light. Hang a print in front of a sunny window, and you may notice some fading or a change in colors in as little as a few months.

Protecting your prints

No matter what the type of print, you can help keep its colors bright and true by adhering to the following storage and display guidelines:

✔ If you're having the picture framed, always mount the photo behind a matte to prevent the print from touching the glass. Be sure to use acid-free, archival matte board and UV-protective glass.

✔ Display the picture in a location where it isn't exposed to strong sunlight or fluorescent light for long periods of time.

✔ In photo albums, slip pictures inside acid-free, archival sleeves.

✔ Don't adhere prints to a matte board or other surface using masking tape, scotch tape, or other household products. Instead, use acid-free mounting materials, sold in art-supply stores and some craft stores.

✔ Limit exposure to humidity, wide temperature swings, cigarette smoke, and other airborne pollutants, as these can also contribute to image degradation.

✔ For the ultimate protection, always keep a copy of the image file on a CD-ROM or other storage medium so that you can output a new print if the original one deteriorates.

Manufacturers have been scrambling to address this issue, and several possible solutions have been introduced recently. Epson now offers a $900 archival inkjet printer (the Epson Stylus Photo 2000P) that promises a print life expectancy of 100 years or more when special Epson inks and papers are used. However, because of the special archival inks, the *color gamut* — range of colors — that the 2000P can reproduce is smaller than with standard inkjets. Epson also offers the 2200P, an update to the 2000P. This printer, which sells for about $700, features an inkset that offers a wider color gamut at the expense of a little shorter expected print life.

Epson and several other vendors also make inks and papers that can be used with some other inkjet printers and are engineered to provide a print life of 25 years or more. You may or may not be able to use these products, depending on your printer. (Note that when you use inks not specifically provided by the printer's manufacturer, you may not get the best print quality and you may void the printer's warranty.)

Some dye-sub printers, such as the Olympus P-400 I mentioned earlier, add a special protective coating to prints to help extend print life. The folks at Olympus say that photos from this printer have about the same life expectancy as a traditional photograph.

The truth is, though, that no one really knows just how long a print from any of these new printers — inkjet or dye-sub — will last because they just haven't been around that long. The estimates given by manufacturers are based on lab tests that try to simulate the effect of years of exposure to light and atmospheric contaminants. But the research results are pretty varied, and the anticipated photo life you can expect from any printing system depends on whose numbers you use.

If your photography requires archival printing, you can dig a little deeper into the subject at the Web site of Wilhelm Imaging Research (www.wilhelm-research.com), a respected source of print life studies. The company posts details about specific papers, inks, and dyes at its site.

Also keep in mind that you can always take important images to a photo lab for output on archival photographic paper. For more information, see "Letting the Pros Do It," later in this chapter. Also see the sidebar, "Protecting your prints," for tips on making your prints last as long as possible.

So Which Printer Should You Buy?

The answer to that question depends on your printing needs and your printing budget. Here's my take on which of the printing technologies works best for which situation:

- If you want the closest thing to traditional photographic prints, go for one of the new photocentric inkjets or dye-sub models. If you go dye-sub, though, remember that you can't print on plain paper.

- If you're buying a printer for use in an office and you want a machine that can handle high-volume printing, look into color lasers.

- For home or small-office printing of both text and photos, opt for a general-purpose inkjet model. You can produce good-looking color and grayscale images, although you need to use high-grade paper and the printer's highest quality settings to get the best results. You can print on glossy photographic paper as well.

A brief warning about general-purpose inkjets: Some of the inkjets I've tried have been so slow and had such page-warping problems that I would never consider using them on a daily basis. Others do a really good job, delivering sharp, clean images in a reasonable amount of time, with little evidence of the problems normally associated with this printing technology. The point is, all inkjets are not created equal, so shop carefully.

- If you're using your digital camera for business and frequently need prints on the road, consider adding a portable printer to your equipment roster. Sony, Hewlett-Packard, Olympus, Canon, and others make

small, lightweight, snapshot printers that can print either directly from the camera or from a memory card. (See the Figure 8-3 for a look at one such printer.) As an alternative, Olympus also offers a camera with a built-in Polaroid printer. You can see this camera in Chapter 3.

✔ Multipurpose printers — those that combine a color printer, fax machine, and scanner in one machine — usually don't produce the kind of output that will satisfy most photo enthusiasts. Typically, you sacrifice print quality and/or speed in exchange for the convenience of the all-in-one design. However, a few all-in-one printers use the same print technology as photo printers and so really can deliver good photographic prints. If you need all three components (fax, scanner, and printer), you may want to take a look at all-in-one machines to see whether the photo-printing capabilities meet your needs.

Keep in mind that most photocentric printers aren't engineered with text printing as the primary goal, so your text may not look as sharp as it would on a low-cost black-and-white laser or inkjet printer. Also, your text printing costs may be higher than on a black-and-white printer because of ink costs.

Comparison Shopping

After you determine which type of printer is best for your needs, you can get down to the nitty-gritty and compare models and brands. Print quality and other features can vary widely from model to model, so do plenty of research.

The easiest feature to compare is the size of print that the machine can produce. You have three basic options:

✔ Standard printers can print on paper as large as 8.5 x 11 inches, or what we commonly refer to as letter-size paper. However, most printers can't print all the way to the edge of the paper — in other words, can't produce borderless photo prints.

✔ Wide-format printers, such as the Epson Stylus Photo 1280 pictured in Figure 8-1, can handle larger paper. The maximum size print you can output varies from model to model. In addition, some wide-format printers can print borderless prints.

✔ Snapshot printers are limited to printing pictures at sizes of 4 x 6 inches or smaller. Figure 8-3 shows two examples of snapshot printers, the Sony DPP-SV77, a $500 dye-sub printer, and the Hewlett-Packard P100, a $180 inkjet model. Most new snapshot printers, including these two, can print directly from camera memory cards. The Sony model even has a small monitor that enables you to view your pictures before printing. You can also do limited picture editing, including adding text to a photo.

Figure 8-3:
Printers
such as
these
models from
Sony (left)
and
Hewlett-
Packard
(right) can
output
snapshot-
size photos
directly from
camera
memory
cards.

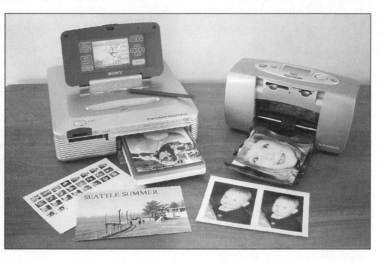

After you get past print size, sorting through the remaining printer features can get a little murky. The information you see on the printer boxes or marketing brochures can be a little misleading. So here's a translation of the most critical printer data to study when you're shopping:

- ✔ **Dpi:** Dpi stands for *dots per inch* and refers to the number of dots of color the printer can create per linear inch. You can find consumer-level color printers with resolutions from 300 dpi up to 2800 dpi.

 A higher dpi means a smaller printer dot, and the smaller the dot, the harder it is for the human eye to notice that the image is made up of dots. So in theory, a higher dpi should mean better-looking images. But because different types of printers create images differently, an image output at 300 dpi on one printer may look considerably better than an image output at the same or even higher dpi on another printer. For example, a 300-dpi dye-sub printer may produce prints that look better than those from a 600-dpi inkjet. So although printer manufacturers make a big deal about their printers' resolutions, dpi isn't always a reliable measure of print quality. For more information about resolution and dpi, take a cab to Chapter 2.

- ✔ **Quality options:** Many printers give you the option of printing at several different quality settings. You can choose a lower quality for printing rough drafts of your images and then bump up the quality for final output. Typically, the higher the quality setting, the longer the print time and, on inkjet printers, the more ink required.

 Ask to see a sample image printed at each of the printer's quality settings and determine whether those settings will work for your needs. For

example, is the draft quality so poor that you would need to use the highest quality setting even for printing proofs? If so, you may want to choose another printer if you print a lot of drafts.

Also, if you need to print many grayscale images as well as color images, find out whether you're limited to the printer's lowest-quality setting for grayscale printing. Some printers offer different options for color and grayscale images.

✔ **Inkjet colors:** Most inkjets print using four colors: cyan, magenta, yellow, and black. This ink combination is known as CMYK (see the sidebar "The separate world of CMYK," later in this chapter). Some lower-end inkjets eliminate the black ink and just combine cyan, magenta, and yellow to approximate black. "Approximate" is the key word — you don't get good, solid blacks without that black ink, so for best color quality, avoid three-color printers.

Some new photocentric inkjets feature six or seven ink colors, adding a light cyan, light magenta, or light black to the standard CMYK mix. The extra inks expand the range of colors that the printer can manufacture, resulting in more accurate color rendition, but add to the print cost.

✔ **Print speed:** If you use your printer for business purposes and you print a lot of images, be sure that the printer you pick can output images at a decent speed. And be sure to find out the per-page print speed for printing at the printer's *highest* quality setting. Most manufacturers list print speeds for the lowest-quality or draft-mode printing. When you see claims like "Prints at speeds *up to . . . ,*" you know you're seeing the speed for the lowest-quality print setting.

✔ **Cost per print:** To understand the true cost of a printer, you need to think about how much you'll pay for consumables each time you print a picture. The paper part is easy: Just find out what kind of paper the man-ufacturer recommends and then go to any computer store or office-supply outlet and check prices for that paper. (Or if you don't feel like getting dressed, see "Thumbing through Paper Options," later in this chapter, for a rough approximation of prices.)

If you're considering a Thermo-Autochrome printer, your only cost lies in paper because all the chemicals that produce the print are contained in the paper. But for other types of printers, you need to add the cost of ink, toner, or dye to the paper cost.

Manufacturers usually include this data in their brochures or on their Web sites. You usually see costs stated in terms of x percentage of coverage per page — for example, "three cents per page at 15 percent coverage." In other words, if your image covers 15 percent of an 8.5 x 11-inch sheet of paper, you spend three cents on toner, ink, or dye. The problem is that no single standard for calculating this data exists, so you really can't com-pare apples to apples. One manufacturer may specify per-print costs based on one size image and one print-quality setting, while another uses an entirely different print scenario.

My advice? Don't discount cost-per-print data entirely, but don't take it as gospel, either. This information is most useful for deciding between different print technologies — inkjet, laser, and so on. But when you compare models within a category, don't drive yourself nuts trying to find the model that claims to shave a percentage of a penny off your print costs. Remember, the numbers you see are approximations at best and are calculated in a fashion designed to make the use costs appear as low as possible. As they say in the car ads, your actual mileage may vary.

That said, if you're buying an inkjet printer, you *can* lower your ink costs somewhat by choosing a printer that uses a separate ink cartridge for each ink color (typically, cyan, magenta, yellow, and black) or at least uses a separate cartridge for the black ink. On models that have just one cartridge for all inks, you usually end up throwing away some ink because one color will be depleted before the others.

Also remember that some printers require special cartridges for printing in photographic-quality mode. In some cases, these cartridges lay down a clear overcoat over the printed image. The overcoat gives the image a glossy appearance when printed on plain paper and also helps protect the ink from smearing and fading. In other cases, you put in a cartridge that enables you to print with more colors than usual — for example, if the printer usually prints using four inks, you may insert a special photo cartridge that enables you to print using six inks. These special photographic inks and overlay cartridges are normally more expensive than standard inks. So when you compare output from different printers, find out whether the images were printed with the standard ink setup or with more expensive photographic inks.

✔ **Host-based printing:** With a *host-based printer,* all the data computation necessary to turn pixels into prints is done on your computer, not on the printer. In some cases, the process can tie up your computer entirely — you can't do anything else until the image is finished printing. In other cases, you can work on other things while the image prints, but your computer runs more slowly because the printer is consuming a large chunk of the computer's resources.

If you print relatively few images during the course of a day or week, having your computer unavailable for a few minutes each time you print an image may not be a bother. And host-based printers are generally cheaper than those that do the image processing themselves. But if you print images on a daily basis, you're going to be frustrated by a printer that ties up your system in this fashion. On the other hand, if you buy a printer that does its own image processing, be sure that the standard memory that ships with the printer will be adequate. You may need to buy additional memory to print large images at the printer's highest resolution, for example.

✔ **Computer-free printing:** Several manufacturers offer printers that can print directly from your camera or memory cards — no computer required. You insert your memory card, use the printer's control panel to set up the print job, and press the Print button.

With some printers, you can get pictures from the camera to the printer via infrared transfer or by cabling the camera to the printer. Typically, these transfer features work only between printers and cameras from the same manufacturer, so read the fine print.

Also look for something called *DPOF* (say it *dee-poff*), which stands for *digital print order format*. DPOF enables you to select the images you want to print through your camera's user interface. The camera records your instructions and passes them onto the printer when you transfer the images between the two devices.

Of course, direct printing takes away your chance to edit your pictures; you may be able to use camera or printer settings to make minor changes, such as rotating the image, making the picture brighter, or applying a prefab frame design, but that's all. Direct printing is great on occasions where print immediacy is more important than image perfection, however. For example, a real-estate agent taking a client for a site visit can shoot pictures of the house and output prints in a flash so that the client can take pictures home that day.

✔ **PostScript printing:** If you want to be able to print graphics created in illustration programs such as Adobe Illustrator and saved in the EPS (Encapsulated PostScript) file format, you need a printer that offers PostScript printing functions. Some photo-editing programs enable you to save in EPS as well. Some printers have PostScript support built in, while others can be made PostScript-compatible with add-on software.

Although the preceding specifications should give you a better idea of which printer you want, be sure to also go to the library and search through computer and photography magazines for reviews of any printer you're considering. In addition, you can get customer feedback on different models by logging onto one of the digital photography or printing newsgroups on the Internet. See Chapter 15 for leads on two newsgroups as well as a list of other sources for finding the information you need.

Just as with any other major purchase, you should also investigate the printer's warranty — one year is typical, but some printers offer longer warranties. And be sure to find out whether the retail or mail-order company selling the printer charges a *restocking fee* if you return the printer. Many sellers charge as much as 15 percent of the purchase price in restocking fees. (In my city, all the major computer stores charge restocking fees, but the office supply stores don't — yet.)

I resent the heck out of restocking fees, especially when it comes to costly equipment like printers, and I never buy at outfits that charge these fees. Yes, I understand that after you open the ink cartridges and try out the printer, the store can't sell that printer as new (at least, not without putting in replacement ink cartridges). But no matter how many reviews you read or how many questions you ask, you simply can't tell for certain that a particular printer can do the job you need it to do without taking the printer home and testing it with your computer and with your own images.

The separate world of CMYK

As you know if you read Chapter 2, on-screen images are *RGB* images. RGB images are created by combining red, green, and blue light. Most professional printing presses and most, but not all, consumer printers create images by mixing four colors of ink — cyan, magenta, yellow, and black. Pictures created using these four colors are called *CMYK* images. (The *K* is used instead of *B* because the people who created this acronym were afraid someone might think that *B* meant blue instead of black. Also, black is called the *key* color in CMYK printing.)

You may be wondering why four primary colors are needed to produce colors in a printed image, while only three are needed for RGB images. (Okay, I know you're probably not wondering that at all, but indulge me. After all, you never know when this question is going to come up on *Jeopardy!* or *Win Ben Stein's Money.*) The answer is that unlike light, inks are impure. Black is needed to help ensure that black portions of an image are truly black, not some muddy gray, as well as to account for slight color variations between inks produced by different vendors.

Aside from looking smart on a game show, what does all this CMYK stuff mean to you? First, if you're shopping for an inkjet printer, be aware that some models print using only three inks, leaving out the black. Color rendition is usually worse on models that omit the black ink.

Second, if you're sending your image to a service bureau for printing, you may need to convert your image to the CMYK color mode and create *color separations*. If you read "The Secret to Living Color" in Chapter 2, you may recall that CMYK images comprise four color channels — one each for the cyan, magenta, yellow, and black image information. Color separations are nothing more than grayscale printouts of each color channel. During the printing process, your printer combines the separations to create the full-color image. If you're not comfortable doing the CMYK conversion and color separations yourself or your image-editing software doesn't offer this capability, your service bureau or printer can do the job for you. (Be sure to ask the service rep whether you should provide RGB or CMYK images, because some archival photographic printers require RGB.)

Don't convert your images to CMYK for printing on your own printer, because consumer printers are engineered to work with RGB image data. And no matter whether you're printing your own images or having them commercially reproduced, remember that CMYK has a smaller *gamut* than RGB, which is a fancy way of saying that you can't reproduce with inks all the colors you can create with RGB. CMYK can't handle the really vibrant, neon colors you see on your computer monitor, for example, which is why images tend to look a little duller after conversion to CMYK and why your printed images don't always match your on-screen images.

One more note about CMYK: If you're shopping for a new inkjet printer, you may see a few models described as CcMmYK or CcMmYKk printers. Those lower-case letters indicate that the printer offers a light cyan, magenta, or black ink, respectively, in addition to the traditional cyan, magenta, and black cartridges. As I mentioned earlier, the added inksets are provided to expand the range of colors that the printer can produce.

For more information about RGB and CMYK, hightail it back to Chapter 2.

Few stores have printers hooked up to computers, so you can't test-print your own images in the store. Some printers can output samples using the manufacturer's own images, but those images are carefully designed to show the printer at its best and mask any problem areas. So either find a store where you can do your own pre-purchase testing, or make sure that you're not going to pay a hefty fee for the privilege of returning the printer.

Thumbing through Paper Options

With paper, as with most things in life, you get what you pay for. The more you're willing to pay for your paper, the more your images will look like traditional print photographs. In fact, if you want to upgrade the quality of your images, simply changing the paper stock can do wonders.

Table 8-1 shows some sample prices of commonly used paper stocks, with the least expensive stocks listed first. If your printer can accept different stocks, print drafts of your images on the cheaper stocks, and reserve the stocks at the end of the table for final output. Note that prices in the table reflect what you can expect to pay in discount office supply or computer stores. The paper size in all cases is 8.5 x 11 inches. You can buy photographic stock in other sizes, however, to use with some printers.

Don't limit yourself to printing images on standard photo paper, though. You can buy special paper kits that enable you to put images on calendars, stickers, greeting cards, transparencies (for use in overhead projectors), and all sorts of other stuff. Some printers even offer accessory kits for printing your photos on coffee mugs and T-shirts. And if you use an inkjet printer, try out some of the new textured papers, which have surfaces that mimic traditional watercolor paper, canvas, and the like.

Table 8-1	Paper Types and Costs	
Type	*Description*	*Cost per Sheet*
Multipurpose	Lightweight, cheap paper designed for everyday use in printers, copiers, and fax machines. Similar to the stuff you've been putting in your photocopier and typewriter for years.	$.01 to .02
Inkjet	Designed specifically to accept inkjet inks. At higher end of price range, paper is heavier and treated with special coating that enables ink to dry more quickly, reducing ink smearing, color bleeding, and page curl.	$.01 to .10

Type	Description	Cost per Sheet
Laser	Engineered to work with the toners used in laser printers. So-called "premium" laser papers are heavier, brighter, smoother, and more expensive. The smooth surface makes images appear sharper; the whiter color gives the appearance of higher contrast.	$.01 to .04
Photo	Thicker stock expressly designed for printing digital photos; creates closest cousin to traditional film print. Available with glossy or matte finish and artistic textures.	$.50 to $2
Dye-sub	Glossy paper specially treated for use with dye-sub printers only.	$1 to $2

Letting the Pros Do It

As you've no doubt deduced if you've read the meaty paragraphs prior to this one — as well as the less meaty but still nutritious ones — churning out photographic-quality prints of your digital images can be a pricey proposition. When you consider the cost of special photographic paper along with special inks or coatings that your printer may require, you can easily spend $1 or more for each print. In addition, unless you're using archival papers and inks, your prints may not retain their original beauty as long as a traditional photographic print.

When you want high-quality, long-lasting prints, you may find it easier and even more economical to let the professional printers handle your output needs. Here are a few options to consider:

✔ For top-notch photographic prints, go to a commercial imaging lab that's geared to serving the needs of professional photographers and graphic artists. Such labs now offer printing of digital files on archival photographic paper. You can output a proof copy of your image on your home or office printer, and the lab can match the colors in your final print to that proof. Prices will vary depending on area; in my city, Indianapolis, an 8 x 10-inch print costs $8 to $16, but the price per print goes down if you buy multiple copies of the same picture. Ask your artist and photographer friends to recommend a good lab, if you're new to the game. And be sure to ask the lab's service rep to explain the different printing and paper options as well as how to prepare and submit your files.

✔ You can also get good prints from your digital files at many retail photo-finishing labs. The cost per print is usually around 30 cents for a snapshot-size print and $5 for an 8 x 10. But color matching and the longest-life archival paper may not be provided at this price range. I find that the best output (and service) in this category comes from labs associated with locally owned camera stores as compared to big, national chains.

✔ Web-based print services offer an option to photographers without access to a walk-in lab. You transmit your images to the company over the Internet and receive your printed images in the mail. Two online labs to try are the Kodak-owned Ofoto (www.ofoto.com) and Shutterfly (www.shutterfly.com). Cost for an 8 x 10 print is about $4, plus another buck or two for shipping.

✔ If you need 50 or more copies of an image or you want to print on a special stock — say, for example, a colored stock — call upon the services of a commercial printer or service bureau. You can then have your images reproduced using traditional four-color CMYK printing. The cost per printed image will depend on the number of images you need (typically, the more you print, the lower the per-print cost) and the type of stock you use.

Sending Your Image to the Dance

Assuming that you decide to print your image yourself, getting the picture on paper involves several steps and a few thoughtful decisions. Here's the drill:

1. **Open the photo file.**

 Sadly, you can't just slap your computer and make the photo walk itself to the printer. To get the print process rolling, you need to fire up your photo software and open the image file.

2. **Set the image size and resolution.**

 This important and sometimes tricky process is outlined in depth in the next section.

3. **Choose the Print command.**

 In almost every program on the planet, the Print command resides in the File menu. Choosing the command results in a dialog box through which you can change the print settings, including the printer resolution or print quality and the number of copies you want to print. You can also specify whether you want to print in *portrait mode,* which prints your image in its normal, upright position, or *landscape mode,* which prints your image sideways on the page.

You don't have to go to all the trouble of clicking on File and then on Print, though. You can choose the Print command more quickly by pressing Ctrl+P in Windows or ⌘+P on a Mac. (Some programs bypass the Print dialog box and send your image directly to the printer when you use these keyboard shortcuts, however. So if you need to adjust any printing settings, as in the next few steps, you need to use the File➪Print approach.)

4. **Specify the print options you want to use.**

 The available options — and the manner in which you access those options — vary widely depending on the type of printer you're using and whether you're working on a PC or a Mac. In some cases, you can access settings via the Print dialog box; in other cases, you may need to go to the Page Setup dialog box, which opens when you choose the Page Setup command, generally found in the File menu, not too far from the Print command. (You can sometimes access the Page Setup dialog box by clicking on a Setup button inside the Print dialog box, too.)

 I'd love to explain and illustrate all kazillion variations of Print and Page Setup dialog box options, but I have neither the time, space, nor psychotherapy budget that task would require. So please read your printer's manual for information on what settings to use in what scenarios, and, for heaven's sake, follow the instructions. Otherwise, you aren't going to get the best possible images your printer can deliver.

 Also, if you have more than one printer, make sure that you have the right printer selected before you go setting all the printer options.

5. **Send that puppy to the printer.**

 Look in the dialog box for an OK or Print button and click the button to send your image scurrying for the printer.

With that broad overview under your belt — and with your own printer manual close at hand — you're ready for some more specific tips about making hard copies of your images. The following section tells all.

How to adjust print size and resolution

Because print size and output resolution have a major impact on print quality, you need to take care when setting these two values prior to printing. If you haven't read Chapter 2 yet, I suggest that you explore the sections on resolution before you continue on with this chapter, because the words of wisdom I'm about to impart will make more sense. But here's a brief recap of the relevant concepts:

✔ Output resolution is measured in *ppi* — pixels per inch. For most consumer printers, you should set the output resolution between 200 to 300 ppi; check your printer manual for the specific ideal image resolution. If you're having your image professionally printed, talk to the lab's service reps about the appropriate output resolution.

✔ Printer resolution is measured in *dpi* — dots per inch. Printer dots and image pixels are *not* the same. I repeat, *not the same.* So don't assume that you should set your image output resolution to match your printer's resolution. On some printers, you do want a one-to-one ratio of image pixels to printer dots. But other printers use multiple ink dots to represent each image pixel. Again, check your printer manual for the optimum output resolution.

✔ Output resolution (pixels per inch) and print size are irrevocably linked. When you enlarge an image, one of two things happens: The resolution goes down and the pixel size increases, or the image-editing software adds new pixels to fill the enlarged image area (a process called *upsampling*). Both options can result in a loss of image quality.

Similarly, you have two options when you reduce the dimensions of the print. You can retain the current pixel count, in which case the resolution goes up and the pixel size shrinks. Or you can retain the current resolution, in which case the image-editing software *downsamples* the image (dumps excess pixels). Because dumping too many pixels can also harm your image, avoid downsampling by more than 25 percent. With some photos, you may not notice any quality loss even if you downsample by a greater degree, however.

✔ To figure out the maximum size at which you can print your image at a desired resolution, divide the horizontal pixel count (the number of pixels across) by the desired resolution. The result gives you the maximum width of the image. To determine the maximum print height, divide the vertical pixel count by the desired resolution.

✔ What if you don't have enough pixels to get both the print size and resolution you want? Well, you have to choose which is more important. If you absolutely need a certain print size, you just have to sacrifice some image quality and accept a lower resolution. And if you absolutely need a certain resolution, you have to live with a smaller image. Hey, life's full of compromises, right?

With these points in mind, you're ready to specify your output resolution and image size. The following steps explain how to resize your image without resampling in Adobe Photoshop Elements:

1. **Choose Image➪Resize➪Image Size.**

 The dialog box shown in Figure 8-4 appears.

Figure 8-4:
The Image
Size
dialog box.

2. **Turn off the Resample Image check box.**

 This option controls whether the program can add or delete pixels as you change the print dimensions. When the option is turned off, the number of pixels can't be altered.

 Click the box to toggle the option on and off. An empty box means that the option is turned off, which is what you want in this case.

3. **Enter the print dimensions or resolution.**

 Enter the print dimensions in the Width or Height boxes; as you change one value, the other changes automatically to retain the original proportions of the picture. Likewise, as you change the dimensions, the Resolution value changes automatically. If you prefer, you can change the Resolution value, in which case the program alters the Width and Height values accordingly.

4. **Click OK or press Enter.**

 If you did things correctly — that is, deselected the Resample Image check box in Step 2 — you shouldn't see any change in your image on-screen, because you still have the same number of pixels to display. However, if you choose View⇨Show Rulers, which displays rulers along the top and left side of your image, you can see that the image will, in fact, print at the dimensions you specified.

If you want to resample the image in order to achieve a certain print resolution, select the Resample Image check box. (Click the box so that a check mark appears inside.) Then set your desired Width, Height, and Resolution values.

When the Resample Image option is enabled, a second set of Width and Height boxes becomes available at the top of the dialog box. Use these options to set your photo dimensions using pixels or percent (of the original image size) as the unit of measure.

If you're using another photo editor, be sure to consult the program's help system or manual for information on resizing options available to you. Advanced photo-editing programs such as Elements offer you the option of controlling resolution as you resize, but some entry-level programs don't. Instead, these programs automatically resample the image any time you resize it, so be careful.

How can you tell if a program is resampling images upon resizing? Check the "before" and "after" size of the image file. If the file size changes when you resize the image, the program is resampling the photo. (Adding or deleting pixels increases or reduces the file size.)

What's Print Image Matching?

Print Image Matching, or *PIM* for short, is a color-management technology developed by Epson in an attempt to enable digital photographers to get printed output that more closely matches what their digital camera captured.

As explained in Chapter 4, many digital cameras record special image data, known as EXIF metadata, in the image file. With cameras that support PIM technology, the metadata includes information about the ideal print settings to use when reproducing the image. When you print the picture on a PIM-enabled Epson printer, the printer refers to this data and adjusts the printed output accordingly.

In theory, PIM enables you to produce prints that more accurately reproduce the colors that you saw through your viewfinder. Epson also claims that PIM results in prints with improved exposure, sharpness, and saturation than you get without the technology. A few hang-ups exist, however.

First, in order for the printer to access the metadata, you have to either print directly from your camera memory or open and print the picture using photo software that supports PIM, such as Epson Software Film Factory. (Depending on your software, you may be able to install a plug-in that enables your existing software to read the PIM data.) Second, you wipe out all the metadata if you edit the photo. Finally, whether or not your eye appreciates what PIM does to your prints is a matter of personal taste — you may not like the amount of sharpening or saturation that the technology delivers, for example.

My take is that PIM is a fine feature for folks who just want to shoot and print and don't mind letting their hardware making all the decisions for them. For photographers who want a little more control, PIM is probably a non-starter — nice to have, but not the most important component in the buying decision. If your camera and printer offer PIM, though, by all means try it out for yourself. In some cases, you'll see a big improvement with PIM enabled; with other photos, the difference may be negligible.

To read more about the technology, visit www.printimagematching.com. Note that if you do own a printer and camera that support PIM, you should check the Web site regularly to look for updated *drivers* (pieces of software that your computer, camera, and printer need in order to converse with each other).

These colors don't match!

You may notice a significant color shift between your on-screen and printed images. This color shift is due in part to the fact that you simply can't reproduce all RGB colors using printer inks, a problem explained in the sidebar "The separate world of CMYK," earlier in this chapter. In addition, the brightness of the paper, the purity of the ink, and the lighting conditions in which the image is viewed can all lead to colors that look different on paper than they do on-screen.

Although perfect color matching is impossible, you can take a few steps to bring your printer and monitor colors closer together, as follows:

- Changing your paper stock sometimes affects color rendition. In my experience, the better the paper, the truer the color matching.

- The software provided with most color printers includes color-matching controls that are designed to get your screen and image colors to jibe. Check your printer manual for information on how to access these controls.

- If playing with the color-matching options doesn't work, the printer software may offer controls that enable you to adjust the image's color balance. When you adjust the color balance using the printer software, you don't make any permanent changes to your image. Again, you need to consult your printer manual for information on specific controls and how to access and use them.

- Don't convert your images to the CMYK color model for printing on a consumer printer. These printers are designed to work with RGB images, so you get better color matching if you work in the RGB mode.

- Many image-editing programs also include utilities that are designed to assist in the color-matching process as well. Some of these are very user-friendly; after printing out a sample image you let the program know which sample most closely matches what you see on-screen. The program then calibrates itself automatically using this information.

Photoshop Elements, Photoshop, and other advanced programs offer more sophisticated color-management options. If you're new to the game, I suggest you leave these settings in their default positions, as the whole topic is a little mind-boggling and you can just as easily make things worse

as improve them. Many of the color settings aren't designed to improve matching between your printer and monitor, anyway, but to ensure color consistency through a production workflow — that is, between different technicians passing an image file along from creation to printing.

✔ If your photography work demands more accurate color-matching controls than your printer software delivers, you can invest in professional color-matching software. This software enables you to calibrate all the different components of your image-processing system — scanner, monitor, and printer — so that colors stay true from machine to machine. However, these programs can cost hundreds of dollars and are complex to use. Expect to spend some time tweaking the software's color profiles (files that tell your computer how to adjust colors to account for different types of scanners, monitors, and printers). The default profiles usually don't deliver maximum results.

Remember, too, that even the best color-matching system can't deliver 100-percent accuracy because of the inherent difference between creating colors with light and reproducing them with ink.

These same comments apply to the color-management systems that may be included free with your operating-system software, such as ColorSync.

✔ If your monitor enables you to adjust the screen display, try this procedure to get your printer and monitor more in synch. Print a color image and then hold the image up next to the monitor. Compare the printed picture with the one on-screen and then adjust the monitor settings until the two fall more in line. But remember that this process is a little backwards in that it calibrates the monitor to the printer rather than the other way around. So if you print your image on another printer, your colors may shift dramatically from what you see on the monitor.

✔ Finally, remember that the colors you see both on-screen and on paper vary depending on the light in which you view them.

More words of printing wisdom

In parting — well, at least for this chapter — let me offer these last few final tidbits of printing advice:

✔ Once more with feeling: The type of paper you use greatly affects image quality. For those special pictures, invest in glossy photographic stock or some other high-grade option. See "Thumbing through Paper Options," earlier in this chapter, for more paper news.

✔ Do a test print using different printer-resolution or print-quality settings to determine which settings work best for which types of images and which types of paper. The default settings selected by the printer's software may not be the best choices for the types of images you print. Be sure to note the appropriate settings so that you can refer to them later. Also, some printer software enables you to save custom settings so that you don't have to reset all the controls each time you print. Check your printer manual to find out whether your printer offers this option.

✔ If your image looks great on-screen but prints too dark, your printer software may offer brightness/contrast controls that enable you to temporarily lighten the image. You may get better results, though, if you do the job using your image editor's Levels or Brightness/Contrast filters. In any case, if you want to make permanent changes to brightness levels, you need to use your image editor, not your printer software. See Chapter 10 for details.

✔ Speaking of printer software — known in geek collectives as a *driver* — don't forget to install it on your computer. Follow the installation instructions closely so that the driver is installed in the right folder in your system. Otherwise, your computer can't communicate with your printer.

✔ If your printer didn't ship with a cable to connect the printer and computer, make sure that you buy the right kind of cable. For parallel-port connections, most printers require bidirectional, IEEE 1284–compliant cables. Don't worry about what that means — just look for the words on the cable package. And don't cheap out and buy less-expensive cables that don't meet this specification, or you won't get optimum performance from your system.

✔ Some printers don't perform well when connected to the computer through a pass-through device. For example, if you have a CD recorder connected to your computer's printer port and then plug your printer into a printer port on the CD recorder, you may experience printing hang-ups. Do a test print after connecting your printer to any new pass-through devices.

✔ Don't ignore your printer manual's instructions regarding routine printer maintenance. Print heads can become dirty, inkjet nozzles can become clogged, and all sorts of other gremlins can gunk up the works. When testing an inkjet model for this book, for example, I almost wrote the printer off as a piece of junk because I was getting horrendous printouts. Then I followed the troubleshooting advice in the manual and cleaned the print heads. The difference was like night and day. Suddenly, I was getting beautiful, rich images, just like the printer's advertisements promised.

Chapter 9

On-Screen, Mr. Sulu!

In This Chapter

▶ Creating pictures for screen display

▶ Preparing photos for use on a Web page

▶ Trimming your file size for faster image downloading

▶ Choosing between the two Web file formats — GIF and JPEG

▶ Making part of your Web picture transparent

▶ Attaching a photo to an e-mail message

Digital cameras are ideal for creating pictures for on-screen display. Even the most inexpensive, entry-level cameras can deliver enough pixels to create good images for Web pages, online photo albums, multimedia presentations, and other on-screen uses.

The process of preparing your pictures for the screen can be a little confusing, however — in part because so many people don't understand the correct approach and keep passing along bad advice to newcomers.

This chapter shows you how to do things the right way. You find out how to set the display size of on-screen photos, which file formats work best for different uses, how to send a picture along with an e-mail message, and more.

Step into the Screening Room

With a printed picture, your display options are fairly limited. You can pop the thing into a frame or photo album. You can stick it to a refrigerator with one of those annoyingly cute refrigerator magnets. Or you can slip it into your wallet so that you're prepared when an acquaintance inquires after you and yours.

In their digital state, however, photos can be displayed in all sorts of new and creative ways, including the following:

🖊 Add pictures to your company's site on the World Wide Web. Many folks these days even have personal Web pages devoted not to selling products but to sharing information about themselves. See "Nothing but Net: Photos on the Web," later in this chapter, for details on preparing a digital photo for use on a Web page.

🖊 E-mail a picture to friends, clients, or relatives, who then can view the image on their computer screens, save the image to disk, and even edit and print the photo if they like. Check out "Drop Me a Picture Sometime, Won't You?" later in this chapter for information on how to attach a picture to your next e-mail missive.

🖊 Alternatively, create an online album through a photo-sharing site such as Ofoto (www.ofoto.com). After uploading pictures, you can invite people to view your album and to buy prints of their favorite photos. You generally can create and share albums at no charge; the Web sites make a profit through their photo printing services.

Figure 9-1 offers a look at an online album that I created at the Ofoto Web site to share pictures of a vacation in Antigua. For a list of other photo-sharing sites, flip to Chapter 14.

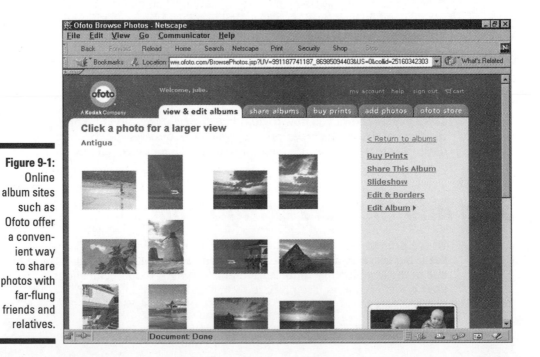

Figure 9-1:
Online album sites such as Ofoto offer a convenient way to share photos with far-flung friends and relatives.

✔ Import the picture into a multimedia presentation program such as Microsoft PowerPoint or Corel Presentations. The right images, displayed at the right time, can add excitement and emotional impact to your presentations and also clarify your ideas. Check your presentation program's manual for specifics on how to add a digital photo to your next show.

✔ Create a personalized screen saver featuring your favorite images. Most consumer photo-editing programs include a wizard or utility that makes creating such a screen saver easy.

✔ With many digital cameras, you can download images to your TV, DVD player, or VCR. You can then show your pictures to a living room full of captive guests and even record your images to videotape. Load up the camera with close-up pictures of your navel, cable the camera to your TV, and you've got an evening that's every bit as effective as an old-time slide show for convincing pesky neighbors that they should never set foot in your house again. For information on this intriguing possibility, see Chapter 7.

That's About the Size of It

Preparing pictures for on-screen display requires a different approach than you use to get them ready for the printer. The following sections tell all.

Understanding monitor resolution and picture size

As you prepare pictures for on-screen use, remember that monitors display images using one screen pixel for every image pixel. (If you need a primer on pixels, flip back to Chapter 2.) The exception is when you're working in a photo-editing program or other application that enables you to zoom in on a picture, thereby devoting several screen pixels to each image pixel.

Most monitors can be set to a choice of displays, each of which results in a different number of screen pixels, or, in common lingo, a different *monitor resolution*. Standard monitor resolution settings include 640 x 480 pixels, 800 x 600 pixels, 1024 x 768 pixels, and 1280 x 1024 pixels. The first number always indicates the number of horizontal pixels.

To size a screen picture, you simply match the pixel dimensions of the photo to the amount of screen real estate that you want the picture to consume. If your photo is 640 x 480 pixels, for example, it consumes the entire screen when the monitor resolution is set to 640 x 480. Raise the monitor resolution, and the same photo no longer fills the screen.

For a clearer idea of how monitor resolution affects the size at which your photo appears on the screen, see Figures 9-2 and 9-3. Both examples show a 640 x 480-pixel digital photo as it appears on a 17-inch monitor. (I used the Windows Desktop Properties control to display the photo as my Windows desktop background.) In Figure 9-2, I set the monitor resolution to 640 x 480. The image fills the entire screen (although the Windows taskbar hides a portion of the image at the bottom of the frame). In Figure 9-3, I displayed the same picture but switched the monitor resolution to 1280 x 1024. The image now eats up about one-fourth of the screen.

Figure 9-2: A 640 x 480-pixel digital photo fills the screen when the monitor resolution is set to 640 x 480.

Unfortunately, you often don't have any way to know or control what monitor resolution will be in force when your audience views your pictures. Someone viewing your Web page in one part of the world may be working on a 21-inch monitor set at a resolution of 1280 x 1024, while another someone may be working on a 13-inch monitor set at a resolution of 640 x 480. So you just have to strike some sort of compromise.

For Web images, I recommend sizing your photos assuming a 640 x 480 monitor resolution — the least common denominator, if you will. If you create an image larger than 640 x 480, people who use a monitor resolution of 640 x 480 have to scroll the display back and forth to see the entire photo. Of course, if you're preparing images for a multimedia presentation and you know what monitor resolution you'll be using, work with that display in mind.

Figure 9-3:
At a monitor
resolution of
1280 x 1024,
a 640 x 480-
pixel photo
consumes
roughly one-
quarter of
the screen.

Sizing images for the screen

To resize your image for screen display, follow the same procedures you use
to size images for print, but choose pixels as your unit of measurement. The
exact steps vary depending on your photo editor.

Here's how to do the job in Photoshop Elements:

1. **Save a backup copy of your picture.**

 In all likelihood, you're going to trim pixels from your photo for on-screen
 display. You may want those original pixels back someday, so save a
 copy of the picture under a different name before you go any farther.

2. **Choose Image⇨Resize⇨Image Size to display the Image Size dialog box.**

3. **Select the Resample Image check box, as shown in Figure 9-4.**

 This option, when turned on, enables you to *resample* the picture — that
 is, to add or delete pixels. After you select the option (by clicking the
 check box), the Pixel Dimensions area at the top of the dialog box offers
 a set of Width and Height controls, as shown in the figure. You'll use
 these controls to add or delete pixels in Step 6.

Image Size

Pixel Dimensions: 88K (was 5.5M)

Width: 200 pixels

Height: 150 pixels

Document Size:

Width: 2.778 inches

Height: 2.083 inches

Resolution: 72 pixels/inch

☑ Constrain Proportions

☑ Resample Image: Bicubic

OK | Cancel | Help | Auto...

Figure 9-4: To add or delete pixels in Photoshop Elements, select the Resample Image check box.

4. **Select Bicubic from the drop-down list next to the Resample Image option.**

 The drop-down list settings affect the method the program uses when adding and deleting pixels. Bicubic, the default setting, produces the best results.

5. **Select the Constrain Proportions check box, as shown in the figure.**

 This option makes sure that the original proportions of your picture are maintained when you change the pixel count.

6. **Using the top set of Width and Height boxes, enter the new pixel dimensions for your photo.**

 Remember, *pixel dimensions* is just a nerdy way of saying "number of pixels across by number of pixels down."

 Before setting the new pixel count, select Pixels as the unit of measurement from the drop-down list next to the Width or Height box. Because the Constrain Proportions option is turned on, the Height value automatically changes when you adjust the Width value, and vice versa.

7. **Click OK or press Enter.**

Remember that if you increase the Width or Height value, you're adding pixels. The software has to make up — *interpolate* — the new pixels, and your picture quality can suffer. Check out the information on resampling and resolution in Chapter 2 for more details on this subject.

Also, the more pixels you have, the larger the image file. If you're preparing photos for the Web, file size is a special consideration because larger files take longer to download than smaller files. See "Nothing but Net: Photos on the Web" for more information about preparing images for use on Web pages.

To view your photo at the size it will display on-screen, choose View➪Actual Pixels in Photoshop Elements. Keep in mind that this view setting displays the photo according to your current monitor resolution; if displayed on a monitor using a different resolution, the photo size will change. For more on this sticky bit of business, refer to the preceding section.

Sizing screen images in inches

Newcomers to digital photography often have trouble sizing images in terms of pixels and prefer to rely on inches as the unit of measurement. And some photo-editing programs don't offer pixels as a unit of measurement in their image-size dialog boxes.

If you can't resize your picture using pixels as the unit of measurement or you prefer to work in inches, set the image width and height as usual and then set the output resolution to somewhere between 72 and 96 ppi. In Photoshop Elements, follow the same steps as outlined in the preceding section, but set the picture size and output resolution using the Width, Height, and Resolution boxes in the Document Size section of the Image Size dialog box.

Where does this 72 to 96 ppi figure come from? It's based on default monitor resolution settings on Macintosh and PC monitors. Mac monitors usually leave the factory with a monitor resolution that results in about 72 screen pixels per linear inch of the viewable area of the screen. PC monitors are set to a resolution that results in about 96 pixels for each linear inch of screen. So if you have a 1 x 1-inch picture and set the output resolution to 72 ppi, for example, you wind up with enough pixels to fill an area that's one-inch square on a Macintosh monitor.

Note that this approach is pretty unreliable because of the wide range of monitor sizes and available monitor resolution settings — the latter of which the user can change at any time, thereby blowing the 72/96 ppi guideline out of the water. For more precise on-screen sizing, the method described in the preceding section is the way to go.

Nothing but Net: Photos on the Web

If your company operates a World Wide Web site or you maintain a personal Web site, you can easily place pictures from your digital camera onto your Web pages.

Because I don't know which Web-page creation program you're using, I can't give you specifics on the commands and tools you use to add photos to your

pages. But I can offer some advice on a general artistic and technical level, which is just what happens in the next few sections.

Basic rules for Web pictures

If you want your Web site to be one that people love to visit, take care when adding photos (and other graphics, for that matter). Too many images or images that are too big quickly turn off viewers, especially impatient viewers with slow modems. Every second that people have to wait for a picture to download brings them a second closer to giving up and moving on from your site.

To make sure that you attract, not irritate, visitors to your Web site, follow these ground rules:

- For business Web sites, make sure that every image you add is *necessary*. Don't junk up your page with lots of pretty pictures that do nothing to convey the message of your Web page — in other words, images that are pure decoration. These kinds of images waste the viewer's time and cause people to click away from your site in frustration.

- If you use a picture as a hyperlink — that is, if people can click the image to travel to another part of the site — also provide a text-based link. Why? Because many people (including me) set their browsers so that images are not automatically downloaded. Images appear as tiny icons that the viewer can click to display the entire image. It's not that I'm not interested in seeing important images — it's just that so many pages are littered with irrelevant pictures. When I use the Internet, I'm typically seeking information, not just cruising around looking at pretty pages. And I don't have time to download a bunch of meaningless images.

 If you want to appeal to antsy folks like me, as well as to anyone who has a limited amount of time for Web browsing, set up your page so that people can navigate your site without downloading images if they prefer. My favorite sites are those that provide descriptive text with the image icon — for example, "Product shot" next to a picture of a manufacturer's hot new toy. This kind of labeling enables me to decide which pictures I want to download and which ones will be of no help to me. At the very least, I expect navigational links to be available as text-based links some- where on the page.

- Save your photos in either the JPEG or GIF file format. These formats are the only ones widely supported by different Web browsers. Two other formats, PNG (pronounced *ping*) and JPEG 2000, are in development, but not fully supported by either browsers or Web-page creation programs yet. You can read more about JPEG and GIF in the next three sections and more about file formats in general in Chapter 7.

✔ Strive for a total page download time of under a minute, using the lowest modem speed commonly in use today — 28.8 kbps per minute — as your guideline. Sure, some lucky Web surfers have lightning-fast Internet connections, but most ordinary folks don't. The more pictures on a page, the smaller per-picture file size you need.

✔ Set the display size of your photos following the guidelines discussed in "Sizing images for the screen," earlier in this chapter. To accommodate the widest range of viewers, size your images with respect to a screen display of 640 x 480 pixels.

Remember, too, that the file size is determined by the total number of pixels in the image, not the output resolution. A 640 x 480-pixel image consumes as much disk space at 72 ppi as it does at 300 ppi. Check out Chapter 2 for a more detailed explanation of all this file-size, pixel-count, and output resolution stuff.

✔ In addition to dumping pixels to get a smaller file size and reduce download times, you can compress the image using JPEG compression. Another alternative, although not always a good one, is to save the picture in the GIF format, which reduces the image to 256 colors, resulting in a smaller file size than a full-color photo requires. The next section explains these options.

✔ Finally, a word of caution: Anyone who visits your page can download, save, edit, print, and distribute your image. So if you want to control the use of your picture, think twice about posting it on a Web page. You can also investigate digital watermarking and copyright protection services, which aim to prevent unauthorized use of your pictures. To start learning about such products, visit the Web site of one of the leading providers, Digimarc (www.digimarc.com). The Web site operated by the organization Professional Photographers of America (www.ppa.com) provides good background information on copyright issues in general.

Decisions, decisions: JPEG or GIF?

As discussed in the preceding section, JPEG and GIF are the two mainstream formats for saving photos that you want to put on a Web page. Both formats have their advantages and drawbacks.

✔ **Color concerns:** JPEG *supports* 24-bit color, which is the technical way of saying that images can contain approximately 16.7 million colors — full-color photos, in plain English. GIF, on the other hand, can save only 8-bit images, which restricts you to a maximum of 256 colors.

To see the difference this color limitation makes, take a look at Color Plate 9-1. In the Color Plate, I zoomed way in on a bowl of fruit. Those yellowish-green objects in the upper-right corner are bananas, the big green blob is a lime, and the red thing is the edge of an apple. The top

image is a 24-bit image; the bottom image was converted to an 8-bit, 256-color image.

The color loss is most noticeable in the bananas. In the 24-bit image, the subtle color changes in the bananas are realistically represented. But when the color palette is limited to 256 colors, the range of available yellow shades is seriously reduced, so one shade of yellow must represent many similar shades. The resulting bananas have a blotchy, unappetizing appearance.

For this reason, JPEG is better than GIF for saving *continuous-tone* images — images like photographs, in which the color changes from pixel to pixel are very subtle. GIF is best reserved for grayscale images, which have only 256 colors or fewer to begin with, and for non-photographic images, such as line art and solid-color graphics.

✔ **File size and compression:** With more color information to store, a JPEG version of an image usually is much larger than a GIF version. Both JPEG and GIF enable you to compress image data in order to reduce file size, but JPEG uses *lossy* compression, while GIF uses *lossless* compression. (In most programs, GIF compression is applied automatically, without any input from you.)

Lossy compression dumps some image data, resulting in a loss of picture detail. Lossless compression, on the other hand, eliminates only redundant data so that any change in image quality is virtually undetectable. So although you can reduce a JPEG file to the same size as a GIF file, doing so typically requires a high degree of lossy compression, which can damage your image just as much as converting it from a 24-bit image to a 256-color GIF file. For a look at how various compression amounts affect an image, see Color Plate 3-1.

✔ **Web effects:** GIF offers two additional features that JPEG does not. First, you can produce *animated* GIF images, which are a series of pictures packaged into one file. When displayed on the Web, the images are flashed on and off in sequence to create the appearance of motion.

Second, you can make a portion of your image transparent, allowing the underlying Web-page background to show through. You can "fake" transparency with JPEG images if you're working with a plain Web page background, however. See "JPEG: The photographer's friend" for details.

Choosing between JPEG and GIF sometimes becomes a question of the lesser of two evils. Experiment with both formats to see which one results in the best-looking picture at the file size you need. In some cases, you may discover that shifting the image to 256 colors really doesn't have that much of an impact — if your photo has large expanses of flat color, for example. Similarly, you may not notice a huge loss of quality on some pictures even when applying the maximum amount of JPEG compression, while other images may look like garbage with the same compression.

Many photo-editing programs offer a so-called *Web optimization* utility that assists you in making the call between JPEG and GIF. The next few sections introduce you to the Save for Web utility that serves this function in Photoshop Elements. In addition to giving you a preview of how the photo will look if you use the various color and compression settings available for GIF and JPEG, such utilities usually tell you how long the picture file will take to download at a particular modem speed. Again, be sure to select 28.8 kpbs as your modem speed when checking the download time.

GIF: 256 colors or bust

The GIF format can support only 8-bit (256-color) images. This color limitation results in small file sizes that make for shorter download times, but it can also make your images look a little pixel-y and rough. (See Color Plate 9-1 for an illustration.)

However, the quality loss that results from converting to 256 colors may not be too noticeable with some images. And, as I explained earlier, GIF does offer a feature that enables you to make a portion of your image transparent and to bundle a series of images into an animated GIF file.

Would you like that picture all at once, or bit by bit?

Both JPEG and GIF enable you to specify whether your Web photos display gradually or all at once. If you create an *interlaced* GIF or *progressive* JPEG image, a faint representation of your image appears as soon as the initial image data makes its way through the viewer's modem. As more and more image data is received, the picture details are filled in bit by bit. With *noninterlaced* or *nonprogressive* images, no part of your image appears until all image data is received.

As with most things in life, this option involves a trade-off. Interlaced/progressive images create the *perception* that the image is being loaded faster because the viewer has something to

look at sooner. This type of photo also enables Web-site visitors to decide more quickly whether the image is of interest to them and, if not, to move on before the image download is complete.

However, interlaced and progressive images take longer to download fully, and some Web browsers don't handle these file options well. In addition, progressive JPEGs require more RAM (system memory) to view, and interlacing adds to the size of a GIF file. For all these reasons, most Web design experts recommend that you don't use interlaced or progressive images on your Web pages.

GIF comes in two flavors: 87a and 89a. My, those are user-friendly names, aren't they? Anyway, 89a is the one that enables you to create a partially transparent image. With 87a, all your pixels are fully opaque. (Don't worry about remembering the numeric labels, though; most people just refer to the two types as *transparent GIF* and *non-transparent GIF.*)

Why would you want to make a portion of your image transparent? Well, suppose that you're selling estate jewelry on the Web. You have a photo of a new pin and earrings that you want to put on your site. The jewelry was shot against a black velvet background. If you save the image as a regular GIF image, viewers see both jewelry and velvet, as in the left example in Figure 9-5. If you make the velvet portions of the photo transparent, only the jewelry shows up on the Web page, as in the right example. The Web page background shows through the transparent velvet pixels.

Figure 9-5:
Here you see the same photo as it appears on a Web page when saved as a standard GIF (left) and with GIF transparency enabled (right).

Neither approach is right or wrong; GIF transparency just gives you an additional creative option. Note, too, that making some of your image pixels transparent doesn't reduce the size of the image file — the pixels are still in the file, they're just clear.

Saving a non-transparent GIF

The process of saving a non-transparent GIF is pretty straightforward. The following steps guide you through the process in Photoshop Elements. If you use other photo software that supports the GIF format, you should find the process much the same in your program. But check your help system or manual just to be sure.

Note that these steps show you just one of several ways to achieve the same end in Elements; I think this method, which takes advantage of the Save for Web utility, is the easiest and safest.

In Elements, these steps create and save a duplicate of your original image in the GIF format. But some programs instead overwrite the original image file. For safety's sake, always save a backup copy of your original image before you go forward. Remember, saving your image as a GIF file reduces the image to 256 colors, and you may want those original image colors back some day. In addition, saving the photo in the GIF format flattens your image — that is, merges all independent image layers into one. (See Chapter 12 for an explanation of image layers.)

1. **Choose File⇨Save for Web.**

 The Save for Web dialog box appears. Figure 9-6 shows the dialog box from Elements 1.0; Version 2 includes options that enable you to change the pixel dimensions of the photo outside of the Image Size dialog box. (See the earlier section "Sizing images for the screen" for details about changing pixel dimensions.)

 In both versions of the program, the left preview shows your image in its current state; the right preview shows you how the GIF version will look.

 Use the Zoom and Hand tools, labeled in the figure, to magnify or scroll the preview. To zoom in on the photo, click the Zoom tool button and then click the preview. To zoom out, Alt-click if you're using Windows and Option-click on a Mac. To scroll the display so that you can see a hidden portion of the photo, click the Hand tool button and then drag in the preview window.

2. **Choose Custom from the Settings drop-down list on the right side of the dialog box.**

3. **Choose GIF from the Format drop-down list (labeled in Figure 9-6).**

4. **Specify the other GIF options as you see fit.**

 Here's a quick look at what the options do in Elements. Refer to the labels on Figure 9-6 to see where to find these options, the first two of which are unlabeled in the dialog box. (And don't freak out when you see the incredibly technical names of the options — they're not as complicated as they sound.)

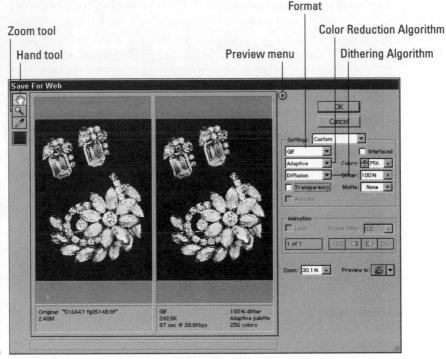

Figure 9-6:
The right preview shows you how your picture will look if saved with the current GIF options.

- **Color Reduction Algorithm:** This option tells the program how to figure out which original image colors to keep when reducing the picture to 256 colors. In most cases, Adaptive works best, but try each one to see which does the least damage to your picture. As you change the option, the right preview updates automatically.

 If you want the program to give preference to the colors found in a certain area of the photo, select that area (as explained in Chapter 11) before opening the Save for Web dialog box. Then choose Selective as the Color Reduction Algorithm setting.

- **Dithering Algorithm:** When displaying a photo color that's outside the limited 256-color palette, the computer attempts to come close to the original color by mixing colors that *are* found in the palette. Tech heads refer to this process as *dithering*.

 The Dithering Algorithm option controls how Elements approaches, er, dithering. Don't give it another thought — just pick Diffusion for the best results in most cases. If you don't like how the preview looks with Diffusion, try one of the other methods to see whether the picture improves. I'm pretty sure it won't, but there's no harm in your trying.

- **Interlaced:** Leave this option turned off. (No check mark in the box means the option is off.) To find out what it does, see the sidebar "Would you like that picture all at once, or bit by bit."

- **Colors:** As I mentioned earlier, a GIF image can have a maximum of 256 colors. If you want to use all 256, set the Colors option to that number. But with some images that contain a small spectrum of colors, you may be able to get away with fewer colors, which reduces the image file size. Try lowering the Colors value and watch the right image preview to see how low you can go before the photo starts to fall apart.

- **Dither:** This setting adjusts how much dithering the program does when processing your photo. For the best possible results, leave the value at 100. However, lowering the value reduces file size, so again, you can try a lower setting and see whether the picture quality goes too far south.

The Transparency and Matte options affect pictures that have transparent areas. For details, see the next section. As for the Animate option, it's related to creating animated GIF images, which is, I'm sad to say, beyond the scope of this book. On second thought, I'm not all that sad to say, because I think animated GIFs are incredibly annoying and terribly overused.

5. **Click OK or press Enter.**

 The Save for Web dialog box disappears, and the Save Optimized As dialog box, which looks like a regular old file-saving dialog box, appears. The program automatically selects GIF as the file format for you, so all you have to do is name the picture file and specify its storage location as you usually do when saving a file.

6. **Click Save or press Enter.**

 Elements saves a copy of your original image in the GIF format, using the settings you specified. Your original image remains open and on-screen; to see the GIF version, you have to open the GIF file.

Remember that whenever you work inside the Save for Web dialog box, the program displays the approximate file size and download time for the image underneath the preview. The download time relates to a specific modem speed, which you can change via the Preview Menu, labeled in Figure 9-6.

Saving a GIF image with transparency

As with saving a standard GIF, you can take different avenues to wind up with a GIF image that contains transparent areas. In some programs, for example, you can make all pixels of a certain color transparent during the file-saving process. Depending on the program, you may be limited to making just one

color transparent, however. In addition, you typically have to make all pixels of the selected color transparent, when you may want only pixels in the photo background to disappear.

When I'm working in Elements or Photoshop, I use a different and, I think, more flexible and reliable approach. Before saving the file, I just erase or delete any areas that I want to be transparent. That way, I control exactly which portions of the photo are invisible.

Before showing you the specific file-saving steps that retain transparent areas, I need to take a side trip to explain a little bit about how Elements and Photoshop handle transparency. You can't have transparent pixels on the original background layer of an image. (Chapter 12 explains layers in detail, if you're unfamiliar with the concept.) The workaround is to convert that background layer into a regular old image layer, which *can* have as many transparent pixels as you want.

To convert the background layer to a standard layer, choose Layer⇨New⇨ Layer from Background. When the New Layer dialog box appears, click OK. If you open the Layers palette (View⇨Show Layers), your background layer is now named Layer 0, as shown in Figure 9-7. And if you delete or erase pixels on this transformed layer, you get transparent pixels. In Elements, as in Photoshop, transparent areas appear as a gray-and-white checkerboard pattern by default.

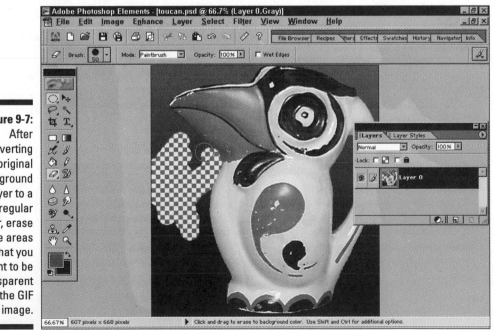

Figure 9-7: After converting the original background layer to a regular layer, erase the areas that you want to be transparent in the GIF image.

Of course, you should save a copy of your image file before you begin erasing, in case you ever want those pixels at full opacity in the future. Also note that if you want to use this technique on an existing GIF image, you must first convert the photo back to a full-color RGB photo. Choose Image⇨Mode⇨RGB Color to do so.

When you finish creating your transparent areas and your photo is ready for the GIF factory, follow the same steps outlined in the preceding section to save a GIF version of the picture. But in Step 4, set the Matte and Transparency options in the Save for Web dialog box as follows:

✔ **Transparency:** This option controls whether your transparent pixels stay transparent or are filled with a solid color when the file is saved. To keep your see-through pixels invisible, turn the option on. If you turn the option off, the program fills transparent areas with a solid color, which you select from the Matte menu, explained next.

✔ **Matte:** This option enables you to select the solid color that the program uses when you choose to fill transparent areas. But it also affects your photo when the Transparency option is turned on.

If you created your transparent areas in such a way that pixels around the edges are only partially transparent — for example, if you erased with a soft-edged brush — the program fills those partially clear pixels with the matte color. Without this option, you can wind up with jagged edges and a halo of background pixels around your subject. That's because when you don't apply a matte, pixels that are 50 percent or less transparent become fully opaque. Only pixels that are more than 50 percent transparent become completely clear.

For example, I saved the image in Figure 9-8, which you can see in its original form in Figure 9-7, with and without the matte feature. I used a soft-edged brush to erase the entire background before saving the file. In the left image in Figure 9-8, which I saved without taking advantage of the Matte option, you can see some stray black background pixels around the edges of the pitcher, and the edges also have a ragged look. In the right image, I applied a matte, matching the matte color to the Web page background, which helps the edges of the pitcher look smoother and blend more gradually into the background.

To set the Matte color to match your Web page background, choose Other from the Matte drop-down list. The program displays the Color Picker, where you can select the color you want. Another option is to click the Eyedropper tool in the upper left corner of the Save for Web dialog box and then click a color in the preview window. After you click, choose Eyedropper Color from the Matte drop-down list. You can also just choose White or Black from the drop-down list to use either color as the matte color.

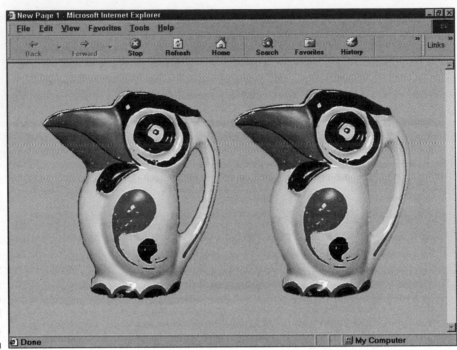

Figure 9-8:
To avoid jagged edges and stray background pixels (left), set the Matte color to match the Web page background (right).

JPEG: The photographer's friend

JPEG, which can save 24-bit images (16.7 million colors), is the format of choice for the best representation of continuous-tone images, including photographs. For more on the advantages and drawbacks of JPEG, see "Decisions, decisions: JPEG or GIF?" a few sections ago.

In order to create smaller files, however, JPEG applies lossy compression, which dumps some image data. Before you save an image in the JPEG format, be sure to save a backup copy using a file format that doesn't use lossy compression — TIFF, for example, or the Photoshop Elements format (PSD). After you apply JPEG compression, you can't get back the image data that gets eliminated during the compression process.

For more about compression, see Chapter 3 and Color Plate 3-1. Note that JPEG also can't retain individual image layers, a feature explained in detail in Chapter 12.

The following steps show you how to use the Photoshop Elements Save for Web utility, introduced earlier in this chapter, to save your picture in the JPEG format. Using this feature enables you to see how much damage your picture will suffer at various levels of JPEG compression. If you're using

another image editor, check the help system for the exact commands to use to save to JPEG. The available JPEG options should be much the same as described here, although you may or may not be able to preview the compression effects on your picture.

1. **Choose File⇨Save for Web to display the Save for Web dialog box, shown in Figure 9-9.**

 The preview on the left side of the dialog box shows your original picture; the right-side preview shows how your photo will look when saved at the current settings. See the earlier section "Saving a non-transparent GIF" for more details about working with the previews.

Preview Menu

Format

Figure 9-9:
The Quality settings determine how much compression is applied.

Quality

2. **Select Custom from the Settings drop-down list on the right side of the dialog box.**

3. **Select JPEG from the Format drop-down list, labeled in Figure 9-9.**

 After you select JPEG, you see the other save options shown in the figure.

4. Set the compression amount.

Using the two Quality controls — the one labeled in the figure and its neighbor to the right — you choose the amount of compression, thereby determining the image quality and file size.

The higher the Quality value, the less compression is applied, and the larger the file size.

The left Quality drop-down list offers four general settings: Maximum, High, Medium, and Low. Maximum provides the best quality/least compression; Low provides the least quality/most compression. If you want to get a little more specific, use the Quality slider on the right. You can specify any Quality value from 0 to 100, with 0 giving you the lowest image quality (maximum compression) and 100 the best image quality (least compression).

As you adjust either control, the right preview in the dialog box updates to show you the impact on your photo. Beneath the preview, the program displays the approximate file size and download time at the selected modem speed. You can change the modem speed via the Preview Menu, labeled in Figure 9-9.

5. Turn off the Progressive, Optimized, and ICC profile check boxes.

If you see a check mark in a box, click the box to remove the check mark and turn off the option. For reasons discussed in the earlier sidebar, "Would you like that picture all at once, or bit by bit?," progressive JPEG files aren't usually a good idea. The Optimized option is supposed to give you better image quality at a given compression setting, but can cause problems with some Web browsers, so I recommend that you elect not to take advantage of the feature.

As for the ICC Profile option, it has to do with some advanced color management issues that professional imaging folks may want to investigate but us ordinary mortals don't need to worry about. In addition, the option adds to the file size.

6. If your picture contains transparent areas, choose a Matte color.

This option works pretty much as described in the preceding section. But in this case, the transparent areas of your picture are always filled with a matte color — white, if you don't select another color. JPEG, as explained earlier in this chapter, can't deal with transparent pixels and so insists that you give them some color.

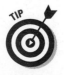

If you're placing the photo on a Web page that has a solid-colored background, you can make the transparent parts of a JPEG photo *appear* to retain their transparency, however. Just match the Matte color to the color of your Web page background. The viewer's eye then won't be able to tell where the image stops and the Web page begins. See the earlier section "Saving a GIF image with transparency" to find out how to set the matte color.

7. **Click OK.**

 The Save for Web dialog box disappears, and the Save Optimized As dialog box comes to life. This dialog box works like any file-saving dialog box. Just give your picture file a name and specify where you want to store the file. The correct file format is already selected for you.

8. **Click Save or Press Enter.**

 The program saves the JPEG copy of your picture. Your original photo remains open and on-screen. If you want to see the JPEG version, you have to open that file.

Drop Me a Picture Sometime, Won't You?

Being able to send digital photos to friends and family around the world via e-mail is one of the most enjoyable aspects of owning a digital camera. With a few clicks of your mouse, you can send an image to anyone who has an e-mail account. That person can then view the photo on-screen, save it to disk, and even edit and print it.

Of course, this capability comes in handy for business purposes as well. As a part-time antique dealer, for example, I often exchange images with other dealers and antique enthusiasts around the country. When I need help identifying or pricing a recent find, I e-mail my contacts and get their feedback. Someone in the group usually can provide the information I'm seeking.

Although attaching a digital photo to an e-mail message is really simple, the process sometimes breaks down due to differences in e-mail programs and how files are handled on the Mac versus the PC. Also, newcomers to the world of electronic mail often get confused about how to view and send images — which isn't surprising, given that e-mail software often makes the process less than intuitive.

One way to help make sure that your image arrives intact is to prepare it properly before sending. First, size your image according to the guidelines discussed earlier in this chapter, in "That's About the Size of It."

Also, save your image in the JPEG format, as explained in the preceding section. Some e-mail programs can accept GIF images, but not all can, so use JPEG for safety's sake. The exception is when sending images to CompuServe users, whose browsers sometimes work with GIF but not JPEG. (In other words, if the recipient has trouble with the image in one format, try resending the picture in the other format.)

Note that these instructions don't apply to pictures that you're sending to someone who needs the image for some professional graphics purpose — for example, if you created an image for a client who plans to put it in a company newsletter. In that case, save the image file in whatever format the client needs, and use the output resolution appropriate for the final output, as explained in Chapter 2. With large image files, expect long download times. As a matter of fact, unless you're on a tight deadline, putting the image on a Zip disk, CD, or some other removable storage medium and sending it off via overnight mail may be a better option than e-mail transmission.

That said, the following steps explain how to attach an image file to an e-mail message in Netscape Communicator in Version 4.0 of that program. If you're using a later version or some other e-mail program, the process is probably very similar, but check your program's online help system for specific instructions.

1. **Connect to the Internet and fire up Communicator.**

2. **Choose Communicator⇨Messenger (or click the little mail icon at the bottom of the program window).**

3. **Choose File⇨New⇨Message or click the New Msg button on the toolbar.**

 You're presented with a blank mail window.

4. **Enter the recipient's name, e-mail address, and subject information as you normally do.**

5. **Choose File⇨Attach⇨File or click the Attach button on the toolbar and then select File from the drop-down menu.**

 Most programs provide such a toolbar button — look for a button that has a paper clip icon on it. The paper clip has become the standard icon to represent the attachment feature.

 After you select the File option, you see a dialog box that looks much like the one you normally use to locate and open a file. Track down the image file that you want to attach, select it, and click Open. You're then returned to the message composition window.

6. **Choose File⇨Send Now or click the Send toolbar button to launch that image into cyberspace.**

If everything goes right, your e-mail recipient should receive the image in no time. In Netscape Navigator, the image either appears as an *inline graphic* — that is, it is displayed right in the e-mail window as in Figure 9-10 — or as a text link that the user clicks to display the image.

But as mentioned earlier, several technical issues can throw a monkey wrench into the process. If the image doesn't arrive as expected or can't be

viewed, the first thing to do is call the tech support line for the recipient's
e-mail program or service. Find out whether you need to follow any special
procedures when sending images and verify that the recipient's software is
set up correctly. If everything seems okay on that end, contact your own
e-mail provider or software tech support. Chances are, some e-mail setting
needs to be tweaked, and the tech support personnel should be able to help
you resolve the problem quickly.

Figure 9-10:
You can
attach
images to
e-mail
messages
as shown
here.

Part IV
Tricks of the Digital Trade

The 5th Wave By Rich Tennant

"I'VE GOT SOME IMAGE EDITING SOFTWARE, SO I TOOK THE LIBERTY OF ERASING SOME OF THE SMUDGES THAT KEPT SHOWING UP AROUND THE CLOUDS. NO NEED TO THANK ME."

In this part . . .

If you watch many spy movies, you may have noticed that image editing has worked its way into just about every plot line lately. Typically, the story goes like this: A Mel Gibson-type hero snags a photograph of the bad guys. But the photograph is taken from too far away to clearly identify the villains. So Mel takes the picture to a buddy who works as a digital imaging specialist in a top-secret government lab. Miraculously, the buddy is able to enhance the picture enough to give Mel a crystal-clear image of his prey, and soon all is well for Earth's citizens. Except for the buddy, that is, who invariably gets killed by the villains just moments after Mel leaves the lab.

I'm sorry to say that, in real life, image editing doesn't work that way. Maybe top-secret government-types have software that can perform the tricks you see in movies — hey, for all I know, our agents really have ray guns and secret decoder rings, too. But the image editors available to you and me simply can't create photographic details out of nothing.

That doesn't mean that you can't perform some pretty amazing feats, though, as this part of the book illustrates. Chapter 10 shows you how to do minor touch-up work, such as cropping your image and correcting color balance. Chapter 11 explains how to apply edits to just part of your image by creating selections, how to cut and paste two or more images together, and how to cover up minor image flaws and unwanted background elements. Chapter 12 gives you a taste of some advanced editing techniques, such as painting on your image, creating photographic montages, and applying special-effects filters.

Although real-world image editing isn't nearly as dramatic as Hollywood implies, it's still way, way cool, not to mention a lot safer. Real-life image editors hardly ever get whacked by villains — although, if you doctor an image to show your boss or some other nemesis in an unflattering light, you may want to stay out of dimly lit alleys for a while.

Chapter 10

Making Your Image Look Presentable

In This Chapter

▶ Opening and saving pictures

▶ Cropping out unwanted elements

▶ Increasing color saturation

▶ Tweaking exposure

▶ Adjusting color balance

▶ Sharpening "focus"

▶ Blurring backgrounds

▶ Removing noise and jaggies

*O*ne of the great things about digital photography is that you're never limited to the image that comes out of the camera, as you are with traditional photography. With film, a lousy picture stays a lousy picture forever. Sure, you can get one of those little pens to cover up red-eye problems, and if you're really good with scissors, you can crop out unwanted portions of the picture. But that's about the extent of the corrections you can do without a full-blown film lab at your disposal.

With a digital image and a basic photo-editing program, however, you can do amazing things to your pictures with surprisingly little effort. In addition to cropping, color balancing, and adjusting brightness and contrast, you can cover up distracting background elements, bring back washed-out colors, paste two or more images together, and apply all sorts of special effects.

Chapter 11 explains how to cover up image blemishes and how to cut and paste two photos together, while Chapter 12 explores painting tools, special-effects filters, and other advanced photo-editing techniques. This chapter explains the basics: simple tricks you can use to correct minor defects in your pictures.

What Software Do You Need?

In this chapter, and in others that describe specific photo-editing tools, I show you how to get the job done using Adobe Photoshop Elements. I chose this software for several reasons. First, it costs under $100 — and is even provided free with some digital cameras. Yet Elements offers many of the same features found in the more sophisticated (and more expensive) Adobe Photoshop, the leading professional-level photo editor. In addition, Elements is available for both Windows-based and MacIntosh computers.

This book isn't intended to provide in-depth instruction for using Elements, however. I touch on just a few features, and I assume that you are already somewhat familiar with the program. If you want more guidance when using Elements to retouch your digital photos, get a copy of — warning, shameless plug about to arrive! — *Photo Retouching & Restoration For Dummies,* written by yours truly and published by Wiley Publishing, Inc.

Text that is marked with an Elements How-To margin icon relates specifically to Elements. I cover both Version 1.0 and 2.0 of the program, although the figures feature Version 1.0. Readers who own Adobe Photoshop will find that many of that program's tools work exactly as they do in Elements, although Photoshop usually offers a broader array of tool options than Elements.

If you use a photo editor other than Elements or Photoshop, please be assured that the information provided in this book can be adapted easily to your software. Most photo-editing programs provide similar tools to the ones discussed here. And the basic photo-retouching concepts and photographic ideas are the same no matter what photo software you prefer.

So use this book as a guide for understanding the general approach you should take when editing your digital pictures, and consult your software's manual or online help system for the specifics of applying certain techniques.

If you don't have any photo-editing software or you're shopping for a new program, you can find demo versions of several good products on the CD accompanying this book. I've also included some sample photos on the CD, in case you don't yet have any at your disposal.

How to Open Your Photos

Before you can work on a digital photo, you have to open it inside your photo-editing program. In just about every program on the planet, you can use the following techniques to crack open a picture file:

✔ Choose File⇨Open.

✔ Use the universal keyboard shortcut for the Open command: Press Ctrl+O on a PC and ⌘+O on a Mac.

✔ Click the Open button on the toolbar. The universal symbol for this button is a file folder being opened. Figure 10-1 shows the Photoshop Elements version of the button.

Open button Palette well

Figure 10-1:
Drag a thumbnail from the File Browser into the program window to open the picture file.

Whichever method you choose, the program displays a dialog box in which you can select the picture file that you want to open.

If you're working with the Windows version of Photoshop or Elements, you can zip to the file-opening dialog box by double-clicking an empty area of the program window. Sorry, Mac users — this one doesn't work for you.

Here are a few other bits of gossip related to opening images:

✔ Some programs, including Elements, offer a built-in file browser that you can use to preview thumbnails of your picture files before you open them. You should be able to open a picture file by either double-clicking

the thumbnail or dragging the thumbnail into the program window, as shown in Figure 10-1.

Display the Elements File Browser by choosing Window⇨File Browser or clicking the File Browser tab in the palette well, labeled in the figure. Click the tab or choose the command again to close the browser.

✔ Depending on your software, you may be able to open images directly from your camera (while the camera is connected to the computer). Check the program and camera manuals to find out how to make your software and hardware talk to each other. Look for information about something called a TWAIN driver. Chapter 7 provides additional enlightenment about this interesting acronym.

✔ Photo editing requires a substantial amount of free RAM (system memory). If your software balks when you try to open a picture, try shutting down all programs, restarting your computer, and then starting your photo software only. (Be sure to disable any startup routines that launch programs automatically in the background when you fire up your system.) Now you're working with the maximum RAM your system has available. If your computer continues to complain about a memory shortage, consider adding more memory — memory prices are relatively cheap right now, fortunately.

✔ Most programs need to use your computer's hard disk space as well as RAM when processing images. As a rule, you should have at least as much free disk space as you have RAM. If your system has 96MB of RAM, for example, you need 96MB of free disk space.

In Elements and Photoshop, you see a message saying that your *scratch disk* is full whenever you run out of the requisite amount of disk space. Other programs may use different terminology. In any case, you can solve the problem by deleting some unneeded files to free up some room on the hard disk.

✔ Most photo editors can't handle the proprietary file formats that some digital cameras use to store images. If your program refuses to open a file because of format, check your camera manual for information about the image-transfer software provided with your camera. You should be able to use the software to convert your images to a standard file format. (See Chapter 7 for a rundown of file formats.)

✔ If your picture opens up on its side, use your software's Rotate commands to set things right. In Elements, the commands reside on the Image⇨ Rotate submenu.

Save Now! Save Often!

Actually, a more appropriate name for this section would be "Saving Your Sanity." Unless you get in the habit of saving your images on a frequent basis, you can easily lose your mind.

Until you save your photo, all your work is vulnerable. If your system crashes, the power goes out, or some other cruel twist of fate occurs, everything you've done in the current editing session is lost forever. And don't think it can't happen to you because you popped for that state-of-the-art computer last month. Large digital images can choke even the most pumped-up system. I work on a souped-up computer with gobs of RAM, and I still get the occasional "This program has performed an illegal operation and will be shut down" message when working on large images.

To protect yourself, commit the following image-safety rules to memory:

✔ Stop, drop, and roll! Oops, no, that's fire safety, not image safety. Neither stopping, dropping, nor rolling will prevent your image from going up in digital flames should you ignore my advice on saving. Then again, when you tell your boss or client that you just lost a day's worth of edits, the stop-drop-roll maneuver is good for dodging heavy objects that may be hurled in your direction.

✔ To save a picture file for the first time, choose File⇨Save As. You're then presented with a dialog box in which you can enter a name for the file and choose a storage location on disk, just as you do when saving any other type of document.

If you don't want to overwrite your original photo file, be sure to give the picture a new name or store it in a separate folder from the original.

✔ While you're working on a picture, store it on your hard drive, rather than on a floppy disk or some other removable media. Your computer can work with files on your hard drive faster than files stored on removable media. But always save a backup copy on whatever removable storage media you use, too, to protect yourself in the event of a system crash. See Chapter 4 for information about different types of removable storage media.

✔ After you first save a picture, resave it after every few edits. You can usually simply press Ctrl+S (⌘+S on the Mac) to resave the image without messing with a dialog box. Or click the Save button on the toolbar, which looks like a floppy disk. (Refer to Figure 10-2, in the next section.)

✔ In most programs, you can specify which file format you want to use when you choose the Save As command. Always save photos-in-progress in your photo editor's *native format* — that is, the program's own file format — if one is available. In Elements and Photoshop, the native format is PSD.

Why stick with the native format? Because it's designed to enable the program to process your edits more quickly. In addition, generic file formats, such as JPEG, GIF, and TIFF, may not be able to save some of the photo features, such as image layers. (Chapter 12 explains layers.)

Save your image in another format only when you're completely done editing. And before you save a file in JPEG or GIF, which destroy some

picture data, be sure to save a backup copy of the original in a non-destructive format, such as TIFF. In most cases, your photo-editor's native format should also be safe for making backups of original files.

Editing Safety Nets

As you make your way through the merry land of photo editing, you're bound to take a wrong turn every now and then. Perhaps you clicked when you should have dragged. Or cut when you meant to copy. Or painted a mustache on your boss's face when all you really intended to do was cover up a little blemish.

Fortunately, most mistakes can be easily undone by using the following options:

✔ The Undo command, usually found on the Edit menu, takes you one step back in time, undoing your last editing action. If you painted a line on your image, for example, Undo removes the line.

Undo can't bail you out of all messy situations, though. If you forget to save a picture file before you close it, you can't use Undo to restore all the work you did before closing. Nor can Undo reverse the Save command.

In many programs, you can choose Undo quickly by pressing Ctrl+Z on a PC or ⌘+Z on a Mac. The program toolbar may also offer Undo and Redo buttons. Figure 10-2 shows the buttons as they appear in Elements 1.0.

✔ In most programs, you can choose the Print command without interfering with the option to use Undo. So you can make a change to your photo, print it, and then use Undo if you don't like the way the picture looks.

✔ Elements, Photoshop, and some other programs offer *multiple Undo,* which enables you to undo a whole series of edits rather than just one. Say that you crop your image, resize it, add some text, and then apply a border. Later, you decide that you don't want the text. You can go back to the point at which you added the text, and reverse your decision. Any edits applied after the one you undo are also eliminated, however. If you undo that text step, for example, the border step is also wiped out.

To undo a series of edits in Elements, keep clicking the Undo button on the toolbar, choosing Edit⇨Step Backward, or pressing Ctrl+Z (⌘+Z on the Mac). Or take advantage of the History palette, shown in Figure 10-2, which lists all your recent edits. Display the palette by clicking its tab in the palette well or by choosing Window⇨Show History (in Elements 2.0,

Window⇨Undo History). Click the change that you want to undo and then click the Trash button at the bottom of the palette to wipe out that edit and any that follow. When the program asks you to confirm your decision, click Yes.

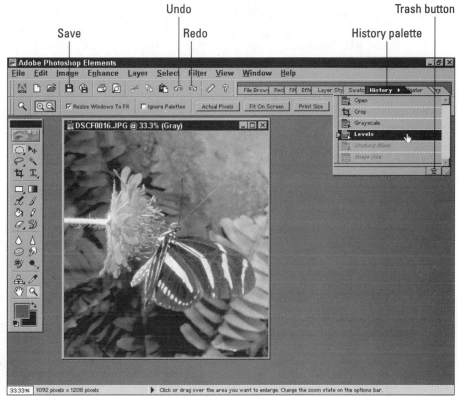

Save Undo Trash button
 Redo History palette

Figure 10-2: The Undo button enables you to reverse bad editing moves.

By default, Elements limits you to undoing your last 20 edits. If you want to change that number, choose Edit⇨Preferences⇨General to open the Preferences dialog box and enter a new value in the History States box. The higher the value, though, the more the program taxes your computer system's resources.

✔ If your image editor does not offer multiple Undo, choose Undo *immediately* after you perform the edit you want to reverse. If you use another tool or choose another command, you lose your opportunity to undo.

✔ Change your mind about that undo? Look for a Redo command (usually, the command is found on the Edit menu or in the same location as the Undo command). Redo puts things back to the way they were before you chose Undo.

As with Undo, some programs enable you to redo a whole series of Undo actions, while others can reverse only the most recent application of the Undo command. Check your software manual or help system to find out how much Undo/Redo flexibility you have. In Elements, use the Redo button or the Edit➪Step Forward command to redo a batch of undone edits. You can also press Ctrl+Y (⌘+Y) repeatedly.

✔ File➪Revert, found in Elements and Photoshop, restores your image to the way it appeared the last time you saved it. This command is helpful when you totally make a mess of your image and you just want to get back to square one. If your software doesn't offer this command, you can accomplish the same thing by simply closing your image without saving it and then reopening the image.

Editing Rules for All Seasons

Before you jump whole hog into editing your digital photos, review these basic rules of success:

✔ Before you begin editing, always make a backup copy of your picture file. That way, you can experiment freely, safe in the knowledge that if you completely ruin your working photo, you can return to the original version at any time.

✔ Save your image at regular intervals in the editing process so that if your system crashes, you don't lose the entire day's work. Saving also provides you with extra editing flexibility. After you complete a particular editing task to your satisfaction, save the image before you move on to the next phase of the project. If you screw up in that next phase or just decide you liked the image better before you applied the latest edits, you can simply return to the saved version.

✔ If your software offers layers, as do Elements and Photoshop, copy the area that you want to alter to a new layer before tackling a significant edit. Then apply the edit to the duplicate. Don't like what you see? Just delete the layer and start over. (Chapter 12 explains what I mean by *layer,* in case you're not familiar with this term.)

✔ Most photo editors enable you to *select* a portion of your image and then apply changes to just the selected area. For example, if the sky in your photo is very bright but the landscape is very dark, you can select the landscape and then increase the brightness of just that area. To find out more about this very useful technique, read Chapter 11.

✔ As you explore the menus in your photo software, you can no doubt find some "instant fix" filters. Elements, for example, offers automatic filters that promise to correct problems with contrast, exposure, and color with one click of your mouse. Feel free to go ahead and experiment with

these tools — who am I to discourage you from seeking instant gratification? But understand that these automatic correction filters typically produce less-than-satisfactory results, either under- or overcompensating for problems. For this reason, most programs also include "manual" correction tools that enable you to control the type and amount of correction applied to your image.

Correcting your photo manually may take a few more seconds than using automatic filters, but your pictures will thank you for your efforts. In this book, I concentrate on manual correction tools.

✔ Don't forget that if you don't like the results of your edits, you can usually reverse them by the techniques explored in the preceding section.

Cream of the Crop

Figure 10-3 shows a common photographic problem: great subject, lousy composition. In this example, my lovely nieces almost get lost in all that pool water. (The older one encouraged me to walk into the pool for a tighter shot, but somehow that didn't seem like a good idea, given that I was using an $800 camera that wasn't even mine!)

Crop tool Options bar

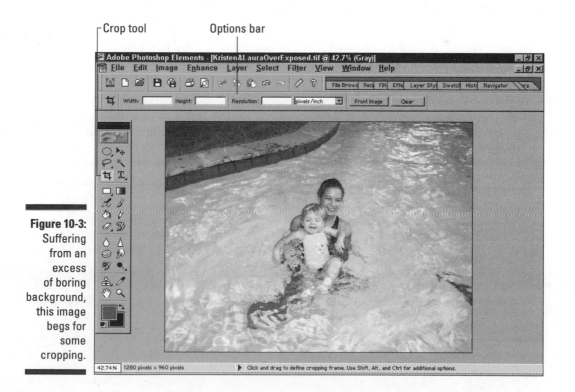

Figure 10-3:
Suffering
from an
excess
of boring
background,
this image
begs for
some
cropping.

If this were a film photograph, I'd have to live with the results or find myself a sharp pair of scissors. But because this isn't a film photograph and because Photoshop Elements (and virtually every other photo editor) offers a Crop tool, I can simply clip away some of the pool, resulting in the much more pleasing image in Figure 10-4.

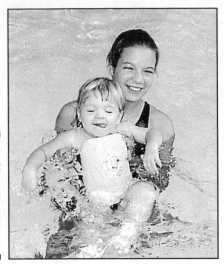

Figure 10-4:
A tight cropping job restores emphasis to the subjects.

The following steps explain how to give your image a haircut using the Elements Crop tool. Most Crop tools in other programs work similarly.

1. **Pick up the Crop tool.**

 Click the Crop tool icon in the toolbox, labeled in Figure 10-3. Make sure that the Width, Height, and Resolution boxes on the Options bar are empty, as shown in the figure. If not, click the Clear button. (The options limit the tool to cropping the photo to a specific size and output resolution.)

2. **Drag to create a crop boundary around the area you want to keep.**

 Drag from one corner of the area you want to keep to the other corner. The boundary appears on your image, as shown in Figure 10-5. Anything outside the boundary is earmarked for a trip to the digital dumpster.

 After you complete your drag, you see a little box at each corner of the crop boundary, as in Figure 10-5, and the area outside the crop boundary becomes shaded. You can drag the little boxes to adjust the crop outline if necessary, as explained in the next step. Adjust the shading feature using the controls on the Options bar.

Crop boundry Crop handle Apply button

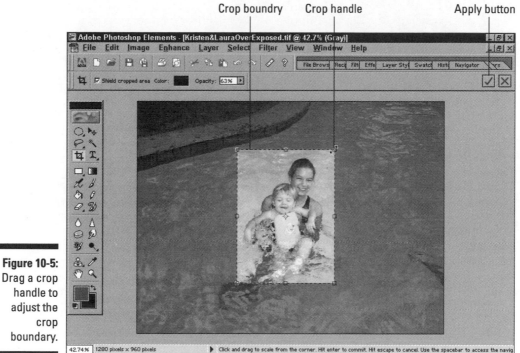

People who edit images for a living call those little boxes around the crop boundary *handles. Boxes* could be too easily understood by outsiders, you know.

3. Drag the crop handles to adjust the crop boundary.

To move the entire boundary, drag anywhere inside the outline.

4. Click the Apply button (labeled in Figure 10-5) or press Enter to crop the picture.

Note that in Elements 2.0, the Apply button and its neighbor, the Cancel button, have swapped positions on the Options bar.

If you don't like what you see after you apply the crop, use the Undo command to go back to square one.

A special function of the Crop tool in Elements, Photoshop, and some other programs enables you to rotate and crop an image in one fell swoop. Using this technique, you can straighten out images that look off-kilter, like the left image in Figure 10-6.

Figure 10-6:
In some programs, you can crop and straighten an image in one step.

To take advantage of this feature in Elements, draw your crop boundary as described in the preceding steps. Then drag a corner crop handle up or down. A curved arrow cursor should appear near the handle, as shown in the left image in Figure 10-6. (The cursor appears above the top right handle in the figure.) After you click the Apply button, the program rotates and crops the image in one step. The right image in Figure 10-6 shows the results of my crop-and-rotate job.

Use this technique sparingly. Each time you rotate the image, the software reshuffles all the pixels to come up with the new image. If you rotate the same image area several times, you may begin to notice some image degradation.

Fixing Exposure and Contrast

At first glance, the underexposed picture on the left side of Figure 10-7 appears to be a throwaway. But don't give up on images like this, because with some creative editing, you may be able to rescue that too-dark image, as I did in the right image in Figure 10-7. The next two sections explain how to use a variety of photo-editing tools to solve exposure problems.

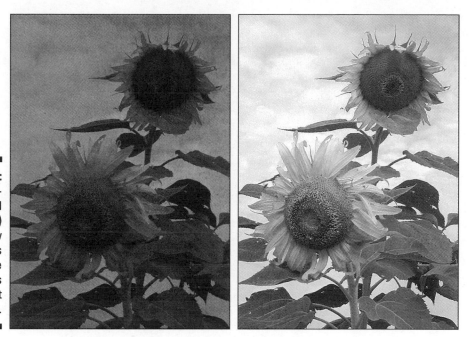

Figure 10-7:
An under-exposed image (left) sees new light, thanks to some brightness and contrast tweaking.

Basic brightness/contrast controls

Many photo-editing programs offer one-shot brightness/contrast filters that adjust your image automatically. As mentioned earlier, these automatic correction tools tend to do too much or too little and, depending on the image, can even alter image colors dramatically.

Fortunately, most programs also provide manual correction controls that enable you to specify the extent of the correction. These controls are very easy to use and almost always produce better results than the automatic variety.

The most basic exposure and contrast tools work like the Elements Brightness/Contrast filter, shown in Figure 10-8. You just drag a slider right or left to increase or decrease exposure or contrast.

To apply the filter in Elements 1.0, choose Enhance⇨Brightness/Contrast⇨Brightness/Contrast. In Elements 2.0, choose Enhance⇨Adjust Brightness/Contrast⇨Brightness/Contrast. You can drag the Brightness slider to adjust exposure, or you can enter values between 100 and –100 in the corresponding option box. Drag to the right or raise the value to make your picture brighter; drag left or lower the value to reduce brightness.

Figure 10-8:
You can
make
wholesale
exposure
changes
using a
Brightness/
Contrast
filter.

After you brighten an image, the colors may look a bit washed out. To bring some life back into your image, you may also need to tweak the contrast a bit. Drag the Contrast slider right to increase contrast; drag left to decrease contrast.

Although the Brightness/Contrast filter is certainly easy to use, it's not always a terrific solution because it adjusts all colors in your picture by the same amount. That's fine for some pictures, but often, you don't need to make wholesale exposure changes.

For example, take a look at the butterfly photo on the left in Figure 10-9. The highlights are where they need to be, exposure-wise, as are the shadows. Only the midtones — areas of medium brightness — need lightening. In the right image in the figure, I raised the Brightness value enough to get the midtones to the right level. As you can see, this change amped up the highlights way too much. Pixels that were formerly light gray become white, and pixels that used to be black jump up the brightness scale, to dark gray. The overall result is a decrease in contrast and a loss of detail in the highlights and shadows.

When you're working with pictures that need selective exposure adjustments, you have a couple of options. If your photo editor offers a Brightness/Contrast filter only, you can use the techniques outlined in the next chapter to select the area that you want to alter before applying the filter. That way, your changes affect the selected pixels only, and the rest of the photo remains the same.

If you're working with Elements, Photoshop, or some other advanced photo editor, check out the next section, which introduces you to something called a *Levels filter*. With this filter, you can adjust the shadows, midtones, and highlights in your image independently. Be sure to also see the sidebar "What's an adjustment layer?" for information about a special feature that gives you some extra flexibility when making exposure changes.

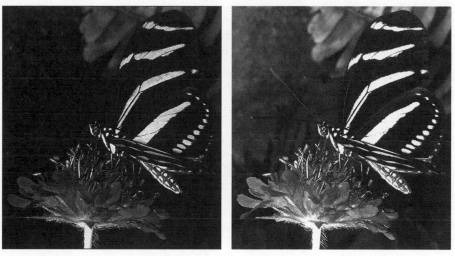

Figure 10-9: Raising the Brightness value enough to correct the midtones results in a loss of contrast and wipes out detail in the high-lights and shadows.

Brightness adjustments at higher Levels

Advanced photo-editing programs provide a Levels filter, which provides a more sophisticated means of adjusting image exposure than the Brightness/Contrast filter discussed in the preceding section. Depending on your software, the Levels filter may go by another name; check the manual or online help system to find out whether you have a Levels-like function.

When you apply this filter, you typically see a dialog box that's full of strange-sounding options, graphs, and such. Figure 10-10 shows the Levels dialog box from Elements, along with the original too-dark butterfly picture from the preceding section. Don't be intimidated — after you know what's what, the controls are easy to use.

The chart-like thing in the middle of the dialog box is called a *histogram*. A histogram maps out all the brightness values in the image, with the darkest pixels plotted on the left side of the graph and the brightest pixels on the right. In a good, properly exposed image, the range of brightness values stretches clear across the histogram. The histogram in Figure 10-10, which represents the too-dark butterfly photo, reveals a heavy concentration of pixels at the dark end of the exposure range and a limited pixel population at the middle and high end.

Being able to read a histogram is a fun parlor game, but the real goal is to adjust those brightness values to create a better-looking picture. Here's what you need to know to get the job done:

✔ Levels dialog boxes generally offer three important controls, often labeled Input Levels. In Elements, you can adjust the Input Levels values by entering a number in the option boxes above the histogram or dragging the sliders beneath the histogram.

- Adjust the shadows in your picture by changing the value in the leftmost Input Levels option box or dragging the corresponding slider, labeled in Figure 10-10. Drag the slider to the right or raise the option box value to darken your image shadows. Some programs refer to this control as the *Low Point control*.

- Tweak the midtones — the medium-brightness pixels — using the middle option box or slider, labeled *Midtones* in Figure 10-10. Typically, you need to brighten up midtones, especially for printing. Drag the slider to the left or raise the option box value to brighten the midtones; drag right or lower the value to darken them. This control sometimes goes by the name *Gamma* or *Midpoint control*.

- Manipulate the lightest pixels in the photo by changing the value in the rightmost option box or dragging its slider, labeled *Highlights* in the figure. To make the lightest pixels in the image lighter, drag the slider to the left or lower the option box value. In some programs, this control goes by the name *High Point control*.

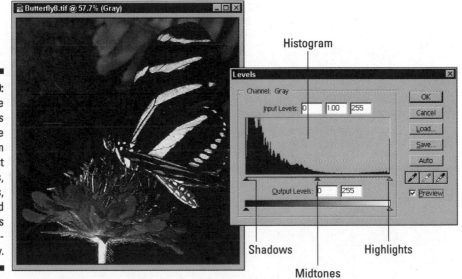

Figure 10-10: Drag the sliders under the histogram to adjust shadows, midtones, and highlights independently.

To produce the corrected butterfly image shown in Figure 10-11, I dragged the midtone slider to the left but didn't move the shadow and

highlight sliders. This change lightened the midtones in the photo while leaving the original shadows and highlights intact. The result creates needed separation between the butterfly and the background without reducing contrast or eliminating shadow and highlight detail.

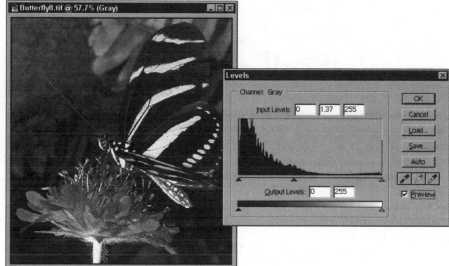

Figure 10-11:
I dragged the middle slider to the left to lighten midtones without altering the shadows or highlights.

✔ When you adjust the shadow or highlights slider in the Elements dialog box, the midtone slider moves in tandem. If you don't like the change to the midtones, just drag the midtone slider back to its original position.

✔ Levels dialog boxes also may contain Output Levels options. Using these options, you can set the maximum and minimum brightness values in your image. In other words, you can make your darkest pixels lighter and your brightest pixels darker — which usually has the unwanted effect of decreasing the contrast in your image. Sometimes, you can bring an image that's extremely overexposed into the printable range by setting a slightly lower maximum brightness value, however. In Elements, nudge the right-hand Output Levels slider to the left to reduce the maximum brightness value.

✔ For color pictures, you may be able to adjust the brightness values for the red, green, and blue color channels independently. (For an explanation of channels, see Chapter 2.) In Elements, you select the channel that you want to adjust from the Channel drop-down list, which appears at the top of the Levels dialog box when you're editing a color photo. However, adjusting brightness levels of individual channels affects the color balance of your photo more than anything else, so I suggest that you just leave the Channel option set to RGB, as it is by default.

What's an adjustment layer?

Some advanced photo-editing programs, including Photoshop Elements, offer a feature known as *adjustment layers.* Adjustment layers enable you to apply exposure and color-correction filters to a photo in a way that doesn't permanently alter the picture. You can go back at any time and easily change the filter settings or even remove the filter. In addition, you can use layer blending features to soften the impact of a filter. You also can easily expand the image area affected by the filter or remove the filter entirely from just a portion of the picture.

I don't have room in this book to cover adjustment layers fully, but I urge you to get acquainted with them if your photo software provides this feature. Using adjustment layers may seem a little complicated at first, but after you get the hang of using them, you'll appreciate the added flexibility and convenience they offer. For a further explanation of layers in general, see Chapter 12.

If you use Elements, Photoshop, or another advanced photo software, you likely have several additional tools to wield against under- or overexposed images. For example, Elements offers *Dodge* and *Burn* tools, which enable you to "paint" lightness or darkness onto your image by dragging over it with your mouse, for example. Check your software manual for information about using these exposure tools.

Give Your Colors More Oomph

Images looking dull and lifeless? Toss them in the image-editing machine with a cup of Saturation, the easy way to turn tired, faded colors into rich, vivid hues.

Now that you understand the dangers of watching too many "daytime dramas" — you start sounding like a laundry-soap commercial — let me point your attention to Color Plate 10-1. The image on the left looks like it's been through the washing machine too many times — the colors just aren't as brilliant as they were in "real life."

All that's needed to give the photo a more colorful outlook is the Saturation command, found in Elements and most other photo editors. The picture on the right in Color Plate 10-1 shows the effects of boosting the saturation. The butterfly regains its original yellow splendor, and the flowers and leaves also benefit from an infusion of color.

To access the saturation knob in Elements 1.0, choose Enhance⇨Color⇨Hue/Saturation. In Version 2.0, choose Enhance⇨Adjust Color⇨Hue/Saturation. Either way, you see the dialog box shown in Figure 10-12. Drag the Saturation slider to the right to increase color intensity; drag left to suck color out of your image.

Figure 10-12: Drag the Saturation slider to the right to boost color intensity.

If Master is selected from the Edit drop-down list at the top of the dialog box, all colors in your picture receive the color boost or reduction. You also can adjust individual color ranges by selecting them from the list. You can tweak the reds, magentas, yellows, blues, cyans, or greens.

For spot saturation adjustments, check to see whether your software also offers a Sponge tool. (Elements does.) With this tool, you can drag over the areas you want to alter to add or decrease saturation. When using the Elements Sponge tool, set the Mode control on the Options bar to Saturate or Desaturate, depending on what you want to do. Use the Pressure control, renamed Flow in Elements 2.0, to adjust how much change the tool applies with each drag.

Help for Unbalanced Colors

Like film photos, digital photos sometimes have *color balance* problems. In other words, the pictures look too blue, too red, or too green, or exhibit some other color sickness. The top left picture in Color Plate 10-2 is a case in point. I shot the picture with a camera that tends to emphasize blue tones. That's okay for pictures that feature expanses of sky or water — who doesn't enjoy a bluer sky or sea? But in the case of this photo, which shows a portion of an antique clover huller, the tendency to favor blue creates an unwanted color

cast. Notice how the belts and the top of the wooden wheel (lower-right corner) look almost navy blue? Trust me, navy blue belts and wheels are not authentic aspects of antique farm machinery.

To remove the blue cast, I used the Variations filter in Photoshop Elements. This color balancing tool is found in many photo editors. The top right image in the color plate shows the corrected picture after I added red and yellow and subtracted blue and cyan. Now the belts and wheel look gray, as they should. The color-balancing act also brought out the faded red and yellow paint of the clover huller.

To access the Variations filter, choose Enhance⇨Variations in Elements 1.0 and Enhance⇨Adjust Color⇨Color Variations in Elements 2.0. If you're using Version 1.0, you see the dialog box shown in Figure 10-13 and Color Plate 10-2. The dialog box sports a new design in Elements 2.0, but the basic function remains the same.

Color-shift thumbnail Intensity slider

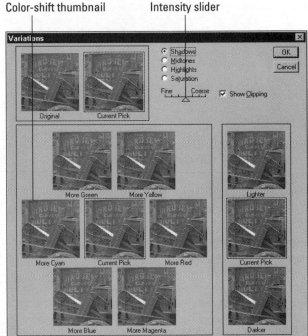

Figure 10-13: Click a color-shift thumbnail to add more of that color and subtract its opposite.

Both versions of the Variations filter enable you to adjust the colors of the image highlights, shadows, and midtones independently. After selecting the

range that you want to alter, click the thumbnail corresponding to the color you want to boost. Use the Intensity slider, labeled in Figure 10-13, to control how much your picture changes with each click of a thumbnail.

Note that in Elements 2.0, the dialog box doesn't offer the More Cyan, More Magenta, and More Yellow thumbnails found in the Version 1.0 dialog box. Instead, you click the Decrease Red thumbnail to add cyan; click the Decrease Green thumbnail to add magenta; and click the Decrease Blue thumbnail to add yellow.

Remember that you can limit the filter's effects to a particular area of your photo by creating a selection outline before opening the dialog box. Chapter 11 shows you how.

Focus Adjustments (Sharpen and Blur)

Although no photo-editing software can make a terribly unfocused image appear completely sharp, you can usually improve things a bit by using a *sharpening filter*. Color Plate 10-3 shows an example of how a little sharpening can give extra definition to a slightly soft image. The left butterfly image shows my original photo; the middle image shows the sharpened version.

When you're making this type of adjustment, be careful not to go overboard, as I did in the right image in Color Plate 10-3. Too much sharpening gives the picture a rough, grainy look. In addition, you can wind up with glowing color halos along areas of high contrast, like the border between the butterfly wings and the green background areas. Notice too, that even with the overabundance of sharpening, the blurrier portions of the background don't come into focus. You simply can't shift focus to this extent.

The following sections explain how to sharpen your image and also how to blur the background of an image, which has the effect of making the foreground subject appear more focused.

Sharpening 101

Before I show you how to sharpen your photos, I want to make sure that you understand what sharpening really does. Sharpening creates the *illusion* of sharper focus by adding small halos along the borders between light and dark areas of the image. The dark side of the border gets a dark halo, and the light side of the border gets a light halo.

To see what I mean, take a look at Figure 10-14. The top-left image shows four bands of color before any sharpening is applied. Now look at the top-right image, which I sharpened slightly. Along the borders between each band of color, you see a dark stripe on one side and a light stripe on the other. Those stripes are the sharpening halos.

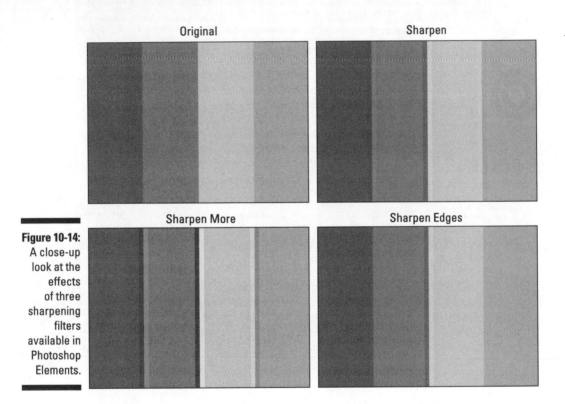

Figure 10-14:
A close-up look at the effects of three sharpening filters available in Photoshop Elements.

Different sharpening filters apply the halos in different ways, creating different sharpening effects. The next few sections explain some of the common sharpening filters.

Automatic sharpening filters

Sharpening tools, like other image-correction tools I discuss in this chapter, come in both automatic and manual flavors. With automatic sharpening filters, the program applies a preset amount of sharpening to the image.

Elements provides three automatic sharpening filters: Sharpen, Sharpen More, and Sharpen Edges. To try out the filters, choose Filter⇨Sharpen. Then click the name of the sharpening filter you want to apply.

The following list explains how each of these automatic filters does its stuff. To see the filters in action, refer to Figure 10-14.

✔ The plain old Sharpen command sharpens your entire image. If your image isn't too bad off, Sharpen may do the trick. But more often than not, Sharpen doesn't sharpen the image enough.

✔ Sharpen More does the same thing as Sharpen, only more strenuously. I feel safe in saying that this command will rarely be the answer to your problems. In most cases, it simply oversharpens.

✔ Sharpen Edges looks for areas where significant color changes occur — known as *edges* in digital imaging lingo — and adds the sharpening halos in those areas only. In Figure 10-14, for example, the sharpening halos appear between the two middle color bars, where there is a significant change in contrast. But no halos are applied between those two bars and the outer bars. The intensity of the sharpening halos is the same as with Sharpen.

I suspect that Sharpen Edges won't do much for your images, either, but you can give it a try if you like. When you discover that I'm telling the truth, head for the Unsharp Mask filter, explained in the next section.

Depending on your software, you may find automatic sharpening filters similar to the ones just discussed. But the extent to which each filter alters your image varies from program to program, so do some experimenting. Again, for the best results, ignore the automatic sharpening filters altogether and rely on your program's manual sharpening controls, if available.

Manual sharpening adjustments

Some consumer-level photo-editing programs provide you with a fairly crude manual sharpening tool. You drag a slider one way to increase sharpening and drag in the other direction to decrease sharpening.

Elements, like Photoshop and other more advanced image-editing programs, provides you with the mother of all sharpening tools, which goes by the curious name of Unsharp Mask.

The Unsharp Mask filter is named after a focusing technique used in traditional film photography. In the darkroom, unsharp masking has something to do with merging a blurred film negative — hence, the *unsharp* portion of the

name — with the original film positive in order to highlight the edges (areas of contrast) in an image. And if you can figure that one out, you're a sharper marble than I.

Despite its odd name, Unsharp Mask gives you the best of all sharpening worlds. You can sharpen either your entire image or just the edges, and you get precise control over how much sharpening is done.

To use the Unsharp Mask filter in Elements, choose Filter⇨Sharpen⇨Unsharp Mask. The dialog box shown in Figure 10-15 appears.

Figure 10-15:
For profes-
sional
sharpening
results,
make friends
with the
Unsharp
Mask filter.

The Unsharp Mask dialog box contains three sharpening controls: Amount, Radius, and Threshold. You find these same options in most Unsharp Mask dialog boxes, although the option names may vary from program to program. Here's how to adjust the controls to apply just the right amount of sharpening:

✔ **Amount:** This value determines the intensity of the sharpening halos. Higher values mean more intense sharpening. In Figure 10-16, I sharpened the original image from Figure 10-14 using two different Amount values in conjunction with two different Radius values and a Threshold value of 0.

To see the impact of the Amount value on a real-life, color photo, check out Color Plate 10-4. For these examples, I used a Radius value of 1.0 and a Threshold value of 0. The inset areas give you a close-up look at how raising the amount value affects the intensity of the sharpening halos.

Amount, 100% Amount, 200%

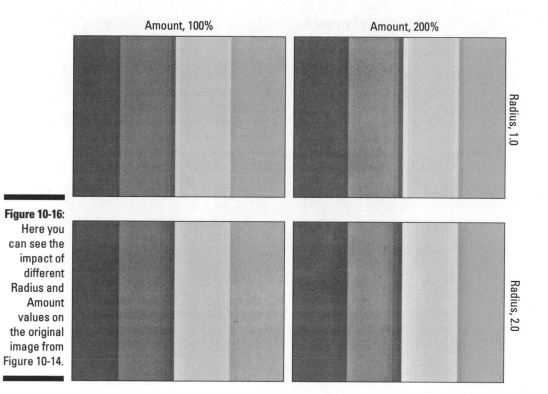

Radius, 1.0

Radius, 2.0

Figure 10-16: Here you can see the impact of different Radius and Amount values on the original image from Figure 10-14.

For best results, apply the Unsharp Mask filter with a low Amount value — between 50 and 100. If your image is too soft, reapply the filter using the same or lower Amount value. This technique usually gives you smoother results than applying the filter once with a high Amount value.

✔ **Radius:** The Radius value controls how many pixels neighboring an edge are affected by the sharpening. With a small Radius value, the haloing effect is concentrated in a narrow region, as in the top two images in Figure 10-16. If you set a higher Radius value, the halos spread across a wider area and fade out gradually from the edge.

Generally, stick with Radius values in the 0.5 to 2 range. Use values in the low end of that range for images that will be displayed on-screen; values at the high end work better for printed images.

✔ **Threshold:** This option tells the program how different two pixels must be before they're considered an edge and, thus, sharpened. By default, the value is 0, which means that the slightest difference between pixels results in a kiss from the sharpening fairy. As you raise the value, fewer

pixels are affected; high-contrast areas are sharpened, while the rest of the image is not (just as when using Sharpen Edges, discussed in the preceding section).

TIP

When sharpening photos of people, experiment with Threshold settings in the 1 to 15 range, which can help keep the subject's skin looking smooth and natural. If your image suffers from graininess or noise, raising the Threshold value can enable you to sharpen your image without making the noise even more apparent.

For a full-color look at how different Radius and Threshold settings alter the sharpening effect, flip to Color Plate 10-5. For all six examples, I set the Amount value to 100. In the left column, I used a Radius value of .5 throughout but used Threshold settings of 0, 5, and 10. With a Threshold value of 10, only areas of strong contrast, like the borders of the white wing spots, get sharpened. At lower values, the sharpening occurs along lower-contrast borders as well.

In the three photos in the right column of Color Plate 10-5, I raised the Radius value to 2.0. Compare the inset wing area of the upper-right image with its neighbor to the left, which uses a much lower Radius value. At a higher Radius value, the sharpening halos appear over a wider area on either side of the color boundaries. As with the left-column images, the Threshold value determines whether the sharpening occurs throughout all color boundaries or just along borders where significant color change occurs.

As you can see, you can create similar sharpening effects by using different combinations of Amount, Radius, and Threshold settings. The right settings vary from picture to picture, so let your eyes be your judge. For the record, I used the following settings to produce the butterfly in the middle of Color Plate 10-3: Amount, 100; Radius, 1.5; and Threshold, 5.

Blur to sharpen?

If your main subject is slightly out of focus and using the sharpening tools explained in the preceding sections don't totally correct the problem, try this: Select everything but the main subject, using the techniques explained in the next chapter. Then apply a blur filter, found in most photo-editing programs, to the rest of the picture. Often, blurring the background in this way makes the foreground image appear sharper, as illustrated in Figure 10-17.

In this figure, I selected everything behind the car and applied a slight blur. I then reversed the selection so that the car and foreground were selected and applied just a wee bit of sharpening. As a result, the car not only looks much crisper than before, but the distracting background elements become much less intrusive on the main subject.

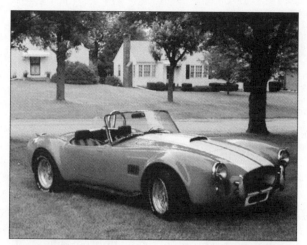

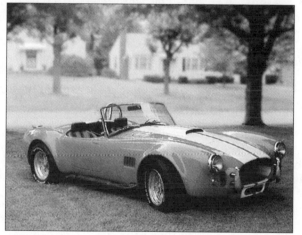

Figure 10-17: Applying a slight blur to everything behind the car makes the car appear more in focus and also helps de-emphasize the distracting background.

Elements gives you six blur filters, all accessed by choosing Filter➪Blur. But only one of them, Gaussian Blur, deserves your attention for blurring a photo background. The others either are automatic filters, which don't give you any control over the amount of blur, or produce special effects.

When you choose the Gaussian Blur command, you see the dialog box shown in Figure 10-18. Drag the Radius slider to the right to produce a more pronounced blur; drag left to reduce the blurring effect.

In case you were wondering, the Gaussian Blur filter is named after a mathematician with the surname Gauss, whose name also is used to describe a type of curve on which the filter is based.

Figure 10-18:
To control
the amount
of blurring,
use the
Gaussian
Blur filter.

Out, Out, Darned Spots!

Sit around a coffee shop with a group of digital photographers, and you may hear the term *jaggies* tossed around. This word refers to a type of defect in digital images, not the nervous condition that results from consuming all that coffee-shop brew.

Jaggies comes from *jagged,* which is how digital images appear if they've been overly compressed or enlarged too much. Instead of appearing smooth and seamless, pictures have a blocky — jaggedy — look, especially along curved or diagonal lines.

A related defect, referred to as *noise, aliasing,* or *color fringing,* depending on the accent of the speaker, shows up as random speckles or color halos. Whatever you call it, this problem also can be caused by too much compression. Other noise-inducers include inadequate light and a too-high ISO setting (see Chapter 5).

Figure 10-19 shows an image with a bad case of the jaggies. For a look at noise, see the top-left image in Color Plate 12-5. If your image exhibits either of these embarrassing properties, try applying a slight blur to the photo, using the Gaussian Blur command discussed in the preceding section. Apply the blur just to the area where the defects are the worst so that you don't lose image detail in the rest of the image.

After applying the blur, you may need to apply a sharpening filter to restore lost focus. The problem is, sharpening can make those defects visible again. If your image editor offers an Unsharp Mask filter, you can avoid this vicious cycle by raising the Threshold value above the default setting, 0.

Many image editors provide a Despeckle or Remove Noise filter, which is specially designed to eliminate noise. All these filters do is apply a slight blur

to the image, just like a blur filter. If your blur filter enables you to control the extent of the blur, forget about the Despeckle/Remove Noise and use the blur filter. If your blur filter is a one-shot filter (totally automatic), try applying both blur and Despeckle/Remove Noise, and see which one does a better job on the image. One filter may blur more than the other.

Figure 10-19:
Too much
JPEG
compression
can lead to
a case of
the jaggies.

Some people use the term *artifacts* when referring to compression-related defects as well as to defects caused by problems with the camera hardware itself. In the archaeological world, artifacts are treasures, remnants of a lost civilization. Digital artifacts, on the other hand, are definitely not considered treasures.

Chapter 11

Cut, Paste, and Cover Up

• •

In This Chapter

▶ Making edits to specific parts of your image

▶ Using different types of selection tools

▶ Refining your selections

▶ Moving, copying, and pasting selections

▶ Creating a patch to cover up flaws

▶ Cloning over unwanted elements

• •

Remember the O.J. Simpson trial (how could you *not*)? At one point in the trial, the defense claimed that a photograph had been digitally altered to make it appear as though the defendant wore a specific type of shoe. That kind of claim, together with the development of photo-editing software that makes digital deception easy to accomplish, has led many people to question whether we now live in an age when the photograph simply can't be trusted to provide a truthful record of an event.

I can't remember the outcome of the shoe debate, but I can tell you that a photograph can just as easily speak a thousand lies as a thousand words. Of course, photographers have always been able to alter the public's perception of a subject simply by changing camera angle, backdrop, or other compositional elements of a picture. But with photo-editing software, opportunities for putting our own spin on a photograph are greatly expanded.

This chapter introduces some basic methods that you can use to manipulate your pictures. I want to emphasize that you should use these techniques solely in the name of creative expression, not for the purpose of deceiving your audience. Combining elements from four or five pictures to make a collage of your vacation memories is one thing; altering a photo of a house to cover up a big crater in the driveway before you place a for-sale ad in the real-estate section is quite another.

That said, this chapter shows you how to merge several pictures into one, move a subject from one photo to another, and cover up image flaws. Along the way, you get an introduction to *selections*, which enable you to perform all the aforementioned editing tricks, and more.

Why (And When) Do I Select Stuff?

If your computer were a smarter being, you could simply give it verbal instructions for how you wanted your digital photo changed. You could say, "Computer, take my head and put it on Madonna's body," and the computer would do your bidding while you went to catch a special edition of *Jenny Jones* or *Jerry Springer* or something equally enlightening.

Computers can do that sort of thing on *Star Trek* and in spy movies. But in real life, computers aren't that clever (at least, not the ones that you and I get to use). If you want your computer to alter a portion of a photo, you have to draw the machine a picture — well, not a picture, exactly, but a *selection outline*.

By outlining the area that you want to edit, you tell your software which pixels to change and which pixels to leave alone. For example, if you want to blur the background of a picture but leave the foreground as it is, you select the background and then apply a blur filer. If you don't select anything before applying the filter, the entire photograph gets the blur.

Selections don't just limit the impact of filters and other editing tools, though. They also protect you from yourself. Say that you have a picture of a red flower on a green background. You decide that you want to paint a purple stripe over the flower petals . . . oh, I don't *know* why, Johnny, maybe it's just been that kind of day. Anyway, if you have a steady hand, you may be able to paint only on the petals and avoid brushing any purple on the background. But people whose hands are that steady are usually busy wielding scalpels, not photo-editing tools. Most people tackling the paint job get at least a few stray dabs of purple on the background.

If you select the petals before you paint, however, you can be as messy as you like. No matter where you move your paintbrush, the paint can't go anywhere but on those selected petals. The process is much the same as putting tape over your baseboards before you paint your walls. Areas underneath the tape are protected, just like pixels outside the selection outline.

As you can see, selections are an invaluable tool. Unfortunately, creating precise selections requires a bit of practice and time. And precise selections

are a major key to editing that looks natural and subtle, instead of editing that looks like a bull ran through the digital china shop. The first few times you try the techniques in this chapter, you may find yourself struggling to select the areas you want. But don't give up; the more you work with your selection tools, the more you'll get the hang of things.

On-screen, selection outlines are usually indicated by a dashed outline known in image-editing cults as a selection *marquee*. Some people are so fond of this term that they also use it as a verb, as in "I'm gonna marquee that flower, okay?" But because the dashes usually are animated in a way that makes them appear to be a parade of ants on the move (if you're really imaginative), some people and photo-editing manuals also refer to the outline using the more colorful term *marching ants*. Still other folks call selection outlines *masks*. The deselected area is said to be *masked*.

What tools should I use?

Most photo-editing programs provide you with an assortment of selection tools. Some tools are special-occasion devices, while others come in handy almost every day.

Photoshop Elements provides the following assortment of tools, which are also found in other advanced programs (although the tool names may be slightly different).

- ✔ **Rectangular Marquee** and **Elliptical Marquee** for creating rectangular, square, oval, and circular selection outlines
- ✔ **Lasso, Polygonal Lasso,** and **Magnetic Lasso** for drawing freeform selection outlines
- ✔ **Magic Wand** for selecting areas based on color

Elements 2.0 also offers a Selection Brush tool, another tool for drawing freeform outlines. To create an outline, you can just drag over either the pixels that you want to select or the area that you want to mask — in other words, the area that you don't want to change.

Because this tool is pretty program specific, I don't cover it here, but if you're using Elements 2.0, check out the Elements manual for instructions on how to use it. You may find the tool especially handy for drawing intricate selection outlines. In other advanced programs, similar tools go by the name Mask tool. In Photoshop, the Quick Mask feature provides the selecting-by-painting function.

Which selection tool you should use depends on what you're trying to select. The next few sections explain how to use the various types of tools so that you can get a better idea of what each tool can help you do.

Although I provide some specific instructions related to selecting in Elements, selection tools in other programs work similarly. So don't skip these pages if you don't use Elements, because much of the information applies to your program, too. (However, if you're working with a very basic entry-level program, you may get only one or two of the tools discussed here.) If you *do* use Elements, keep in mind that I don't cover all your selection possibilities due to space limitations.

In other words, use this chapter as just a jumping off point for exploring your selection tools. For a more detailed look at selecting, including some professional tricks for selecting difficult subjects such as hair and fur, you may want to pick up a copy of *Photo Retouching & Restoration For Dummies*. (I wrote that book, too, so I have it on good authority that it includes an entire chapter on the topic of selecting.)

Activating the Elements selection tools

In Elements, you activate a selection tool by clicking its icon in the toolbox. Figure 11-1 shows the top of the toolbox, where the selection tools live. (This toolbox is from Elements 1.0, so the Selection Brush tool that I discuss in the preceding section isn't shown. You can find it directly below the Lasso tool slot in the Elements 2.0 toolbox.)

Figure 11-1:
The Elements selection tools are housed at the top of the toolbox.

A little triangle at the bottom of any tool icon means that two or more tools share the same slot in the toolbox. Click the triangle, labeled in Figure 11-1, to display a *flyout menu* — a little menu that flies out from the toolbox — and access the hidden tools. Then click the icon for the tool you want to use. The flyout menu disappears, and the current tool appears in the toolbox.

In Elements 2.0, you also can change from one tool on a flyout menu to another by clicking the tool icons on the Options bar.

Selecting rectangular and oval areas

The simplest selection tools enable you to draw regularly shaped selection outlines. In most programs, you get at least one tool for drawing rectangular outlines and another for drawing oval outlines. Elements names these tools the Rectangular Marquee and the Elliptical Marquee.

Whatever the tool name, you create your selection outline by dragging from one side of the area you want to select to the other, as illustrated in Figure 11-2. (You won't see the direction arrow; I added that for illustration purposes.)

Options bar

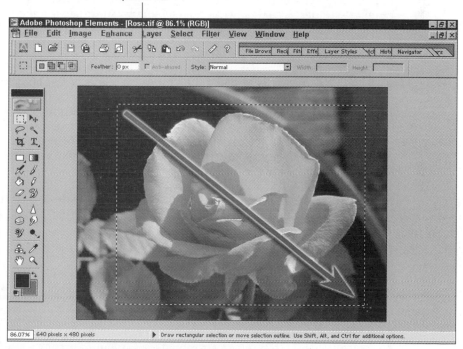

Figure 11-2: To select a rectangular area, drag from one corner to another.

You can adjust the performance of the Rectangular and Elliptical Marquee tools via the controls on the Options bar, also labeled in Figure 11-2. The following list explains what each option does.

 ✔ **Feather:** To create a soft-edged selection outline, so that whatever edit you apply fades gradually from the edges of the selected area, enter a value other than 0 in the Feather box. For more information about

feathering, including how you can feather a selection outline after you draw it, see "Creating a seamless patch," toward the end of this chapter.

✔ **Anti-aliased:** This option, when enabled, smoothes out the jagged edges that can occur when your selection outline contains curved or diagonal lines. For retouching purposes, this option is usually a good idea. When you're selecting a subject in order to copy and paste it into another photo, though, experiment with turning the option off. Anti-aliasing isn't available for the Rectangular Marquee tool (because rectangular marquees don't have curved or diagonal edges).

✔ **Style:** Set this option to Normal for full control over the shape and size of the selection outline. The other two options limit the tool to drawing an outline with a specific aspect ratio — say, two times as wide as it is tall — or at a fixed size, such as 300 pixels wide by 200 pixels tall.

In addition, you can press the Shift key as you drag to create a square or circular outline. Shift+drag with the Rectangular Marquee to create a square outline. Shift+drag with the Elliptical Marquee to draw a circular outline.

Selecting by color

One of my favorite selection weapons ropes off pixels based on color. Elements calls its color-based selection tool the Magic Wand, while other programs call it the Color Wand, Color Selector, or something similar.

Whatever the name, the tool works pretty much the same everywhere you find it. You click on your picture, and the program automatically selects pixels that are the same color as the one you clicked.

Suppose that you have a picture like the one in Color Plate 11-1 (the color version of the rose shown in Figure 11-2). To select the rose petals, you just click one of the petals.

When you activate the Elements Magic Wand (labeled in Figure 11-1), the Options bar offers a handful of tool controls. If your software offers a color-selecting tool, you likely have access to similar tool options. They work as follows:

✔ **Tolerance:** This option enables you to specify how discriminating you want the tool to be when searching for similar colors. At a low Tolerance value, the tool selects only pixels that are very close in color to the pixel you click. Raise the value to tell the program to select a broader range of similar shades.

Color Plate 11-1 shows the results of using four different Tolerance values: 10, 32, 64, and 100. The little x in each rose indicates the position of the Magic Wand when I clicked; the yellowish tint indicates the regions included in the resulting selection.

In Elements, you can enter a Tolerance value as high as 255, but anything above 100 or so tends to make the Magic Wand *too* casual in its pixel roundup. A value of 255 selects the entire image, which is pretty pointless; if you want to select the entire image, most programs provide a Select All command or something similar that does the job more quickly.

As you can see in Color Plate 11-1, a value of 100 selected most of the rose pixels, leaving just a few dark petal areas unselected. I can easily add those spots to the selection using the techniques described in "Refining your selection outline," later in this chapter.

✔ **Anti-aliased:** This one works just as described in the preceding section, so I won't go over it again here.

✔ **Contiguous:** Use this option to limit the tool to selecting only similarly colored pixels that are *contiguous* to the one you click. In plain English, that means that similarly colored pixels are *not* selected if any pixels of another color lie between them and the pixel you click.

For example, if you were to click the rightmost green leaf in Color Plate 11-1, that leaf would be selected, as would the neighboring leaf. But the leaves to the left would not be selected because areas of brown (in the rose stem) and black (the background) lie between the two regions of leaves. When creating Color Plate 11-1, I had the Contiguous option turned on.

To make the Magic Wand select all similarly colored pixels, regardless of their position in your photo, turn off the Contiguous option.

✔ **Use All Layers:** If your picture contains multiple layers, a feature explained in Chapter 12, select this check box if you want the Magic Wand to "see" pixels on all layers when creating the selection outline. Remember, though, that the outline that you create affects only the active layer — the program just takes all layers into account when drawing the selection outline.

Drawing freehand selections

Another popular type of selection tool enables you to select irregular areas of an image simply by tracing around them with your mouse. Well, I say "simply," but frankly, you need a pretty steady hand to draw precise selection outlines. Some people can do it; I can't. So I normally use these tools to select a general area of the image and then use other tools to select the exact pixels I want to edit. (Building selection outlines in this way is discussed in the upcoming section "Refining your selection outline.")

At any rate, this tool goes by different names depending on the software — Freehand tool, Lasso tool, and Trace tool are among the popular labels. Elements opts for Lasso, as does Photoshop. Both programs offer two

variations on the Lasso, the Polygonal Lasso and the Magnetic Lasso. (Refer to Figure 11-1, earlier in this chapter, if you need help locating these tools in the Elements toolbox.)

Use the Elements Lasso and Polygonal Lasso as follows:

- **Lasso:** Just drag to draw your selection outline, as if you were drawing with a pencil. When you reach the point where you began dragging, let up on the mouse button to close the selection outline.

- **Polygonal Lasso:** This tool assists you with drawing straight segments in a freeform outline. Click to set the start of the first line, move the mouse to the spot where you want to end the segment, and then click to set the end point. Keep clicking and moving the mouse to draw more line segments. When you get back to the starting point of the outline, let up on the mouse button to close the outline.

When working with either tool, you can temporarily switch to the other one by pressing and holding the Alt key on a PC or the Option key on a Mac. Let up on the Alt (Option) key to return to the original tool you were using.

The next section explains the third tool in the Elements Lasso trio, the Magnetic Lasso.

Selecting by the edges

If you read Chapter 10, you know that the term *edges* refers to areas where very light areas meet very dark areas. Many photo-editing programs, including Elements, provide a selection tool that simplifies the task of drawing a selection outline along an edge.

As you drag with this tool, called the Magnetic Lasso in Elements, the tool searches for edges and lays down the selection outline along those edges. Figure 11-3 shows a close-up view of me using this tool to create a selection outline along the edges of the rose petals from the rose picture featured in Figure 11-2.

The process of using an edge-detection tool typically works like so:

1. **Click at the point where you want the selection outline to begin.**

2. **Move or drag your mouse along the border of the object you're trying to select.**

 Keep your tool cursor centered over the border, as shown in Figure 11-3. Whether you need to simply move the mouse or drag, with the mouse button depressed, depends on your software. In Elements, you can do either.

As you move or drag the mouse, the tool automatically draws the selection outline along the border between the object and the background — assuming that at least some contrast exists between the two. At regular intervals, the program adds little squares to anchor the outline. You can see these squares, called *fastening points* in Elements, in Figure 11-3.

Magnetic Lasso Fastening point Brush cursor

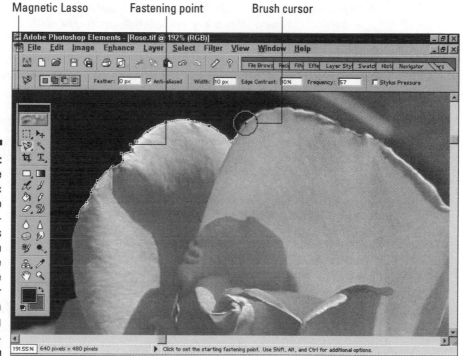

Figure 11-3:
The Magnetic Lasso automatically places a selection outline along the border between contrasting areas.

You can click to create your own fastening points if needed. To remove a fastening point, move the mouse cursor over the point and press Delete.

3. To finish the outline, place your cursor over the first point in the outline and click.

As with color-based selection tools, you can usually control the sensitivity of edge-detection tools. In Elements, use the following Options bar controls to adjust this and other aspects of the Magnetic Lasso's performance:

✔ **Feather, Anti-aliased:** These controls affect your selection outline as described in the earlier section, "Selecting rectangular and oval areas."

✔ **Width:** This control determines how far the tool can wander in its search for edges. Larger values tell the tool to go farther afield;

smaller values keep the tool closer to home. You can enter any value from 1 to 40.

To make your cursor reflect the width value, as in Figure 11-3, instead of displaying the standard tool cursor, choose Edit⇨Preferences⇨Display and Cursors to display the Elements Preferences dialog box. In the Other Cursors section of the dialog box, select Precise.

✔ **Edge Contrast:** Adjust this value to make the tool more or less sensitive to contrast changes. Use a low value if not much contrast exists between the object you want to select and the neighboring area. The maximum value is 100.

✔ **Frequency:** This setting affects how often the program adds fastening points. The default value usually works fine. Adding too many points can lead to a jaggedy outline, so try to go lower, if anything. Remember that you can always click to add your own fastening points, if needed.

✔ **Stylus Pressure (Pen Pressure in Elements 2.0):** If you're working with a drawing tablet, this option enables you to reduce the Width value on the fly. Press harder to decrease the Width value. When you apply no stylus pressure, the tool uses the Width value that you originally set on the Options bar. (As you change stylus pressure, the value in the Width box doesn't change, but the tool cursor does if you have the cursor style set to Precise, as suggested earlier.) I find it difficult to predict how much pressure will produce the Width value I want, so I don't usually take advantage of this technique.

Selecting (and deselecting) everything

Want to make a change to your entire photo? Don't monkey around with the selection tools described in the preceding sections. Most programs provide a command or tool that automatically selects all pixels in your picture.

In some entry-level photo editors, you simply click the image with a particular selection tool, usually called a Pick tool or Arrow tool. Click once to select; click again to deselect.

Other programs provide menu commands for selecting and deselecting the entire image:

✔ Look in the Edit menu or the same menu that holds the selection commands for a Select All command or something similar. You can probably also find a Select None command that deselects the entire image — that is, removes an existing selection outline.

In Elements, choose Select➪All to select everything. Choose Select➪ Deselect to get rid of a selection outline. If you decide you want your last selection outline back, choose Select➪Reselect.

✔ For the quickest route to whole-image selection, use the universal keyboard shortcut: Ctrl+A on a PC and ⌘+A on a Mac.

✔ Some programs also provide a shortcut for deselecting everything; in Elements, press Ctrl+D on a PC and ⌘+D on a Mac.

✔ In most programs, starting a new selection outline also gets rid of the existing outline. If you instead want to edit the size or shape of the existing outline, you have to set the tool into a different working mode. See the next section for details.

Note that if your photograph includes multiple image layers, your selection outline affects only the current layer even when you use the command to select everything. If you want to make a change to all layers, you must merge the layers into one or apply the same change to each layer individually. Chapter 12 gives you the complete story on layers.

Taking the inverse approach to selections

You can sometimes select an object more quickly if you first select the area that you *don't* want to edit and then *invert* the selection. Inverting simply reverses the selection outline so that the pixels that are currently selected become deselected, and vice versa.

Consider the left image in Figure 11-4. Suppose that you wanted to select just the buildings, flagpole, and street lamp. Drawing a selection outline around all those spires and ornate trimmings would take forever. But with a few swift clicks of the Elements Magic Wand, I was able to easily select the sky and then invert the selection to select the buildings. In the right image in Figure 11-4, I deleted the selected area to illustrate how cleanly this technique selected the buildings.

To reverse a selection outline in Elements, choose Select➪Inverse. Or press Shift+Ctrl+I (Shift+⌘+I on the Mac).

In other photo-editing programs, look for an Invert or Inverse command. The command typically hangs out in the same menu or palette that contains your other selection tools. But be careful — some programs use the name Invert for a filter that inverts the colors in your image, creating a photographic negative effect. If you find Invert or Inverse on a menu that contains mostly special effects, the command probably applies the negative effect instead of inverting the selection.

Figure 11-4: To select these ornate structures (left), I used the Magic Wand to select the sky and then inverted the selection outline. Deleting the selected pixels (right) shows how precisely this technique selected even the intricate architectural elements.

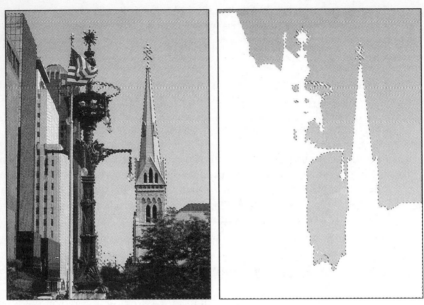

Refining your selection outline

In theory, creating selection outlines sounds like a simple thing. In reality, getting a selection outline just right on the first try is about as rare as Republicans and Democrats agreeing on who should pay fewer taxes and who should pony up more. In other words, you should expect to refine your selection outline at least a little bit after you make your initial attempt.

All advanced photo-editing programs and some consumer-level programs enable you to adjust your selection outline. The preceding section explains one way to alter an outline — to reverse it using the Invert command. You also can enlarge or reduce a selection outline using these techniques:

✔ **Adding to a selection outline:** To enlarge the selection outline, you set the selection tool to an additive mode. You can then draw a new selection outline while retaining the existing outline. To select the unselected pixels in the center of the rose in the lower-right image in Color Plate 11-1,

I could simply drag around them with an elliptical selection tool, for example.

✔ **Shrinking a selection outline:** To deselect certain pixels currently enclosed in a selection outline, you set the selection tool to a subtractive mode. The tool then works in reverse, deselecting instead of selecting pixels. For example, suppose that you select both the flower and the leaves in Color Plate 11-1. If you change your mind and decide to select the flower only, you just set your color selection tool to the subtractive mode and click on the leaves to deselect the green pixels.

✔ **Intersecting a selection outline:** Some programs go even further, enabling you to create a selection outline that encompasses the area of overlap between an existing outline and a second outline. For example, if you draw a rectangular outline and then draw a second outline that overlaps the right half of the first outline, only pixels inside the area of overlap become selected. In other words, the "intersection" of the two outlines becomes selected.

Methods for switching selection tools from their normal operating mode to the additive, subtractive, or intersection mode vary widely from program to program. In some programs, you click a toolbar icon; in other programs, you press a key to toggle the additive and subtractive modes on and off.

In Elements, you can hold down the Shift key as you drag or click with a selection tool if you want to add to the existing selection outline. Press and hold the Alt key (Option, on a Mac) if you want to subtract from the selection outline. Alternatively, use the tool-mode buttons that appear on the left end of the Options bar whenever a selection tool is active. Figure 11-5 gives you a close-up look at the buttons. To get rid of an existing outline and start a new one entirely, click the Normal button before using the selection tool.

Figure 11-5:
To set the
selection
tool mode in
Elements,
you can use
these
Options bar
buttons.

In Elements, you can adjust a selection outline in these additional ways:

✔ **Move the selection outline:** Sometimes, you may simply want to move the selection outline rather than enlarge or reduce it. Just drag inside

the outline with any selection tool to do so. Or press the arrow keys on your keyboard to nudge the outline one pixel in the direction of the arrow.

✓ **Expand or contract the outline by a specific number of pixels:** Choose Select⇨Modify⇨Expand or Select⇨Modify⇨Contract and enter a value (in pixels) in the resulting dialog box. Elements then removes or adds that many pixels from the entire perimeter of the outline.

✓ **Add similarly colored pixels to the outline:** Use Select⇨Grow to select any pixels that are both adjacent to, and similar in color to, the selected pixels. To add similarly colored pixels throughout the image, choose Select⇨Similar. Both commands make their selections based on the current Tolerance setting for the Magic Wand tool, explained earlier in this chapter. (See "Selecting by color.")

✓ **Smooth a selection outline:** To round off any jagged edges in your outline, choose Select⇨Modify⇨Smooth and enter a value in the resulting dialog box. Raise the value to apply more smoothing.

Don't forget that you can also use the Anti-aliased control to smooth outlines as you draw them. Refer to the earlier section, "Selecting rectangular and oval areas" for details.

Check your software Help system to find out whether the program provides a way for you to save a selection outline as part of the picture file. That way, if you need to use the same selection outline during a later editing session, you don't have to waste time recreating it. Elements 2.0 offers this function; explore the Save Selection and Load Selection commands on the Select menu. Unfortunately, Elements 1.0 does not provide this feature.

Selection Moves, Copies, and Pastes

After you select a portion of your image, you can do all sorts of things to the selected pixels. You can paint them without fear of dripping color on any unselected pixels, for example. You can apply special effects or apply color-correction commands just to the selected area, leaving reality undistorted in the rest of your image.

But one of the most common reasons for creating a selection outline is to move or copy the selected pixels to another position in the image or to another image entirely, as I did in Color Plate 11-2. I cut the rose out of the image on the left and pasted it into the wood photo to create the image on the right.

The following sections give you all the information you need to become an expert at moving, copying, and pasting selected portions of a photo.

You can also copy pixels using a special editing tool known as the Clone tool. This specialized tool enables you to "paint" a portion of your image onto another portion of your image, as discussed later in this chapter, in "Cloning without DNA."

Cut, Copy, Paste: The old reliables

One way to move and copy selections from one place to another is to use those old-time computer commands: Cut, Copy, and Paste. These commands are available in most every photo editor; usually, you find them on the Edit menu.

Before I get any further into this discussion, though, one caveat: When you paste a portion of one photo into another in many programs, including Elements, the pasted element may appear to change size. This happens if the output resolution for both photos isn't the same. The number of pixels in the pasted element doesn't change, just the number of pixels per inch, which affects the print dimensions. If you want your copied selection to retain its original size when placed in the other image, be sure that the output resolution is the same for both pictures. (See the resizing information in Chapters 2, 8, and 9 for further details on resizing and resolution.)

With that bit of business out of the way, here's the Cut/Copy/Paste routine in a nutshell:

✔ **Copy** duplicates the selected pixels and places the copy on the Clipboard, a temporary virtual storage tank. Your original image is left intact.

To save yourself the hassle of clicking through the Edit menu, memorize this keyboard shortcut for the Copy command: Ctrl+C on a Windows-based PC and ⌘+C on a Mac. This same shortcut works in almost every computer program, by the way.

✔ **Cut** snips the pixels out of your image and places them on the Clipboard. You're left with a hole where the pixels used to be, as illustrated in the left image in Figure 11-6.

For this command, use the keyboard shortcut Ctrl+X (Windows) or ⌘+X (Mac).

✔ **Paste** glues the contents of the Clipboard into your image. To paste from the keyboard, press Ctrl+V (Windows) or ⌘+V (Mac).

Figure 11-6:
I used the Cut command to snip the rose out of its original background (left) and then pasted the flower into another photo (right).

Chances are, after you dump the contents of the Clipboard into your photo, you'll need to adjust the position of the pasted element slightly. The next section explains how.

Adjusting a pasted object

Different programs treat pasted pixels in different fashions. In some programs, the Paste command works like super-strong epoxy — you can't move the pasted selection without ripping a hole in the image, just as when you cut a selection. In other programs, your pasted pixels behave more like they're on a sticky note. You can "lift" them up and move them around without affecting the underlying image.

Elements takes the second approach to pasting, as does Photoshop. Both programs place your pixels on a new *layer*. Layers are explained more fully in Chapter 12, but for now, just understand the following facts:

✔ Open the Layers palette, shown in Figure 11-7, to see all the layers in your photo, including the one containing the newly pasted pixels. To display the Layers palette, click its tab in the palette well or choose Window⇨Show Layers. To keep the palette open and accessible, drag it by its tab into main workspace, as I did in the figure.

✔ By default, any transparent areas in the pasted layer appear as a gray-and-white checkerboard pattern in the thumbnail previews in the Layers palette, as shown in the figure. Pixels on the layer below show through the transparent areas. In Figure 11-7, for example, the wood background is visible through the empty areas of the rose layer.

✔ To retain the individual image layers when you save your picture, save in the program's native format, PSD. Other formats may merge the layers, which means that you can no longer manipulate the pasted element independently of the rest of the photo.

Transformation handle

Rotate cursor

Move tool Maintain Aspect Ratio Layers palette Apply

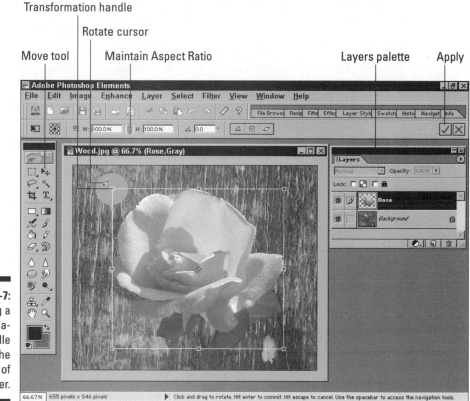

Figure 11-7: Drag a transformation handle to rotate the contents of a layer.

Because your pasted element exists on its own layer, you can adjust it as necessary to fit its new home. In Elements, first click the name of the pasted layer in the Layers palette. This makes the layer active. The layer name appears highlighted in the Layers palette, as shown in Figure 11-7. With the pasted layer active, use these techniques to alter its contents:

✔ **Move the pasted object:** Select the Move tool, labeled in Figure 11-7, and drag the element in the image window. While the Move tool is active, you also can press the arrow keys on your keyboard to nudge the element a distance of one pixel. Press Shift plus an arrow key to nudge the element ten pixels.

✔ **Rotate the pasted element:** Choose Image➪Transform➪Free Transform or press Ctrl+T (⌘+T on a Mac). A square outline, which I call a

transformation boundary, appears around the element, as shown in Figure 11-7. Six boxes — called *transformation handles* — appear around the perimeter of the boundary.

Place your cursor outside a corner handle to display the curved rotate handle, as shown in the figure. (I added a solid spotlight to make the cursor and handle easier to see.) Then drag up or down to spin the element. Click the Apply button, labeled in the figure, to finalize the rotation. (If you're using Elements 2.0, the Apply button and the neighboring Cancel button have swapped positions.)

Don't see any transformation handles? Enlarge the image window to reveal them.

To cancel out of a transformation, press the Esc key or click the Cancel button, which is next to the Apply button.

✔ **Resize the pasted element:** You can resize the pasted object by dragging the transformation handles, but keep in mind that doing so can lead to poor image quality. (See Chapter 2 for information about why resizing digital photos can reduce picture quality.)

To avoid distorting the element as you resize, be sure that the Maintain Aspect Ratio button on the Options bar is pressed in, as shown in Figure 11-7. Again, click the Apply button to complete the resizing.

✔ **Flip the pasted element:** Choose one of the Flip commands on the Image⇨Rotate submenu.

Deleting Selected Areas

You can use the Cut command to move a selected object from your current photo to the Clipboard, where it stays until you cut or copy something else. But don't go to that trouble if all you want to do is simply remove a selected something from your picture — just press the old Delete key.

Instead of traveling to the Clipboard, your selection goes to the great pixel hunting ground in the sky. All that remains is a hole in the shape of the selection. If you're working on a layer, you see the underlying layer through the hole. For more on layers, see Chapter 12.

Digital Cover-Ups

When I shot the image in Figure 11-8, the city of Indianapolis refused to cooperate and relocate that darned tower thing in the background. I shot the

picture anyway, knowing that I could cover up the tower in the image-editing phase. The next two sections describe two methods for tackling this sort of photographic spot-removal: patching and cloning.

Figure 11-8: An ugly tower in the background spoils this picture.

Creating a seamless patch

Many photo editors enable you to *feather* a selection. To feather the selection means to fuzz up the edges of the selection outline a little bit. Figure 11-9 shows the difference between a bit of black that I copied and pasted using a standard (hard-edged) selection and a feathered selection.

Figure 11-9: A normal selection has hard edges (left); a feathered selection fades gradually into view (right).

Feathering enables you to create less-noticeable edits because the results of your changes fade gradually into view. Without feathering, you often get abrupt transitions at the edges of the selection, making alterations very noticeable.

Figure 11-10 provides an illustration. In both figures, based on the image in Figure 11-8, I got rid of the offending construction tower by copying some sky pixels and pasting them on top of the tower — applying a digital "patch," if you will.

For the left example, I drew a standard rectangular selection outline around an area of sky and then copied and pasted the selection onto the tower. At the top of the tower, my patch blended fairly well with the surrounding sky because I was patching in a solid area of color. But in the bottom portion of the image, you can see distinct edges along the borders of the area I pasted because the patch has hard edges, which interrupts the natural fluffiness of the clouds. I was able to create a much less noticeable patch in the right example by using a feathered selection when I copied the patch pixels.

Figure 11-10:
An unfeath-
ered patch
is obvious
(left), but a
feathered
patch
blends
seamlessly
with the
original
image
(right).

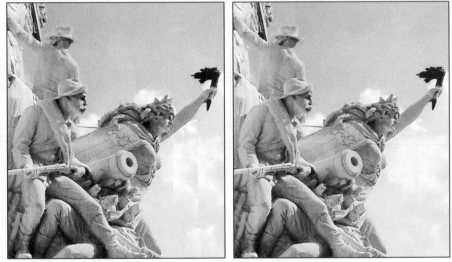

To create and apply a feathered patch, follow these steps:

1. **Locate a "good" area of the image that you can use as a patch.**

2. **Create a feathered selection outline around the patch pixels.**

 How you produce a feathered outline depends on your software. In many photo editors, you can set your selection tools to draw feathered

selections. In Elements, use the Feather control that appears on the Options bar when a selection tool is active. Enter a higher value for fuzzier selection borders, a lower value for less fuzzy borders.

You may also be able to feather an outline after drawing it. In Elements, choose Select⇨Feather to display the dialog box shown in Figure 11-11. Enter the feathering amount in the Feather Radius box and then click OK or press Enter.

Figure 11-11:
Raise the
Feather
Radius
value to
create a
selection
outline
with softer
edges.

Feather Selection ☒

Feather Radius: |15 pixels OK

Cancel

The amount of feathering you need depends on the area surrounding the flaw you want to cover. If the neighboring pixels are in soft focus, you need a patch with very feathery edges. To apply a patch in a sharply focused, highly detailed area, use just a little feathering. Otherwise, the edges of the patch will be detectable because they will appear slightly blurry.

 3. **Choose Edit⇨Copy to copy the selected patch pixels to the Clipboard.**

 4. **Choose Edit⇨Paste to paste the patch into the photo.**

 5. **Position the patch over the flaw, adjusting the patch as necessary for a seamless fit.**

See the earlier section "Selection Moves, Copies, and Pastes" for more details about the Copy and Paste commands as well as information about adjusting a pasted object.

Cloning without DNA

Now that humankind has successfully figured out how to clone sheep — like sheep needed our help to replicate themselves — it should come as no surprise to you that you can easily clone pixels in your image.

With the Clone tool, provided in many consumer-level image editors and all advanced programs, you can "paint" pixels from one picture onto another, as

shown in Figure 11-12. But I usually use the Clone tool to duplicate pixels within the same picture in order to cover up small blemishes, such as the blown highlights at the top of the lemon in Color Plate 11-3.

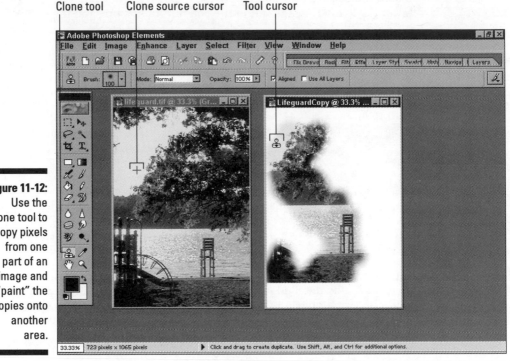

Figure 11-12:
Use the Clone tool to copy pixels from one part of an image and "paint" the copies onto another area.

The Clone tool has no real-life counterpart — in the photography and art world, that is — so you need to practice with the tool for a bit to fully understand how it works. But I guarantee that after you get acquainted with this tool, you'll use it all the time.

Depending on your program, the Clone tool may go by another name. In Photoshop, for example, the tool used to be known as the Rubber Stamp, which is why the tool cursor still looks like a rubber stamp in both Photoshop and Elements. In recent versions of Photoshop, the tool name was changed to Clone Stamp, which is the official name in Elements as well. For the sake of brevity, I'm just going to call it the Clone tool.

Regardless of what you call it, you use the same basic approach to clone in most programs:

1. **First, activate your Clone tool.**

 In Elements, click the tool icon in the toolbox, labeled in Figure 11-12.

2. **Establish the *clone source*.**

 The *clone source* refers to the area of your picture that you want to clone — the source of the cloned pixels, in other words. This step sets the initial clone source. The process for setting the clone source varies from program to program.

 In Elements, Alt+click (Option+click on a Mac) to set the clone source.

3. **Click on or drag over the flaw that you want to cover.**

 The program copies pixels from the clone source onto the pixels underneath your tool cursor.

 If you drag to clone, the position of the clone source moves in tandem with the tool cursor. For example, if you drag down and to the left, you clone pixels that fall below and to the left of the initial clone source.

In Elements, a clone source cursor appears when you begin to clone. (I labeled this cursor in Figure 11-12.) You can look at the clone source cursor to see which pixels the program is about to clone.

You can adjust the performance of the Elements Clone tool by using the Options bar controls shown in the figure. The following list describes these options, which are similar to those provided for Clone tools in other advanced photo-editing programs.

- ✔ **Brush:** You can specify the size, shape, and softness of the tool brush by using the Brush controls on the Options bar. In Figure 11-12, I used a soft-edged brush, which results in soft-edged cloning strokes. For a crisper edge, choose a harder brush. The size of your brush determines how many pixels will be cloned onto the flawed pixels with each click or drag.

- ✔ **Mode:** This option controls how the cloned pixels blend with the original pixels. In Normal mode, the cloned pixels completely obscure the underlying pixels, which is usually the goal when you're doing touch-up work. You can create a variety of different effects by playing with the other blending modes. (Chapter 12 touches on blending modes a little more.)

- ✔ **Opacity:** You can vary the opacity of the pixels you clone by using this control. I often use 60 or 70 percent opacity when using the Clone tool to blend cloned pixels with the original more naturally. But if you want your cloned pixels to completely cover the original pixels, set the value to 100 percent.

- ✔ **Aligned:** This control determines whether the clone source reverts to its original position — the spot you clicked to establish the clone source — each time you click or drag with the tool. When the option is turned off, the clone source cursor does return to the original position. With your next click or drag, you clone the same pixels again.

If you turn the Aligned check box on, the clone source cursor stays put, however. So on your next click or drag, you just continue cloning from where you left off. This option prevents you from cloning the same pixels more than once. If you do want to clone from the same source again, you must reset the clone source (by Alt+clicking or Option+ clicking).

✔ **Use All Layers:** If you're working on a photo that has multiple image layers, a feature described in Chapter 12, select this check box if you want the Clone tool to be able to "see" pixels on all layers. When the check box is turned off, the tool can clone only pixels on the active layer. So if you're working on Layer 2, for example, you can't clone pixels from Layer 1.

The Clone tool is the perfect answer for eliminating red-eye problems. Usually, the red glint doesn't cover the entire eye. So you can clone some of the unaffected pixels over the red ones. Be sure not to cover over any white highlights in the eye — leave those intact for a natural look. If you don't have *any* good eye pixels to use as your clone source, you can select the red pixels and then fill them with eye-colored paint using one of the painting tools discussed in Chapter 12.

Hey Vincent, Get a Larger Canvas!

When you cut and paste pictures together, you may need to increase the size of the image *canvas*. The canvas is nothing more than an invisible backdrop that holds all the pixels in your image.

Suppose that you have two images that you want to join, placing them side by side. Perhaps image A is a picture of your boss, and image B is a picture of the boss's boss. You open image A, increase the canvas area along one side of the image, and then copy and paste image B into the empty canvas area.

How you adjust the canvas varies from program to program. Look for information about canvas size, image background, or picture size in your software's Help system. Just make sure that you're changing the dimensions of the canvas and not the image itself. (See Chapter 2 for more information on changing image size.)

To adjust the canvas size in Elements, choose Image⇨Resize⇨Canvas Size command to open the Canvas Size dialog box, shown in Figure 11-13. Enter the new canvas dimensions into the Width and Height option boxes. Next, use the little grid at the bottom of the dialog box to specify where you want to position the existing image on the new canvas. For example, if you want the extra canvas area to be added equally around the entire image, click in the center square.

Figure 11-13:
To enlarge
the picture
canvas in
Elements,
head for this
dialog box.

To trim away excess canvas, reduce the Width and Height values. Again, click in the grid to specify where you want the image to be located with respect to the new canvas. Note that you can also use the Crop tool to cut away excess canvas; see Chapter 10 for information. But using the Canvas Size command is a better option if you want to trim the canvas by a precise amount — a quarter-inch on all four sides, for example.

In Elements 2.0, the Canvas Size dialog box contains a Relative option. If you select the option, you can then enter the amount of canvas that you want to add or trim in the Width and Height boxes. For example, to add an inch to all four sides of the canvas, set the Width and Height values to 2 inches and then click the center anchor square.

Chapter 12

Amazing Stuff Even You Can Do

● ●

In This Chapter

▶ Painting on your digital photos

▶ Choosing your paint colors

▶ Filling a selected area with color

▶ Replacing one color with another

▶ Spinning the Hue wheel

▶ Using layers for added flexibility and safety

▶ Erasing your way back to a transparent state

▶ Applying special-effects filters

● ●

*F*lip through any popular magazine, and you can see page after page of impressive digital art. A review of hot new computers features a photo in which lightning bolts are superimposed over a souped-up system. A car ad shows a sky that's hot pink instead of boring old blue. A laundry detergent promotion has a backdrop that looks as though Van Gogh himself painted it. No longer can graphic designers get away with straightforward portraits and product shots — if you want to catch the fickle eye of today's consumer, you need something with a bit more spice.

Although some techniques used to create this kind of photographic art require high-end professional tools — not to mention plenty of time and training — many effects are surprisingly easy to create, even with basic photo software. This chapter gets you started on your creative journey by showing you a few simple tricks that can send your photographs into a whole new dimension. Use these ideas to make your marketing images more noticeable or just to have some fun exploring your creative side.

Give Your Image a Paint Job

Remember when you were in kindergarten and the teacher announced that it was time for finger painting? In a world that normally admonished you to be

neat and clean, someone actually *encouraged* you to drag your hands through wet paint and make a colorful mess of yourself.

Photo-editing programs bring back the bliss of youth by enabling you to paint on your digital photographs. The process isn't nearly as messy as those childhood finger-painting sessions, but it's every bit as entertaining.

To paint in a photo editor, you can drag with your mouse or other pointing device to create strokes that mimic those produced by traditional art tools, such as a paintbrush, pencil, or airbrush. Or you can dump color over a large area by selecting the area and then choosing the Fill command, which paints all selected pixels in one step.

Why would you want to paint on your photographs? Here are a few reasons that come to mind:

- ✔ You can change the color of a particular object in your photo. Say that you shoot a picture of a green leaf to use as artwork on your Web site. You decide that you'd also like to have a red leaf and a yellow leaf, but you don't have time to wait for autumn to roll around so that you can photograph fall-colored leaves. You can use your photo software to make two copies of the green leaf and then paint one copy red and the other yellow.

- ✔ You can hide minor flaws. Is a small blown highlight ruining an otherwise good photo? Set your paint tool to a color matching the surrounding pixels, and dab the spot away.

 Paint tools also offer a way to get rid of red-eye — the demonic glint caused when a camera flash reflects in the subject's eyes. Choose a color close to the natural eye color, and paint over the red pixels.

- ✔ Aside from practical purposes, paint tools enable you to express your creativity. If you enjoy painting or drawing with traditional art tools, you'll be blown away by the possibilities presented by digital painting tools. You can blend photography and hand-painted artwork to create awesome images. I wish that I could show you some of my own artwork as an example of what I mean, but unfortunately I am absolutely talentless in this area, as evidenced by Figure 12-1. So I think it's better to send you to your local bookstore or library, where you can find all the creative inspiration and guidance you need in the many available volumes on digital painting.

- ✔ And of course, painting tools provide you with one more way to adulterate photos of friends and family. Okay, you've probably already discovered this one on your own. Admit it, now — the first thing you tried in your photo software was painting a mustache on someone's picture, wasn't it?

Figure 12-1:
A painted
sun shines
on a lake-
side vista.

Now that you know why you might want to pick up a paint tool, the following sections give you an introduction to some of the more common painting options. Put on your smock, grab a glass of milk and some graham crackers, and have a blast.

What's in your paint box?

Different photo editors offer different assortments of painting tools. Programs such as Corel Painter, which are geared toward photo artistry and digital painting, provide an almost unlimited supply of painting tools and effects. You can paint with brushes that mimic the look of chalk, watercolors, pastels, and even liquid metal. Figure 12-2 provides a sampling of different paint strokes you can create in this program.

If you're skilled at drawing or painting, you can express endless creative notions using this kind of program. You may also want to invest in a digital drawing tablet, which enables you to paint with a pen-like stylus, which most people find easier than using a mouse. (Be sure that the software you choose supports this function if you take the leap.) See Chapter 4 for a look at a drawing tablet if you're unfamiliar with this device.

Figure 12-2:
Corel
Painter
and other
programs
marketed
toward
photo
artisans
enable you
to create a
broad range
of brush
stroke
effects.

Keep in mind that programs that emphasize painting tools sometimes don't offer as many image-correction or retouching options as programs such as Adobe Photoshop and Photoshop Elements, which concentrate on those functions rather than painting. On the other hand, programs that focus on retouching and correction usually don't offer a wide range of painting tools. Elements, for example, provides just a handful of painting tools.

Still, you can accomplish quite a bit even with a few basic painting tools. The following sections provide a brief introduction to the major Elements painting tools, which are similar to those found in most comparable programs.

Paintbrush, Airbrush, and Pencil

Your photo software likely provides at least three painting tools:

- **Paintbrush:** This tool typically can paint hard-edged strokes, like a ballpoint pen, or soft-edged strokes, like those painted with a traditional paintbrush.
- **Pencil:** A Pencil tool is usually limited to drawing hard-edged strokes.
- **Airbrush:** Digital airbrush tools create effects similar to what you can produce with a real-life airbrush. If you're never worked with one of those, imagine painting with spray paint.

To activate any of these tools in Elements 1.0, click its toolbox icon. Figure 12-3 provides a guide to the Elements 1.0 toolbox. In Elements 2.0, the Paintbrush goes by the name Brush tool, and it and the Pencil are located side by side in the toolbox. In addition, the Airbrush no longer has an official toolbox icon. Instead, you access the Airbrush capabilities via an Airbrush button that is available on the Options bar whenever the Brush tool is active.

Airbrush Paintbrush Pencil Options bar

Figure 12-3: Got red-eye? Use your software's paint brush to paint the correct eye color over the red areas.

In either version of the program, you just drag across your image to lay down a paint stroke. Or click to put down a single spot of color. When you work with the Airbrush, the tool pumps out more and more paint the longer you hold down the mouse button, even if you're not moving the mouse.

To paint a perfect horizontal or vertical stroke, press Shift as you drag. You can also paint a straight line by clicking at the spot where you want the line to begin and then Shift+clicking at the point where you want the line to end.

In Elements, as in most photo editors, you can adjust the following characteristics of the strokes that the paint tools produce:

✔ **Paint color:** See the upcoming section "Pick a color, any color!" for information about this one.

✔ **Stroke size, softness, and shape:** You adjust these aspects of your paint strokes by choosing a different tool brush. In addition to changing the thickness and type of stroke edge — crisp or fuzzy — you can change the shape of the brush. You can paint with a square brush, for example, or even a brush that mimics calligraphic pen strokes.

✔ **Paint opacity:** You can make your paint strokes fully opaque, so that they completely obscure the pixels you paint over, or reduce the opacity so that some of the underlying image shows through the paint. Figure 12-4 shows examples of different opacity settings. I painted inside each of the letters with white but varied the opacity for each letter.

Figure 12-4:
Change
the paint
opacity
to create
different
effects.

✔ **Blending Mode:** A *blending mode* control enables you to mix your painted strokes with the underlying pixels in different ways. The upcoming section "Pouring color into a selection" introduces you to a few blending modes.

For touch-up painting, the two most useful modes are Normal and Color. Use Normal when you want the painted pixels to cover the original pixels completely (assuming that the paint opacity is 100 percent). Color enables you to change the color of an object realistically. The program

applies the new color to the pixels but uses the original brightness values. In other words, you retain the original highlights and shadows in the painted area. Try this mode when painting away red-eye pixels, as I'm doing in Figure 12-3.

In Elements, you make all these tool adjustments via controls on the Options bar, shown in Figure 12-3. Note that the Elements 1.0 and 2.0 Brush palettes are significantly different from each other, and both offer a wealth of options, so I'm going to point you to your program manual for details.

For greater painting flexibility, always paint on a new, independent image layer, as I'm doing in Figure 12-3. That way, you can further adjust painted strokes after you create them by varying the opacity and blending mode of the layer itself. In addition, if you decide you don't like your painted pixels, you can get rid of them by simply deleting the layer. Read the section "Uncovering Layers of Possibility," later in this chapter, for the full story on layers.

Smudge tool

This tool, found in many photo editors, isn't so much a painting tool as a paint-smearing tool. It produces an effect similar to what you get when you drag your finger through a wet oil painting. When you drag with the Smudge tool, it takes whatever color is underneath your cursor at the beginning of your drag and smears it over the pixels you touch over the course of your drag.

To get an idea of the kind of effects you can create with the Smudge tool, see Figure 12-5. I used the tool to give my antique pottery toucan a new 'do. Who says a toucan can't have a little fun, after all? To create the effect, I just dragged upward from the crown of the bird.

Figure 12-5: I used the Smudge tool to give my toucan a change of hairstyle.

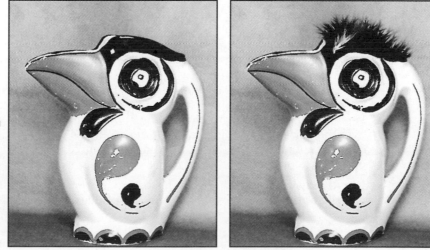

In Elements, you can adjust the Smudge tool brush and blending mode as you can for the painting tools, discussed in the preceding section. Also take note of these other controls on the Options bar:

- ✔ **Finger Painting:** Be sure that this check box is deselected, as shown in Figure 12-6, for standard smudging. When the option is selected, the Smudge tool smears the current foreground paint color over your image instead of the color that's under your cursor at the start of your drag. (See the next section to find out more about the foreground paint color.)

Smudge tool

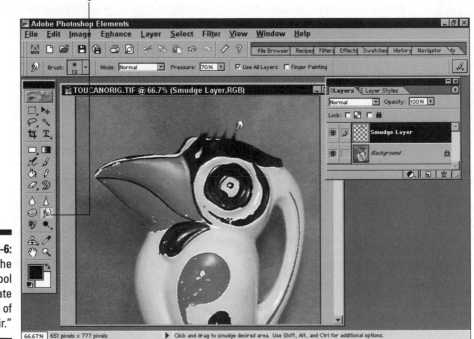

Figure 12-6: Use the Smudge tool to create wisps of "hair."

- ✔ **Pressure or Strength:** You also can adjust the impact of the Smudge tool by using the Pressure control in Elements 1.0 and the Strength control in Version 2.0. At full strength, the Smudge tool smears the initial color over the full length of your drag. At lower strengths, color isn't smeared over the entire distance. I used a setting of about 70 percent when working on my toucan.

- ✔ **Use All Layers:** When you select this option, the Smudge tool smears colors from every visible image layer. This enables you to do your

smudging on a layer separate from the rest of the photo, as shown in Figure 12-6. (See the section "Uncovering Layers of Possibility," later in this chapter, for more information about working with image layers.)

Just in case you want to try your own hand at creating hairstyles for inanimate objects, the toucan image is included on the CD in the back of this book. The filename is Toucan.jpg.

Pick a color, any color!

Before you lay down a coat of paint, you need to choose the paint color. In most photo editors, two paint cans are available at any one time:

- ✔ **Foreground color:** Usually, the major painting tools apply the foreground color. In Elements, that includes the Paintbrush, Pencil, and Airbrush.

- ✔ **Background color:** The background color typically comes into play when you use certain special-effects filters that involve two colors. But in Elements, as in Photoshop, the Eraser tool also applies the background color if you're working on the background layer of the photo. ("Uncovering Layers of Possibility," later in this chapter, provides details.) In addition, when you delete a selected area on the background layer, the resulting hole is filled with the background color.

Check your software's online help system to figure out which tools paint in which color — or just experiment by painting with each tool.

Like many other aspects of photo editing, the process of choosing the foreground and background colors is similar no matter what program you're using. Some programs provide a special color palette in which you click the color you want to use. Some programs rely on the Windows or Macintosh system color pickers, while other programs, including Elements, provide you with a choice between the program color picker and the system color picker.

The next three sections explain how to choose a color using the Elements color picker, the Windows system color picker, and the Macintosh color picker. After you read about these color pickers, you should have no trouble figuring out how to select colors in just about any program.

Choosing colors in Photoshop Elements

In Elements, the bottom section of the toolbox contains five important color controls, labeled in Figure 12-7. The controls work as follows:

Figure 12-7:
Click the
Default
Colors icon
to quickly
restore
black and
white as
the fore-
ground and
background
colors.

✔ The two large color swatches show you the current foreground and background colors.

✔ Click the Default Colors icon to re-establish the default foreground and background colors, which are black and white, respectively.

✔ Click the Swap Colors icon to make the foreground color the background color, and vice versa.

To use a foreground or background color other than black or white, you can use three color-picking features:

✔ **Swatches palette:** Display the Swatches palette, shown in Figure 12-8, by choosing Window⇨Show Swatches in Elements 1.0 and Window⇨ Color Swatches in Elements 2.0. Then click a color swatch to set the foreground color.

To set the background color in Elements 1.0, Alt+click a swatch on a Windows-based PC; on a Mac, Option+click. In Elements 2.0, Ctrl+click or ⌘+click instead.

Figure 12-8:
The
Swatches
palette
offers quick
access to
standard
colors.

TIP

➤ **Eyedropper:** Grab the Eyedropper tool, labeled in Figure 12-7, and click a pixel in the image window to lift a color from your picture and make it the foreground color. Using this technique, you can easily match the paint color to a color in your photo.

To set the background color using the Eyedropper, Alt+click on a Windows-based PC and Option+click on a Mac.

By default, the tool exactly matches the single pixel that you click. If you want to blend a color that's a mix of a larger group of pixels, set the Sample Size control on the Options bar to 3 by 3 Average or 5 by 5 Average.

➤ **Color Picker:** Click the foreground or background color swatch in the toolbox, depending on which color you want to change. By default, the program then displays the Elements Color Picker, shown in Figure 12-9. If you get your operating system (Windows or Apple) color picker instead, choose Edit⇨Preferences⇨General to open the Preference dialog box. Then set the Color Picker option to Adobe.

Color field Color slider Current color New color

Figure 12-9: To blend a custom paint color, use the Elements Color Picker.

Inside the Color Picker, you can select colors using the HSB color model or the RGB color model, both explained in Chapter 2. For most people, the HSB model is most intuitive. Click the H button to set up the dialog box controls as shown in Figure 12-9 (again, this is the setup that most people find easiest). Then click in the color field and drag the color slider to adjust the color. The New Color swatch shows you the color

that you're making. When the color is just right, click OK or press Enter to close the dialog box.

If you know the exact RGB or HSB values for the color you want to use, you can just enter them into the corresponding boxes instead of using the color field and slider.

As with other Elements information given in this book, I've provided just the basics of using the Swatches palette and Color Picker. Both offer additional features that can come in handy for some editing projects, so I urge you to explore them.

Using the Windows color picker

Many Windows-based photo-editing programs enable you to choose colors using the Windows Color dialog box, shown in Figure 12-10.

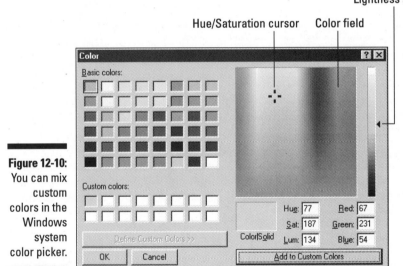

Figure 12-10: You can mix custom colors in the Windows system color picker.

The following list explains how to use the dialog box controls.

✔ To choose one of the colors in the Basic Colors area, click its swatch.

✔ To access more colors, click the Define Custom Colors button at the bottom of the dialog box. Clicking the button displays the right half of the dialog box, as shown in Figure 12-10. (This button is grayed out in the figure because I already clicked it.)

✔ Drag the crosshair cursor in the color field to choose the hue and saturation (intensity) of the color, and drag the Lightness slider, to the right of the color field, to adjust the amount of black and white in the color.

✔ As you drag the cursor or the slider, the values in the Hue, Sat, and Lum boxes change to reflect the hue, saturation, and luminosity (brightness) of the color. The Red, Green, and Blue option boxes reflect the amount of red, green, and blue light in the color, according to the RGB color model. (See Chapter 2 for more about color models.)

✔ After you produce a color you like, you can add the color to the Custom Colors palette on the left side of the dialog box by clicking the Add to Custom Colors button. The palette can hold up to 16 custom colors. To use one of the custom colors on your next trip to the dialog box, click the color's swatch.

✔ To replace one of the Custom Colors swatches with another color, click that swatch before clicking the Add to Custom Colors button. If all 16 swatches are already full, Windows replaces the selected swatch (the one that's surrounded by a heavy black outline). Click a different swatch to replace that swatch instead.

✔ The Color/Solid swatch beneath the color field previews the color. Technically, the swatch displays two versions of your color — the left side shows the color as you've defined it, and the right side shows the nearest solid color. See, a monitor can display only so many solid colors. The rest it creates by combining the available solid colors — a process known as *dithering*. Dithered colors have a patterned look to them and don't look as sharp on-screen as solid colors.

How many solid colors are available to you depends on the settings of your system's video card. Today, most people set their systems to display at least 32,000 colors, also known as 16-bit color. But people working on older computers may be limited to as few as 256 colors. For this reason, many Web designers limit their image color palettes to 256 solid colors or fewer.

If you're creating Web images and want to stick with solid colors, set your monitor to display a maximum of 256 colors before heading to the Color dialog box. Otherwise, you won't see any difference between the two sides of the Color/Solid swatch. After defining a color, click the right side of the swatch to select the nearest solid color.

After you choose your color, click OK to leave the dialog box.

Using the Apple color picker

If you're working on a Macintosh computer, your photo software may enable you — or require you — to select colors using the Apple color picker, shown in Figure 12-11.

Color wheel

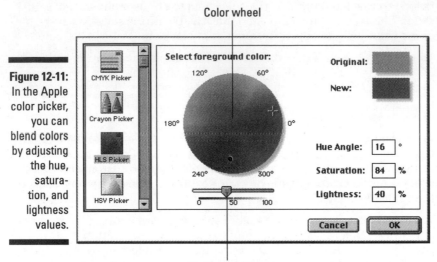

Figure 12-11:
In the Apple
color picker,
you can
blend colors
by adjusting
the hue,
satura-
tion, and
lightness
values.

Lightness slider

The color picker design varies slightly with different versions of the Mac
operating system — the one shown in the figure is from Mac OS 9.1. But the
basics remain the same. At the very least, the color picker enables you to
select a color using either the Apple HSL color model, which sometimes goes
by the alternative name HLS, or the Apple RGB color model.

Apple HSL (Hue, Saturation, and Lightness) is a variation of the standard HSB
(Hue, Saturation, and Brightness) color model. See Chapter 2 for background
information on color models.

Use whichever color model suits your fancy — click the icons on the left side
of the dialog box to switch between the color models. In HSL mode, drag the
crosshair in the color wheel to set the hue (color) and saturation (intensity)
of the color, as shown in the figure. Drag the lightness slider bar to adjust
the lightness of the color. In RGB mode, drag the R, G, and B color sliders to
select your color or enter values in the Red, Green, and Blue option boxes.

Whichever color model you use, the Original and New boxes at the top of
the dialog box represent the current foreground or background color and the
new color you're mixing, respectively. When you're satisfied with your color,
press Return or click OK.

Pouring color into a selection

Brushing paint over a large area can be tedious, which is why most photo-
editing programs provide a menu command that fills an entire selected area

with color. (For information on how to select a portion of a photo, see Chapter 11.) Most programs call this command the Fill command.

I used the Fill command to fill the apple in the upper-left corner of Color Plate 12-1 with purple. You see the results of a normal fill job in the upper-right corner of the color plate. The look is entirely unnatural because a normal fill pours solid color throughout your selection, obliterating the shadows and highlights of the original photograph.

To enable you to create more natural-looking fills, many programs offer a choice of *blending modes*, which you can use to combine the fill pixels with the original pixels in slightly different ways. I filled the apple in the lower-left corner of Color Plate 12-1 using the Color blend mode, which is available in most programs that offer blending modes. Color applies the fill color while retaining the shadows and highlights of the underlying image. Now that's a purple apple you can sink your teeth into.

Programs that provide blending modes tend to offer the same assortment of modes. I could provide you with an in-depth description of how different blend modes work, but frankly, predicting how a blending mode will affect an image is difficult even if you have this background knowledge. So just play around with the available modes until you get an effect you like.

Your software may also offer two other fill options: You may be able to vary the opacity of the fill so that some of the underlying image pixels show through even with the Normal blending mode. And you may be able to fill the selection with a pattern instead of a solid color. This last option is especially useful for creating backgrounds for collages.

Elements offers all three fill options in its Fill dialog box, shown in Figure 12-12. To open the dialog box, choose Edit➪Fill. Note that if you want to fill the entire active image layer, you do not need to create a selection outline first.

Figure 12-12:
Use the Fill command to dump color into a large area of your photo.

Here's what you need to know about the dialog box options not yet covered:

- ✔ **Use:** This control determines what the program uses to fill your selected area. If you want a solid color fill, set the foreground or background color to the fill color you want before opening the dialog box. Then select Foreground Color or Background Color from the Use drop-down list.

- ✔ **Preserve Transparency:** If the area you're trying to fill contains transparent pixels, selecting the Preserve Transparency check box prevents the program from adding color to those pixels. This option typically only comes into play in a multilayered image.

If you're good at remembering keyboard shortcuts, you can bypass the Fill dialog box altogether. Just press Alt+Backspace (or Option+Delete on a Macintosh) to fill the area with the foreground color. Press Ctrl+Backspace (or ⌘+Backspace) to fill the area with the background color.

Using a Fill tool

I'm about to show you yet one more way to fill a portion of your image with color. But before I do, I want to say that I don't recommend using this method. I bring it up here only because many programs offer this option, and new users invariably gravitate toward it.

The feature in question is a special tool that is a combination of a selection tool and a Fill command. Elements calls the tool the Paint Bucket; the tool's icon in the toolbox looks like a paint bucket, as does the tool cursor. (You can see the cursor in Figure 12-13.) In other programs, this tool is often called the Fill tool, but it usually works quite differently from the Fill command covered in the preceding section.

When you click in your image with the tool, the program selects an area of the image as though you had clicked with the Magic Wand (or whatever the color selection tool is called in your software). If you click a red pixel, for example, red pixels are selected. Then the selected area is filled with the foreground color.

So what's my problem with this tool? The results are too unpredictable. You can't tell in advance how much of your image will be filled. As an example, see Figure 12-13. The paint-bucket cursor indicates the spot I clicked; the white area is the resulting fill. Had I clicked just a few pixels to the left or right, a totally different region of the apple would have been painted white. For more accurate results, select the area you want to fill manually, using the selection tools described in Chapter 11. Then use your regular Fill command or a painting tool to color the selection.

Paint-bucket cursor

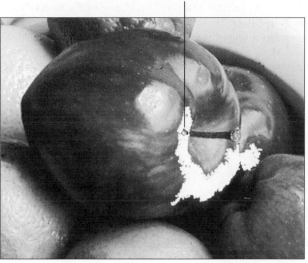

Figure 12-13: Clicking with the Paint Bucket fills similarly colored pixels with the fore- ground color (white, in this case).

I can see that you're the skeptical sort and want to try out the fill tool yourself. Here's how to do it in Elements: First, set the tool options via the Options bar. The controls are a blend of those available in the Fill dialog box, discussed in the preceding section, and for the Magic Wand, covered in Chapter 11. After setting the options, click the area you want to fill.

Didn't work very well? Try adjusting the sensitivity of the tool by changing the Tolerance value, as you do with the Magic Wand. If you use a low Tolerance value, pixels must be closer in color to the pixel you click in order to be selected and filled. In Figure 12-13, I clicked at the position of the paint-bucket cursor with the fill color set to white, the Tolerance value set to 32, and the opacity set to 100 percent. I also had the Contiguous option selected, so only pixels adjacent to the one I clicked were selected.

You can keep playing around with these options all day until you arrive at the right settings if you want. But if I were you, I'd ignore this tool altogether and use one of the other methods for swapping colors described in this chapter.

Spinning Pixels around the Color Wheel

Another way to play with the colors in your image is to use the Hue filter, if your photo editor provides one.

This filter takes the selected pixels on a ride around the color wheel, which is nothing more than a circular graph of available hues. Red is located at the 0-degree position on the circle, green at 120 degrees, and blue at 240 degrees. When you change the hue value, you send pixels so many degrees around the wheel. If you start with green, for example, and raise the hue value 120 degrees, your pixel becomes blue. Green is located at 120 degrees, so adding 120 degrees takes you to 240 degrees, which is where blue is located.

To change the apple color in the bottom-right image in Color Plate 12-1, I selected the apple and then lowered the hue value by 83 degrees, using the Elements Hue/Saturation filter. (Choose Enhance⇨Color⇨Hue/Saturation in Elements 1.0 and Enhance⇨Adjust Color⇨Hue/Saturation in Elements 2.0.) You can see the filter dialog box in Figure 12-14.

Figure 12-14:
Drag the
Hue slider to
spin pixels
round the
color wheel.

At first glance, the results look similar to what I got by applying the Fill command with the Color blend mode. But with the Color mode, all pixels are filled with the same hue — in the apple, for example, you get lighter and darker shades of purple, but the basic color is purple throughout. The Hue filter shifted the red apple pixels to purple but shifted the yellowish-green areas near the center of the fruit to light pink.

The Colorize check box in the Hue/Saturation dialog box offers yet another way to change the color of selected objects. If you select the option, the program dumps the current foreground color over your photo but retains the original shadows and highlights, just like the Color blending mode discussed elsewhere in this chapter. By dragging the Hue slider, you can adjust the fill color.

Uncovering Layers of Possibility

Photoshop Elements, Photoshop, and many other photo-editing programs provide an extremely useful feature called *layers.* Layers sometimes go by

other names, such as Objects, Sprites, or Lenses. But whatever the name, this feature is key to creating many artistic effects and is also extremely helpful for ordinary retouching work.

To understand how layers work, think of those clear sheets of acetate used to create transparencies for overhead projectors. Suppose that on the first sheet, you paint a birdhouse. On the next sheet, you draw a bird. And on the third sheet, you add some blue sky and some green grass. If you stack the sheets on top of each other, the bird, birdhouse, and scenic background appear as though they are all part of the same picture.

Layers work just like that. You place different elements of your image on different layers, and when you stack all the layers on top of each other, you see the *composite image* — the elements of all the layers merged together. Where one layer is empty, pixels from the underlying layer show through.

You gain several image-editing advantages from layers:

✔ You can shuffle the *stacking order* of layers to create different pictures from the same layers, as shown in Figure 12-15. (Stacking order is just a fancy way of referring to the arrangement of layers in your image.)

Figure 12-15: What appears to be a peaceful, lily-in-a-pond scene (left) becomes far more sinister when the order of the top and middle image layers is reversed (right).

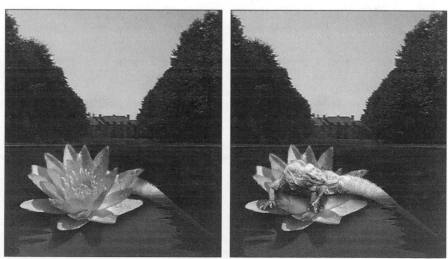

Both images contain three layers: one for the pond and trees, one for the lily, and one for a prehistoric-looking creature that I probably should be able to name but can't. The pond-and-trees scene occupies the bottom

layer in both pictures. In the left image, I put the reptilian thing on the second layer and placed the lily on the top layer. Because the lily obscures most of the reptile layer, the picture appears to show nothing more menacing than a giant, mutant lily. Reversing the order of the top two layers reveals that what appeared to be the stem of the lily actually is the tail of a science experiment gone wrong.

To make the end of the tail appear to be immersed in the water, I dragged across the tail with my photo-editor's Eraser tool set to 50-percent opacity. You can read more about this technique in "Editing a multilayered image," later in this chapter. I also painted subtle shadows, using a soft brush and a low opacity setting, under both the scaly thing and the lily to make the scene appear a bit more realistic.

✔ Layers also make experimenting easier. You can edit objects on one layer of your image without affecting the pixels on the other layers one whit. So you can apply the paint tools, retouching tools, and even image-correction tools to just one layer, leaving the rest of the image untouched. You can even delete an entire layer without repercussions.

Suppose that you decide you want to get rid of the lily in Figure 12-15 so that the scaly monster appears to walk on water. If the lily, reptile, and background all existed on the same layer, deleting the lily would leave a flower-shaped hole in the image. But because the three elements are on separate layers, you can simply delete the lily layer. In place of the jettisoned flower petals, the water from the background layer appears.

✔ Layers simplify the process of creating photo collages, too. By placing each element in the collage on a different layer, you can play around with the positioning of each element to your heart's content.

As an example, see Color Plates 12-2 and 12-3. To create Color Plate 12-3, I copied the subjects of the top seven images in Color Plate 12-2 and pasted them into the bottom, brick image. I put each subject on its own layer, stacking the layers in the same order as they are shown in Color Plate 12-2.

If I pasted all seven images into one layer, I would have to get the placement of each element right on the first try. Why? Because moving an element after it's been pasted leaves a hole in your image, just as deleting an element does. But you can move individual layers around without harming the image. You just drag them back and forth, this way and that, until you arrive at a composition you like.

✔ You can vary the opacity of layers to create different effects. Figure 12-16 shows an example. Both images contain two layers: The rose is on the top layer, while the faded wood occupies the bottom layer. In the left image, I set the opacity of both layers to 100 percent. In the right image, I lowered the opacity of the rose layer to 50 percent so that the wood image is partially visible through the rose. The result is a ghostly rose that almost looks like part of the wood.

Figure 12-16:
At left, the rose layer rests atop the wood layer at 100 percent opacity. At right, I set the rose layer opacity to 50 percent, turning the rose into a ghost of its former self.

✔ You can vary how the colors in one layer merge with those in the underlying layers by applying different blending modes. Layer blending modes determine how the pixels in two layers are mixed together, just like the fill and paint blending modes discussed earlier in this chapter. In Color Plate 12-1, I used two different blending modes, Normal and Color, to create two different fill effects (see the top-right and bottom-left images). These same blending modes, as well as many others, are usually available for blending layers. Some blending modes create wacky, unearthly color combinations, perfect for eye-catching special effects, while others, like Color, are useful for changing image colors with natural-looking results.

✔ In some programs, you can apply an assortment of automatic layer effects. Elements, for example, provides an effect that adds a drop shadow to the layer. If you move the layer, the shadow moves with it. (To explore the effects, open the Layer Styles palette by choosing Window⇨Show Layer Styles.)

Not all photo-editing programs provide all these layer options, and some entry-level programs don't provide layers at all. But if your program offers layers, I urge you to spend some time getting acquainted with this feature. I promise that you will never go back to unlayered editing after you do.

Layers do have one drawback, however: Each layer increases the file size of your image and forces your computer to expend more memory to process the image. So after you're happy with your image, you should smash all the layers together to reduce the file size — a process known as *flattening* or *merging*, in image-editing parlance.

After you merge layers, though, you can no longer manipulate or edit the individual layer elements without affecting the rest of the image. So if you think you may want to play around with the image more in the future, save a copy in a file format that supports layers. Check your software's help system for specifics on flattening and preserving layers.

If you want some more specifics on using layers, the next sections provide some basics about layer functions in Elements and explain the process I used to create the collage in Color Plate 12-3.

Although the steps for taking advantage of layer functions vary from program to program, the available features tend to be similar no matter what the program. So reading through the instructions I give for Elements should give you a head start on understanding your program's layering tools.

Working with Elements layers

To view, arrange, and otherwise manipulate image layers in Photoshop Elements, you need to display the Layers palette, shown in Figure 12-17. To open the palette, click its tab in the palette well or choose View➪Show Layers.

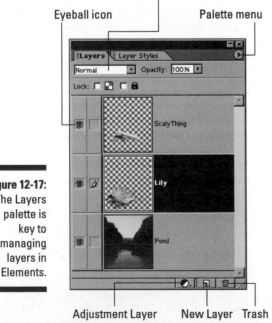

Blending Mode menu

Eyeball icon Palette menu

Figure 12-17:
The Layers
palette is
key to
managing
layers in
Elements.

Adjustment Layer New Layer Trash

Here's a quick tour of the Layers palette:

✔ Each layer in the image is listed in the palette. To the left of the layer name is a thumbnail view of the layer contents.

By default, transparent areas appear as a checkerboard pattern, as shown in the figure. If you want to change that display, choose Edit➪Preferences➪Transparency to open the Transparency panel of the Preferences dialog box, where the transparency options are housed.

✔ Only one layer at a time is *active* — that is, available for editing. The active layer is highlighted in the Layers palette. To make a different layer active, click its name in the palette.

✔ The eyeball icon indicates whether the layer is visible in the image. Click the icon to hide the eyeball and the layer. Click in the now-empty eyeball column to redisplay the layer.

✔ Click the right-pointing arrow at the top of the palette to open the Layers palette menu, which contains layer-management commands. (In Elements 2.0, the arrow is on a button labeled *More.*) Most commands found on the palette menu also appear on the Layer menu at the top of the program window.

✔ You can choose two of the most-frequently used commands, New Layer and Delete Layer, by clicking the New Layer and Trash buttons at the bottom of the palette. For more on adding and deleting layers, pass your peepers over the next section.

✔ Click the Adjustment Layer button to create a special type of layer that enables you to apply color and exposure changes without permanently altering the original image. See Chapter 10 for more information.

✔ The Blending Mode menu and Opacity control enable you to adjust the way that pixels on a layer blend with pixels on the layer below. These controls work just like the blending mode and opacity controls described earlier, in the discussion about the Fill command, except that the Layers palette controls affect pixels that already exist on a layer. The Fill command controls affect pixels that you're about to paint, as do the Mode and Opacity controls related to the painting tools.

✔ The Lock controls near the top of the palette enable you to "lock" the contents of a layer, thereby preventing you from messing up a layer after you get it just so. The leftmost of the two lock controls prevents you from making any changes to transparent parts of the layer; the right control prevents you from altering the entire layer. However, in either case, you can still move the layer up and down in the layer stack.

To preserve independent layers between editing sessions, you must save the image file in a format that *supports* layers — that is, can deal with the layers feature. In Elements, go with the program's native format, PSD. See Chapters 7 and 10 for more details about file formats and saving files.

Adding, deleting, and flattening layers

Every Elements image starts life with one layer, named *Background* layer. You can add and delete layers as follows:

- ✔ To add a new layer, click the New Layer button in the Layers palette. (Refer to Figure 12-17.) Your new layer appears directly above the layer that was active at the time you clicked the button. The new layer becomes the active layer automatically.

- ✔ To duplicate a layer, drag it to the New Layer button.

- ✔ To delete a layer — and everything on it — drag the layer name to the Trash button in the Layers palette. Or click the layer name and then click the Trash button.

- ✔ *Flattening* an image means to merge all independent image layers into one. Flattening an image has two benefits: First, it reduces the file size and the amount of muscle your computer needs to process your edits. Second, it prevents you from accidentally moving things out of place after you arrange them to your liking.

 After you flatten the image, however, you can no longer manipulate the layers independently. So be sure that you're really satisfied with your picture before you take this step. You may want to make a backup copy of the picture in its multilayered state just for good measure.

 To flatten your image, choose Layer⇨Flatten Image from either the Layers palette menu or the Layer menu at the top of the program window.

- ✔ In addition to flattening all layers, you can merge just two or more selected layers together. To go this route, you have a couple of options:

 - • To merge a layer with the layer immediately underneath, click the upper layer in the pair and then choose Merge Down from either the palette menu or the main Layer menu.

 - • To merge two layers that aren't adjacent, or to merge more than two layers, first hide the layers that you *don't* want to fuse together. (Click their eyeball icons in the Layers palette.) Then choose Merge Visible from the palette menu or main Layer menu. After you merge the visible layers, redisplay the hidden layers.

Editing a multilayered image

Editing multilayered images involves a few differences from editing a single-layer image. Here's the scoop:

✔ **Changing layer order:** Drag a layer name up or down in the Layers palette to rearrange the layer's order in your image.

✔ **Selecting the entire layer:** To select an entire layer, just click its name in the Layers palette. For some commands, however, you must use the Select➪Select All command to create a layer-wide selection outline. (If a command that you want to use appears dimmed in a menu, this is likely the cause.)

✔ **Selecting part of a layer:** Use the selection techniques outlined in Chapter 11 to create a selection outline as usual. Then click the layer name in the Layers palette, if the layer isn't already the active layer.

A selection outline always affects the active layer, even if another layer was active when you created the outline.

✔ **Copy a selected area to a new layer:** Press Ctrl+J in Windows; press ⌘+J on a Mac. Or choose Layer➪New➪Layer via Copy. Your selection goes on a new layer immediately above the layer that was active when you made the copy.

✔ **Deleting a selection:** On any layer but the background layer, deleting something creates a transparent hole in the layer, and the underlying pixels show through the hole. If you delete a selection on the background layer, the hole becomes filled with the current background color. (See the earlier section "Pick a color, any color!" to find out how to change the background color.)

✔ **Erasing on a layer:** On any layer but the background layer, you can also use the Eraser tool to rub a hole in a layer, as I did in Figure 12-18. In the left half of the image, I nestled my ceramic elf into a field of wildflowers, with the elf occupying the top layer in the image and the wildflowers consuming the bottom layer. The right half of the image shows me swiping away at the elf's chest and legs with the Eraser, bringing the wildflowers in the bottom layer into view.

You can find both images on the CD, by the way. The filenames are Elf.jpg and Flowers.jpg.

As with the Elements painting tools, you can adjust the impact of the Eraser by changing the Opacity value on the Options bar. At 100 percent, you swipe the pixels clean; anything less than 100 percent leaves some of your pixels behind. I used a lowered Eraser opacity when creating the collage image in Figure 12-15, earlier in this chapter. Using a soft brush and 50 percent tool opacity, I erased the lower portion of the lizardy-thing's tail to make the tail appear to hang in the water. Figure 12-19 shows this process. (I hid the bottom, water layer so that you can see what I'm erasing more clearly. Again, the checkerboard pattern indicates transparent pixels.)

Figure 12-18:
After putting the elf on the top layer and the wildflowers on the bottom layer (left), I used the Eraser tool to rub away some elf pixels, revealing the underlying wildflower pixels (right).

Eraser cursor

Move tool

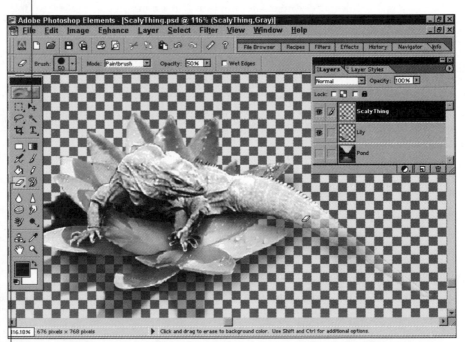

Figure 12-19:
I erased part of the tail with the Eraser tool set to 50 percent opacity to make the tail pixels translucent.

Eraser

✔ **Erasing on the background layer:** If you're working on the background (bottom) layer, using the Eraser doesn't result in a transparent area. Instead, the erased area is filled with the current background color, just as when you delete something from the background layer.

What if you want areas of your background layer to be transparent — say, to create a single-layer GIF image with transparent areas? The trick is to convert the background layer to a "regular" layer. Click the background layer name in the Layers palette and then choose Layer⇨ New⇨Layer from Background.

Head to Chapter 9 for details about how to preserve the transparent areas when you save the picture in the GIF format. The same chapter shows you how to fill the transparent areas with color when you save the file in the JPEG format.

✔ **Moving a layer:** Click the layer name in the Layers palette to select the layer. Then drag in the image window with the Move tool, labeled in Figure 12-19. Note that if the Auto Select Layer check box is selected on the Options bar, clicking any pixel on a layer automatically selects the layer that contains that pixel.

✔ **Transforming a layer:** After clicking the layer name in the Layers palette, use the commands on the Image menu to rotate, flip, and otherwise transform a layer. You can use the same techniques and commands as when you transform a selected area; Chapter 11 offers details.

Remember that resizing and rotating image elements can damage your image quality. You can typically reduce your image without harm, but don't try to enlarge the image very much, and don't rotate the same layer repeatedly.

Also don't forget to save your image file in the native Elements file format, PSD, if you want to retain your individual image layers between editing sessions.

Building a multilayered collage

Layers are useful on an everyday-editing basis because they provide you with more flexibility and security. But where layers really shine is in the creation of photo collages like the one in Color Plate 12-3. I put this collage together for a marketing piece for my part-time antiques business, which focuses on the kind of small, whimsical decorating items featured in the image. I also turned this picture into a birthday card for a friend by adding the text "Happy Birthday to another oldie-but-goodie!"

To help you understand the process of creating a collage — and hopefully provide you with a little inspiration — the following list outlines the approach I took to build the collage in the color plate.

✔ I opened each of the collage images individually and did whatever color correction and touch-ups were needed to get the images in good shape. Then I saved and closed the images.

✔ To begin building the collage, I first opened the brick image. This image was much larger than I needed for the final collage, so I resized it to the dimensions you see in Color Plate 12-3.

✔ One by one, I opened the other collage images and selected, copied, and pasted the subjects into the brick picture. You can find out how to select, copy, and paste in Chapter 11.

Shooting your pictures with the end use of the image in mind saves you time and trouble when you build your collage. I knew when I shot the images in Color Plate 12-2 that I would cut them out of their backgrounds. So when shooting the images, I got as close as I could so that the majority of the image pixels would be devoted to the subjects, not wasted on the background that I would be trimming away. This practice gives you the highest possible resolution for your collage subjects (see Chapter 2 for more information on resolution).

Additionally, I shot the objects against plain backgrounds, using background colors that contrasted with the subjects. I then was able to use the Magic Wand to select the backgrounds with relative ease. After selecting the background, I simply inverted the selection, which selected the object and deselected the background. Chapter 11 provides details about both aspects of this selection process.

✔ I kept each collage object on its own layer, which meant eight layers altogether. You see the stacking order of the layers in Figure 12-20. I repositioned and rotated the individual layers, playing around with different compositions until I arrived at the final image.

In a few cases, I scaled individual elements down slightly. (Remember, reducing a photo element is usually harmless; enlarging it usually does noticeable damage.) With the exception of the elf's head and the bottle stopper (that's the little guy in the bowler hat), I oriented the objects in a way that moved at least some of the original image off the canvas area.

✔ To make the elf's head appear partially in front of and partially behind the iron, I put the elf layer under the iron layer. Then I used the Eraser tool to wipe away the iron pixels around the elf's ears and chin.

✔ I saved one copy of the image in its layered state so that I could retain the layers for further editing in case the mood to do some rearranging ever hit me. Then, because I needed to turn this image over to the folks in the publisher's production department for printing, I flattened the image and saved it as a TIFF file. (See Chapter 10 for details on saving files; read Chapter 7 for information on file formats.)

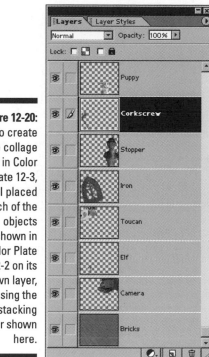

Figure 12-20:
To create
the collage
in Color
Plate 12-3,
I placed
each of the
objects
shown in
Color Plate
12-2 on its
own layer,
using the
stacking
order shown
here.

✔ For added effect, I desaturated the image, turning everything to shades
of gray. Then I created a new layer and filled that layer with a dark gold
color. I set the layer blending mode to Color and set the layer opacity to
50 percent, resulting in the antique-photograph look shown in Color
Plate 12-4. That old-time atmosphere is perfect for the subject of this
image. (Note that you can also create this effect in Elements by using the
Hue/Saturation filter with the Colorize option selected; see the earlier
section "Spinning pixels around the color wheel" for more information.)

If you want to try re-creating the collage in Color Plates 12-3 and 12-4, you can
find all the collage images on the CD at the back of this book. See Appendix B
for more information about using these photos.

Working with multiple images and large images such as this collage can strain
even the most hardy computer system. So be sure to save your collage at
regular intervals so that you're protected in the case of a system breakdown.
And be sure to save in your photo software's native format; other formats
may flatten all your layers together.

Turning Garbage into Art

Sometimes, no amount of color correction, sharpening, or other editing can rescue an image. The top-left photo in Color Plate 12-5 is an example. I shot this cityscape just past sunset, and I knew I was pushing the limits of my camera. Just as I feared, the image came out very grainy due to the low lighting conditions.

After trying all sorts of corrective edits, I decided that this image was never going to be acceptable in its "real" state. That is, I wasn't able to capture the scene with enough detail and brightness to create a decent printed or on-screen image. Still, I really liked the composition and colors of the picture. So I decided to use it as a basis for some digital creativity.

By applying different special-effects filters, I created the five other images in the color plate. For these pictures, I used filters found in Adobe PhotoDeluxe, Elements, and Photoshop. You can find similar filters — or, at least, equally entertaining filters — in other programs.

In just a few seconds, I was able to take a lousy photograph and turn it into an interesting composition. And the samples in the color plate are just the beginning of the creative work you can do with a picture such as this. You can combine different filters, play with layering and blending modes, and use any of the other editing tricks discussed throughout this chapter and the others in this part of the book to create colorful, inventive artwork.

In other words, the artistic possibilities you can achieve with digital photos aren't limited to the scene you see when you look through the viewfinder. Nor are you restricted to the image that appears on your screen when you first open it in your photo software. So never give up on a rotten picture — if you look hard enough, you can find art in them-there pixels.

Part V
The Part of Tens

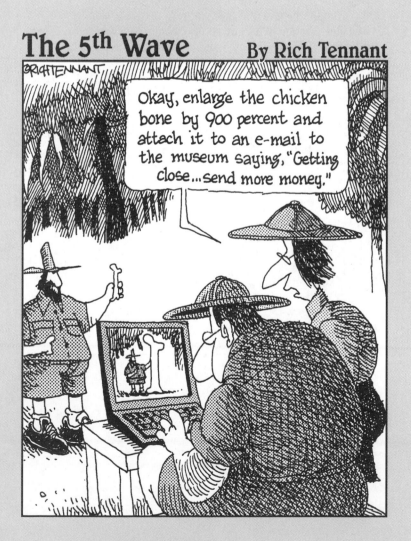

In this part . . .

Some people say that instant gratification is wrong. I say, phooey. Why put off until tomorrow what you can enjoy this minute? Heck, if you listen to some scientists, we could all get flattened by a plunging comet or some other astral body any day now, and then what will you have for all your waiting? A big fat nothing, that's what.

In the spirit of instant gratification, this part of the book is designed for those folks who want information right away. The three chapters herein present useful tips and ideas in small snippets that you can rush in and snag in seconds. Without further delay. *Now,* darn it.

Chapter 13 offers ten techniques for creating better digital images; Chapter 14 gives you ten suggestions for ways to use your images; and Chapter 15 lists ten great Internet resources for digital photographers.

If you like things quick and easy, this part of the book is for you. And if instant gratification is against your principles, you may want to . . . look up! I think that big, black ball in the sky is an asteroid, and it's headed this way!

Chapter 13

Ten Ways to Improve Your Digital Images

In This Chapter

▶ Capturing the right number of pixels

▶ Choosing the optimum compression setting

▶ Composing a scene for maximum impact

▶ Shedding some light on the subject

▶ Avoiding "shaky" images

▶ Acquiring a digital perspective

▶ Correcting flaws inside your photo software

▶ Choosing paper for the best printed output

▶ Spending quality time with your camera

▶ Paying attention to the manufacturer's instructions

Digital cameras have a high "wow" factor. That is, if you walk into a room full of people and start snapping pictures with your digital camera, just about everyone in the room will say, "Wow!" and ask for a closer look. Oh sure, one guy will look unimpressed and even make a few snide remarks, but that's just because he's secretly jealous that you managed to sneak up unnoticed and kick his keister in the who's-got-the-latest-and-greatest-technology game.

Sooner or later, though, people will stop being distracted by the whiz-bang technology of your camera and start paying attention to the quality of the pictures you turn out. And if your images are poor, whether in terms of image quality or photographic composition, the initial "wows" turn to "ews," as in "Ew, that picture's *terrible*. You'd think after spending all that money on a digital camera, you could come up with something better than *that*."

So that you don't embarrass yourself — photographically speaking, anyway — this chapter presents ten ways to create better digital images. If you pay attention to these guidelines, your audience will be as captivated by your pictures as they are by your shiny digital camera.

Remember the Resolution!

When you print digital photos, the image output resolution — the number of pixels per linear inch — makes a big impact on picture quality. To get the best results from most printers, you need an output resolution of between 200 to 300 pixels per inch (ppi).

Most digital cameras offer a few different capture settings, each of which delivers a certain number of pixels. Before you take a picture, consider how large you may want to print the photo. Then select the capture setting that gives you the number of pixels you need to be able to print a good picture at that size.

Remember that you usually can get rid of excess pixels in your photo software without affecting picture quality, but you almost never get good results from adding pixels. In other words, better to wind up with too many pixels rather than too few.

For the complete lowdown on output resolution, pixels, and print quality, see Chapters 2 and 8.

Don't Overcompress Your Images

Most cameras enable you to select from several *compression* settings. Compression is a technique used to shrink the size of an image file.

In most cases, camera compression settings have quality-related names — Best, Better, Good, for example, or Fine and Normal. That's appropriate because compression affects picture quality.

Digital cameras typically use *lossy* compression — meaning that some image data is sacrificed during the compression process. The more lossy compression you apply, the lower the photo quality. So for the best-looking images, shoot your pictures using the setting that applies the least amount of compression. Of course, less compression means larger file sizes, so you can't fit as many pictures in the camera's memory as you can at a lower-quality setting.

You also need to consider the compression factor when saving your images after editing them. Some file formats, such as JPEG, apply lossy compression during the save process, while others, such as TIFF, use *lossless* compression. With lossless compression, your file size isn't reduced as much as with lossy compression, but you don't lose important image data.

To find out more about compression, check out Chapter 3; for information on JPEG, TIFF, and other file formats, flip to Chapter 7.

Look for the Unexpected Angle

As explored in Chapter 5, changing the angle from which you photograph your subject can add impact and interest to the picture. Instead of shooting a subject straight on, investigate the unexpected angle — lie on the floor and get a bug's-eye-view, for example, or perch yourself on a sturdy chair and capture the subject from above.

As you compose your scenes, also remember the rule of thirds — divide the frame into vertical and horizontal thirds and position the main focal point of the shot at a spot where the dividing lines intersect. And quickly scan the frame for any potentially distracting background elements before you press the shutter button.

For more tips on how to take better digital photographs, see Chapters 5 and 6.

Light 'Er Up!

When you're working with a digital camera, good lighting is essential for good pictures. The light sensitivity of most digital cameras is equivalent to the sensitivity of ISO 100 film, which means that shooting in low lighting usually results in dark and grainy images.

If your camera has a flash, you may need to use the flash not just when shooting in dimly lit interiors, but also to bring your subjects out of the shadows when shooting outdoors. For extra flash flexibility, you can buy accessory slave flash units that work in conjunction with your camera's built-in flash.

Some higher-end cameras also have a synchronization socket for connecting an extension flash. To shed even more light on the situation, you may want to invest in some inexpensive photography lights.

For a thorough exploration of flash photography and other lighting issues, check out Chapter 5.

Use a Tripod

To capture the sharpest possible image, you must hold the camera absolutely still. Even the slightest movement can result in a blurry image.

This statement applies to shooting with film as well as when you use a digital camera, of course. But the exposure time required by the average digital camera is comparable to that required by ISO 100 film. If you're used to shooting with a film that's faster than ISO 100, remember that you need to hold your digital camera still for a slightly longer period of time than you do when taking film pictures.

For best results, use a tripod, especially when shooting in dimly lit settings. See Chapter 5 for additional shake-free shooting tricks, and check out Chapters 2 and 5 if you want more information about film ISO ratings and image exposure.

Compose from a Digital Perspective

When you compose pictures, fill as much of the frame as possible with your subject. Try not to waste precious pixels on a background that will be cropped away in the editing process.

If you're shooting objects that you plan to use in a photo collage, set the objects against plain, contrasting backgrounds, as I did in Color Plate 12-2. That way, you can easily select the subject using photo-editing tools that select pixels according to color (such as the Magic Wand in Photoshop Elements).

For more information on shooting pictures for digital compositions, see Chapter 6. To get the skinny on selecting objects in your photographs, turn to Chapter 11.

Take Advantage of Image-Correction Tools

Don't automatically toss photos that don't look as good as you would like. With some judicious use of your photo software's retouching tools, you can

brighten up under-exposed images, correct color balance, crop out distracting background elements, and even cover up small blemishes.

Part IV explores some basic techniques you can use to enhance your images. Some are simple to use, requiring just one click of the mouse button. Others involve a bit more effort but are still easily mastered if you put in a little time.

Being able to edit your photographs is one of the major advantages of shooting with a digital camera. So take a few minutes each day to become acquainted with your photo software's correction commands, filters, and tools. After you start using them, you'll wonder how you got along without them.

Print Your Images on Good Paper

As discussed in Chapter 8, the type of paper you use when printing your images can have a dramatic effect on how your pictures look. The same picture that looks blurry, dark, and oversaturated when printed on cheap copy paper can look sharp, bright, and glorious when printed on special glossy photographic paper.

Check your printer's manual for information on the ideal paper to use with your model. Some printers are engineered to work with a specific brand of paper, but don't be afraid to experiment with paper from other manufacturers. Paper vendors are furiously developing new papers that are specifically designed for printing digital images on consumer-level color printers, so you just may find something that works even better than the recommended paper.

Practice, Practice, Practice!

Digital photography is no different from any other skill in that the more you do it, the better you become. So shoot as many pictures as you can, in as many different light situations as you can. As you shoot, jot down the camera settings you used and the lighting conditions at the time you snapped the image. Later, evaluate the pictures to see which settings worked the best in which situations.

If your camera stores the capture settings as metadata in the image file, you don't need to bother writing down settings for each shot. Instead, you can use a special piece of software to view the capture settings for each image that you download to your computer. See Chapter 4 for more information on this option.

After you spend some time experimenting with your camera, you'll start to gain an instinctive feel for what tactics to use in different shooting scenarios, increasing the percentage of great pictures in your portfolio. As for those pictures that don't make the grade, keep them to yourself, suggests Alfred DeBat, technical editor for this book and an experienced professional photographer. "Never share your bad photos! Show your friends and family ten really outstanding pictures, and they will say, 'Wow! You really are a great photographer.' If you show them 50 great photos and 50 mediocre shots, they won't be impressed with your abilities. So bury your bad pictures if you want to build a reputation as a good photographer."

Read the Manual (Gasp!)

Remember that instruction manual that came with your camera? The one you promptly stuffed in a drawer without bothering to read? Go get it. Then sit down and spend an hour devouring every bit of information inside it.

I know, I know. Manuals are deadly boring, which is why you invested in this book, which is so dang funny you find yourself slapping your knee and snorting milk through your nose at almost every paragraph. But you aren't going to get the best pictures out of your camera unless you understand how all its controls work. I can give you general recommendations and instructions in this book, but for camera-specific information, the best resource is the manufacturer's own manual.

After your initial read-through, drag the manual out every so often and take another pass at it. You'll probably discover the answer to some problem that's been plaguing your pictures or be reminded of some option that you forgot was available. In fact, reading the manual has to be one of the easiest — and most overlooked — ways to get better performance out of your camera.

Chapter 14

Ten Great Uses for Digital Images

In This Chapter

▶ Joining the merry band of communicators on the World Wide Web

▶ Skipping the trip to the post office and e-mailing your pictures instead

▶ Creating and sharing digital photo albums

▶ Making your marketing materials sizzle

▶ Putting your smiling face on a coffee cup or T-shirt

▶ Publishing custom calendars, greeting cards, or stationery

▶ Adding pictures to spreadsheets and databases

▶ Creating photo name badges

▶ Showing 'em what you mean

▶ Printing and framing your best work

When I introduce most people to their first digital camera, the exchange goes something like this:

Them: "What's that?"

Me: "It's a digital camera."

Them: "Oh." (Pause.) "What can you do with it?"

Me: "You can take digital pictures."

Them: (Thoughtful nod.) "Hmm." (Another pause, this time longer.) "And then what?"

It is at this point that the conversation takes one of two tracks: If my schedule is tight, I simply discuss the most popular use for digital photos — distributing them electronically via the Internet. But if I have time to kill or have ingested an excess of caffeine in the past hour, I sit the person down and launch a full-fledged discussion of all the wonderful things you can do with digital images. Around this point in the conversation, the person subtly begins looking for the closest escape route and probably starts praying that the phone will ring

or some other interruption will distract me. I can be, well, overly enthusiastic when it comes to this topic.

This chapter enables you to enjoy the long version of my "what you can do with digital photos" speech in the safety of your own home or office. Feel free to leave at any time — I'll be here with more ideas when you come back. But before you go, could you order some more coffee? I have a feeling that someone else might pass by soon and ask me about this funny-looking camera, and I want to be ready.

Design a More Exciting Web Site

Perhaps the most popular use for digital images is to spice up World Wide Web sites. You can include pictures of your company's product, headquarters, or staff on your Web site to help potential customers get a better idea of who you are and what you're selling.

Don't have a business to promote? That doesn't mean you can't experience the fun of participating in the Web community. Create a personal Web page for yourself or your family. Many Internet service providers make a limited amount of free space available for those who want to publish personal Web pages. And with today's Web-page creation software, the process of designing, creating, and maintaining a Web page isn't all that difficult.

For information on how to prepare your images for use on a Web page, check out Chapter 9.

E-Mail Pictures to Friends and Family

By attaching a photo to an e-mail message, you can share pictures with friends, family, and colleagues around the world in a matter of minutes. No more waiting for the film lab to develop and print your pictures. No more hunting for the right size envelope to mail those pictures, and no more waiting in line at the post office to find out how many stamps you need to slap on that envelope. Just snap the picture, download it to your computer, and click the Send button in your e-mail program.

Whether you want to send a favorite aunt a picture of your new baby or send a client an image of your latest product design, the ability to communicate visual information quickly is one of the best reasons to own a digital camera. For more about attaching images to e-mail messages, turn to Chapter 9.

Create Online Photo Albums

If you regularly have batches of pictures that you want to share, check out online photo-sharing sites. You can create personal digital photo albums and then invite other people to visit the site and view your pictures. Most photo-sharing sites offer printing services so that your friends and family can order copies of pictures in your albums.

Creating and maintaining an online album is easy, thanks to user-friendly tools available at each site. Best of all, posting and sharing albums is usually free. You pay only for prints that you order.

To get started, check out these leading photo-sharing sites:

- www.ofoto.com
- www.shutterfly.com
- www.nikonnet.com
- www.fujifilm.net

One word of caution: Don't rely on a photo-sharing site for storage of important, irreplaceable photos. If the site experiences problems with its equipment — or worse, goes out of business — your photos could be lost. Always keep copies of your pictures on your own computer or removable storage media. See Chapter 4 for guidance about storage options that provide the most security for your pictures.

Add Impact to Sales Materials

Using a desktop publishing program such as Adobe PageMaker or Microsoft Publisher, you can easily add your digital photos to brochures, fliers, newsletters, and other marketing materials. You can also use your images in multimedia presentations created in Microsoft PowerPoint or Corel Presentations.

For best results, size your pictures to the desired dimensions and resolution in your photo software before you place them into your presentation or publishing program. See Chapter 9 for information about preparing images for use in on-screen presentations; Chapter 8 contains details on preparing pictures for print use.

Put Your Mug on a Mug

If you own one of the new color printers designed expressly for printing digital images, the printer may come with accessories that enable you to put your images on mugs, T-shirts, and other objects. (If your software doesn't, online photo-sharing sites such as those listed earlier in this chapter can do the job for you.) Many consumer-level photo-editing programs also provide tools that make it a snap to prepare your pictures for use in this fashion.

Being a bit of a jaded person, I expected to get rather cheesy results from these kinds of print projects. But after I created my first set of mugs and saw the professional-looking results, I was hooked. I chose four different images featuring my parents, my sisters, and my nieces and nephews and placed each image on a different mug.

Call me sentimental, but I can envision these mugs being around for generations (assuming nobody breaks one, that is) to serve as a reminder of how we twentieth-century Kings once looked. Hey, 100 years ago, nobody thought that old tintype photographs would be considered heirlooms, right? So who's to say that my photographic mugs won't be treasured tomorrow? In the meantime, the family members who have laid claim to the mugs I created seem to be treasuring them today.

Print Photo Calendars and Cards

Many photo-editing programs include templates that enable you to create customized calendars featuring your images. The only decision you need to make is which picture to put on December's page and which one to use on July's. You can also find templates for designing personalized greeting cards and stationery.

If your photo editor doesn't include such templates, check the software that came with your printer. Many printers now ship with tools for creating calendars and similar projects.

When you want more than a handful of copies of your creation, you may want to have the piece professionally reproduced instead of printing each copy one by one on your own printer. You can take the job to a quick-copy shop or to a commercial service bureau or printer. Most online photo-sharing sites also offer this service.

Don't forget that the paper you use to print your stationery or cards plays a large role in how professional the finished product appears. If you're printing the piece yourself, invest in some high-quality paper or special greeting-card stock, available as an accessory for many color printers. If you're having your piece professionally printed, ask your printer for advice on which paper stock will generate the results you want.

Include Visual Information in Databases

You can add digital images to company databases and spreadsheets in order to provide employees with visual as well as text information. For example, if you work in human resources, you can insert employee pictures into your employee database. Or if you're a small-business owner and maintain a product inventory in a spreadsheet program, you can insert pictures of individual products to help you remember which items go with which order numbers. Figure 1-4 in Chapter 1 shows an example of a spreadsheet that I created in Microsoft Excel to track the inventory in my antique shop.

Merging text and pictures in this fashion isn't just for business purposes, though. You can take the same approach to create a household inventory for your personal insurance records, for example.

Put a Name with the Face

You can put digital pictures on business cards, employee badges, and nametags for guests at a conference or other large gathering. I love getting business cards that include the person's face, for example, because I'm one of those people who never forgets a face but almost always has trouble remembering the name.

Several companies now offer special, adhesive-backed sticker paper for inkjet printers. This paper is perfect for creating badges or nametags. After printing the image, you simply stick it onto your preprinted badge or nametag.

Exchange a Picture for a Thousand Words

Don't forget the power of a photograph to convey an idea or describe a scene. Did your roof suffer damage in last night's windstorm? Take pictures of the damage and e-mail them to your insurance agent and roofing contractor.

Looking for a bookcase that will fit in with your existing office decor? Take a picture of your office to the furniture store, and ask the designer for suggestions.

Written descriptions can be easily misunderstood and also take a lot longer to produce than shooting and printing a digital image. So don't tell people what you want or need — show 'em!

Hang a Masterpiece on Your Wall

Many ideas discussed in this chapter capitalize on the special capabilities that going digital offers you — the ability to display images on-screen, incorporate them into publishing projects, and so on. But you can also take a more traditional approach and simply print and frame your favorite images.

For the best-looking pictures, print your image on a dye-sub printer or photo inkjet using top-grade photo paper. If you don't own such a printer, you can take the image file to a commercial printer or photo-finishing lab for output. (For more on printer types and printing options, read Chapter 8.)

Keep in mind that prints from dye-sub and inkjet printers do fade when exposed to sunlight, so for those really important pictures, you may want to invest in a frame that has UV-protective glass. Also, hang your picture in a spot where it won't get pummeled with strong light on a regular basis, and be sure to keep a copy of the original image file so that you can reprint the image if it fades too badly.

Chapter 15

Ten Great Online Resources for Digital Photographers

In This Chapter

▶ www.dpreview.com

▶ www.imaging-resource.com

▶ www.megapixel.net

▶ www.pcphotomag.com

▶ www.pcphotoreview.com

▶ www.peimag.com

▶ www.shutterbug.net

▶ rec.photo.digital

▶ comp.periphs.printers

▶ Manufacturer Web sites

*I*t's 2 a.m. You're aching for inspiration. You're yearning for answers. Where do you turn? No, not to the refrigerator. Well, okay, maybe just to get a little snack — some cold pizza or leftover chicken wings would be good — but then it's off to the computer for you. Whether you need solutions to difficult problems or just want to share experiences with like-minded people around the world, the Internet is the place to turn. At least, it is for issues related to digital photography. For anything else, talk to your spiritual leader, psychic hotline, Magic 8-Ball, or whatever source you usually consult.

This chapter points you toward some of my favorite online digital photography resources. New sites are springing up every day, so you can no doubt uncover more great pages to explore by doing a Web search on the words "digital photography" or "digital cameras."

Note that the site descriptions provided in this chapter are current as of press time. But because Web sites are always evolving, some of the specific features mentioned may be updated or replaced by the time you visit a particular site.

www.dpreview.com

Click here for a broad range of digital photography information, from news about recently released products and promotional offers to discussion groups where people debate the pros and cons of different camera models. Photographers interested in delving into advanced picture-taking techniques will appreciate the educational section of the site.

www.imaging-resource.com

Point your Web browser to this site for equipment-buying advice and digital photography news. An especially helpful "Getting Started" section of the site offers thorough, easy-to-understand answers to frequently asked questions about choosing and using digital cameras. In-depth product reviews and discussion forums related to digital photography round out this well-designed site.

www.megapixel.net

Home to a monthly online magazine offered in English and French, this site offers in-depth product reviews and technical information, as well as articles covering all aspects of digital photography. The site also maintains an excellent glossary of photographic terms and is home to several discussion groups.

www.pcphotomag.com

Geared to beginning digital photographers, the bimonthly print magazine *PC Photo* makes articles from current and past issues available at its Web site. Along with equipment reviews, the magazine offers tutorials on photography and photo-editing as well as interviews with noted photographers.

www.pcphotoreview.com

Whether you're shopping for your first camera or looking for accessories to enhance your digital photography fun, this site helps you make good choices. You'll find hardware and software reviews as well as discussion groups where

you can share information with other users. A glossary of digital photography terms and explanations of camera features make this site even more useful.

www.peimag.com

At this site, you can browse archived editions of *Photo Electronic Imaging* magazine. Geared to imaging professionals, this publication features the work of leading digital artists and will open your eyes to the amazing possibilities that you can explore using your digital camera and photo-editing software. The site also offers discussion forums related to digital cameras and photo printers.

www.shutterbug.net

At this site, you can explore the online version of the respected magazine *Shutterbug,* which offers how-to articles and equipment reviews related to both film and digital photography. A comprehensive buyer's guide provides extensive information about digital cameras and other imaging tools.

rec.photo.digital

For help with specific technical questions as well as an interesting exchange of ideas about equipment and approaches to digital photography, subscribe to the rec.photo.digital newsgroup. (For the uninitiated, a *newsgroup*, also called a *discussion group*, is not a Web site, but a discussion forum where folks with similar interests send messages back and forth about a particular topic.)

Many of the people who participate in this newsgroup have been working with digital imaging for years, while others are brand new to the game. Don't be shy about asking beginner-level questions, though, because the experts are happy to share what they know.

You can use your Web browser's newsgroup reader to participate (the software's Help system should explain how). Or point your browser to www.google.com to access a newsgroup portal offered by the popular Google search engine. Click the link for Groups to load the main newsgroup page. Then type the newsgroup name in the Search box and click the Search button to display newsgroup messages.

comp.periphs.printers

Shopping for a new photo printer? Having trouble making your existing printer work correctly? Check out this newsgroup, which deals specifically with issues related to printing.

Newsgroup members debate the pros and cons of different printer models, share troubleshooting tips, and discuss ways to get the best possible output from their machines.

Manufacturer Web Sites

Just about every manufacturer of digital-imaging hardware and software maintains a Web site. Typically, there sites are geared to marketing the company's products, but many also offer terrific tutorials and other learning resources for newcomers to digital photography. Sites that rank high on my list include the following:

- ✔ Kodak (www.kodak.com): Take a look at the Taking Great Pictures area of the site.

- ✔ Hewlett-Packard (www.hp.com): Look for the Digital Photography Center in the Home and Home Office section of the site.

- ✔ Fujifilm (www.fujifilm.com): Find your way to the Picture Your Life pages at this site.

- ✔ Wacom Technologies (www.wacom.com): Click the Tips link for photo retouching tips and creative inspiration.

- ✔ Adobe (www.adobe.com): Check out the Adobe Studio portion of this site for tutorials and feature articles related to photo editing and digital painting.

Many vendors also make updates to software available through their Web sites. For example, you may be able to download an updated printer driver or a patch that fixes a bug in your photo software.

I recommend that you get in the practice of checking your manufacturer's Web site routinely — say, once a month or so — to make sure that you're working with the most current version of the product software.

Part VI
Appendixes

The 5th Wave By Rich Tennant

"My God! I've gained 9 pixels!"

In this part . . .

You're reading along in this or some other digital photography tome, and you stumble across an unfamiliar term. Don't be proud and pretend to know what's going on — check out Appendix A, which defines digital photography terms in plain English.

When you've had enough of deciphering strange computer acronyms and are ready for something a bit more fun, pop the CD that's attached to the back of this book into your computer. The CD includes trial and demo versions of a bunch of cool programs to use in your digital photography studio, including image editors, catalog programs, and other goodies. And just in case you don't have any of your own images to use as you try out the software, I've included a few sample images on the CD as well.

To make sure that everything goes smoothly, read Appendix B, which describes all the freebies provided on the CD and outlines the process for accessing and installing them.

Appendix A
Digital Photography Glossary

· ·

*C*an't remember the difference between a pixel and a bit? Resolution and resampling? Turn here for a quick refresher on that digital photography term that's stuck somewhere in the dark recesses of your brain and refuses to come out and play.

8-bit image: An image containing 256 colors.

16-bit image: An image containing roughly 32,000 colors.

24-bit image: An image containing approximately 64.7 million colors.

aliasing: Random color defects, usually caused by too much JPEG compression.

aperture: An opening in a small diaphragm between the camera lens and shutter; opens to allow light into the camera.

artifact: Noise, an unwanted pattern, or some other defect caused by an image capture or processing problem.

bit: Stands for *binary digit*; the basic unit of digital information. Eight bits equals one *byte*.

BMP: The Windows bitmap graphics format. Reserved today for images that will be used as system resources on PCs, such as screen savers or desktop wallpaper.

burst mode: A special capture setting, offered on some digital cameras, that records several images in rapid succession with one press of the shutter button. Also called *continuous capture* mode.

byte: Eight bits. *See* bit.

CCD: Short for *charge-coupled device*. One of two types of imaging sensors used in digital cameras.

CIE Lab: A color model developed by the Commission International de l'Eclairange. Used mostly by digital-imaging professionals.

cloning: The process of copying one area of a digital photo and "painting" the copy onto another area or picture.

CMOS: Pronounced *see-moss*. A much easier way to say *complementary metal-oxide semiconductor*. A type of imaging sensor used in digital cameras; used less often than CCD chips.

CMYK: The print color model, in which cyan, magenta, yellow, and black inks are mixed to produce colors.

color correction: The process of adjusting the amount of different primary colors in an image (for example, reducing red or increasing green).

color model: A way of defining colors. In the RGB color model, for example, all colors are created by blending red, green, and blue light. In the CMYK model, colors are defined by mixing cyan, magenta, yellow, and black.

color temperature: Refers to the amount of red, green, and blue light emitted by a particular light source.

CompactFlash: A type of removable memory card used in many digital cameras. A miniature version of a PC Card — about the size and thickness of a matchbook.

compositing: Combining two or more images in a photo-editing program.

compression: A process that reduces the size of the image file by eliminating some image data.

depth of field: The zone of sharp focus in a photograph.

downloading: Transferring data from one computer device to another.

dpi: Short for *dots per inch*. A measurement of how many dots of color a printer can create per linear inch. Higher dpi means better print quality on some types of printers, but on other printers, dpi is not as crucial.

DPOF: Stands for *digital print order format*. A feature found in some digital cameras that enables you to add print instructions to the image file; some photo printers can read that information when printing your pictures directly from a memory card.

dye-sub: Short for *dye-sublimation.* A type of printer that produces excellent digital prints.

edges: Areas where neighboring image pixels are significantly different in color; in other words, areas of high contrast.

EV compensation: A control that slightly increases or decreases the exposure chosen by the camera's autoexposure mechanism. EV stands for exposure value; EV settings typically appear as EV 1.0, EV 0.0, EV-1.0, and so on.

file format: A way of storing image data in a file. Popular image formats include TIFF, JPEG, and GIF.

FlashPix: A file format developed to facilitate the editing and online viewing of digital images. Currently supported by only a handful of software programs.

gamut: Say it *gamm-ut.* The range of colors that a monitor, printer, or other device can produce. Colors that a device can't create are said to be *out of gamut.*

Gaussian blur: A type of blur filter available in many photo-editing programs; named after a famous mathematician.

GIF: Pronounced *gif,* with a hard g. GIF stands for *graphics interchange format.* One of the two image file formats used for images on the World Wide Web. Supports 256-color images only.

gigabyte: Approximately 1,000 megabytes, or 1 billion bytes. In other words, a really big collection of bytes. Abbreviated as GB.

grayscale: An image consisting solely of shades of gray, from white to black.

histogram: A graph that maps out brightness values in a digital image; usually found inside exposure-correction filter dialog boxes.

HSB: A color model based on hue (color), saturation (purity or intensity of color), and brightness.

HSL: A variation of HSB, this color model is based on hue, saturation, and lightness.

ISO: Traditionally, a measure of film speed; the higher the number, the faster the film. On a digital camera, raising the ISO allows faster shutter speed, smaller aperture, or both, but also can result in a grainy image.

jaggies: Refers to the jagged, stair-stepped appearance of curved and diagonal lines in low-resolution photos that are printed at large sizes.

JPEG: Pronounced *jay-peg.* One of two formats used for images on the World Wide Web and also used for storing images on many digital cameras. Uses *lossy compression,* which sometimes damages image quality.

JPEG 2000: An updated version of the JPEG format; not yet fully supported by most Web browsers or other computer programs.

Kelvin scale: A scale for measuring the color temperature of light.

kilobyte: One thousand bytes. Abbreviated as *K,* as in 64K.

LCD: Stands for *liquid crystal display.* Often used to refer to the display screen included on some digital cameras.

lossless compression: A file-compression scheme that doesn't sacrifice any vital image data in the compression process. Lossless compression tosses only redundant data, so image quality is unaffected.

lossy compression: A compression scheme that eliminates important image data in the name of achieving smaller file sizes. High amounts of lossy compression reduce image quality.

marquee: The dotted outline that results when you select a portion of your image; sometimes referred to as *marching ants.*

megabyte: One million bytes. Abbreviated as MB. *See* bit.

megapixel: One million pixels. Used to describe digital cameras that can capture high-resolution images.

Memory Stick: A memory card used by several Sony digital cameras and peripheral devices. About the size of a stick of chewing gum.

metadata: Extra data that gets stored along with the primary image data in an image file. Metadata often includes information such as aperture, shutter speed, and EV setting used to capture the image, and can be viewed using special software.

metering mode: Refers to the way a camera's autoexposure mechanism reads the light in a scene. Common modes include spot metering, which bases exposure on light in the center of the frame only; center-weighted metering, which reads the entire scene but gives more emphasis to the

subject in the center of the frame; and matrix or multizone metering, which calculates exposure based on the entire frame.

noise: Graininess in an image, caused by too little light, a too high ISO setting, or a defect in the electrical signal generated during the image-capture process.

NTSC: A video format used by televisions and VCRs in North America. Many digital cameras can send picture signals to a TV or VCR in this format.

output resolution: The number of pixels per linear inch in a printed photo; the user sets this value inside a photo-editing program.

PAL: The video format common in Europe and several other countries. Few digital cameras sold in North America can output pictures in this video format (*see also* NTSC).

PCMCIA Card: A type of removable memory card used in some models of digital cameras. Now often referred to simply as PC Cards. (PCMCIA stands for *Personal Computer Memory Card International Association*.)

Photo CD: A special file format used by professional imaging labs for writing images to a CD.

PICT: The standard format for Macintosh system images. The equivalent of BMP on the Windows platform, PICT is most widely used when creating images for use as system resources, such as startup screens.

pixel: Short for *picture element*. The basic building block of every image.

platform: A fancy way of saying "type of computer operating system." Most folks work either on the Windows platform or the Macintosh platform.

ppi: Stands for *pixels per inch*. Used to state image output (print) resolution. Measured in terms of the number of pixels per linear inch. A higher ppi usually translates to better-looking printed images.

RAW: A file format offered by some digital cameras; records the photo without applying any of the in-camera processing that is normally done when saving photos in other formats.

resampling: Adding or deleting image pixels. A large amount of resampling degrades images.

resolution: A term used to describe the capabilities of digital cameras, scanners, printers, and monitors; means different things depending on the device. (See Chapter 2 for details.)

RGB: The standard color model for digital images; all colors are created by mixing red, green, and blue light.

sharpening: Applying an image-correction filter inside a photo editor to create the appearance of sharper focus.

shutter speed: The length of time that the camera shutter remains open, thereby allowing light to enter the camera and expose the photograph.

SmartMedia: A thin, matchbook-sized, removable memory card used in some digital cameras.

TIFF: Pronounced *tiff,* as in little quarrel. Stands for *tagged image file format.* A popular image format supported by most Macintosh and Windows programs.

TWAIN: Say it *twain,* as in "never the twain shall meet." A special software interface that enables image-editing programs to access images captured by digital cameras and scanners.

transparent GIF: A GIF image that contains transparent areas; when placed on a Web page, the page background shows through the transparent areas.

unsharp masking: The process of using the Unsharp Mask filter, found in many image-editing programs, to create the appearance of a more focused image. The same thing as *sharpening* an image, only more impressive sounding.

uploading: The same as downloading; the process of transferring data between two computer devices.

USB: Stands for *Universal Serial Bus.* A type of new, high-speed port included on the latest computers. USB ports permit easier connection of USB-compatible peripheral devices such as digital cameras, printers, and memory-card readers.

white balancing: Adjusting the camera to compensate for the type of light hitting the photographic subject. Eliminates unwanted color casts produced by some light sources, such as fluorescent office lighting.

Appendix B
What's on the CD

In This Appendix

▶ System requirements for using the CD that accompanies this book

▶ Instructions for using the CD with Windows-based PCs and Macintosh computers

▶ Descriptions of content provided on the CD

▶ Troubleshooting tips

Glued to the inside back cover of this book is a little plastic envelope containing a CD-ROM. The CD contains a treasure trove of goodies, including try-before-you-buy versions of popular photo editing, cataloging, and specialty software. I've also included some sample digital images that you can use when working through techniques covered in this book if you don't have any of your own pictures yet.

For a brief description of each program included on the CD, see the section "What You'll Find," later in this appendix.

System Requirements

Make sure your computer meets the minimum system requirements listed below. If your computer doesn't match up to most of these requirements, you may have problems using the contents of the CD.

✔ **A PC with a Pentium or faster processor, or a Mac OS computer with a 68040 or faster processor.** Keep in mind that, with these minimum processor requirements, opening and editing large images may be very slow.

✔ **Microsoft Windows 95 or later, or Mac OS System software 7.6.6 or later.**

✔ **At least 64MB of total RAM installed on your computer.** For best performance, I recommend even more RAM.

 ⯈ **A CD-ROM drive.**

 ⯈ **A monitor capable of displaying at least 256 colors.**

How to Use the CD Using Microsoft Windows

To install the items from the CD on your hard drive, follow these steps:

1. **Insert the CD into your computer's CD-ROM drive and close the drive door.**

2. **Click the Start button and then click Run.**

3. **In the dialog box that appears, type** D:\START.EXE.

 This instruction assumes that your CD-ROM drive is set up as drive D. Substitute the proper drive letter if your CD-ROM drive uses a different letter.

4. **Click OK.**

 A License Agreement window appears.

5. **Read through the license agreement, nod your head, and then click the Accept button.**

 After you click Accept, you'll never be bothered by the License Agreement window again.

 From here, the CD interface appears. The CD interface lets you install the programs on the CD without typing cryptic commands or using yet another finger-twisting hot key in Windows.

 The software on the interface is divided into categories whose names you see on the screen.

6. **To view the items within a category, just click the category's name.**

 A list of programs in the category appears.

 Note that the Images folder does not contain software, but rather sample images that you can open and edit from inside an image-editing program. So the remaining steps in this section don't apply to anything inside the Images folder.

7. **For more information about a program, click the program's name.**

 Be sure to read the information that's displayed. Sometimes a program may require you to do a few tricks on your computer first, and this screen will tell you where to go for that information, if necessary.

8. **To install the program, click the appropriate Install button.**

 If you don't want to install the program, click the Back button to return to the previous category screen.

 After you click an Install button, the CD interface drops to the background while the CD begins installation of the program you chose.

 When installation is finished, the interface usually reappears in front of other opened windows. Sometimes the installation confuses Windows and leaves the interface in the background. To bring the interface forward, just click once anywhere in the interface's window, or use whatever keystroke or mouse move that your version of Windows uses to switch between programs (the Alt+Tab key, and so on).

9. **To install other items, repeat Steps 6 through 8.**

10. **When you finish installing programs, click the Quit button to close the interface.**

 You can eject the CD now. Place it back in the plastic jacket of the book for safekeeping.

To run some of the programs, you may need to keep the CD inside your CD-ROM drive. Otherwise, the installed program would have required you to install a very large chunk of the program to your hard drive space, which would have kept you from installing other software.

How to Use the CD Using a Mac OS Computer

To install the items from the CD to your hard drive, follow these steps:

1. **Insert the CD into your computer's CD-ROM drive and close the drive door.**

 In a moment, an icon representing the CD you just inserted appears on your Mac desktop. Chances are, the icon looks like a CD-ROM.

2. **Double-click the License Agreement icon.**

 This is the End-User License that you are agreeing to by using the CD. After you've looked it over, you can close the file and get on to the good stuff.

3. **Double-click the Read Me First icon.**

 This text file contains information about the CD's programs and any last-minute instructions you need to know about installing the programs on the CD that I don't cover in this appendix.

4. **Double-click the CD icon to show the CD's contents.**

5. **To install most programs, just drag the program's folder from the CD window and drop it on your hard drive icon.**

6. **To install other, larger programs, open the program's folder on the CD, and double-click the icon with the words "Install" or "Installer."**

After you install the programs that you want, you can eject the CD. Carefully place it back in the plastic jacket of the book for safekeeping.

What You'll Find

The following sections list the various products included on the CD. Before you start exploring the CD, though, please make note of the following terminology: *Shareware programs* are fully functional, free, trial versions of copyrighted programs. If you like particular programs, register with their authors for a nominal fee and receive licenses, enhanced versions, and technical support.

Freeware programs are free, copyrighted games, applications, and utilities. You can copy them to as many PCs as you like — for free — but they offer no technical support. *Trial, demo,* or *evaluation* versions of software are usually limited either by time or functionality (such as not letting you save a project after you create it).

Photo-editing software

If you're in the market for new photo-editing software, take a look at these popular offerings.

- **AfterShot, from JASC, Inc.:** Evaluation version for Windows. This easy-to-use program offers a basic set of features for beginning digital photography enthusiasts, including tools for stitching panoramic images, creating screensavers, and more. www.jasc.com.

- **FotoCanvas, from ACDSystems:** Trial version for Windows. Another offering geared to the novice, this program focuses on tools for retouching problem images. Some artistic filters and advanced creative features are also provided. www.acdsystems.com.

- **Paint Shop Pro, from JASC, Inc.:** Evaluation version for Windows. Designed for intermediate to advanced users, this popular program has a good selection of editing tools and special effects. www.jasc.com.

- **PhotoExpress, from Ulead Systems:** Trial version for Windows. The Ulead entry in the consumer image-editing market, PhotoExpress provides a nice assortment of tools and special effects in an easy-to-understand interface. www.ulead.com.

- **PhotoImpact, from Ulead Systems:** Trial version for Windows. PhotoImpact offers professional-level image editing with an emphasis on tools for creating Web images and graphics. www.ulead.com.

- **Photoshop, from Adobe Systems, Inc.:** Tryout version for Windows and Macintosh. An outstanding set of retouching and editing tools in a clean, elegant interface keep Photoshop at the top of the list for users who need professional power. Note that the tryout version is for Photoshop 6.0; Adobe offers a preview of its latest Photoshop update, Version 7.0, at its Web site. www.adobe.com.

- **Photoshop Elements, from Adobe Systems, Inc.:** Tryout version for Windows and Macintosh. With this image-editing program, you get many of the same power-user tools provided in Photoshop plus features that are designed to guide the novice. www.adobe.com.

Specialty software

In addition to the photo-editing programs listed in the preceding section, the CD also includes the following special-purpose digital photography programs:

- **ACDZip, from ACDSystems:** Trial version for Windows. If you regularly need to send or share batches of image files, this program can assist you by packaging your files into a "zipped" archive file. Unlike other zip programs (StuffIt, PKZip), this one enables you to view thumbnails of files inside an archive. www.acdsystems.com.

- **BrainsBreaker, from Juan Trujillo Tarradas:** Shareware version for Windows. Turn your favorite photo into a virtual jigsaw puzzle! The program breaks your image into puzzle pieces, and you can then solve the puzzle on-screen. www.brainsbreaker.com.

- **Digital ROC and Digital SHO:** Trial version for Windows and Macintosh. These software plug-ins work with Photoshop and many other photo editors. Digital ROC is a tool for correcting photo colors; Digital SHO assists you with improving exposure and contrast. www.asf.com.

- **FotoSlate, from ACDSystems:** Trial version for Windows. This program makes printing batches of pictures a snap, providing a huge assortment of print layout templates plus tools for producing contact sheets and albums. www.acdsystems.com.

- **nik Sharpener Pro! from nik multimedia, Inc.:** Demo version for Windows and Macintosh. Compatible with any program that accepts Photoshop plug-ins, this tool assists you with sharpening images appropriately for different output devices — inkjet printer, commercial printer, and so on. www.nikmultimedia.com

- **nik Color Efex Pro! Complete Edition, from nik multimedia, Inc.:** Demo version for Windows and Macintosh. This plug-in, also compatible with Photoshop and many other photo editors, enables you to create effects similar to those produced by traditional camera filters and more. www.nikmultimedia.com.

- **OfotoNow, from Ofoto, Inc.:** Demo version for Windows and Macintosh. Use this image-browser to gather and upload photos to an online photo album at Ofoto, an online photo-sharing community. www.ofoto.com.

- **Picture Information Extractor, from PicMeta:** Evaluation version for Windows. If your camera records capture settings as metadata, you can use this nifty program to view the information. See Chapter 4 for more information about metadata. www.picmeta.com.

- **Print Station, from PicMeta:** Evaluation version for Windows. This handy utility simplifies the process of printing multiple images on one sheet of paper. www.picmeta.com.

Catalog/album programs

After you shoot all those digital pictures, you need a way to organize them. The following programs provide you with different approaches to keeping track of your photos:

- **ACDSee, from ACDSystems:** Trial version for Windows and Macintosh. One of the leading image-browsing and management programs around, ACDSee offers a thorough assortment of tools for keeping track of your image files. www.acdsystems.com.

- **FlipAlbum Suite, from E-Book Systems, Inc.:** Trial version for Windows. This program enables you to place your photos into digital photo albums and then easily burn them to a CD that other people can enjoy by downloading a free viewer. www.flipalbum.com.

- **PhotoExplorer, from Ulead Systems:** Trial version for Windows and Macintosh. This full-featured image-cataloging tool enables you to view and manage your digital photo files as well as video clips. www.ulead.com.

- **ThumbsPlus, from Cerious Software, Inc.:** Evaluation version for Windows. This popular shareware program enables you to browse and manage image files using a Windows Explorer-style interface. You can also organize movie files, fonts, and other multimedia files. www. thumbsplus.com.

- **Virtual Album, from Radar Software, Inc.:** Trial version for Windows. Create digital photo albums, photo Web pages, slide shows, and more with this user-friendly software. www.albumsoftware.com.

Images on the CD

I've included an assortment of the original images that I used to create some of the figures and color plates in this book. Figure B-1 provides thumbnail views of the images.

You can open the images inside your photo software by using the same procedure you would to open any other file. All images are stored in Image folder on the CD.

Feel free to use these images in whatever manner you see fit, with the exception of selling them in exchange for fame or fortune. They're my little thank-you gift to you for buying this book. I know, it's not much, but the store didn't have any "I ♥ Julie!" T-shirts in your size.

Web links page

Here's a tool to help you connect quickly to some of my favorite Web sites. The great folks who developed the CD have created a Web page containing all the links mentioned in Chapter 15, as well as links to software companies whose products are on the CD. To use the page, connect to the Internet and start your browser; then choose File⇨Open and open the Web page file (D:\Links.htm if your CD drive is D). You can then just click a link to jump to the corresponding Web site. Cool!

And one last thing. . . .

- **Acrobat Reader from Adobe Systems, Inc.:** Freeware for Windows and Mac. Acrobat Reader is a free program that lets you view and print

Portable Document Format, or PDF, files. Some of the programs on this CD include manuals in PDF format. www.adobe.com.

If you are using Windows, you can find the Adobe Acrobat Reader in the Other Cool Things section of the CD interface.

Figure B-1: You can find these photos in the Images folder on the CD at the back of the book.

If You've Got Problems (Of the CD Kind)

I tried my best to compile programs that work on most computers with the minimum system requirements. Alas, your computer may differ, and some programs may not work properly for some reason.

The two likeliest problems are that you don't have enough memory (RAM) for the programs you want to use, or you have other programs running that are affecting the installation or running of a program. If you get error messages saying that your computer's out of memory or the Setup program can't continue, try one or more of these methods and then try using the software again:

- **Turn off any antivirus software that you have on your computer.** Installers sometimes mimic virus activity and may make your computer incorrectly believe that it is being infected by a virus.

- **Close all running programs.** The more programs you're running, the less memory is available to other programs. Installers also typically update files and programs. So if you keep other programs running, installation may not work properly.

- **In Windows, close the CD interface and run demos or installations directly from Windows Explorer.** The interface itself can tie up system memory or even conflict with certain kinds of interactive demos. Use Windows Explorer to browse the files on the CD and launch installers or demos.

- **Have your local computer store add more RAM to your computer.** This is, admittedly, a drastic and somewhat expensive step. However, adding more memory can really help the speed of your computer and allow more programs to run at the same time.

If you still have trouble installing the items from the CD, please call the Wiley Publishing Customer Service phone number: 800-762-2974 (outside the U.S.: 317-572-3994) or send email to techsupdum@wiley.com.

Index

• *Numerics* •

8-bit images, 42, 161, 199–200, 323
4-megapixel (and up) cameras, 46, 47
96 ppi monitor resolution, 197
"1-button transfer" feature, 69
1-megapixel cameras, 47
1-shot panorama tools, 141
72 ppi monitor resolution, 197
16-bit images, 42, 323
35mm lens, 58, 59
3-megapixel cameras, 46, 47
24-bit images, 42, 199–200, 323
256-color images. *See* GIF (Graphics Interchange Format) format
2-megapixel cameras, 46, 47

• *A* •

AC adapters for cameras, 69, 153
accessories, 93–94
ACDSee (ACDSystems), 334.
 See also installing
ACDSystems
 ACDSee (on the CD), 334
 ACDZip (on the CD), 333
 FotoCanvas (on the CD), 332
 FotoSlate (on the CD), 333
ACDZip (ACDSystems), 333.
 See also installing
Acrobat Reader (Adobe), 335–336.
 See also installing
action shots
 burst mode for, 18, 68, 127, 135–136
 camera options for, 67–68
 camera resolution and, 47, 137
 ISO settings and, 109
 overview, 135–137
 shutter-priority autoexposure for, 111, 137
 tips, 136–137
activating tools (Elements), 250–251, 277

adjustment layers, 234, 295
Adobe. *See also* Adobe Photoshop; Adobe Photoshop Elements
 Acrobat Reader (on the CD), 335–336
 PhotoDeluxe, 16, 87, 88
 Web site, 320
Adobe Photoshop. *See also* Adobe Photoshop Elements
 color-matching utility, 187–188
 Elements versus, 218
 overview, 88–89
 PSD format, 155
 scratch disk full message, 220
 trial version on the CD, 333
Adobe Photoshop Elements. *See also* layers; painting on photos; photo editing; selecting
 activating selection tools, 250–251
 adjustment layers, 234
 Airbrush tool, 276–279
 artistic possibilities with, 274, 302
 backing up photos, 221, 222, 224
 blur filters, 242–244
 brightness/contrast controls, basic, 229–231
 Burn tool, 234
 canvas size, changing, 270–271
 cloning, 267–270
 Color Picker, 283–286
 color-matching utility, 187–188
 cropping images, 226–228
 described, 89
 Dodge tool, 234
 as example software for this book, 218
 Eyedropper tool, 283
 feathering selections, 265–267
 File Browser, 163, 219–220
 focus adjustments using, 237–244
 Gaussian Blur filter, 243–244
 Hue filter, 289–290
 icon in book margins, 6
 image-safety rules, 220–222, 224
 image-stitching (panorama) tool, 139, 140

Adobe Photoshop Elements *(continued)*
 "instant fix" filters, 224–225
 JPEG, saving image as, 208–211
 layers, using, 290–301
 Levels filter, 230, 231–233
 non-transparent GIF, saving image as, 203–205
 opening photos, 218–220
 Options bar, 277, 279
 other photo-editing programs and, 2–3
 Paint Bucket tool, 288–289
 Paintbrush tool, 276–279
 painting on photos, 273–289
 patching, 265–267
 Pencil tool, 276–279
 Photoshop versus, 218
 PSD format, 155
 redoing after undoing, 223–224
 resizing images for screen display, 195–197
 resizing without resampling in, 184–186
 reverting to saved image, 224
 rotating images, 220, 227–228
 scratch disk full message, 220
 selecting colors for painting, 281–286
 selecting portions of images, 248–260
 selection moves, copies, and pastes, 260–264
 selection tools, 249–250
 Sharpen Edges filter, 238, 239
 Sharpen filter, 238, 239
 Sharpen More filter, 238, 239
 sharpening filters, 237–242
 Smudge tool, 279–281
 Sponge tool, 235
 Swatches palette, 282
 transparent GIF, saving image as, 205–208
 trial version on the CD, 333
 undoing mistakes, 222–223
 Unsharp Mask filter, 239–242, 244
 Variations filter, 236–237
AfterShot (Jasc), 87, 332. *See also* installing
Airbrush tool, 276–279
aliasing, 244–245, 323

Aligned option for cloning, 269–270
Amount value for Unsharp Mask filter, 240–241
animation, JPEG versus GIF format and, 200
Anti-aliased option
 Magic Wand, 253
 Magnetic Lasso, 255
 Marquee tools, 252
aperture (f-stops)
 aperture-priority autoexposure, 62, 110, 111
 defined, 37, 38, 323
 depth of field and, 123–124
 in digital cameras, 39–40
 in film cameras, 37–39
 illustrated, 39
aperture-priority autoexposure, 62, 110, 111
Apple. *See also* Macintosh platform
 color models, 286
 iPhoto, 163
ArcSoft Panorama Maker, 139
artifacts, 245, 323
artificial light sources, 115–116.
 See also flash
artistic effects, 274, 302
attaching images to e-mail.
 See e-mailing images
audio recording capabilities, 65
auto flash mode, 57, 112
auto shutdown (power saver), 143
autoexposure
 aperture-priority, 62, 110, 111
 locking, 106, 137
 shutter-priority, 62, 110–111, 137
autofocus, 121–122, 137
automatic bracketing, 63, 114
automatic defaults at power up, 142–143

• *B* •

background color for painting, 281
background of images
 compositing and, 131–132, 133
 composition and, 101, 102

shooting surfaces for compositing, 133
zooming and, 133–134
backing up photos, 221, 222, 224
backlighting, 118–120
batteries, 48, 68, 137, 143
Bicubic resampling, 196
bit, 42, 323
bit depth, 42
black-and-white images, 42
blending modes, 278–279, 287, 293, 295
blooming. *See* blown highlights (blooming)
blotchy images. *See* jagged or
blotchy images
blown highlights (blooming)
CCD versus CMOS chips and, 48
defined, 48
described, 105, 117
removing by cloning, 267–270
removing by painting, 274
blur filters, 242–244, 245
blurred images. *See* camera shake; focus
BMP (Windows Bitmap) format,
161–162, 323
borderless prints, 174
bounce lighting, 116
bracketing, 63, 114
BrainsBreaker (on the CD), 90, 91, 333
brightness. *See also* contrast;
exposure; light
adjusting color channels separately, 233
adjustment layers for, 234
basic controls for adjusting, 229–231
Dodge and Burn tools for, 234
Levels filter for adjusting, 230, 231–233
brightness value, 25
Brightness/Contrast filter, 229–231
Brush option for cloning, 269
built-in memory, 50–51, 53
Burn tool, 234
burst mode
described, 18, 68, 323
resolution and, 127
using, 135–136
business cards, digital photos for, 315
buying a camera
action-oriented options, 67–68
caveats, 11

color perspectives, 64–65
compression schemes, 48, 49–50
computer-like components, 66–67
digital video cameras, 55
discount store bargains, 64
exposure features, 62–63
filters, 61–62
flash capabilities, 56–57
information sources for, 70–71
LCD monitor, 53–54
lenses, 57–62
Macintosh versus Windows and, 46
memory, 50–53
minor features to be aware of, 68–70
multifunction devices, 55, 56
personal nature of, 45
remote-control units, 66
renting before buying, 71
resolution, 46–48
self-timer mechanisms, 65–66
video-out capabilities, 65
Webcams, 55, 56
buying photo printers
choosing printer type, 173–174
comparison shopping, 174–178, 180
byte, 323
byte order for TIFF files, 158

• C •

cable transfer. *See* downloading images
from a camera
cables for printers, 189
calendars, photos on, 314–315
camcorders, digital, 55
camera case, 94
camera resolution
action shots and, 47, 137
buying a camera and, 46–48
capture resolution settings, 126–127, 306
compression and, 48
interpolated, 48
overview, 34–35
camera shake, avoiding, 117, 123, 308
cameras. *See* digital cameras; film cameras

Canon
 photocentric printers, 169
 portable snapshot printers, 173–174
canvas, resizing, 270–271
Canvas Size dialog box (Elements), 270–271
capture resolution. *See* camera resolution
card readers, 80–81
cards, photos on, 314–315
cataloging programs. *See* image-cataloging
 programs
CCD (charge-coupled device) chips, 24,
 48, 323
CD-R or CD-RW burners, 84–85, 86
CD-R or CD-RW discs, 84–85, 86, 160
CD-ROM with this book. *See Digital
 Photography For Dummies, 4th Edition*
 CD-ROM
center-weighted metering, 63, 107, 108, 119
Cerious Software's ThumbsPlus (on the
 CD), 163–164, 165, 335
charge-coupled device chips.
 See CCD chips
children, taking pictures of, 103, 104
CIE Lab color model, 43, 324
Clone Stamp tool, 268
Clone tool, 268
cloning, 267–270, 324
close-up pictures
 LCD monitor for, 53
 macro mode for, 58, 60, 122
 manual focus for, 122
Cloud Dome, 117–118
CMOS (complementary metal-oxide
 semiconductor) chips, 24, 48, 324
CMYK color model
 converting RGB to, 25, 179, 187
 defined, 324
 inkjet printers and, 176
 overview, 42, 179
 for printing, 42, 176, 179, 187
collages. *See* compositing
color
 selecting by, 252–253
 selecting for painting, 281–286
color artifacting, 50
color balance, 235–237

Color blending mode, 278–279, 287
color channels
 adjusting brightness separately, 233
 in CIE Lab color model, 43
 in CMYK color model, 25, 179
 defined, 25
 in grayscale images, 25
 in RGB color model, 25, 26, 41
color correction. *See also* painting
 on photos
 adjustment layers for, 234
 color balance adjustment, 235–237
 color fringing, fixing, 244–245
 color-matching for printing, 186, 187–188
 defined, 324
 Hue filter for, 289–290
 Saturation adjustment, 234–235
color images. *See also* color correction
 bit depth for, 42
 CMYK color model, 25, 42, 176, 179
 color-matching for printing, 186, 187–188
 file size and, 32
 JPEG versus GIF format, 199–200
 RGB color model, 24–26, 41
 sRGB color model, 41
color laser printers, 169–170, 181
color model, 41, 324. *See also specific
 color models*
color perspectives of cameras, 64–65
Color Picker (Elements), 283–286
Color Selector. *See* Magic Wand tool
color space, 41. *See also specific
 color spaces*
color temperatures, 116, 129–130, 324
Color Wand. *See* Magic Wand tool
color-matching for printing, 186, 187–188
ColorSync color-management system, 188
combining two images. *See* compositing
commercial printers, 181–182
CompactFlash cards. *See also* memory
 cards and other camera media
 care and maintenance, 76–77
 described, 51, 52, 75, 324
 download devices for, 79–91
complementary metal-oxide
 semiconductor chips. *See* CMOS chips

compositing
 defined, 131, 324
 filling the frame when shooting, 132
 layers for, 292, 299–301
 plain background for, 131–132
 shooting surfaces for backgrounds, 133
composition
 digital perspective for, 308
 overview, 99–104, 307
 rule of thirds for, 101, 307
compression
 artifacts from, 245
 buying a camera and, 48, 49–50
 camera settings for, 50, 127, 306–307
 color artifacting from, 50
 defined, 48, 49, 324
 downloading images and, 153
 GIF format and, 161, 200
 image quality and, 48, 49–50
 jagged or blotchy images from, 141
 jaggies from, fixing, 244–245
 JPEG format and, 49, 156, 200, 208, 210
 JPEG 2000 format and, 19, 326
 JPEG versus GIF, 200
 lossless, defined, 127
 lossy, defined, 49, 127
 LZW, 153, 158, 161
 "maximum storage capacity" and, 53
 QuickTime, for PICT images, 162
 RLE, 162
 TIFF format and, 153, 158
 for Web images, 157
CompuServe, e-mailing images and, 211
computer-like camera components, 66–67
computers. *See also* screen display
 (computer); system requirements
 camera hookup to, 69–70
 cost, 20
 drawing tablets for, 94–95, 275
 host-based printers and, 177
consumables, 170, 180–181
Contiguous option for Magic Wand, 253
continuous-capture mode. *See* burst mode
contrast, adjusting, 229–231
convergence, 59

Copy command, 261
copying
 adjusting pasted objects, 262–264
 before altering layers, 224
 cloning, 267–270
 resolution differences and image size
 changes, 261
 selection copies, 260–264
 selection to new layer, 297
Corel
 Painter, 275, 276
 PHOTO-PAINT, 88–89
 Presentations, 193
cropping images, 225–228
Cut command, 261
cutting. *See* deleting; moving

• D •

DAM (digital asset management), 82–83, 90.
 See also storing images
databases, 15, 315
DeBat, Alfred (technical editor), 93
defaults, automatic at power up, 142–143
deleting
 erasing parts of images, 206, 297, 299
 fastening points (Elements), 255
 image areas for transparent GIF
 format, 206
 images on camera, 53, 54
 layers, 296
 selected areas, 264
 selections on layers, 297
depth of field
 aperture and, 123–124
 aperture-priority autoexposure for, 111
 defined, 324
 focal length and, 60
 zooming and, 124, 133, 134
deselecting entire photo, 256–257
Despeckle filter, 244–245
Digita scripting, 67
digital asset management. *See* DAM;
 storing images

digital cameras. *See also* buying a camera
 advantages of, 12–17, 311–316
 annoying "features," 142–143
 development of, 1
 disadvantages of, 18–19
 film cameras versus, 13, 15, 17, 18–19
 f-stop settings, 39–40
 grayscale or sepia option on, 43
 image-creation technology, 23–24
 manufacturer Web sites, 320
 opening images directly from, 220
 printing directly from, 67, 177–178
 reading the manual, 310
 resolution of, 34–35, 46–48
 shutter speed settings, 39–40
 TWAIN drivers for, 151
 video-out capabilities, 65, 153–155
digital images
 advantages of, 12–17, 311–316
 on the CD-ROM, 335, 336
 defined, 12
 film or print images versus, 13–17
 film-and-scanner approach, 12–13
Digital Photography For Dummies, 4th Edition
 CD-ROM
 Adobe Acrobat Reader on, 335–336
 catalog/album programs on, 163–165,
 334–335
 icon in book margins, 6
 images on, 335, 336
 installing items from, 330–331
 overview, 5
 photo-editing software on, 218, 332–333
 specialty software on, 90–91, 92, 333–334
 system requirements, 329–330
 troubleshooting, 337
 using on Macintosh platform, 331–332
 Web links page, 335
Digital Photography For Dummies, 4th Edition
 (King, Julie)
 assumptions about the reader, 3
 conventions, 607
 icons in book margins, 5–6
 need for, 2
 organization, 3–5
 overview, 2–3
 using, 7

digital print order format. *See* DPOF
Digital ROC (on the CD), 333
Digital SHO (on the CD), 333
digital video cameras, 55
Digital Video For Dummies (Doucette,
 Martin), 55
digital zoom, 59, 133, 134–135
digitization, 12
direct printing, 67, 177–178
discussion groups, 319–320
dithering, 204, 205
docking stations for cameras, 82
Dodge tool, 234
Doucette, Martin (*Digital Video For
 Dummies*), 55
downloading images from a camera
 cable transfer, 77–78, 148, 149–151,
 152–153
 camera as hard drive, 152
 defined, 324
 download devices, 77–82
 image-transfer software for, 149, 220
 IrDA transfer, 69, 70, 148–149
 memory card transfer, 77–82, 148
 on-board storage versus removable
 media and, 51–52
 tips, 152–153
 TWAIN drivers for, 151
downsampling, 32, 33, 184. *See also*
 resampling
dpi (dots per inch), 35, 175, 184, 324
DPOF (digital print order format), 178, 324
dpreview.com, 318
drawing freehand selections, 253–254
drawing tablets (computer), 94–95, 275
drivers
 for PIM technology, 186
 printer software, 187, 189
 TWAIN, 151
dual lenses, 58
durability of camera, 69
DVD players for image display,
 153–155, 193
DVD-R or DVD-RW burners, 85
dye-sub (thermal dye) printers, 170, 171,
 172–173, 181, 325

• *E* •

ease of use
 buying a camera and, 69
 as digital camera drawback, 18–19
E-Book Systems' FlipAlbum Suite (on the
 CD), 164–165, 334
Edge Contrast option for Magnetic
 Lasso, 256
edges. *See also* sharpening
 defined, 254, 325
 fastening points (Elements), 255
 feathering selections, 265–267
 selecting by, 254–256
editing. *See* photo editing
8-bit images, 42, 161, 199–200, 323
electronic viewfinders. *See* viewfinders
Elements. *See* Adobe Photoshop Elements
Elements How-To icon, 6
Elliptical Marquee tool, 249, 251–252
e-mailing images
 benefits of, 192, 211, 312
 digital camera advantages for, 14–15
 JPEG format for, 211
 platform and software issues for, 211,
 212–213
 for professional graphics purposes, 212
 using Netscape Communicator 4.0 for, 212
employee badges, digital photos for, 315
EPS (Encapsulated PostScript) format, 162
Epson
 photocentric printers, 169
 Print Image Matching (PIM)
 technology, 186
 Software Film Factory, 186
 Stylus Photo 1280 printer, 168, 174
 Stylus Photo 2200P printer, 172
 Stylus Photo 2000P printer, 172
Eraser tool, 206, 297, 299
EV (exposure value) compensation, 62–63,
 109–110, 325
exchange policy for cameras, 70
EXIF (Exchangeable Image Format), 92, 157
exposure. *See also* aperture (f-stops);
 brightness; light; shutter speed

aperture-priority autoexposure, 62,
 110, 111
 bracketing, 63, 114
 camera features, 62–63
 defined, 37, 106
 EV compensation, 62–63, 109–110
 fixing exposure and contrast, 228–234
 ISO ratings, 40–41, 63, 107–109, 141
 LCD monitors and, 114
 locking, 106, 137, 139
 metering modes, 63, 107, 108, 110, 119
 overexposure, 37
 for panoramas, 139–140
 shutter-priority autoexposure, 62,
 110–111, 137
 underexposure, 37
external flash, 57, 114, 307
Eyedropper tool (Elements), 283

• *F* •

fastening points (Elements), 255
Feather option
 Magnetic Lasso, 255
 Marquee tools, 251–252
feathering selections, 265–267
File Browser (Elements), 219–220
file formats. *See also* compression; GIF
 (Graphics Interchange Format) format;
 JPEG (Joint Photographic Experts
 Group) format; *specific formats*
 BMP, 161–162, 323
 choosing when taking pictures, 128–129
 defined, 155, 325
 downloading images and, 149, 153
 EPS, 162
 FlashPix, 129, 160–161, 325
 GIF89a, 161
 JPEG (EXIF), 92, 157
 JPEG 2000, 159, 326
 native format for photo-editing software,
 221, 295
 overview, 155
 Photo CD, 160, 327
 PICT, 162, 327

file formats *(continued)*
 PNG, 161
 proprietary, 128, 149, 155, 220
 PSD, 155
 RAW, 159–160, 327
 for saving images, 221–222
 TIFF, 128, 153, 157–159, 328
file size
 color versus grayscale images, 32
 compression and image quality, 48, 127
 file format and, 128
 JPEG versus GIF format and, 200
 layers and, 293
 pixel dimensions and, 32, 36
 RAM requirements and, 32
 transparent GIF and, 202
Fill dialog box (Elements), 287–288
fill flash mode, 57, 112
Fill tool, 288–289
filling selections with color, 286–289
film cameras
 aperture, f-stops, and shutter speeds in, 37–39
 digital cameras versus, 13, 15, 17, 18–19
 film-and-scanner approach to digital imagery, 12–13
 image-creation process, 23
film speed. *See* ISO ratings
filters (camera), 61–62, 130
filters (photo editing)
 for artistic effects, 302
 blur filters, 242–244, 245
 Brightness/Contrast filter, 229–231
 Despeckle/Remove Noise filter, 244–245
 Gaussian Blur filter, 243–244, 325
 Hue filter, 289–290
 "instant fix," 224–225
 Levels filter, 230, 231–233
 sharpening filters, 237–242
 Unsharp Mask filter, 239–242, 244
 Variations filter, 236–237
Finger Painting option of Smudge tool, 280
fixed-focus cameras, 60, 120–121
flash
 for action shots, 137
 auto flash mode, 57, 112
 buying a camera and, 56–57
 external, 57, 114, 307
 fill flash mode, 57, 112
 no flash mode, 57, 112
 raising or lowering intensity of, 57
 red-eye reduction mode, 57, 112–114
 shiny objects and, 117
 slow-sync flash mode, 57, 114
 taking pictures with, 111–114, 307
FlashPix file format, 129, 160–161, 325
flattening layers, 293–294, 296
FlipAlbum Suite (E-Book Systems), 164–165, 334. *See also* installing
flipping pasted objects, 264
floppy disks. *See also* memory cards and other camera media
 adapters for memory cards, 79
 as camera storage media, 51, 52, 75, 148
 as long-term storage media, 83, 85
 photo editing and, 221
focal length of lenses, 58–59, 60
focus
 adjusting in photo-editing software, 237–244
 autofocus, using, 121–122
 blur filters for, 242–244
 fixed-focus cameras, 60, 120–121
 landscape mode, 60, 122
 locking, 121, 137
 macro mode, 58, 60, 122
 manual, 60, 122
 manual sharpening adjustments, 239–242
 multi-spot autofocus, 121
 for panoramas, 139
 sharpening filters for, 237–242
 single-spot autofocus, 121, 122
focus-free (fixed-focus) cameras, 60, 120–121
folders, organizing photos in, 163
foreground color for painting, 281
FotoCanvas (ACDSystems), 332. *See also* installing
FotoSlate (ACDSystems), 333. *See also* installing
four megapixel (and up) cameras, 47
Freehand tool. *See* Lasso tool

Frequency option for Magnetic Lasso, 256
f-stops. *See* aperture
Fujifilm
 FinePix 601 Zoom, 12
 Web site, 320

• G •

Gamma control, 232
gamut, 41, 325
Gaussian Blur filter, 243–244, 325
GIF (Graphics Interchange Format) format
 animated images, 200
 color concerns, 199–200
 defined, 325
 interlaced (gradual) display, 201
 JPEG format versus (for Web images),
 199–201
 non-transparent GIF (GIF87a), 202, 203–205
 overview, 161
 saving images in non-transparent format,
 203–205
 saving images in transparent format,
 205–208
 transparent GIF (GIF89a), 161, 202,
 205–208, 328
gigabyte, 325
grain. *See also* noise
 defined, 40
 ISO ratings and, 40–41, 63, 108, 141
 low light and, 141
grayscale images
 black-and-white images versus, 42
 camera option for, 43
 converting RGB to, 25
 defined, 42, 325
 file size and, 32
 power of, 43

• H •

halos
 fixing, 244–245
 from sharpening, 238

hard drives
 camera as, 152
 camera resolution and storage
 requirements, 47
 requirements for photo editing, 20, 220
"head room," rule about, 103
Hewlett-Packard
 photocentric printers, 169
 P100 portable snapshot printer,
 173–174, 175
 psc 950 multipurpose printer, 174
 Web site, 320
High Point control, 232
highlights. *See also* blown
 highlights (blooming)
 adjusting with Levels filter, 232–233
 CCD versus CMOS chips and, 48
histogram, 231, 232, 325
Hoodman LCD hoods, 93
host-based printing, 177
HP. *See* Hewlett-Packard
HSB color model, 43, 325
HSL color model, 43, 286, 325
Hue filter, 289–290
Hue/Saturation dialog box (Elements), 290

• I •

IBM Microdrive, 76, 79, 80. *See also*
 memory cards and other
 camera media
icons in margins of this book, 5–6
image editing. *See* photo editing
image quality
 camera price and, 18, 19–20
 compression and, 48, 49–50, 127
 digital zoom and, 59
 downsampling and, 33, 184
 file format and, 128
 "maximum storage capacity" and, 53
 paper and, 180–181, 188
 printer options, 175–176
 resolution and, 28–30, 31, 36, 126
 upsampling and, 33, 184
Image Size dialog box (Elements), 184–186,
 195–196

image size (for prints). *See* print size
image size (resolution). *See* pixel
 dimensions; resolution of images
image-cataloging programs, 90, 151,
 334–335
image-stitching programs, 90, 139. *See also*
 panoramas
imaging-resource.com, 318
inches, resizing screen images in, 197
infinity lock, 122
infrared transfer, 69, 70, 148–149
inkjet printers, 168–169, 172–173, 176, 180
installing items from CD-ROM
 on the Macintosh, 331–332
 troubleshooting, 337
 in Windows, 330–331
"instant fix" filters, 224–225
intensity (Saturation) of colors, 234–235
interchangeable lenses, 61–62
interlaced GIF images, 201
Internet resources. *See* Web resources
interpolated resolution, 35, 48
Intuos 2 drawing tablets (Wacom), 95
inverting selections, 257–258
Iomega Zip drives, 83, 85
iPhoto (Apple), 163
IrDA for image transfer, 69, 70, 148–149
ISO ratings
 buying a camera and, 63
 choosing settings for, 108–109
 defined, 325
 light variations and, 105
 noise or grain and, 40–41, 63, 108, 141
 overview, 40–41, 107

• *J* •

jagged or blotchy images
 avoiding, 141–142
 editing, 244–245
 fixing with cloning, 267–270
jaggies, 244, 326. *See also* jagged
 or blotchy images
Jasc
 AfterShot (on the CD), 87, 332
 Paint Shop Pro (on the CD), 89, 332

JPEG compression. *See* compression
JPEG (Joint Photographic Experts
 Group) format
color concerns, 199–200
defined, 49, 156, 326
for e-mailing images, 211
EXIF format, 92, 157
GIF format versus (for Web images),
 199–201
JPEG 2000, 159, 326
overview, 156–157
PICT format versus, 162
progressive (gradual) display, 201
QuickTime compression for PICT
 images, 162
saving images in, 208–211
transparency and, 200, 210

• *K* •

Kaidan
 KiWi+ Panoramic Tripod Head, 140, 141
 one-shot panorama tools, 141
Kelvin scale, 326
keyboard shortcuts, conventions for, 7
kilobyte, 326
King, Julie (*Photo Retouching & Restoration
 For Dummies*), 4, 218
KiWi+ Panoramic Tripod Head (Kaidan),
 140, 141
Kodak
 EasyShare docking station, 82
 EZ200, 55, 56
 Web site, 320

• *L* •

lag time between shots, 18, 68
landscape mode
 in cameras, 60, 122
 in printers, 182
laser printers, 169–170, 181
Lasso tool, 249, 253–254
layers. *See also* Layers palette (Elements)
 active layer, 295
 adding, 296

adjusting pasted objects, 262–264
adjustment layers, 234, 295
 advantages of, 291–293
 blending modes and, 293, 295
 cloning with all layers, 270
 composite image, 291
 compositing (collages) using, 292,
 299–301
 converting background layer to standard
 layer, 206
 copying before altering, 224
 deleting entire layers, 296
 deleting selections on, 297
 editing multilayered images, 296–299
 erasing on, 297, 299
 file size and, 293
 flattening or merging, 293–294, 296
 Layers palette (Elements), 294–299
 locking, 295
 main discussion, 290–301
 moving, 299
 opacity of, 292–293
 retaining when saving images, 263, 295
 selecting entire layer, 297
 selecting part of layer, 297
 stacking order, 291, 297
 transforming, 299
 transparent areas in, 206, 262
 using in Elements, 294–299
Layers palette (Elements), 295–299
LCD (liquid-crystal display) monitor
 buying a camera and, 53–54, 64
 color perspective of camera and, 64
 defined, 326
 exposure and, 111
 hoods for, 93, 143
 optical viewfinders versus, 53–54
 parallax errors avoided by, 105, 133
 washed-out, 143
 zooming and, 133
lens adapters, 93
lenses
 buying a camera and, 57–62
 dual, 58
 fixed-focus, 60, 120–121
 focal length, 58–59, 60

focusing aids, 60
 interchangeable, 61–62, 93
 optical versus digital zoom, 59, 133, 134
 rotating, 61
 telephoto, 58, 133–134
 35mm, 58, 59
 wide-angle, 58, 59, 133–134
 zoom lenses, 58, 133–134
Lenses for photo editing. *See* layers
Levels filter, 230, 231–233
Lexar Media JumpShot cable, 81
light. *See also* brightness; contrast;
 exposure
 artificial sources, using, 115–116
 backlighting, compensating for, 118–120
 bounce lighting, 116
 CCD versus CMOS chips and, 48
 color temperatures, 116, 129–130
 exposure and, 37
 flash, 56–57, 111–114, 307
 grain and low light, 141
 ISO ratings, 40–41, 63, 107–109, 141
 LCDs and bright light, 54, 143
 metering modes, 63, 107, 108, 110, 119
 overview, 105–106
 for shiny objects, 116–118
 strong sunlight, shooting in, 120
 tripod for low light, 69
 white balance, 61, 116, 129–130
light dome or tent, 93–94
line art, 42
liquid-crystal display monitor.
 See LCD monitor
locking
 autoexposure, 106
 autofocus, 121, 137
 exposure, 106, 137, 139
 layer contents, 295
long-term storage. *See* storing images
lossless compression
 defined, 127, 326
 GIF format, 161, 200
 LZW, 153, 158, 161
 RLE, 162
 TIFF format, 153, 158

lossy compression
 defined, 49, 127, 326
 JPEG format, 49, 156, 200, 208
Low Point control, 232
LZW compression, 153, 158, 161

• *M* •

Macintosh platform
 author's platform neutrality, 3
 buying a camera and, 46
 Color Picker (Elements), 285–286
 downloading images, 150–151, 152, 153
 installing items from CD-ROM, 331–332
 monitor ppi setting, default, 197
 photo-file browser, 163
 TIFF file byte order, 158
macro mode, 58, 60, 122
magazines, online, 318–319
Magic Wand tool, 249, 252–253
Magnetic Lasso tool, 249, 254–256
manual exposure, 62
manual focus, 60, 122
manual for camera, reading, 310
manufacturer Web sites, 320
marching ants, 249
marquee for selection outlines, 249, 326
masks (selection outlines), 249
matrix metering, 63, 107, 108
Matte option (Elements), transparency
 and, 207–208, 210
Maxtor external hard drives, 83
megabyte, 326
megapixel magazine, 318
megapixel resolution, 35, 46, 47, 326
memory, built-in or on-board, 50–51, 53
memory cards and other camera media.
 See also specific types
 buying a camera and, 52–53
 camera resolution and storage
 requirements, 47, 74, 126
 capacities, 20, 52
 costs, 20, 75–76
 download devices, 77–82
 downloading images and, 52

 "maximum storage capacity" and, 53
 on-board memory versus, 51–52
 overview, 74–77
 photo editing and, 221
 printing directly from, 67, 177–178
 types of, 51, 52, 74–76
memory (computer). *See* RAM
Memory Stick (Sony), 51, 52, 76, 79–91, 326.
 See also memory cards and other
 camera media
menu conventions in this book, 6
merging layers, 293–294, 296
metadata, 92, 157, 326
metering modes
 backlighting and, 119
 buying a camera and, 63
 choosing for taking pictures, 107, 108
 defined, 326–327
 EV compensation with, 110
 overview, 63, 107
MGI Software's Photovista Panorama, 139
Microsoft
 Picture It!, 87
 PowerPoint, 193
 Windows Explorer, 163
Microsoft Windows platform. *See* PC
 platform
Microtech USB CameraMate, 80, 81
Midpoint control, 232
midtones, adjusting, 232, 233
mini CD-R or CD-RW, 51, 52, 76, 78.
 See also memory cards and
 other camera media
Minolta Dimage X, 12
Mode option for cloning, 269
monitor (camera). *See* LCD (liquid-crystal
 display) monitor
monitor (computer). *See* screen display
 (computer)
motion blur, 111. *See also* camera shake
movie recording camera features, 68
moving
 adjusting pasted objects, 262–264
 layers, 299
 resolution differences and image size
 changes, 261

selection moves, 260–264
selection outlines, 259–260
moving targets. *See* action shots
mugs, printing on, 314
multifunction devices, 55–56
multiple Undo, 222–223
multipurpose printers, 174, 180
multizone (matrix) metering, 63, 107, 108

• *N* •

nametags, digital photos for, 315
native format for photo-editing software, 221, 295
Netscape Communicator 4.0, e-mailing images using, 212
newsgroups, 319–320
nik multimedia
 Color Efex Pro! (on the CD), 334
 Sharpener Pro! (on the CD), 334
Nikon
 Coolpix line of cameras, 61
 Coolpix 2500, 12
96 ppi monitor resolution, 197
no flash mode, 57, 112
noise. *See also* grain
 defined, 327
 fixing, 244–245
 ISO ratings and, 40–41, 63, 108
Normal blending mode, 278
NTSC (National Television Standards Committee) output, 65, 155, 327

• *O* •

Objects. *See* layers
Ofoto
 OfotoNow (on the CD), 334
 photo-sharing service, 192
 print service, 182
Olympus
 Camedia C-211 Zoom, 55, 56
 D-520 Zoom, 12
 E-20, 60, 66
 P-400 printer, 170, 171, 172
 portable snapshot printers, 173–174

On the CD icon, 6
on-board image correction, 67, 142, 151, 220
on-board memory, 50–51, 53
one megapixel cameras, 47
"one-button transfer" feature, 69
one-shot panorama tools, 141
online albums, 192, 313
online resources. *See* Web resources
on-screen display. *See* LCD (liquid-crystal display) monitor; screen display (computer)
opacity. *See also* transparency
 cloning option, 269
 of layers, 292–293
 of paint strokes, 278
opening photos for editing, 218–220
optical resolution of scanners, 35
optical viewfinders. *See* viewfinders
optical zoom
 background of images and, 133–134
 defined, 59, 133
 depth of field and, 124, 133
 digital zoom versus, 59, 133, 134
 parallax errors, avoiding, 133
 shooting with, 133–134
 zoom lenses, 58, 133–134
organization tools for images, 162–165
output resolution. *See* resolution of images
oval areas, selecting, 251–252
overexposure, 37. *See also* exposure

• *P* •

Paint Bucket tool (Elements), 288–289
Paint Shop Pro (Jasc), 89, 332.
 See also installing
Paintbrush tool, 276–279
Painter (Corel), 275, 276
painting on photos
 Airbrush tool for, 276–279
 blending modes, 278–279, 287
 drawing tablets for, 275
 filling selections with color, 286–289
 opacity of paint, 278
 Paintbrush tool for, 276–279

painting on photos *(continued)*
 Pencil tool for, 276–279
 selecting colors for, 281–286
 Smudge tool for, 279–281
 software for, 275, 276
 strokes, 275, 276, 277, 278
 uses for, 273, 274–275
PAL (phase alteration line-rate), 65,
 155, 327
Panorama Maker (ArcSoft), 139
panorama mode, 139
panoramas, 90, 138–140, 141
paper for prints, 180–181, 188, 309
parallax errors, avoiding, 104–105, 133
parallel port card reader connection, 80–81
pass-through connections for printer,
 80–81, 189
Paste command, 261
pasting. *See* copying; moving
patching, 265–267
PC Cards (PCMCIA Cards), 75, 79–80, 327.
 See also memory cards and other
 camera media
PC Photo magazine, 318
PC platform
 author's platform neutrality, 3
 buying a camera and, 46
 Color Picker (Elements), 284–285
 downloading images, 150–151, 152, 153
 installing items from CD-ROM, 330–331
 monitor ppi setting, default, 197
 photo-file browser, 163
 TIFF file byte order, 158
 USB support and Windows versions, 46,
 70, 78, 150
pcphotoreview.com, 318–319
peimag.com, 319
Pen Pressure option for Magnetic
 Lasso, 256
Pencil tool, 276–279
phase alteration line-rate. *See* PAL
Photo CD format, 160, 327
photo editing. *See also* layers; painting on
 photos; resizing; selecting
 adjustment layers, 234

advantages of, 308–309
for artistic effects, 274, 302
automatic sharpening filters, 238–239
backing up photos, 221, 222, 224
basic rules of success, 224–225
blur filters, 242–244, 245
Burn tool, 234
canvas size, changing, 270–271
cloning, 267–270
color balance adjustment, 235–237
color correction, 234–237
cropping, 225–228
deleting selected areas, 264
digital camera advantages for, 13–14
Dodge tool, 234
exposure and contrast adjustments,
 228–234
feathering selections, 265–267
focus adjustments, 237–244
fun with, 16
hard drive space requirements, 20, 220
Hue filter, 289–290
image-safety rules, 220–222, 224
"instant fix" filters, 224–225
jaggies, fixing, 244–245
layers for, 290–301
Levels filter, 230, 231–233
manual sharpening adjustments, 239–242
noise, fixing, 244–245
opening photos, 218–220
painting on photos, 273–289
patching, 265–267
RAM requirements, 20, 220
redoing after undoing, 223–224
reverting to saved image, 224
rotating images, 220, 227–228, 263–264
Saturation adjustment, 234–235
selecting, 248–260
selection moves, copies, and pastes,
 260–264
sharpening, 237–244
truthfulness and, 247
undoing mistakes, 222–223
Variations filter, 236–237
Photo Electronic Imaging magazine, 319

photo organization tools
 browsers in operating systems, 163
 browsers in photo-editing programs, 163
 folders as, 163
 image-cataloging programs, 90, 151,
 163–165
 need for, 162
 stand-alone programs, 163–165
photo printers. *See* printers
*Photo Retouching & Restoration For
 Dummies* (King, Julie), 4, 218
PhotoDeluxe (Adobe), 16, 87, 88
photo-editing software. *See also* Adobe
 Photoshop Elements; *specific programs*
 Adobe Photoshop Elements
 examples, 218
 advanced programs, 88–90
 on the CD-ROM, 332–333
 color-matching utilities with, 186, 187–188
 demo versions on the CD, 218
 entry-level programs, 87–88
 included with cameras, 70
 native format for, 221, 295
 TWAIN compliant, 151
 Web optimization utilities in, 201
PhotoExplorer (Ulead), 334. *See also*
 installing
PhotoExpress (Ulead), 87, 333. *See also*
 installing
PhotoImpact (Ulead), 89, 333. *See also*
 installing
PHOTO-PAINT (Corel), 88–89
photo-sharing Web sites, 192
Photoshop. *See* Adobe Photoshop
Photoshop Elements. *See* Adobe
 Photoshop Elements
Photovista Panorama (MGI Software), 139
physical fit of camera, 69
PicMeta
 Picture Information Extractor (on the
 CD), 92, 334
 Print Station (on the CD), 90, 91, 334
PICT file format, 162, 327
Picture CD, 160
Picture Information Extractor (PicMeta),
 92, 334. *See also* installing

Picture It! (Microsoft), 87
picture taking. *See* taking pictures
PIM (Print Image Matching)
 technology, 186
pixel dimensions. *See also* resizing;
 resolution; resolution of images
 camera setting for, 31, 36
 computer screen display and, 30, 126,
 193–195
 defined, 27, 196
 file size and, 32, 36
 print size and, 31, 36
 for Web images, 31, 126, 194
pixelated images, 141
pixels. *See also* ppi (pixels per inch);
 resolution
 cloning, 267–270
 defined, 27, 327
 resolution and pixel size, 28–30, 36
platforms, 327. *See also* Macintosh
 platform; PC platform
PNG (Portable Network Graphics)
 format, 161
Polygonal Lasso tool, 249, 253–254
portable snapshot printers, 173–174
portrait mode
 cameras, 60
 printers, 182
PowerPoint (Microsoft), 193
ppi (pixels per inch). *See also* pixel
 dimensions; resolution of images
 default settings for Macintosh and
 PC monitors, 197
 defined, 327
 dpi versus, 35, 184
 file size and, 32
 print quality and, 28–30, 31, 184
 print size and, 184
 scanner resolution, 35
 setting for printing, 184
Presentations (Corel), 193
pressure options
 Magnetic Lasso tool, 256
 Smudge tool, 280

Print Image Matching technology. *See* PIM technology
print services, 181–182
print size
 adjusting when printing, 183–187
 camera resolution and, 47
 defined, 27
 output resolution and, 184
 pixel dimensions and, 31, 36
print speed, 176
Print Station (PicMeta), 90, 91, 334.
 See also installing
printer resolution, 35, 184
printers. *See also* printing; prints
 buying, 173–178, 180
 camera hookup to, 69–70
 costs, 21
 dye-sub (thermal dye), 170, 171, 172–173, 181
 host-based, 177
 inkjet, 168–169, 172–173, 176, 180
 laser, 169–170, 181
 memory card slots in, 82
 multipurpose, 174, 180
 overview, 21, 167–168
 paper options for, 180–181
 pass-through connections, 80–81, 189
 portable (snapshot), 173–174
 print life issues, 171–173
 Thermo-Autochrome, 170–171
printing
 archival, 172–173
 basic process, 182–183
 calendars and cards, 314–315
 CMYK color model for, 42, 176, 179, 187
 color matching, 186, 187–188
 directly from camera or memory card, 67, 177–178
 host-based, 177
 on mugs, T-shirts, and other objects, 314
 paper for, 180–181, 188, 309
 portrait versus landscape mode, 182
 print size and resolution for, 183–187
 by professional printers, 181–182
 tips, 188–189

prints
 borderless, 174
 calculating output resolution for, 31, 36
 camera resolution and print size, 47
 for framing, 316
 output resolution and quality of, 28–30, 31, 36, 47
 paper options for, 180–181
 from photo printers, life of, 171–173
 pixel dimensions and print size, 31, 36
 screen display versus, 191–193
 storage and display guidelines, 172
professional printers, 181–182
programs. *See* software; *specific programs*
progressive JPEG images, 201
proprietary file formats, 128, 149, 155, 220
PSD format, 155

• *Q* •

QuickTime compression for PICT images, 162

• *R* •

Radar Software's Virtual Album (on the CD), 335
Radius value for Unsharp Mask filter, 241, 242
RAM
 file size and requirements for, 32, 36
 requirements for photo editing, 20, 220
RAW file format, 159–160, 327
recording images on VCRs, 154–155
rectangular areas, selecting, 251–252
Rectangular Marquee tool, 249, 251–252
red-eye
 cloning to eliminate, 270
 painting to eliminate, 274, 277
 red-eye reduction mode, 57, 112–114
Redo command, 223–224
redoing, 223–224
Remember icon, 6
remote-control feature, 66, 123

removable media. *See* memory cards and other camera media
Remove Noise filter, 244–245
renting before buying, 71
resampling
 for adjusting print size, 184
 defined, 327
 downsampling, 32, 33, 184
 overview, 32–33
 resizing images for screen display, 195–196
 resizing without, 34, 36, 184–187
 upsampling, 32, 33, 184
resizing. *See also* resampling
 adjusting print size, 183–187
 apparent, when pasting selections, 261
 canvas for images, 270–271
 cropping, 225–228
 in inches for screen display, 197
 pasted objects, 264
 for screen display, 195–197
 without resampling, 34, 36, 184–187
resolution. *See also* camera resolution; resolution of images
 of computer monitor, 30, 35, 193–195
 defined, 327
 digital zoom and, 59
 of printers, 35, 184
 of scanners, 35
resolution of images. *See also* camera resolution; pixel dimensions
 adjusting when printing, 183–187
 blocky (pixelated) images and, 141
 calculating output resolution, 31, 36
 camera resolution and, 31, 34
 choosing when taking pictures, 126–127, 306
 features requiring lower resolutions, 127
 file size and, 32, 36
 main discussion, 27–36
 on-screen picture quality and, 30
 pasting images and, 261
 pixel size and, 28–30, 36
 print quality and, 28–30, 31, 36, 184
 resampling to increase or decrease, 32–33
 summary, 36

restocking fees, 70, 178
Revert command, 224
reverting to saved image, 224
reviewing images on camera, 53, 54, 137
RGB color model
 Apple, 286
 color channels, 25, 26
 converting to CMYK, 25, 179, 187
 converting to grayscale, 25
 defined, 25, 328
 overview, 24–26, 41
 sRGB, 41
RLE (Run-Length Encoding) compression, 162
rotating images, 220, 227–228, 263–264
rotating lenses, 61
Rubber Stamp tool, 268
rule of thirds for composition, 101, 307

• *S* •

sales materials, photos in, 313
Saturation adjustment, 234–235
Save for Web dialog box (Elements), 203–205, 207–208, 209–211
saving image files. *See also* storing images
 backing up photos, 221, 222, 224
 formats for, 221–222
 image-safety rules, 220–222, 224
 in JPEG format, 208–211
 metadata and, 157
 in native format when editing, 221, 295
 in non-transparent GIF format, 203–205
 retaining layers, 263, 295
 in transparent GIF format, 205–208
scanner resolution, 35
scanners, 12, 17
scratch disk full message, 220
screen (camera). *See* LCD (liquid-crystal display) monitor
screen display (computer). *See also* Web images
 color matching for printing, 186, 187–188
 monitor or screen resolution, 30, 35, 193–195

screen display *(continued)*
 picture size and monitor resolution,
 193–195
 pixel dimensions and, 30, 126
 prints versus, 191–193
 resizing images for, 195–197
 resolution and, 30
screen savers, 193
SD (Secure Digital) cards, 51, 52, 76, 79–91.
 See also memory cards and other
 camera media
selecting
 activating selection tools, 250–251
 adjusting pasted objects, 262–264
 by color, 252–253
 colors for painting, 281–286
 deleting selected areas, 264
 deselecting entire photo, 256–257
 drawing freehand selections, 253–254
 by edges, 254–256
 entire layer, 297
 entire photo, 256–257
 feathering selections, 265–267
 filling selections with color, 286–289
 inverting selections, 257–258
 part of layer, 297
 rectangular and oval areas, 251–252
 refining selection outlines, 258–260
 selection outlines, 248, 249
 tools for, 249–250
 uses for, 248–249
Selection Brush tool (Elements), 249
selection moves, copies, and pastes,
 260–264
selection outlines. *See also* selecting
 feathering, 265–267
 overview, 248, 249
 refining, 258–260
self-timer feature, 65–66, 123
sepia tone images, 43
serial cable, downloading images using,
 148, 149–151, 152
service bureaus, 182
Seurat, Georges (painter), 27
72 ppi monitor resolution, 197
shadows, adjusting, 232, 233

sharpening
 automatic sharpening filters for, 238–239
 blur filters for, 242–244
 defined, 328
 halos, 238
 manual adjustments, 239–242
 on-board, 142
 Sharpen Edges filter, 238, 239
 Sharpen filter, 238, 239
 Sharpen More filter, 238, 239
 Unsharp Mask filter, 239–242, 244
shiny objects, lighting, 116–118
shooting photos. *See* taking pictures
shutter button, 37, 123
shutter speed
 defined, 37, 328
 in digital cameras, 39–40
 in film cameras, 37, 38
 shutter-priority autoexposure, 62,
 110–111, 137
Shutterbug magazine, 71, 319
shutterbugs, 37
Shutterfly print service, 182
shutter-priority autoexposure, 62,
 110–111, 137
single-spot autofocus, 121, 122
16-bit images, 42, 323
size. *See* file size; pixel dimensions; print
 size; resizing
skills, requirements for digital
 photography, 18
slave flash units, 114
slow-sync flash mode, 57, 114
SmartMedia cards. *See also* memory cards
 and other camera media
 care and maintenance, 76–77
 described, 51, 52, 75, 328
 download devices for, 79–91
smoothing selection outlines, 260
Smudge tool, 279–281
snapshot printers, 173–174
software. *See also* drivers; photo-editing
 software; *specific programs*
 advanced photo-editing programs, 88–90
 on the CD-ROM, 332–335
 color-matching, 186, 188

demos and trial versions on the CD, 90
entry-level photo-editing programs, 87–88
image-cataloging programs, 90, 151,
 334–335
image-stitching programs, 90, 139
image-transfer programs, 149, 220
included with cameras, 70
one-shot panorama tools, 141
painting programs, 275, 276
photo organization tools, 162–165
photo-utility software, 90
specialty programs, 90–91, 333–334
Web optimization utilities, 201
Software Film Factory (Epson), 186
Solid State Floppy Disk Cards.
 See SmartMedia cards
Sony
 CD Mavica cameras, 76, 78
 Digital Mavica cameras, 75, 78
 DPP-SV77 portable snapshot printer,
 173–174, 175
 DSC-F707 Cyber-shot, 12
 Memory Stick, 51, 52, 76, 79–91, 326
specialty software, 90–91, 92, 333–334
Sponge tool, 235
spot metering, 63, 107, 108, 119
Sprites. *See* layers
sRGB color model, 41
SSFDC cards. *See* SmartMedia cards
stacking order of layers, 291, 297
stitching images together. *See* panoramas
storing images
 on CD discs, 84–85, 86
 digital asset management, 82–83
 on DVD discs, 85
 on external hard drives, 83, 85
 on floppy disks, 83, 85
 life expectancy of media, 85
 photo organization tools, 162–165
 prints, 172
 on super floppies, 83, 85
 swapping images and, 85
Strength option of Smudge tool, 280
Style option for Marquee tools, 252
Stylus Pressure option for Magnetic
 Lasso, 256

super floppies, 83, 85
Swatches palette (Elements), 282
system requirements
 for CD-ROM with this book, 329–330
 for digital photography, 20
 hard drive storage, 20, 47, 220
 RAM for photo editing, 20, 32, 36, 220

● *T* ●

tablets (computer), 94–95, 275
Tagged Image File Format. *See* TIFF format
taking pictures
 action shots, 135–137
 annoying "features," dealing with,
 142–143
 blotchy or jagged images, avoiding,
 141–142
 capture resolution settings, 126–127, 306
 color temperatures and, 116, 129–130
 for compositing, 131–133
 composition, 99–104, 307
 compression settings, 50, 127, 306–307
 depth of field, 123–124
 file formats, 128–129
 focusing, 120–122
 keeping the camera still, 117, 123
 light and exposure, 105–120, 307–308
 for panoramas (stitched together),
 138–141
 parallax errors, avoiding, 104–105, 133
 practicing, 309–310
 zooming, 133–135
Talbot, William Henry Fox (inventor), 1
Tarradas, Juan Trujillo (programmer), 333
Technical Stuff icon, 6
telephoto lenses, 58, 133–134
templates, 16
thermal dye (dye-sub) printers, 170, 171,
 172–173, 181
Thermo-Autochrome printers, 170–171
thirds, rule for composition, 101, 307
35mm lens, 58, 59
three megapixel cameras, 47

Threshold value for Unsharp Mask filter, 241–242, 244
thumbnails, opening images from, 219–220
ThumbsPlus (Cerious Software), 163–164, 165, 335. *See also* installing
TIFF (Tagged Image File Format) format
 byte order, 158
 defined, 328
 file size and, 128
 lossless compression for, 153, 158
 overview, 157–159
time. *See also* action shots
 digital cameras versus film cameras and, 12, 17, 18
 lag time between shots, 18, 68
time-lapse photography, 67
Tip icon, 6
Tolerance option
 for Magic Wand, 252–253
 for Paint Bucket tool, 289
Trace tool. *See* Lasso tool
transferring images. *See* downloading images from a camera
transforming layers, 299
transparency. *See also* opacity
 for color fills, 288
 JPEG versus GIF format and, 200
 Matte option (Elements) and, 207–208
 mimicking in JPEG format, 210
 transparent GIF (GIF89a) format, 161, 202, 205–208
transparent GIF. *See* GIF (Graphics Interchange Format) format
tripod mount, 69
tripods
 buying, 93
 for holding the camera steady, 123, 308
 for low light, 69
 for panoramas, 139, 140, 141
troubleshooting the CD-ROM, 337
truthfulness, photo editing and, 247
T-shirts, printing on, 314
TV, displaying images on, 153–155, 193
TWAIN drivers, 151, 328
24-bit images, 42, 199–200, 323

two megapixel cameras, 47
256-color images. *See* GIF (Graphics Interchange Format) format

• U •

Ulead
 PhotoExplorer (on the CD), 334
 PhotoExpress (on the CD), 87, 333
 PhotoImpact (on the CD), 89, 333
underexposure, 37. *See also* exposure
Undo command, 222–223
undoing, 222–223
Unsharp Mask dialog box, 240–242
Unsharp Mask filter, 239–242, 244
unsharp masking, 239–240, 328
uploading, 328
upsampling, 32, 33, 184. *See also* resampling
USB CameraMate (Microtech), 80, 81
USB (Universal Serial Bus)
 defined, 328
 download devices using, 80, 81–82
 downloading images using, 77–78, 148, 149–150, 153
 Windows versions and support for, 46, 70, 78, 150
Use All Layers option
 for cloning, 270
 for Magic Wand, 253
 for Smudge tool, 280–281

• V •

Variations filter, 236–237
VCRs, recording images on, 154–155, 193
VGA resolution, 35, 46, 47
video-out capabilities of cameras, 65, 153–155
viewfinders
 electronic, 54
 LCD monitor versus, 53–54
 optical, 53–54
 parallax errors and, 104–105, 133

Virtual Album (Radar Software), 335. *See also* installing
Visual Infinity's Grain Surgery AE (on the CD), 334

• *W* •

Wacom
 drawing tablets, 95
 Web site, 320
Warning! icon, 6
warranties, 70, 178
Web images. *See also* GIF (Graphics Interchange Format) format; JPEG (Joint Photographic Experts Group) format
 basic rules for, 198–199
 for company site, 192
 compression setting for, 157
 digital camera benefits for, 15, 312
 file size for, 32, 36
 GIF format, 199–208
 gradual display of, 201
 JPEG format, 199–201, 208–211
 JPEG versus GIF for, 199–201
 monitor resolution and, 194
 Photo CD format and, 160
 on photo-sharing sites, 192
 pixel dimensions for, 31, 126, 194
 sRGB color model for, 41
 Web optimization utilities, 201
Web resources
 on the CD-ROM, 335
 FlipAlbum, 164
 Hoodman LCD hoods, 93

JPEG 2000, 159
manufacturer Web sites, 320
Ofoto, 182, 192
photo-sharing sites, 192
Print Image Matching (PIM) technology, 186
print services, 182
Shutterfly, 182
ThumbsPlus, 163
useful Web sites, 317–320
Wacom drawing tablets, 95
Webcams, 55, 56
white balance
 for artificial lighting, 116
 defined, 328
 filters mimicked by, 61, 130
 overview, 129–130
wide-angle lenses, 58, 59, 133–134
Width option for Magnetic Lasso, 255–256
Windows Bitmap format. *See* BMP format
Windows Explorer, 163
Windows platform. *See* PC platform

• *X* •

XGA resolution, 35

• *Z* •

Zip drives (Iomega), 83, 85
zoom lenses, 58, 133–134. *See also* optical zoom
zooming with camera. *See* digital zoom; optical zoom

Notes

Wiley Publishing, Inc.,
End-User License Agreement

READ THIS. You should carefully read these terms and conditions before opening the software packet(s) included with this book "Book". This is a license agreement "Agreement" between you and Wiley Publishing, Inc."WPI". By opening the accompanying software packet(s), you acknowledge that you have read and accept the following terms and conditions. If you do not agree and do not want to be bound by such terms and conditions, promptly return the Book and the unopened software packet(s) to the place you obtained them for a full refund.

1. **License Grant.** WPI grants to you (either an individual or entity) a nonexclusive license to use one copy of the enclosed software program(s) (collectively, the "Software" solely for your own personal or business purposes on a single computer (whether a standard computer or a workstation component of a multi-user network). The Software is in use on a computer when it is loaded into temporary memory (RAM) or installed into permanent memory (hard disk, CD-ROM, or other storage device). WPI reserves all rights not expressly granted herein.

2. **Ownership.** WPI is the owner of all right, title, and interest, including copyright, in and to the compilation of the Software recorded on the disk(s) or CD-ROM "Software Media". Copyright to the individual programs recorded on the Software Media is owned by the author or other authorized copyright owner of each program. Ownership of the Software and all proprietary rights relating thereto remain with WPI and its licensers.

3. **Restrictions On Use and Transfer.**

 (a) You may only (i) make one copy of the Software for backup or archival purposes, or (ii) transfer the Software to a single hard disk, provided that you keep the original for backup or archival purposes. You may not (i) rent or lease the Software, (ii) copy or reproduce the Software through a LAN or other network system or through any computer subscriber system or bulletin- board system, or (iii) modify, adapt, or create derivative works based on the Software.

 (b) You may not reverse engineer, decompile, or disassemble the Software. You may transfer the Software and user documentation on a permanent basis, provided that the transferee agrees to accept the terms and conditions of this Agreement and you retain no copies. If the Software is an update or has been updated, any transfer must include the most recent update and all prior versions.

4. **Restrictions on Use of Individual Programs.** You must follow the individual requirements and restrictions detailed for each individual program in the "What's on the CD" appendix of this Book. These limitations are also contained in the individual license agreements recorded on the Software Media. These limitations may include a requirement that after using the program for a specified period of time, the user must pay a registration fee or discontinue use. By opening the Software packet(s), you will be agreeing to abide by the licenses and restrictions for these individual programs that are detailed in the "What's on the CD" appendix and on the Software Media. None of the material on this Software Media or listed in this Book may ever be redistributed, in original or modified form, for commercial purposes.